For Katharine 梦琪

Cover Photo

Madeln Company
'Focus', 2011
12 x 18 x 21 cm
Camera (HASSELBLAD 500C/M),
with aboriginal spear, variable dimension

The camera is an instrument that captures events.
It represents our eyes, as well as a record of reality.
It can also voice, from various viewing angles,
an opinion which differs completely from others.
The spear is a common weapon, facilitating both
resistance and violence. Penetrated by a spear, the
camera here also implies specific injury and conflict.
Metaphorically, this could be considered either
the murder of a reality or the resistance to a lie,
depending on the standpoint one decides to take.

ARTISTS IN CHINA

SHORT

THOMAS FUESSER

CUTS

SKIRA

"I feel that art has something to do with the achievement of stillness in the midst of chaos. A stillness which characterizes prayer, too, and the eye of the storm. I think that art has something to do with an arrest of attention in the midst of distraction."

Saul Bellow (1915–2005)

Cited in Alfred Kazin and George Plimpton (eds.), *Writers at Work: The Paris Review Interviews*, Volume 3. New York, NY, Viking Press, 1967

I first met Thomas Fuesser in Beijing in 1993. Both foreigners from Europe, we shared a fascination for China's new outlook and how we could each involve ourselves in a creative dialogue with its artists. But it was not until 2000 in Shanghai that we began to collaborate professionally, when I organised a series of general visits for various artists, curators, and art writers from Germany. At the time Thomas was working closely with the Ministry for Cultural Affairs of Hamburg, facilitating their sister city exchange with Shanghai. I had a small space then called Fuxing Lu Gallery. Later I also took them through my Suzhou Creek Warehouse next to Moganshan Lu. It was before the M50 art district emerged.

Then in 2009 we organised the "Stolen Treasures from Modern China" group show in Beijing and Shanghai, along with Zhou Tiehai, Andy Hall, and Chris Gill. It was the first opportunity to see the images Thomas had previously kept tucked away as negatives for over a decade. Beautifully intimate photographs, he documented the Chinese 'renaissance' of the early 1990s, with many of China's now famous artists. Accompanying these images and some artworks, we set up a forum to discuss the changes that had taken place in China over the previous two decades, as well as the media's influences on art practice and the careers of contemporary artists here. It was a truly unique period; the country was stirring with reforms and the unprecedented atmosphere was the catalyst for a select group of artists to fly well above the cultural clouds. The purpose of our initiative was to trace some of the creative and psychological processes that had taken place since 1993. The ways in which China's art, self-image, and history were sculpted by local and foreign interventions. We included Zhou Tiehai's seminal silent film entitled 'Will/ We Must', which depicts a band of artists intent on building their own airport to lure foreign collectors and critics to Shanghai. It cleverly satirises the earliest naive notions of how artists become important, and some of their emotional responses to their counterparts in the West. We received welcome attention, and came away eager to continue exploring the dynamics that had been generated. I remember urging Thomas to develop his ideas further along a similar vein, and I'm very happy to see that his *Short Cuts* project has since evolved into this first volume account of an art world that is otherwise typically reclusive and difficult to access.

Having grown up surrounded by art — my father and two brothers are artists — I decided to study art history in Zurich. But I also wanted to travel, so I took up Chinese in the 1980s and became interested in Chinese art through its cinema. After some time in Hong Kong, I moved to Shanghai in 1996, hoping to work closely with artists, not just selling their work. Shanghai was a very different place back then. I wanted a gallery that provided information and nurtured relationships, but there was no market and I had to invest heavily.

For artists in China the early 1990s was a particularly challenging time. They would send their work to Hong Kong to be sold and many felt great pressure to become 'successful'. Running a contemporary art gallery was no less complicated. In the beginning, we set up exhibitions at the Portman Hotel in Shanghai. It was a very small but free space, the owner had a license to sell paintings, and some people seemed to enjoy discovering contemporary art in a five-star setting. In 1999 I moved to Fuxing Park, in the downtown French Concession. In fact, our first real show was on Ding Yi's abstract works in 1996. It was a series of fifteen paintings, all basically the same size and colour. Abstraction was virtually unknown in China then. Art

was considered for the people, so abstract work was seen as elitist. It was almost too much for the locals to take. In 1993 Wang Guangyi and other artists went to the Venice Biennale with their 'Political Pop'. I found a younger generation of Shanghainese artists, and later began working with older ones, like Li Shang. In 1998 we started collaborating with artists in Beijing. I wanted a pluralist approach, with no specific or predefined program. Everything on show was good, but it was not easy for people to digest. Audiences were just beginning to realise what was being produced in China and its potential internationally.

I believe the most important thing is to see whether an artist can do something new, something distinct from what they did in their early stages; work that demonstrates a continuity of development. I like to play my part in that process, quietly motivating from the side and watching them attempt something interesting and innovative. I try to do this with all my artists and many have become friends. It's what I have encouraged Thomas to do, and we still trust each other after all these years.

Cultural visionaries like Hans van Dijk (1946–2002) were vital to many artists' careers and the fermentation of the art scenes in Beijing, Shanghai, and Hangzhou. The period Thomas spent covering this was a vital one in China's artistic consciousness. With the accelerated changes that have happened since, there is little time for reflection. We almost have to steal opportunities to stop and think. I admit I am personally driven by the need to make things happen. To break new ground, like a path in the jungle. Of course, this is never easy, but I try to maintain a focused and practical approach to the often painstaking process of birthing ideas and working collaboratively.

My aim has always been to build a cultural and aesthetic bridge; supporting and inviting artists to take their rightful place on the world stage. Strictly speaking, I have never seen myself as a collector or a conventional gallerist. After all is said and done, I think it's about how artists feel about their work and what various kinds of people think about their journey. In China the practice of patronising contemporary art is still developing. Until relatively recently it was not considered a priority. By contrast, foreigners have been collecting in this part of the world for over two decades.

Personal, spontaneous, and creative adventures are for me always the most interesting kind. And it's what I hope Thomas will continue to do for artists in China and photography itself.

Time Against Time

Dr. Shen Qilan

This is not a history of contemporary Chinese art, nor is it a catalogue of portraits. *Short Cuts* is about destiny, chance, and luck. It demonstrates the mysterious relationship between a unique proposition and its energetic inventor. Thomas Fuesser did not deliberately set out to photograph artists in China. The act of photographing them suddenly chose him and from that moment on his true creativity began.

In an age of digital archives and search engines, what is the raison d'être for this kind of book? These celebrated artists are not short on media coverage, so why present them in this way? Fuesser once placed a beer bottle on the edge of a table and a coffee mug in the middle and said, "Look, these two items appear quite apart, but if you observed them from the depths of a different universe, you would see them as located on the same spot." I still remember that bottle as it stood precariously, so much so that I was taken with fear for its fall, which seemed inevitable but difficult to predict. Fortune and death, chance and choice, and other such tangled propositions are forever intriguing for Thomas Fuesser; hence his "short cuts". Of course, our transient existence is in stark contrast to the constant marching of time. This book freezes a set of experiences and offers a rare glimpse into a moment of destiny.

In 1993 Fuesser photographed Chinese artists working on their first exhibition in Berlin. He shot several projects at the same time and this was just one of his daily and unassuming tasks. One day the exhibition was cordoned off due to the arrival of an important visitor. Fuesser had to turn back to pick up the light meter he had left behind and inadvertently ran into the mysterious VIP, who turned out to be the godfather of contemporary art, Leo Castelli. Thomas recalls, "It felt like a strange face-to-face encounter with the future. Back then nobody knew anything about Chinese contemporary art, but Leo was interested and he was surely right about those artists." From that day on Thomas Fuesser followed the call of destiny.

Since the early 1990s, he has worked between East and West, and across Europe. Artists in China have featured in his life and granted one serendipitous event after another. While Hans van Dijk was the first to shed light on the works of these artists, Wu Shanzhuan, with his unique blend of humour and intellect, also became Fuesser's close confidante. It seems the hand of fate wanted this photographer in China. They say a man is already fortunate to have five close friends throughout his life. After coming to China, Fuesser discovered an emotional intimacy he had not expected. *Short Cuts* was not born from a process of deliberate labour, but rather as the fruit of natural gestation. Those attracted to the warmth of emotions always seem a little awkward in the face of material pursuits. But such difficulty also helps one to avoid the pitfalls of too much cleverness.

This photographer has always claimed, "I'm not an artist, I'm just presenting things as they are. I don't create objects." And yet, how an object is presented is also an art form, by which I mean the realization of the photographer's intention rather than the techniques of photography. And this is perhaps what sets this project apart. It seems inappropriate to call the single images in this book 'artworks', and while turning its pages you can just feel the passing of time. Photography can override reality by way of immediate representation, which is naturally afforded by the camera, but Fuesser avoids over-interpretation and resists photography's capacity to enhance realism. Susan Sontag believed that a photograph confirms

facts and that images are a means by which something can become real. Thomas Fuesser does not want to confirm any such reality. He is convinced that a true photographer eclipses his or her camera. What fascinates him is the very instant the camera disappears within the creative process. He admits that not every attempt yields a moment like that, and that photographers are always tempted by the kind of 'reality' a particular camera is capable of constructing, thereby falling into the expressional trap of 'confirming facts' and reducing photography to a conceptual tool. *Short Cuts* aims to present the flow of life between the photographer and the photographed. It represents no information or specific knowledge, and advocates no aesthetic or critical position. Instead, it documents overlapping time and encounters between individual destinies.

"Had I been cleverer, I would be living an easier life now", Thomas once lamented. He has read Saul Bellow's *Humboldt's Gift* over and over again. Humboldt's fate is quite representative of those kind souls and their drifting lives. Fuesser finds consolation and empathy in a metaphor of human history — "Artists are the souls of society" — which he has often mumbled to himself. This book records these creative people, who have necessarily experienced the struggles of fate and will eventually settle their accounts with history. The reader can hear the clanging of the clock in the precision of the photographer's method.

Reminiscing, he recalls: "I still remember our opening conversation — are you a collector? Me? No, I'm not." A few decades ago, an artist who later gained worldwide fame wanted to sell him his artworks at very low prices. Fuesser gave him the money, but never took the pieces away. "I didn't want to own them, I never do." And yet this project is a treasure trove. If you look carefully you will notice the persistence of time and the remnants of providence.

From the Inside

Rosa Maria Falvo

Almost twenty years ago, in Andrew Solomon's candid report on China's art scene for the *New York Times* magazine (19 December 1993), Shanghai born, painter and art scholar Xu Hong was quoted as saying: "People speak all the time of mixing Western and Eastern influences, as though it were like mixing red and blue ink to paint pictures in purple. They do not think of what it means to understand these two cultures and to try to incorporate their different ways of thought". While neither Thomas Fuesser nor Lorenz Helbling are naturally attracted to the limelight, even today, their lives have been independently and inextricably linked to those seeking that limelight and bringing these worlds together. Dissolving the borders between cultures and art practices, between artists and photographers, and even between the public and the gallery space, is what appears to inform their imaginations. Fuesser is no doubt interested in those subtle but fertile 'interior' spaces, explored in the process of making art, which courageous artists of all kinds deal with everyday. Perhaps this is the common thread that links otherwise disparate perspectives and experiences, and remains constant in these images as much as in his migratory soul between Europe and Asia.

Inspired by Robert Altman's acclaimed film about an ensemble of relationships and circumstances in Los Angeles, Fuesser has put together his own mosaic of artists living in China. We see loosely-knit, intimate, and parallel flashes of their faces and ideas juxtaposed with their artworks and their busy, even frenetic, lives. And Fuesser demonstrates an intuitive feel for their individual journeys. Of course, Altman was concerned with the shadowy social tapestry of middleclass America in the 1990s. But Fuesser's subjects today are also elusive, in that, as outsiders, whether culturally or otherwise, we can only begin to understand them through a kind of artistic 'interpreter', as it were; someone on the inside, who shares their world. The overall effect is less about narrative and more about mood. Each image implies cooperation and these artists are clearly comfortable with their photographer. While they are the conspicuous protagonists, even in their absence, we can feel the pulsating Chinese metropolis that surrounds them, feeding them a context for their work. Fuesser emphasises the 'stillness' of our privileged moments with them. Their concentration, efforts, and in some cases dismay, is ours vicariously, for the few minutes that we allow ourselves to enter into their world. We can feel Liu Wei's improvisation, Zhang Ding's versatility, and Sun Xun's meticulousness. Zhang Peili's overwhelming screens and Chris Gill's burgeoning canvases frame their subjects and makers perfectly. Fuesser sees all of this, in an instant, but there is a mutually creative drive to his approach, a deep empathy and connection, that makes this project transcendent. In this sense, the imagery here was made collaboratively.

Most photographers agree that a good portrait is one of the hardest pictures to achieve. There's a sense of uncertainty, an awareness of the emotional evocation someone can offer, and a typically awkward prelude to shooting. Indeed, it seems that a dedicated photographer has the same kinds of dilemmas as a sculptor, painter, or musician. Fuesser has followed these artists from their beginnings, taking an interest in them as people across the gamut of their lives; a commitment that is essentially coming from a place of understanding. And therein lies the catch: when you photograph an unknown artist, as opposed to a star for the cover of a big magazine, most of the images are likely to remain in a box. But this is what is meant by participating in the history of art. The journey is made up of all those who have carried the torch and contributed to a certain discourse or significant moment in time. An artist, great or small, emerges from

a cultural humus, consisting of others who may never be recognised by critics or the larger market but are nonetheless indispensable to the process. Fuesser's environmental approach to portraiture ensures these pictures have historical significance, while he plays an active role in animating the scene. If artists are a kind of litmus paper for society, then this wryly observant photographer has shown good instincts in defining his own artistic achievements in such a substantial body of work.

Ugo Mulas (1928–1973) famously concluded: "When I photograph painters, I often try to go beyond the mere reportage... what I'm interested in is to make clear the artist in connection with the results of their own works, that is to say, that I have tried to understand which of their attitudes is crucial to the final product". His brief but intense relationships in the art world produced compelling imagery that showed a certain complicity of mind. So if a good portrait is the result of a unique collaboration between photographer and subject, then we can safely say that the emotional reciprocity in Fuesser's work is based on trust; a shared moment of exchange between one kind of artist and another. Even fleetingly, there is evidence of familiarity or rapport. In the case of Cai Guo-Qiang, the journalistic encounter itself provides the backdrop to a more confidential 'recording' of his personality. Here the reflexivity creates an engrossing set of portraits that ask more questions than they answer. But visual language is unwieldy and open to very subjective interpretation. And yet even in the context of its inherent variations, we get the feeling this person is a complex imaginative being. Which begs another question: who and what is an artist? Historically, taking pictures of them meant being an integral part of a passionate, improvised community; an intellectual hub, attracting kindred spirits ready to challenge and support each other's assumptions and aspirations.

Fuesser is what you might call a creators' photographer. And not just because his colleagues admire his work, but because they are his work. You can see their quick bursts of thinking, alongside the time it takes for their ideas to percolate, even while they're doing something apparently unrelated, like cooking in their kitchen. Viewers are invited to witness the creative process, and how artists conceive their practice becomes a central theme. This photographer maintains that his work is "all about emotions, observing, and personal and private access". It is a slow, tentative process, but he has earned his status as an insider; empowering these artists to confide in him and invest in his efforts. Some shots have an experimental feel, such as the psychedelic red enveloping Zhang Ding, and others are ostensibly playful for the artist but metaphorically poignant for the photographer, such as the cover image by Madeln Company, entitled 'Focus', with an aboriginal spear skewering a Hasselblad. Fuesser describes it as either "the murder of reality or the resistance of a lie", depending on one's perspective.

Sequentially these images convey a naturalness that comes from Fuesser's own working method, coupled with a reverence for each artist's adherence to their craft. We get a sense of the passage of time, but more specifically of the tenacity of artistic drive and the pressures of public personas. We can almost hear the street interjecting the silence of a studio or the moment when an artist is lost in thought. In his ongoing physiognomy of the creative essence of contemporary China, Fuesser seeks a balance between the internal world and the one outside. Happily, he has applied a contemplative style to his documentation. One that validates a similar intuition from another kind of artist and culture, over a century earlier:
"It is not likely that posterity will fall in love with us, but not impossible that it may respect or sympathize; so a man would rather leave behind him the portrait of his spirit than a portrait of his face". (Robert Louis Stevenson, 1850–1894)

Portrait of a Photographer

Jean Loh

The origins of Thomas Fuesser's photographic project come from a unique opportunity, which he is probably the only one to enjoy. He penetrated museum and gallery walls, ignored the auction house hammer, and captured the intimacy of some of the most acclaimed contemporary artists in China. He has revealed the way they work, the spaces where they create, how they paint, and what they do with their time. In carefully structured intervals, he demonstrates how he has been profoundly inspired by life in China and the varied personalities of its artists.

Fuesser first came into contact with artists in China as early as 1993, when Dutch curator Hans van Dijk arranged for a group of foreign journalists and photographers to visit the up-and-coming members of the then fledgling avant-garde art scene in Beijing and Shanghai. Fuesser knew nothing about China at the time, but was instantly hooked. He has since become a welcome fixture in artists' studios, those very ones who were, to quote him, "poor and unknown" at the time. As these artists grew in stature, they embraced him despite the fact that he did not speak a word of Chinese and they knew no German and little English. This special rapport has given him very privileged access to a typically reclusive art community.

When photography emerged in the 1800s there was a temptation for photographers to substitute 'art' with photographic compositions that competed with the best paintings of the times. However, Fuesser's artistic aspiration lies in his following of one of the greatest traditions of this genre, the photographer's observations of an artist at work. We can clearly recall George Brassaï's images of Picasso and Matisse, Henri Cartier-Bresson's intimate portrayals of Matisse and Giacometti, and even the most recently unveiled images of Lucian Freud by David Dawson. Thomas Fuesser's *Short Cuts* offers an exceptional look into the inner sanctums of artists in China; how they work, rest, and play.

The shuttered bull's-eye

To begin with, we are struck by the cover image of an arrow shot through the lens of a camera, an artwork by the artists' collective Madeln Company. As a metaphorical bull's-eye, one could interpret this as the photographer's ambition to illustrate his creative purpose. That is, to penetrate the secrets of art making and even the souls of these artistic minds.

But what I did not suspect was this candid confession by the photographer himself: "I didn't have that in mind when I chose this picture, because that artwork provoked a lot of pain in my brain and in my heart when I first saw it in the Madeln studio. They created it with three cameras and one of them was this Hasselblad. It was shocking for me. Coming from classical photography, everything I had done before was on film. Most of the portraits I did were in black and white or Polaroid. I fell in love with portrait photography because it gave me time to pay attention to the person I was capturing. But times have changed. Now few people have the patience to let you prepare the shooting, loading, and changing of films in your camera. It has taken me a long time to make peace with myself as I completely changed my approach, switching from analogue to digital. This picture translates the pain I felt in destroying my own past."

The temple of art

Having settled this technical issue Fuesser set upon a grandiose idea. The work begins with a kind of temple invocation. We see Ding Yi's 'crosses', meticulously arranged across his large canvasses and religiously installed as neon lights outside the Minsheng Art Museum in Shanghai. And still more images focus on Zeng Fanzhi's stained glass and veiled sculptures, a 'veiled' reference to Michelangelo's 'Pietà'. It is as if this photographer wants the viewer to appreciate his photo album with the same respect, rigour, and seriousness he has devoted to the portrayal of these artists. Yu Hong's scenography in the deserted exhibition halls of the Shanghai Art Museum gave Fuesser the opportunity to produce a classical portrait of the female artist, rendering the contemplation of her work like in a kind of Sistine Chapel. We can understand why this photographer likes Saul Bellow's words: "I feel that art has something to do with the achievement of stillness in the midst of chaos. A stillness which characterizes prayer, too, and the eye of the storm." Fuesser explains, "For me artists are the soul of society. They are its reflection and in a sense they are also its psychiatrists, be they oriental or western, from North or South. You will find in their work something that reflects what is happening everywhere." Indeed, Zeng Fanzhi is represented in this way, because the photographer feels his search for salvation: "I have included the black and white portrait of him I took in 1995, alongside a painting in his 'mask' series. Although his face looks serene, underneath he was burning like hell." And Ding Yi is truly the most contemplative artist he has met, as Fuesser confides: "Back in 1993, Hans van Dijk told me that there were three developments in Chinese contemporary art: new socialism, new realism, and Ding Yi."

Armchair portraits

The meditative picture of Ding Yi's empty armchair is composed in such a way that one notices the crosses on the ceiling and the art deco windows; that is, the artist's omnipresence. Fuesser was impressed by the fact that this artist always sat in that chair when receiving guests, like some kind of evangelist preaching art and offering them excellent coffee. Curiously, Zhang Enli is also portrayed sitting in a huge leather armchair. Although these chairs appear to be a little oversized for the two artists, they provide a statuesque and stoic stillness. Another empty, velvet, armchair was featured in the atelier of the art couple Wu Shanzhuan and Inga Thorsdottir, and in photographing Chris Gill at work. Fuesser reveals that the blue velvet chair on which Gill sits to paint remains impeccably immaculate while paint is splattered all over his clothes and the floor. Here the chairs appear to anchor the artists' living and working spaces; providing safe havens where they can rest after a demanding work session. Zhang Enli's portrait in the armchair is an especially moving reminder of Cartier-Bresson's 1944 portrayal of Matisse in almost the same pose, with the great master holding a white dove in one hand and sketching with the other.

Lines, structures and patterns

Since Fuesser comes from a German photographic school in the broad sense, one can feel that he is particularly inspired and excited by the different geometrical compositions and architectural installations in the artists' ateliers and the exhibition halls of the museums and art centres where they display their work. With his judicious placement of the camera inside some installations, like in the case of Liu Wei, he is able to magnify the artist's verticality, like a forest in the city, creating a relationship between his trees and the confined space. Fuesser's sensitivity to lines and forms led him to craft a painting within a painting — 'un tableau dans un tableau' — such as when he borrows the huge painted walls of the Rockbund Museum in Shanghai to illustrate Zeng Fanzhi's electric blue zebra-stripes. And when he places the Chinese calligraphy 'Peasant' above Cai Guo-Qiang's head, presenting the artist like a great orator talking to the press.

Artists on the move

In contrast to these 'sofa artists', Fuesser's images mostly maintain an energetic tension. Artists are viewed as intense physical workers who are actively on the move, like Liu Wei constantly talking on the phone and the non-stop physicality of Pu Jie's painting process, almost like a labourer or brick layer. "He's always in action, walking around, jumping up and down, he would not even sit down for a tea", explains Fuesser. "I saw this installation by an Austrian artist, Elizabeth Gruebl, who built a sculpture with all of Pu Jie's canvasses and the interiors she had assembled from his studio. So I suggested he climb up there for a photo. Up he went and sat inside the cubicle, ready with this pose. I said 'please don't move', and you know what, he actually stopped for a few minutes, like he really enjoyed the peace and quiet he had found!" It makes you wonder whether these are the modern-day characteristics of multimedia artists, such as Zhang Ding and Liu Wei. They are always multi-tasking, organizing the team works, and intimately connected to all the newest communication systems. Fuesser had to use a flash-light to immobilize Zhang Ding while paradoxically producing even larger images of his movements — "he's a very intense worker, everything he does is carefully planned." Sun Xun's blurred portraits also reflect a young and talented artist constantly at work. Fuesser made a point of saying that Sun Xun used to work only in black, but this time he was painting in white. From a photographic point of view, this black and white coincidence materialized in the picture he took while waiting for the artist who had been delayed at the airport. Sun Xun's favourite pet, a nervously energetic black and white American Checkered Giant rabbit, happened to be wearing the same black-rimmed eye-glasses as his owner.

Another 'physical' artist is Chris Gill, here wearing a sweater splattered with paint in the colours of the South African flag. His smeared face emerges above his blue canvas, almost echoing Francis Bacon. At the same time it reminds me of those portraits of Lucian Freud painting, made by his assistant David Dawson, and illustrates that photography can assimilate the brushstrokes. It also demonstrates Fuesser's creative efforts in consistently finding an original and effective method of portraying seventeen major and individually very diverse artists.

The concept of *shen* in Chinese traditional portraiture

"Zhang Enli is an extremely sensitive guy," explained Thomas, "before the opening of his exhibition at the Shanghai Art Museum, those around him said he had stomach cramps for two days because he was feeling the pressure." This makes his smiling portrait even more remarkable: "I caught him at the end of the opening ceremony and I sensed his relief, the pressure was off, finally he relaxed and cracked a smile."

In Chinese traditional ink brush painting there is a genre called *ren wu*, literally 'people and things', which corresponds to the concept of portraiture in Western art. However, this 'people and things' genre is much less practiced than 'mountains and waters' (landscape) or 'flowers and birds' (nature). Is this because of the tradition of Confucian pudeur, an avoidance of overly frank portrayals, or could it be that painting a portrait of someone is actually more difficult than sublimating an idea with mountains and bamboo? Here there is a widely accepted theory that in portraiture the artist should achieve an expression of *shen*, an almost untranslatable concept, somewhat akin to notions of 'spirit', 'inner soul', 'energy', and even the quality of that energy. For his representation of the Madeln Company, Fuesser arranged their individual portraits in a sort of Facebook style, and to make it interesting he directed each artist to look up or down. I remember the first time he asked me to sit for his portrait project almost ten years ago. He gave me two very simple instructions: "please don't move" and "smile with your eyes, not with your face." Fuesser's first monograph was in fact entitled *Please Don't Move* and though I never saw that portrait of me, assuming he was not happy with my inability to smile with my eyes, I spent a long time wondering what he had meant.

Perhaps 'aura' is a more appropriate definition of *shen*, which is what this photographer does best. Instead of pursuing the long tradition of seated, studio portraiture, with all its necessary lighting and backdrops, he has focused on people in their own environments, attempting to capture their auras on the fly, on the move, and while they are not looking into his camera.

Power faces

The creative energy radiating from an artist is especially detectable in a powerful face. This project has a decidedly historical dimension, as we are looking at some of the most powerful figures in China's contemporary art scene. I wonder what Fuesser was thinking as he photographed such heavy-weights as Zeng Fanzhi, Cai Guo-Qiang, and Ai Weiwei, and whether he still remembers the way they looked when he first met them almost twenty years ago. Perhaps it is this very familiarity, accumulated over time, which has allowed him to pinpoint who they are and what can be read from their "power faces". For instance, in the two consecutive diptych portraits of the famously angry Zhang Peili, we see one with his eyes wide-open and the other with eyes shut, conveying the idea of inner and outer worlds. But it also looks as if Peili were sending us a signal behind his "Correct pronunciation of weather broadcast" work; a powerful artistic statement evoking an obviously sensitive historical event in China.

Paramount to his status in the global art world community, Ai Weiwei's striking face speaks for itself. His blurred head-shaking portrait, as if saying NO to whatever he cannot tolerate, is a strong declaration of his unwavering personality: "I am an individual. I am not part of any system. My system is my conscience" (2009). It is interesting to note here that many years ago in his New York 1983–1993 photography series Ai Weiwei experimented with self-portraiture, images of himself shaking his head from left to right, creating blurry faces. This also reminds me of Duane Michals' and Francesca Woodman's 1970's experimental photography; particularly Michals, having photographed Marcel Duchamp, René Magritte, and Giorgio de Chirico, for whom portraiture is still a real challenge as it deals mainly with appearance. He argues that the photographic image is essentially a lie, because people cannot be what they look like. Observing Fuesser's images of artists' paintings, sculptures, and installations we could ask whether these artists are really what they paint. In this context, Cai Guo-Qiang's face is the most representative of Fuesser's style. Far from being a total convert or in awe of these influential art world figures, this German photographer seems to practice the concept of 'distanciation' (Verfremdung). These eleven 'snapshots' of Cai Guo-Qiang, perhaps taken in the celebrity-hunting paparazzi manner, portray this fireworks artist as an object of strangeness, particularly worthy of a face study. As our photographer put it: "Well, I followed Cai Guo-Qiang for three days. He acted like a superstar, which he is, and I noticed that he looked different depending on the circumstances. His

facial expression was constantly changing, immediately expressing what was going on in his brain. This is very different from other Chinese artists, who are usually detached and subdued. During interviews Yang Fudong wears a stereotypical expression and always looks very cool. Ai Weiwei is always cool too."

A day in the life of an artist

Nonetheless, sometimes we find that an artist really reflects what he or she makes. Both Wu Shanzhuan and Inga Thorsdottir have a certain resemblance to their creative works. Perhaps for this reason Fuesser's approach with them is rather like a documentary, a quasi reportage for a magazine piece on a day in the life of an art couple. "Wu has three major issues in his life", says Thomas, "first is what's going on in the world, second is swimming, and the third is food — nothing but healthy food". Indeed, the portraits of Wu and Inga are a sensitive re ~tage on the artists at work, rest and play. They are shown in their complete intimacy, working togethe' ' a pool, and preparing dinner in their kitchen. One surreal image stands out, where Inga is '~d in the middle of the mezzanine floor of the Shanghai Art Museum. "She dec nock and amusement of everyone watching. She's a wonderful artist and a ('mas.

Listening to Bach, E vinyl record player! What a surprising representation of Feng Mengbo. Wh(his digitalized world of video-inspired violence, a calm and solemn looking ar' ouette of a bloody Bruce Lee figurine? In a studio littered with electronic compo ary on walls and computer screens, we can hardly tell if this artist's paper-cu or just another pixilated painting he has created. As with Zeng Fanzhi, Fuesse ite portrait he took of Feng in the 1990s, as a poignant measure of time gone k a image in an old photo album.

Short-c sés

Like in r ne same name that came out in 1993, the very year Thomas Fuesser former(Una's art community, the seventeen artists here are not represented as m' hris Gill's revelation about how Ai Weiwei became a master internet com orks is one striking example. "Twitter... Like a bird", this innocent phrase in (i opened up a new artistic activism for this artist. Without it, we cannot un d, shaved-hair portrait, and the 'MISSING' poster in Fuesser's photograph. It esence of Chris Gill and Inga Svala Thorsdottir among Chinese artists. And hina's contemporary artists had to be made by this German photographer. as actors and witnesses — in the history making, especially the invisible but esent, figures of Hans van Dijk and Lorenz Helbling, who together with Fuesser s connecting these seventeen profiles. Another vital figure is Zhou Tiehai, now in of the Minsheng Art Museum, who is dedicated to promoting exhibitions on the short rie. e contemporary artists and is an indispensable keystone in the *Short Cuts* project. As Fuesser has rc.. .ted, were it not for the omission of Andrew Solomon (*New York Times* art critic) in his most important first reportage on Chinese artists in 1993, there would not have been any 'fake' magazine covers by Zhou Tiehai with his own portrait, which eventually defined Tiehai's art practice and therefore his undeniable stature today. He is portrayed here alongside his quasi miniature paintings in his 'dessert' series. In one of them we have to look closely to see that each delicacy has a caption, in French, of a certain profession: diplomat, judge, minister, professor, dancer, washerwoman, financier, buffoon, ragman, bottom-smacker, and so on. Pointing to the importance of the written text, Fuesser suggests: "The dessert

series has somehow liberated, freed Tiehai from what he has been doing until now." It is also clear to me that Tiehai left out his own profession; he is indeed the 'philosophe'.

As a whole, this entire project evolved over the course of its shooting. From the simple portraiture of contemporary artists to a series of interconnected photo essays, each one representing the way Fuesser himself sees each artist, or as he puts it, "my interpretation of them". There is no precedent or equivalent work in China. In 1996 Chinese photographer Xiao Quan published a book entitled *Our Generation*, which includes portraits of artists such as Wang Guangyi, Zhang Xiaogang, Xu Bing, He Duoling, and Fang Lijun, all shot in the 1980s and 1990s, with a single black and white portrait per artist and a text recounting their relationship.

Short Cuts is not another book on China's contemporary art. Nor is it an art critic's thesis or even an historical or theoretical analysis. It is a photographer's attempt to integrate a variety of photographic genres under the pretext of intimately describing seventeen of the most successful contemporary artists in China today. It is an exercise in portraiture, still-life, architectural photography, documentary, and reportage. What we can all perceive is an undeniably passionate visual story by an inspired photographer with obvious affection and respect for 'his' artists. In the end, I suspect that the whole process belies Fuesser's own aspirations to be an artist. Of course, his "short cuts" also provide an enjoyable opportunity to learn something more about the dynamics of the contemporary art world, which still remains a mystery to me. Thank you Thomas!

DING YI

LIU WEI

ZHANG ENLI

CAI GUO-QIANG

ZHANG DING

ZENG FANZHI

INGA SVALA THORSDOTTIR

WU SHANZHUAN

ZHANG PEILI

SUN XUN

CHRIS P. GILL

PU JIE

YU HONG

FENG MENGBO

AI WEIWEI

MADEIN COMPANY

ZHOU TIEHAI

INDEX

Cover artwork
Focus, Madeln Company, 2011

Visual concept
Thomas Fuesser

Graphic design
Karkuidesign

Editor
Rosa Maria Falvo

Copy editing
Anna Albano

First published in Italy in 2012 by
Skira Editore S.p.A.
Palazzo Casati Stampa
via Torino 61
20123 Milano
Italy
www.skira.net

Printed and bound in Italy. First edition

ISBN: 978-88-572-1486-3

Distributed in USA, Canada, Central & South
America by Rizzoli International Publications, Inc.,
300 Park Avenue South, New York, NY 10010, USA.
Distributed elsewhere in the world by Thames and
Hudson Ltd., 181A High Holborn, London WC1V
7QX, United Kingdom.

CREDITS

I would like to acknowledge the following wonderful people, whose invaluable support and contributions helped me to create *Short Cuts*. I sincerely appreciate their individual inspiration and patience over the past months:

Chris P. Gill, Jean Loh, Shen Qilan, Rolf A. Kluenter, Marten von Rauschenberg, Sven Ruff, Christin and Michael Kalweit, Goetz Lehmann, Wu Shanzhuan and Inga Svala Thorsdottir, Zhou Tiehai, Zhang Peili, Vivienne Li, David Tung and Lu Jie from Long March Space, Pu Jie, Alexia Dehaene, Vivian Yutianzheng, Nannan Liu, Fred Kranich, Huang Yun and Bo Ye, Elisabeth Gruebl, Claus Christensen, Sam Wang, Key Chow, Tony Cheng, Henry Ng, and Lam Kar Kui.

Without their kind involvement this book would not have been possible! A heartfelt thank you to you all.

For their generous support, I thank Nathan Kaiser, Swiss Attorney-at-Law, and Torsten Hendricks at Integrated Fine Arts Solutions, who both believed in this project from day one.

My very special thanks for all their personal efforts and engagement to realize this book go to my editor Rosa Maria Falvo and the team at Skira in Milan, and to Lorenz Helbling and all the amazingly helpful hands at ShanghART Gallery in Shanghai.

SUPPORTED BY

karkuidesign

Thomas Fuesser

Born in 1960 in Essen, Germany, Fuesser has been living and working in China for almost a decade. He graduated in communication science and design from the University of Essen in Germany, and since 1986 has been working internationally as a professional photographer and designer in the fields of advertising, print magazines, and contemporary art.

In 2000 he received the prestigious German Prize for Communication Design for his design excellence from the Design Zentrum NRW in Essen, Germany.

Major Projects and Exhibitions

2012 *Short Cuts: Artists in China*, book project in collaboration with ShanghART Gallery in Shanghai, Skira editore in Milan, and 17 contemporary artists working in China
2009 "Stolen Treasures from Modern China", ShanghART Gallery in Shanghai and Beijing, China; two group shows with works by Zhou Tiehai, Andy Hall, Chris P. Gill, and Thomas Fuesser
2008 "Loss of the Real", Shanghai Xuhui Art Museum, Shanghai, China; "Time-Place-Person", group show on German and Chinese contemporary art
2007 "Borderlines", curated by Jean Loh, Beaugeste Photo Gallery in Shanghai, China; solo exhibition at the Pingyao International Photo Festival, Pingyao, China
2006 "Between the Observer and the Observed", solo exhibition; "Eyes of Life", curated by Lin Lu, Lianzhou International Photo Festival, Guangdong Province, China
2005 "The Search for Meaning and the Pursuit of Happiness", Jerusalem Foundation, Israel; group shows in Hamburg, Germany, and Jerusalem, Israel, curated by Nirith Nelson and Claus Mewes
2000–2004 "Please Don't Move: Portraits 2000", touring show supported by ZEIT-Culture Foundation and the Ministry for Cultural Affairs of the Free and Hanseatic City of Hamburg, Germany; exhibitions held in Hamburg (2000), International Arts Festival in Shanghai (2001), Photokina Cologne (2002), Goethe-Institute Inter Nationes in Singapore (2003) and Germany (2004)
1992 "Masters of Light: Cinematographers, their Actors and Directors", portrait series commissioned by the Academy of Arts in Berlin, curated by Wim Wenders, European Film Academy in Berlin, Germany

Awards

2000 "Decades" Award for Design Excellence and the German Prize for Communication Design from the Design Center Essen, NRW, Germany

Guest Lectures

2005–2011 "Photography and Design" at the International School of Communication Design (ISCD) and the Design Factory International (DFI-Zhuhai), Department of Beijing Normal University, Zhuhai City, Guangdong Province, China

2003 Goethe-Institute Inter Nationes in Singapore, together with the Nanyang Academy of Fine Arts (NAFA), Raffles University, Lasalle SIA College of the Arts, and the Design College of Temasek Polytechnic in Singapore

Dr. Shen Qilan

Born in Shanghai, Dr. Shen is the chief editor of arts and the director of international projects at the Shanghai Insight Media Company, a subsidiary of the China South Publishing & Media Group. She obtained her masters in philosophy at Fudan University, Shanghai, China, and her PhD. at Westfälische Wilhelms-Universität Münster in Germany.

Dr. Shen is advisor and co-author of *Europe-China Cultural Compass*, a project initiated by the European Union's National Institute for Culture, with partners EUNIC in China, Goethe-Institute, Danish Cultural Institute, and the British Council. She served as the director of the editorial department for the Chinese magazine *Art World* from 2010–2011, and an overseas journalist in Germany since 2008. She has also lectured at the Shanghai Institute of Visual Art at Fudan University, and is a keen observer of global contemporary art.

Jean Loh

French-Chinese, Loh graduated from Sciences Po International University in Paris, and has been living in Shanghai since 2000. He is a member of the editorial board of the *Trans Asia Photographic Review*, published by Hampshire College in collaboration with MPublishing at the University of Michigan Library.

Loh has curated many photography exhibitions, including the "Marc Riboud Retrospective" in China (2010–2012) at the Shanghai Art Museum, Beijing CAFA Art Museum, Xi'an Art Museum, Hong Kong City Hall, Macao Museum of Art, Wuhan Art Museum, Chengdu Center of Photography, Dalian Art Exhibition Hall, Xiamen Luoca Art Center, and Guangdong Museum of Art. His international projects include "Lu Guang" (Eugene Smith Award winner) at the Yangon Photo Festival in Myanmar (2012) and "Five Chinese Photographers" at the Biennale di Alessandria in Italy (2011).

AUTHORS

Lorenz Helbling

Swiss born, Helbling has lived and worked in China for over sixteen years.
He studied art history at the University of Zürich and Chinese at Shanghai's Fudan University. In 1996 he founded the ShanghART Gallery, now one of China's most influential contemporary art institutions.

ShanghART Gallery is located in Shanghai's popular Moganshan Road complex, otherwise known as M50. In 2000 it was the only gallery from China (including Hong Kong and Taiwan) to be invited to participate in the Basel Art Fair. ShanghART also featured in *International Art Galleries, Post-War to Post-Millennium*, a narrative chronology of the dealers, artists, and spaces that have defined modern art (Dumont, 2005).

Rosa Maria Falvo

Italian-Australian, Falvo is a writer and curator, and Skira's international commissions editor in Milan, specialising in Asian contemporary art and photography.

She graduated with honours in English literature from Monash University in Australia and art history from Perugia University in Italy. Falvo curates exhibitions and book projects on the work of a variety of artists from the Asia-Pacific region. She has travelled extensively across China, and regularly throughout Asia. Her most recent projects include *Shahidul Alam: My Journey as a Witness* book and London exhibition (2011), and the *Contemporary and Great Masters of Bangladesh* artists monographs series (2012).

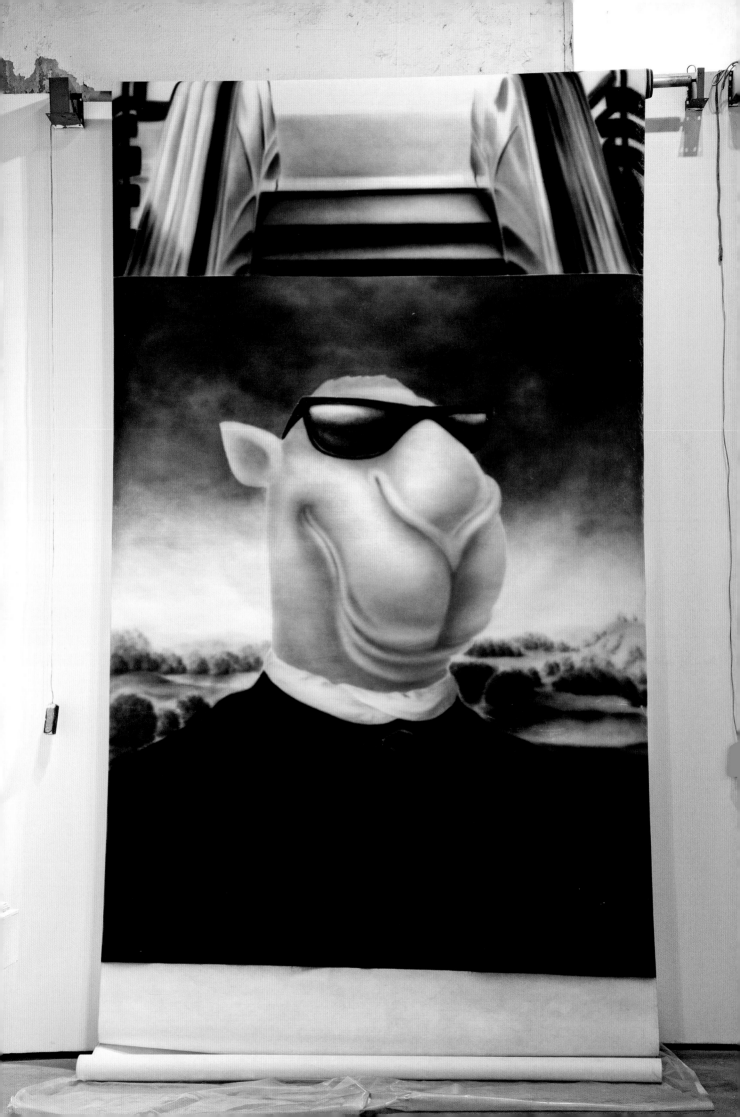

ZHOU TIEHAI

1966 Born in Shanghai, China
1989 Graduated from Fine Arts School of Shanghai University, Shanghai, China
2010 to present Director of Minsheng Art Museum, Shanghai, China

Lives and works in Shanghai, China

Selected Solo Exhibitions

2010 "Desserts: Zhou Tiehai", Shanghai Museum of Contemporary Art, Shanghai, China

2006 "An 'Other' History", Shanghai Art Museum, Shanghai, China

2000 "Placebo Swiss", Hara Museum, Tokyo, Japan

Selected Group Exhibitions

2011 "The Global Contemporary: Art Worlds After 1989", ZKM Center for Art and Media, Karlsruhe, Germany

"TASTE: The Good, the Bad, and the Really Expensive", Staatliche Kunsthalle, Baden-Baden, Germany

2010 "By Day, By Night or Some (Special) Things a Museum Can Do", Rockbund Art Museum, Shanghai, China

2009 "Cina: Rinascita Contemporanea", Palazzo Reale, Milan, Italy

2007 "Rockers Island: Olbricht Collection", Museum Folkwang, Essen, Germany

"The Real Thing: Contemporary Art from China", Tate Liverpool, Liverpool, UK

2006 "Infinite Painting, Contemporary Painting and Global Realism", Villa Manin, Centro per l'Arte Contemporanea, Codroipo, Italy

2005 "Mahjong: Contemporary Chinese Art from the Sigg Collection", Kunstmuseum Bern, Bern, Switzerland

"On the Edge: Contemporary Chinese Artists Encounter the West", Stanford University, Stanford, USA

"Follow Me! - Contemporary Chinese Art at the Threshold of the Millennium", Mori Art Museum, Tokyo, Japan

2004 "Shanghai Modern", Museum Villa Stuck, Munich, Germany

"The American Effect", Whitney Museum, New York, USA

"Alors la Chine?", Centre Pompidou, Paris, France

4th Gwangju Biennial, Gwangju, South Korea

2001 "Living in Time: 29 Contemporary Artists from China", Hamburger Bahnhof-Museum für Gegenwart, Berlin, Germany

1999 48th Venice Biennale, "APERTO over ALL", Venice, Italy

1997 "Promenade in Asia", Shiseido Gallery, Tokyo, Japan

关于一个人的幻想：
我了解的周铁海
的的无兼带
独运何依赖路逢达道人
无将语默对

东堂不折桂
南华不学仙
本质空灵性
坦荡无称赞

有缘同浊界
当然正天年
幻想多摇曳
宁论在哪边

自心幻想自心惊
全成无漏一真精
雄关漫道真如铁
金刚形容弗曾经

民生现代美术馆

MINSHENG ART MUSEUM

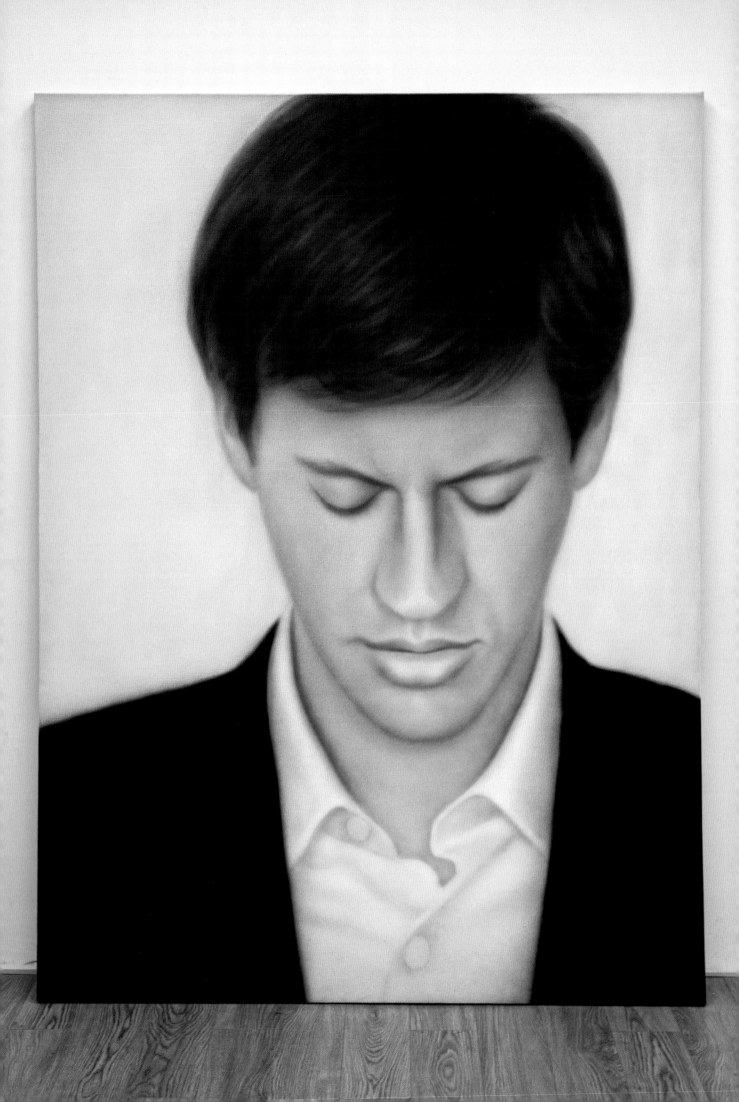

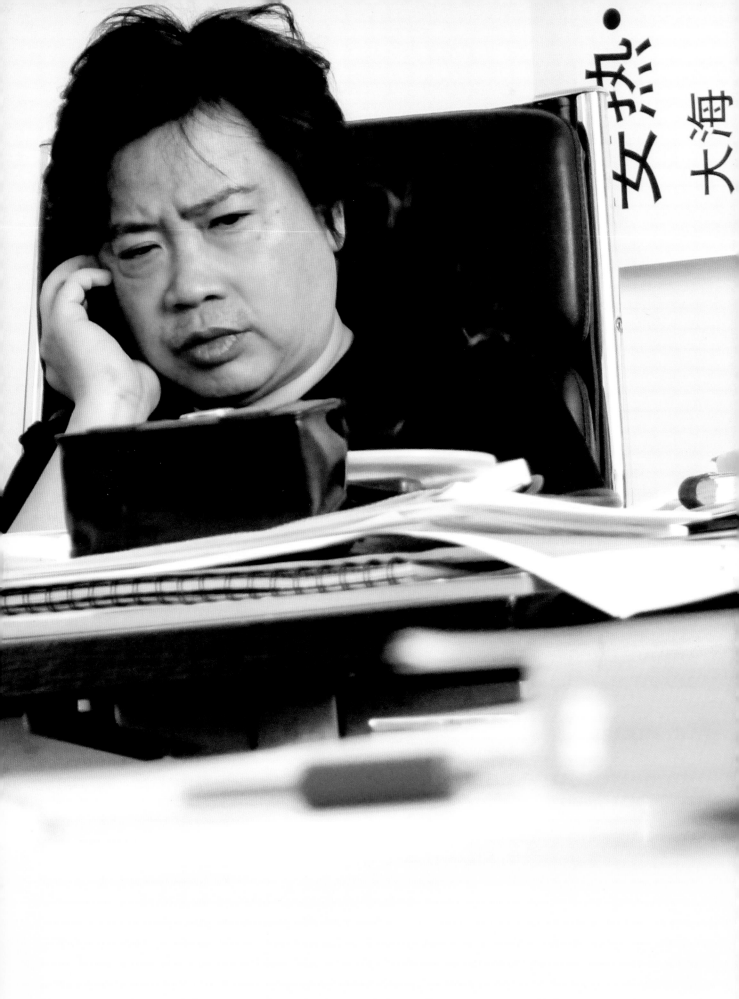

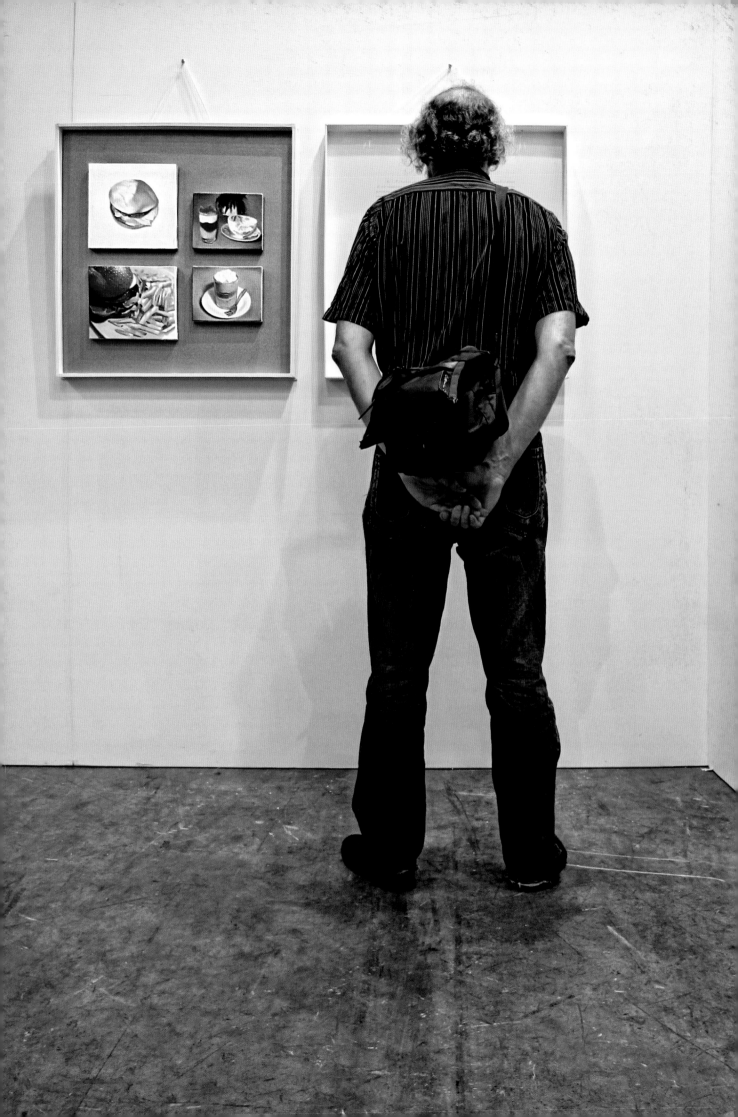

De parties inter

à la fine champag

Pointe de cay

frotter à brun

Pin

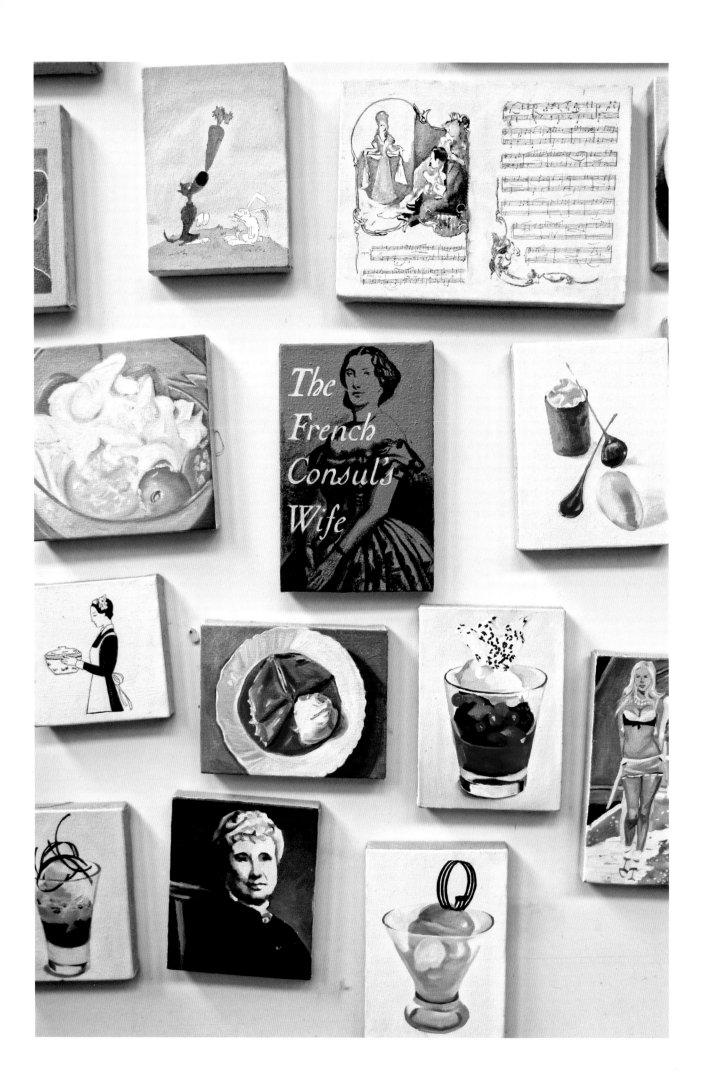

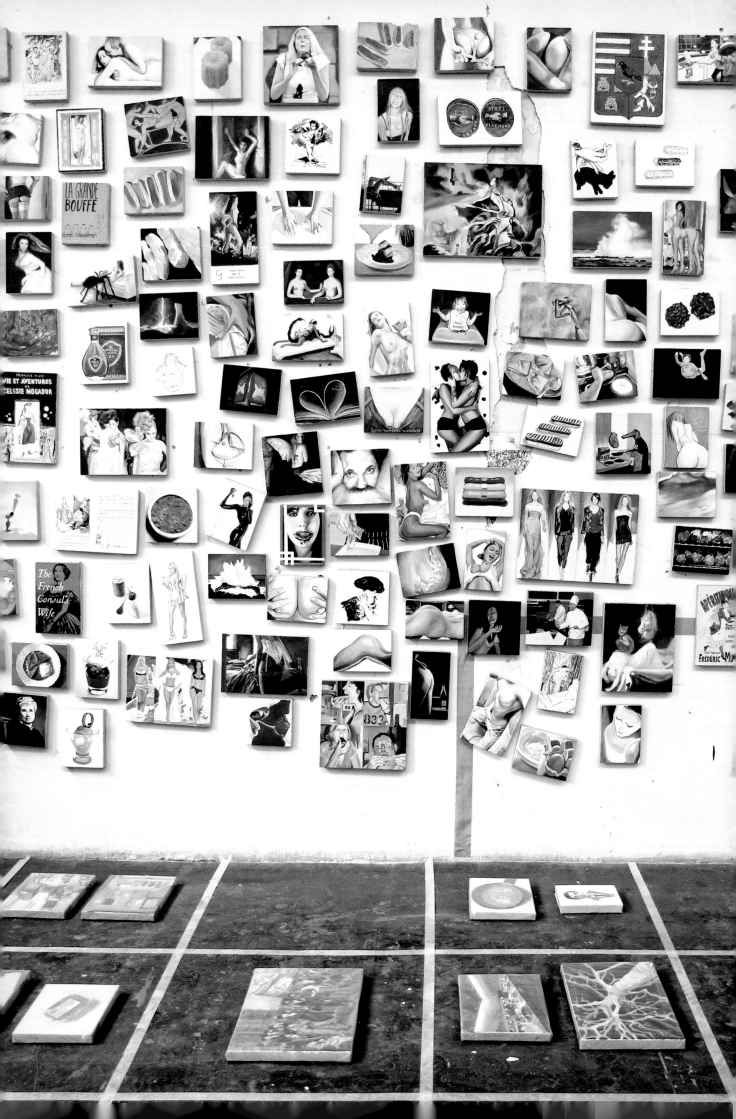

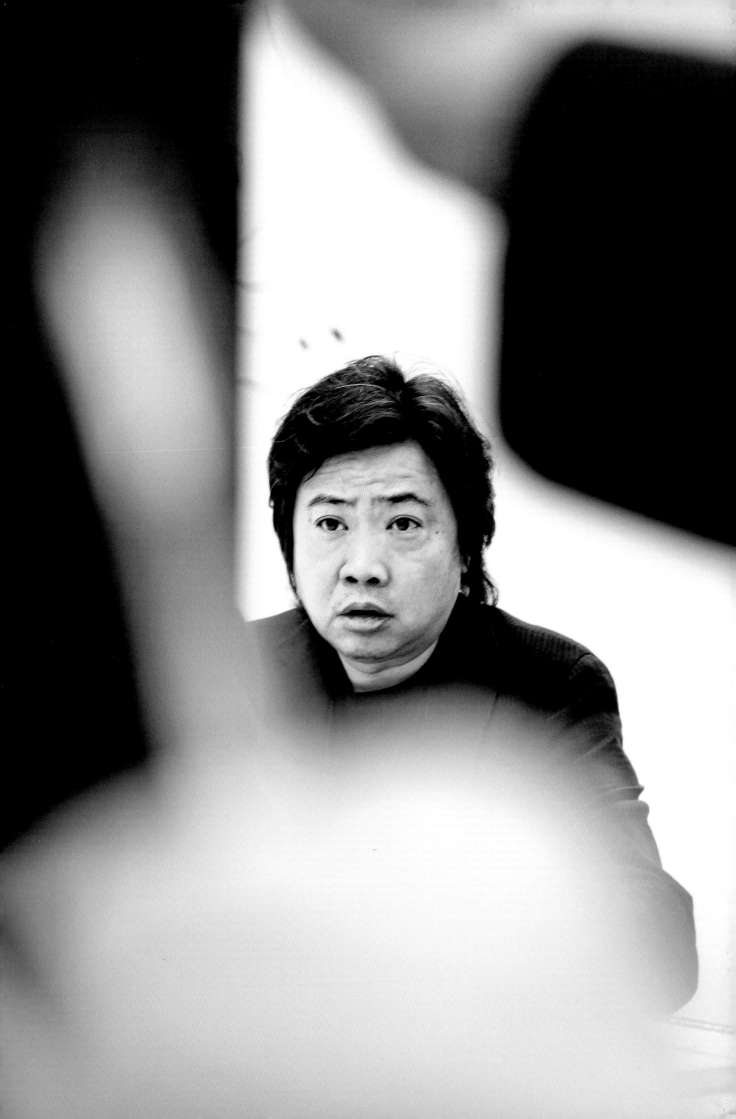

...tion judicieuse afin de par...

...ec la mangue et le letchi...

...uimauve auraient pallié l...

...biques, leur joyeux désora...

...é l'allure, mais à la dégusta...

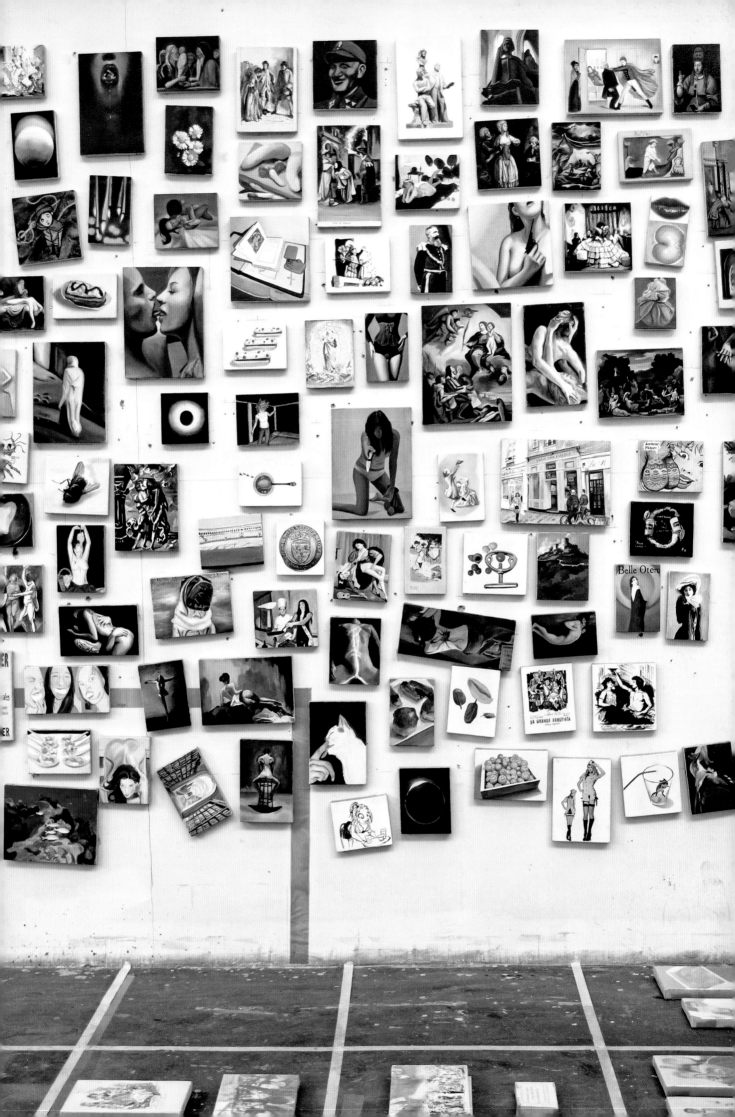

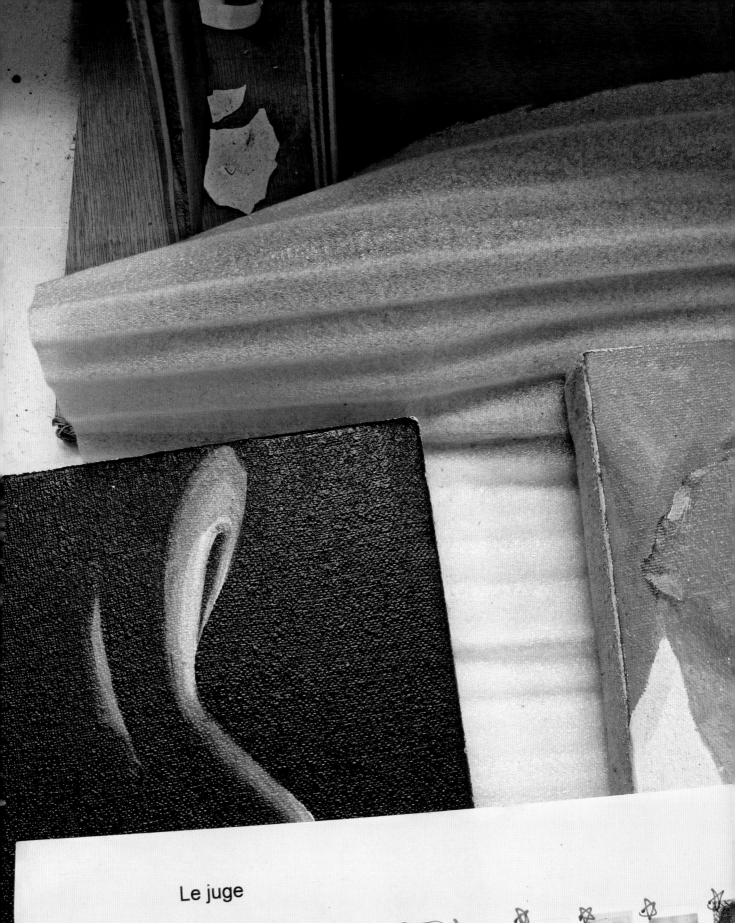

Le juge

(home)Le juge-08-06, 2007, 19x25cm, oil on canvas

(home)Le juge-14-08, 2007, 40x30cm

{Le juge} 2008, 400x300cm 鉛筆

Le juge-01-01

Le juge-01-02, 2007, 15x20cm, oil o...

Le juge-01-03, 2007, 15x20cm, oil o...

Le juge-01-04, 2008, 30x30cm, oil o...

Le juge-01-05, 2008, 15x25cm, oil o...

30x30

Le juge-01-08, 2008, 20x16cm, oil o...

Le juge-01-09, 2007, 20x29cm, pencil

Le juge-01-10, 2008, 15x20cm, oil o...

Le juge-01-11, 2007, 35x35cm, oil o...

La juge-1, 2008, 100x88cm, acrylic...

Le juge-02-01, 2007, 15x20cm, oil o...

Le juge-02-02, 2008, 20x15cm, oil o...

Le juge-02-03, 2007, oil o...

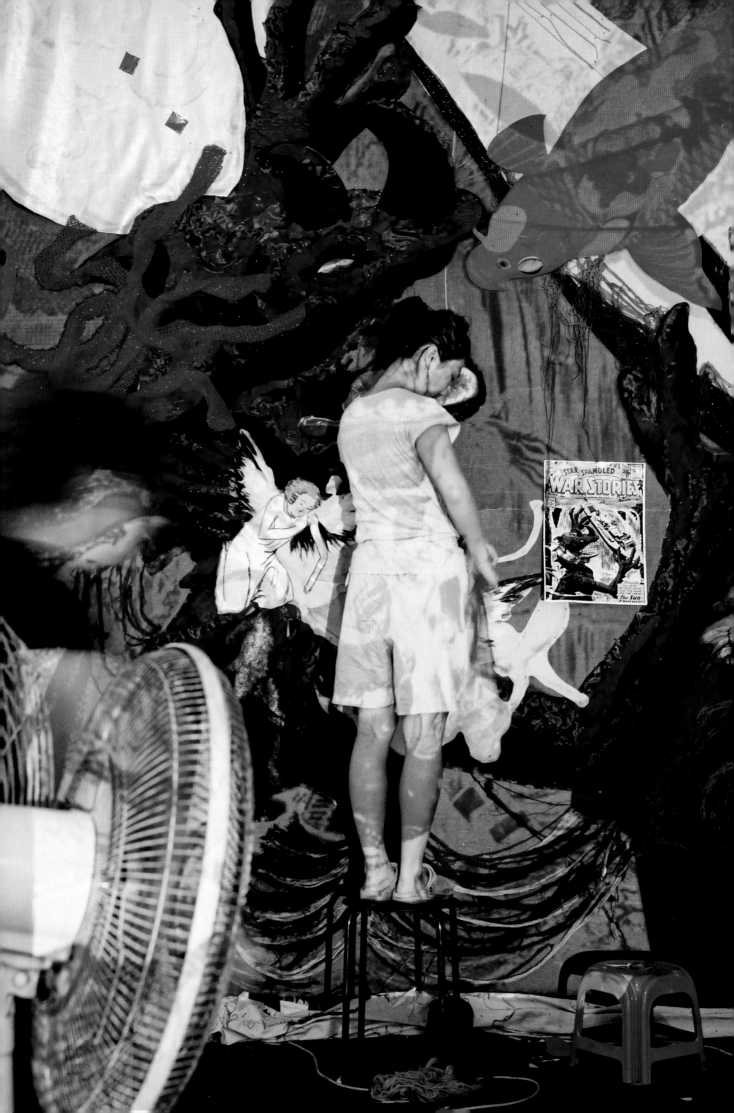

MADEIN COMPANY

2009 Artist Xu Zhen established this contemporary art production company in Shanghai, China

It is focused on the development of creativity, and combines research into contemporary culture through exhibitions, art production, and curating.

Its members live and work in Shanghai, China.

Selected Solo Exhibitions

2011 "Action of Consciousness", ShanghART Gallery, Shanghai, China

"Physique of Consciousness", Long March Space, Beijing, China

"Physique of Consciousness", Kunsthalle Bern, Bern, Switzerland

2010 Frieze Art Fair, Regent Park, London, UK

"Don't Hang Your Faith on the Wall", Long March Space, Beijing, China

"Seeing One's Own Eyes", IKON Gallery, Birmingham, UK

2009 "Metal Language", ShanghART Gallery, Shanghai, China

"Seeing One's Own Eyes - europalia.china", SMAK Municipal Museum of Contemporary Art, Ghent, Belgium

"Lonely Miracle: Middle East Contemporary Art", James Cohan Gallery, New York, USA
"Seeing One's Own Eyes-Middle East

Contemporary Art", ShanghART Gallery and ShanghART H-Space, Shanghai, China

Selected Group Exhibitions

2011 "CREATIVE TIME-LIVING AS FORM", Essex Street Market, New York, USA

"ACT▶TION — Video Exhibition", Long March Space, Beijing, China

"Growing Up", exhibition celebrating SWFC 3rd anniversary Shanghai World Financial Center and ShanghART Gallery, Shanghai, China

"A Pile of Passion", ShanghART Gallery, Shanghai, China

2010 "Negotiations: The Second Today's Documents", Today Art Museum, Beijing, China

"Useful Life", ShanghART Gallery, Shanghai, China

8th Shanghai Biennale Rehearsal, Shanghai Art Museum, Shanghai, China

"LONG MARCH PROJECT – HO CHI MINH TRAIL (Beijing)", Long March Space, Beijing, China

"Thirty Years of Chinese Contemporary Art", Minsheng Art Museum, Shanghai, China

"Credit Suisse Today Art Award", Today Art Museum, Beijing, China

2009 "Breaking Forecast-8 Key Figures of China's New Generation Artists", Ullens Center for Contemporary Art, Beijing, China

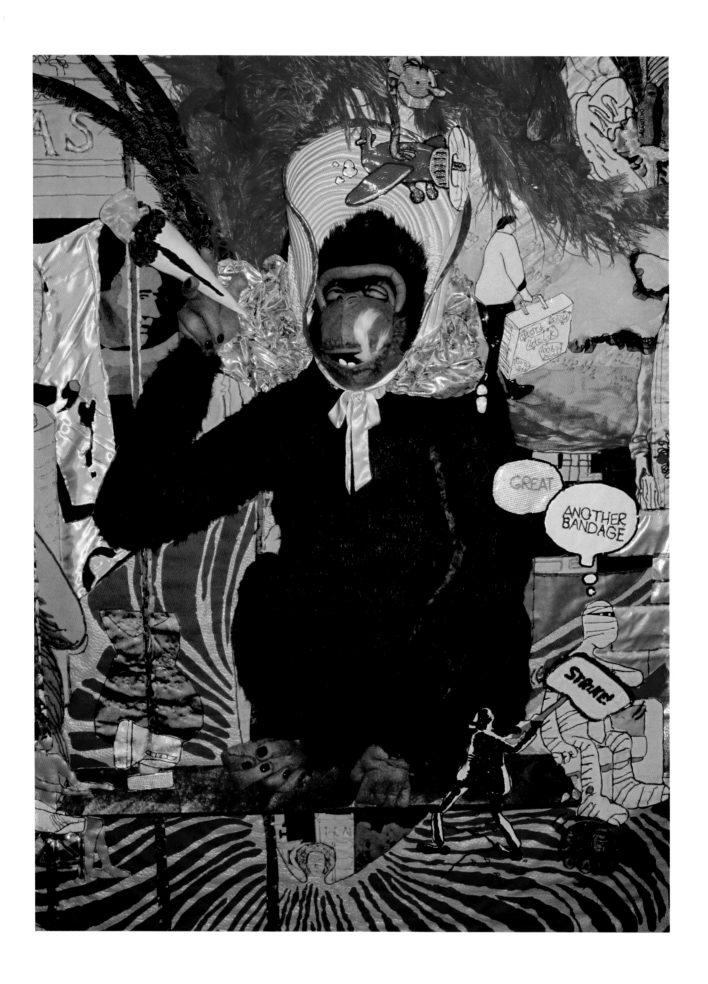

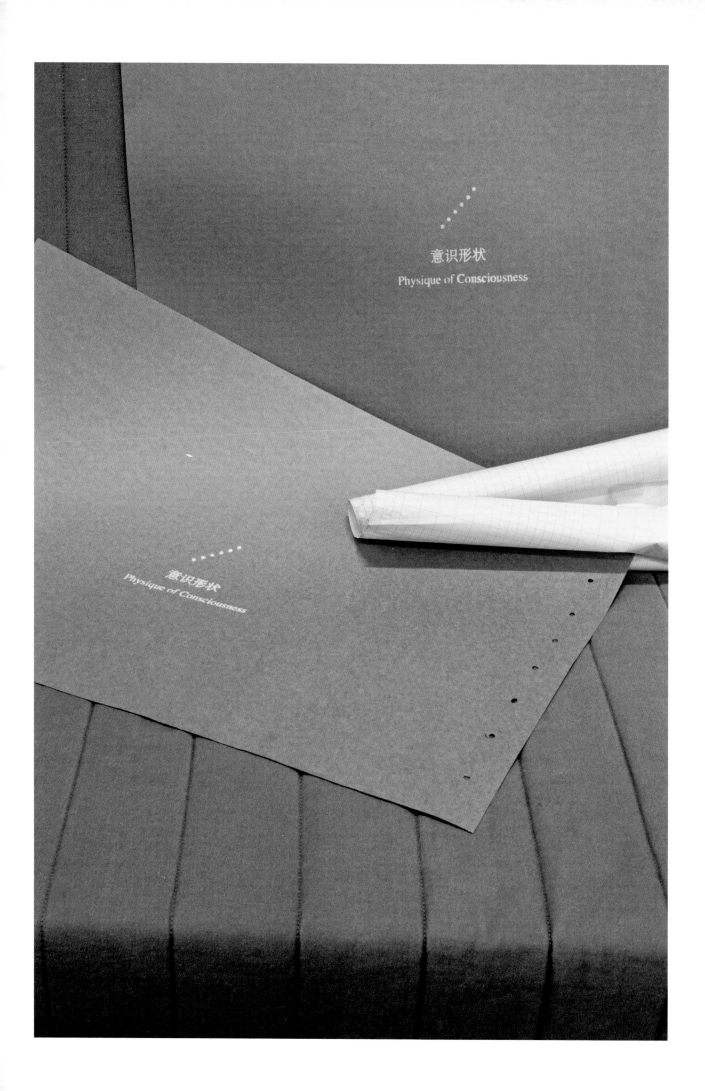

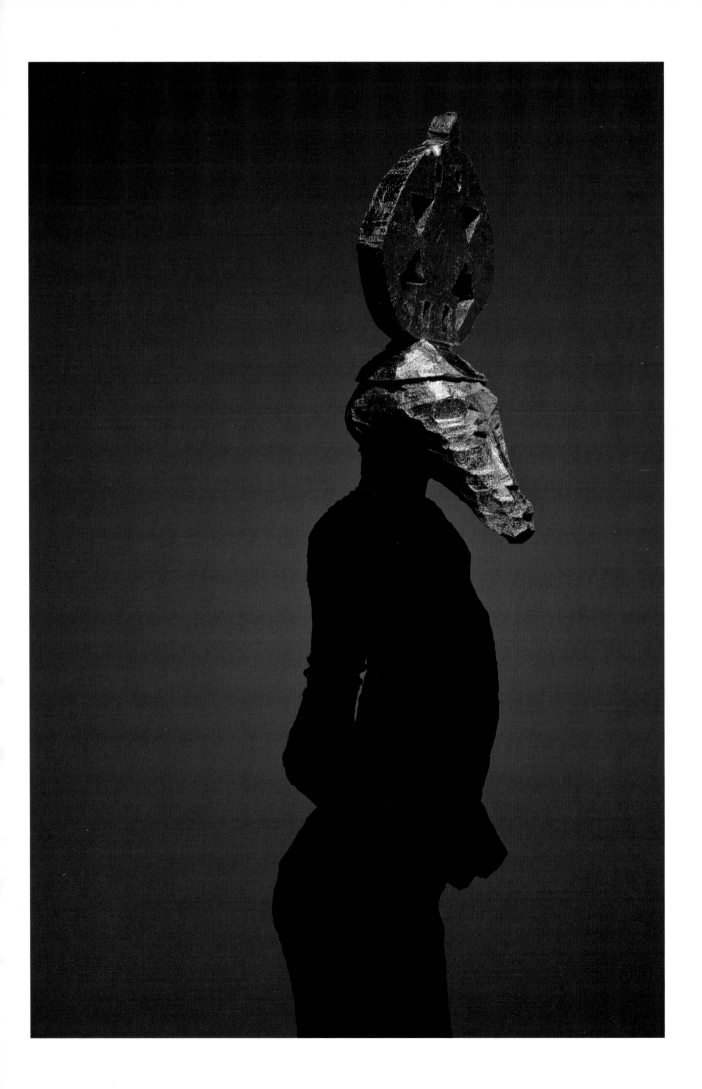

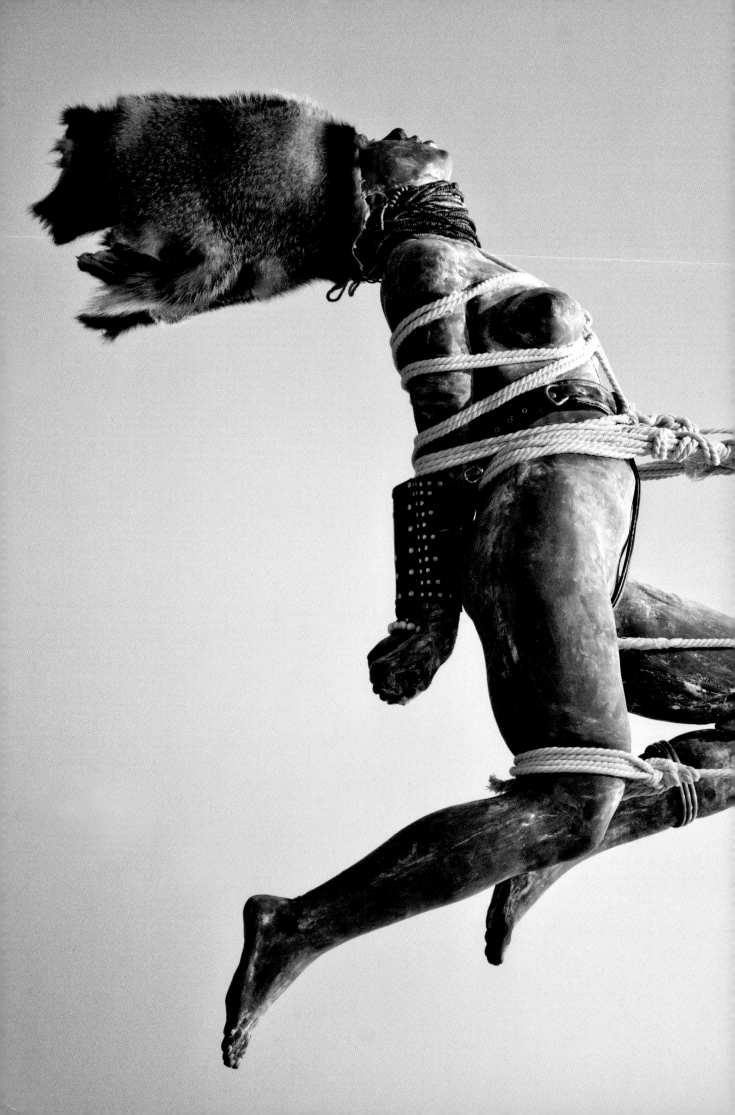

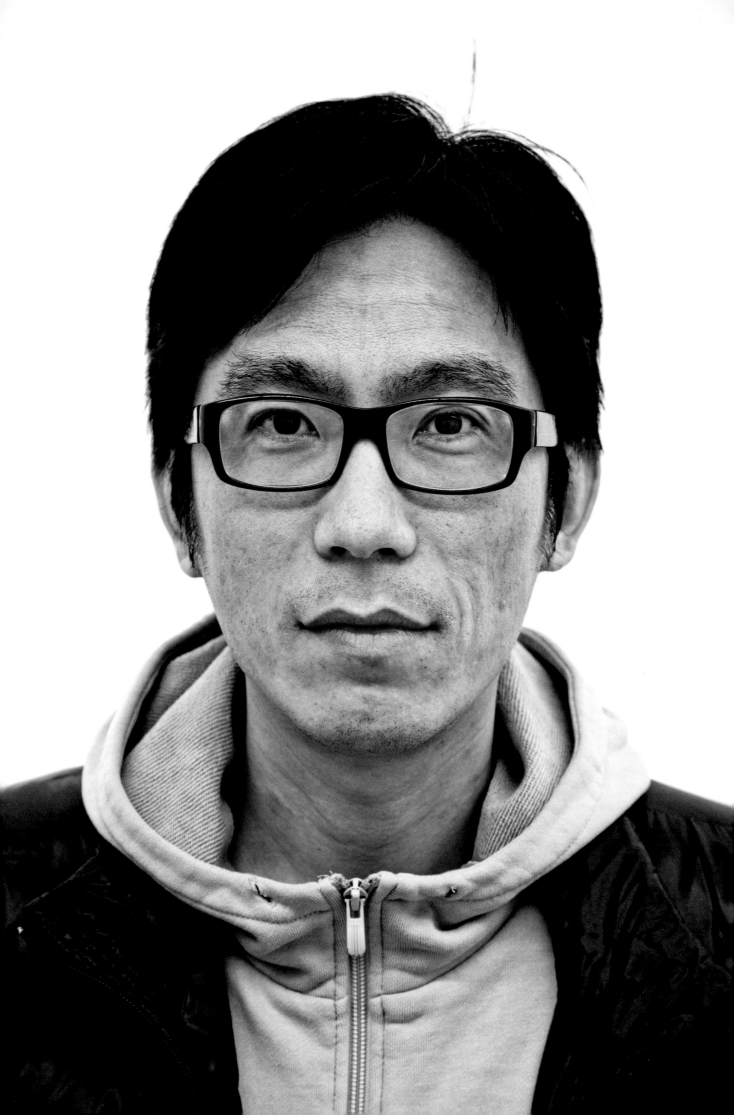

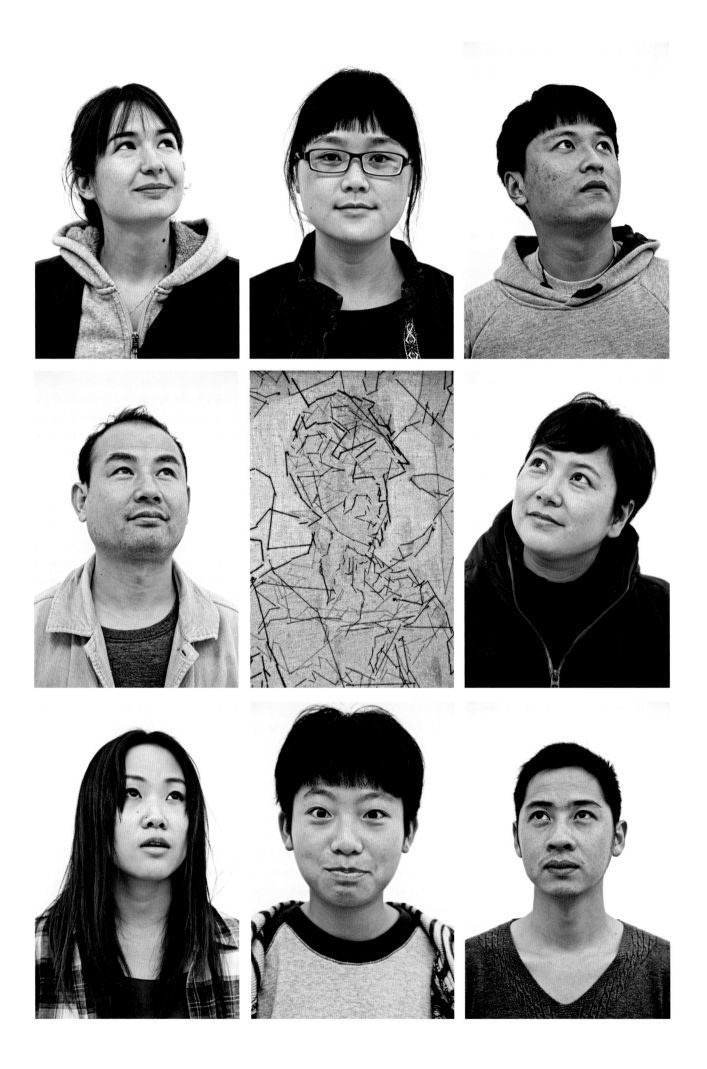

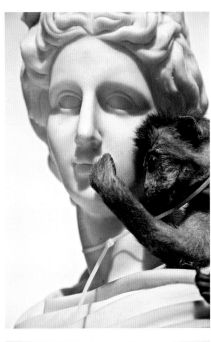
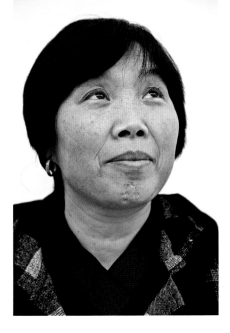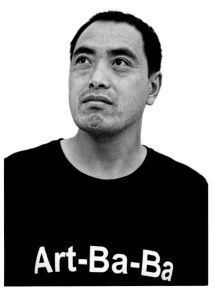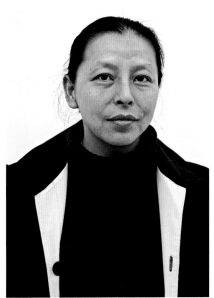

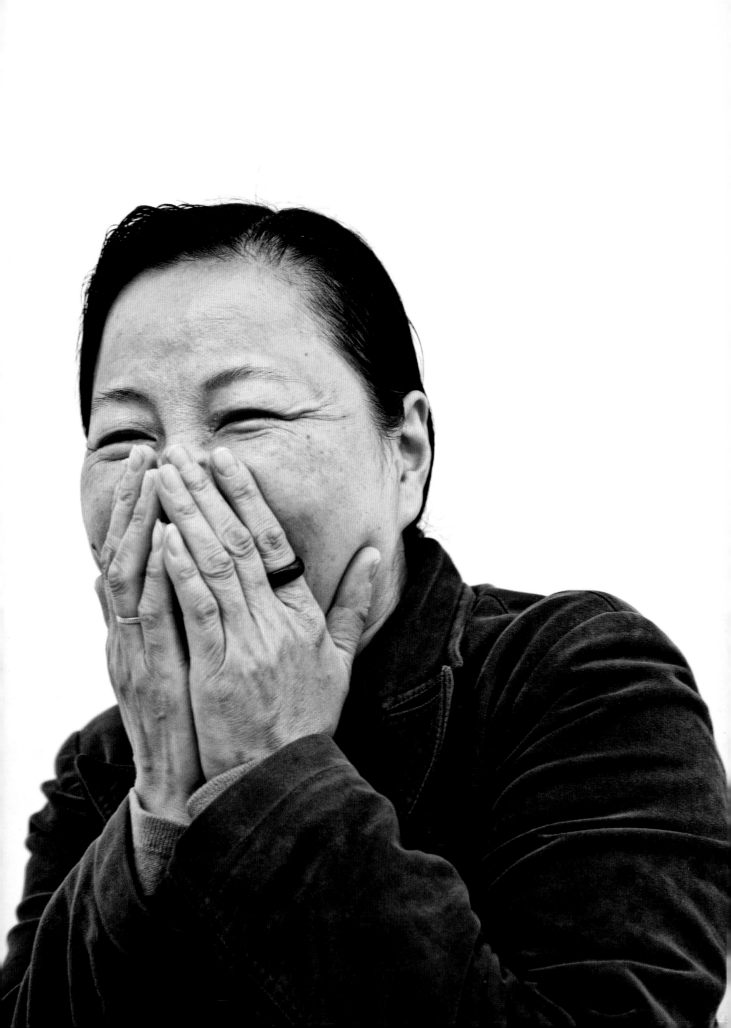

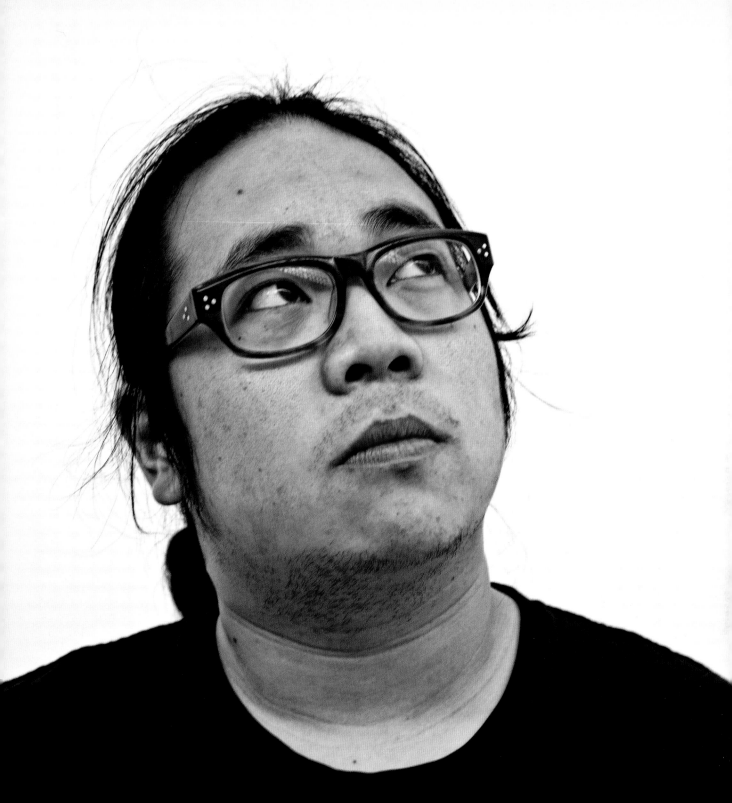

Art-Ba-Ba

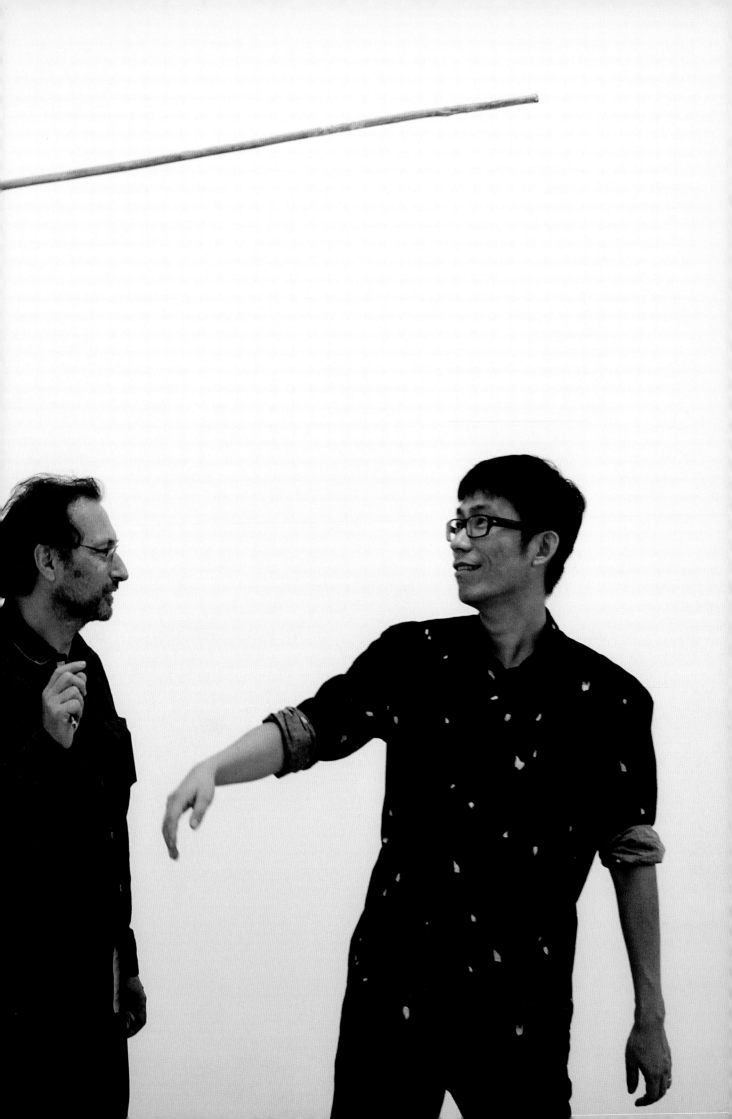

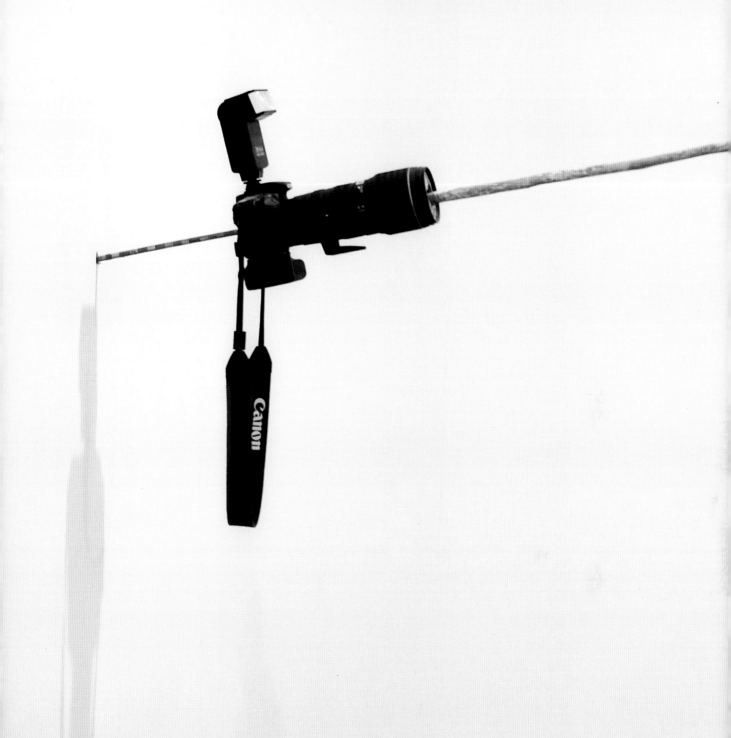

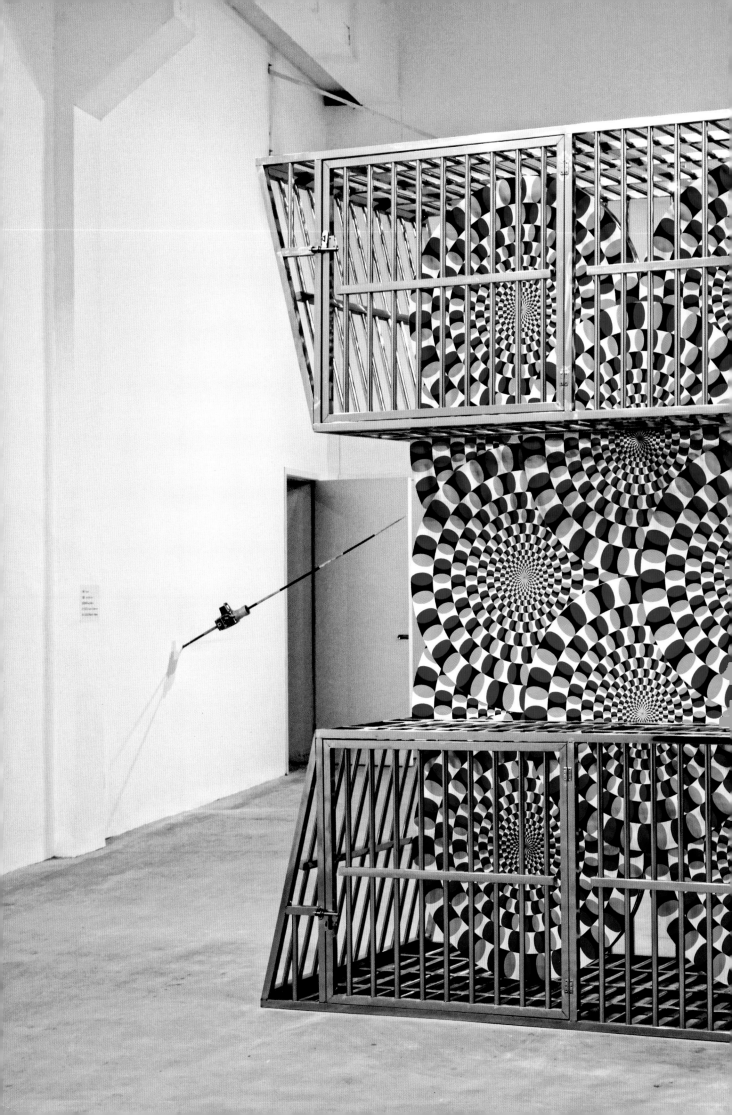

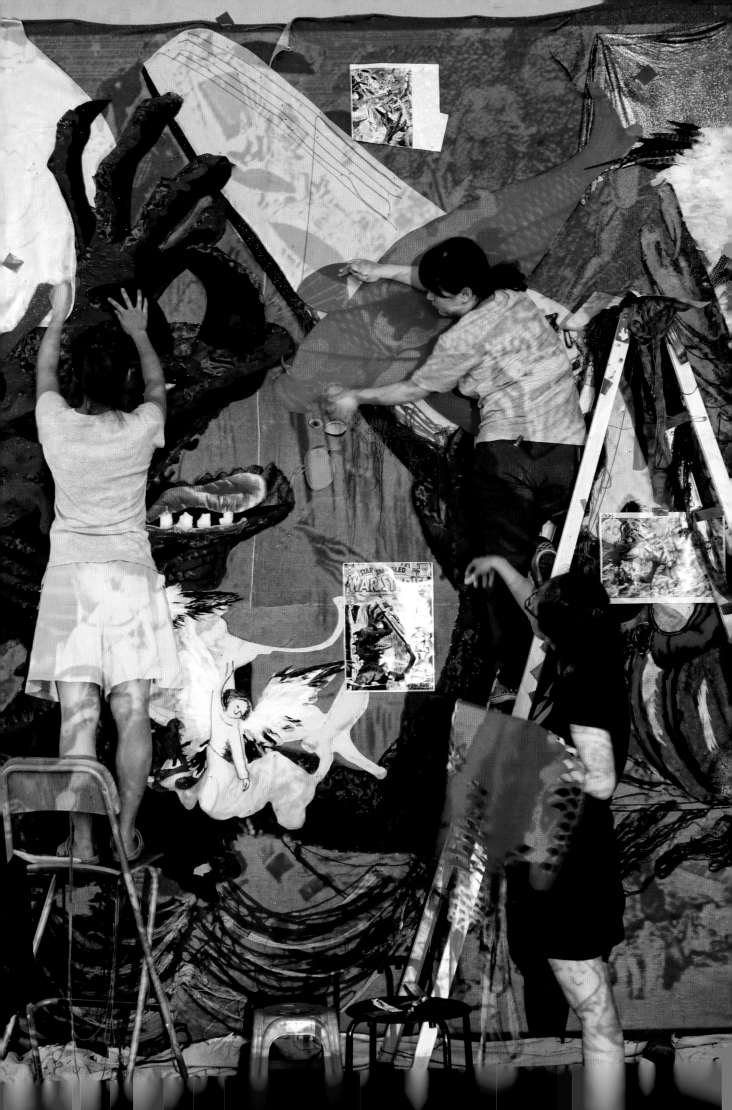

没顶公司
MadeIn

AI WEIWEI

1957 Born in Beijing, China
1978 Studied at the Beijing Film Academy,
Beijing, China
1981–1993 Studied at Parsons School of
Design and Art Students League of New York,
New York City, USA

Lives and works in Beijing, China

Awards and Nominations

2008 Chinese Contemporary Art Awards-
Lifetime Achievement

2009 GQ Men of the Year 2009, Moral Courage
(Germany); The Art Review Power 100, ranked
43; International Architecture Awards for Tsai
Residence, Athenaeum Museum of Architecture
and Design, Chicago, USA

2010 Honorary doctoral degree in politics and
social science from University of Ghent, Belgium;
Das Glas der Vernunft (The Prism of Reason),
Kassel Citizen Award, Kassel, Germany

2012 Honorary degree from Pratt Institute;
Honorary fellowship from Royal Institute of
British Architects; elected as foreign member of
Royal Swedish Academy of Arts; recipient of the
International Center of Photography Cornell Capa
Award

Selected Solo Exhibitions

2011 "Ai Weiwei", Fotomuseum, Winterthur,
Zürich, Switzerland

"Ai Weiwei", Lisson Gallery, London, UK

"Ai Weiwei", Kunsthaus Bregenz, Bregenz, Austria

"Ai Weiwei Absent", Taipei Fine Art Museum,
Taipei, Taiwan

"Ai Weiwei", Louisiana Museum of Modern Art,
Copenhagen, Denmark

2010 "Ai Weiwei", Faurschou Gallery,
Copenhagen, Denmark

"Cube Light", Misa Shin Gallery, Tokyo, Japan

"A Few Works from Ai Weiwei", Alexander Ochs
Galleries, Berlin, Germany

"The Unilever Series: Ai Weiwei", Turbine Hall, Tate
Modern, London, UK

"Hurt Feelings", Galerie Christine Koenig Galerie,
Vienna, Austria

"Ai Weiwei", Galerie Urs Meile, Lucerne,
Switzerland

"Ai Weiwei", Haines Gallery, San Francisco, USA

"Dropping the Urn: Ceramics 5000 BCE – 2010
CE", Arcadia University Gallery, Glenside, USA

2009 "With Milk, Find Something Everybody Can
Use", Mies van der Rohe Pavilion, Barcelona,
Spain

"World Map", Faurschou Gallery, Beijing, China

"So Sorry", Haus der Kunst, Munich, Germany

"According to What?", Mori Art Museum, Tokyo,
Japan

"Ways Beyond Art", Ivory Press Space, Madrid,
Spain

"Four Movements", Phillips de Pury & Company,
London, UK

"Ai Weiwei: New York Photographs 1983–1993",
Three Shadows Photography Art Centre, Beijing,
China

2008 "Ai Weiwei", Albion Gallery, London, UK

"Ai Weiwei", Hyundai Gallery, Seoul, Korea

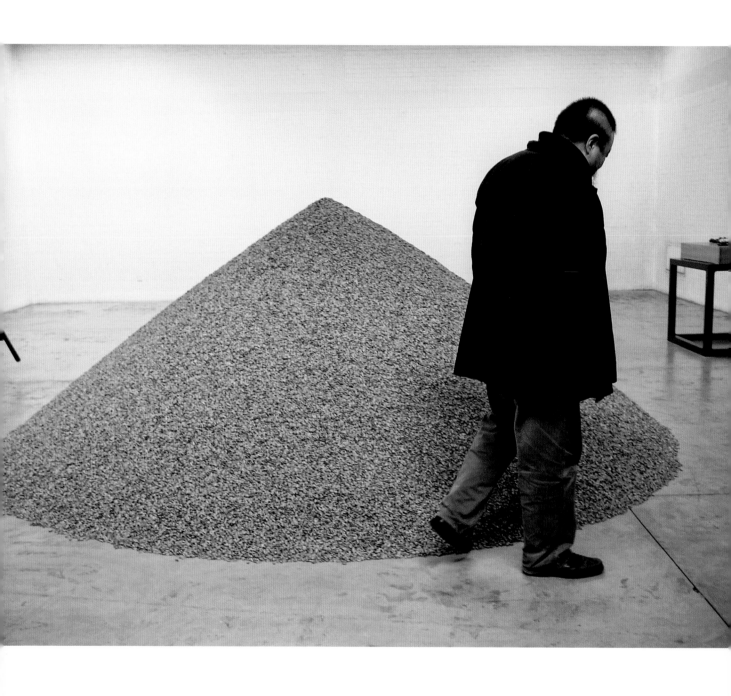

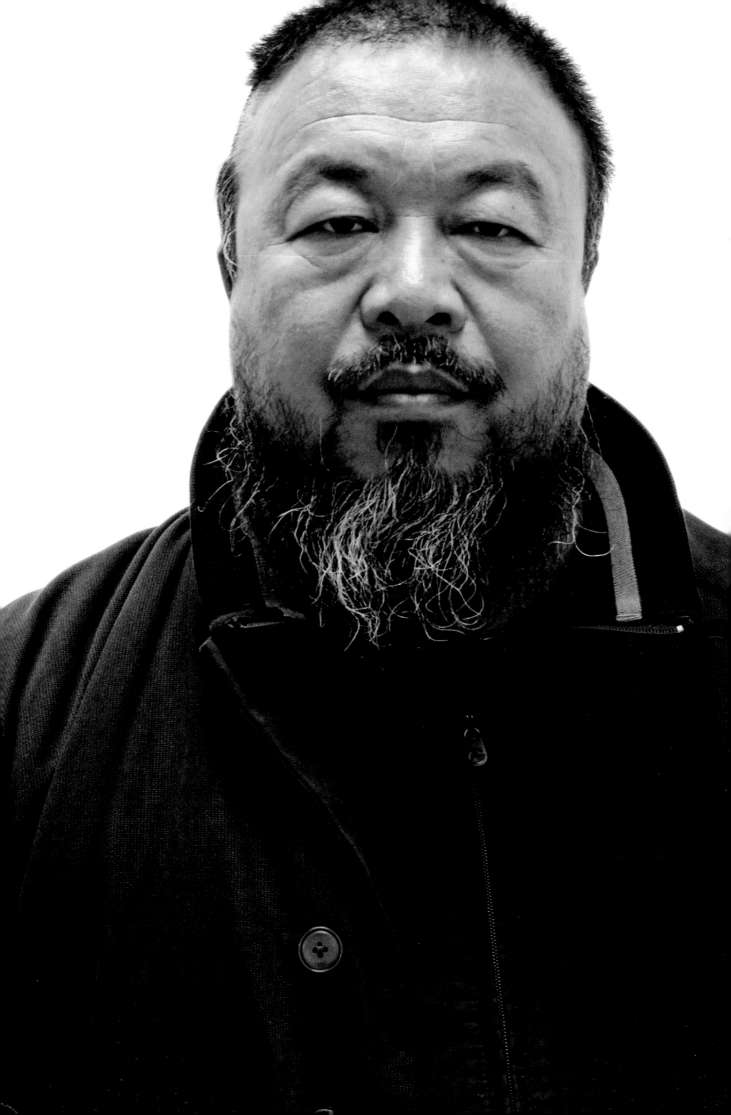

CPG: I don't know. I've also been working as a journalist for about ten years, for Russia.
AW: But you're still in the art world.

CPG: I heard you are involved in the West Kowloon Project?
AW: Ah, where did you hear that?

CPG: You know, the M+ museum...
AW: Yes, but how could you have heard that? Have they announced it...?

CPG: It was on the internet.
AW: Ah, so it's on the internet, so someone announced it right?

CPG: No, not really.
AW: But how could the internet know? Nobody knows. Someone just called me. Norman Foster called me, but nobody else knows. That's strange.

CPG: It was on Twitter, I don't know if you know what that is… it's a new kind of thing.
You know, you have a blog, and other things, but now there's a new service where people just write 100 characters (up to 140 "tweets"), then boom, boom, boom, and it's there, just very brief.
AW: So you can also check out a person's name and something will come up?

CPG: Well, you have to follow that person.
AW: Oh.

CPG: So as Ai Weiwei you would create an account and people would follow your words, subscribe to your feed, and you could follow other people, it's just like a new internet thing.
AW: Twooser?

CPG: Twitter, T…W…I…T…T…E…R.
AW: Oh, Twitter.

CPG: Like a bird. Anyway, I just saw it on there. You didn't want to mention that? Is it sensitive or...?
AW: No, no, no. Only until you mentioned it, I thought it might be sensitive.
It's just an architectural development issue in Hong Kong.

On 15 March 2010, Ai Weiwei took part in "Digital Activism in China", a discussion hosted by the Paley Media Center in New York with Jack Dorsey (founder of Twitter) and Richard MacManus (founder and editor-in-chief of readwriteweb.com).

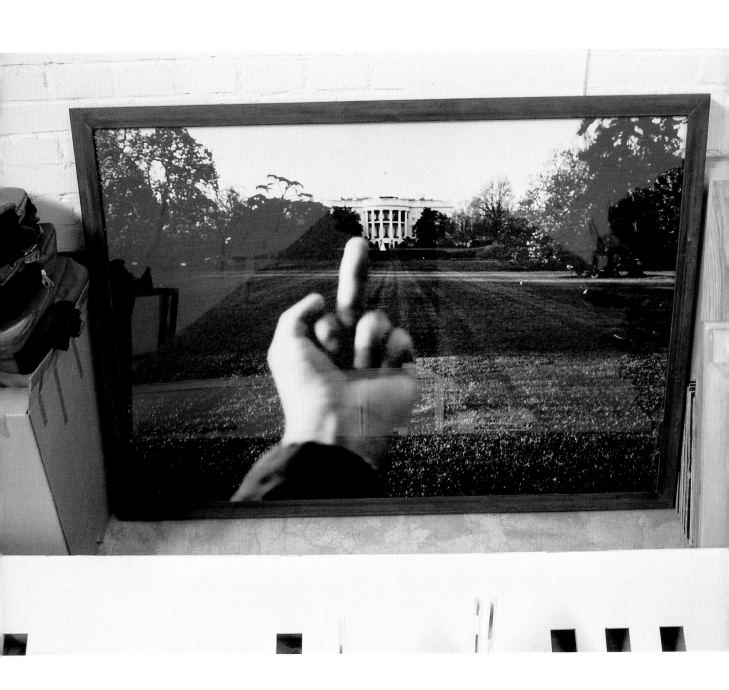

Chris P. Gill in conversation with Ai Weiwei

These are a couple of brief transcripts from an interview with Ai Weiwei back in autumn 2009. During our talk I inadvertently introduced him to Twitter. It was just a small part of our discussions, and I didn't realize at the time it was that significant, as I was more focused on Ai's blogging and political opinions, history, and other issues. The way it came up was that I had noticed he was involved in the M+ project, and since I had written about it a few times it was one of the questions I had in my mind to ask him. The M+ is a multi-billion dollar art museum project in Hong Kong.

Whether Ai later forgot all about it and someone else introduced him to the idea, I imagine is a strong possibility. But I did find it quite amusing watching Christiane Amanpour, chief international correspondent and anchor of CNN introducing a whole TV special about Ai Weiwei's activities on Twitter a year later, and also watching Ai in discussions with the founder of Twitter in front of a global audience. Sometimes small impromptu actions can have larger consequences. It also says a lot about Ai Weiwei himself. Within a year of grasping a new idea and technology he was a master of it.

CPG: Are you jetlagged? Flying in from London?
AW: Me? No.

CPG: I get it bad.
AW: I'm just too busy… so many things to do.

CPG: Have you tried sleeping pills?
AW: My friends have tried them, they say they're fantastic, but I won't take them.

CPG: Me neither. Is it alright if I record?
AW: Sure.

CPG: So, I have just become *The Art Newspaper* reporter for China.
AW: But you've been in China a long time.

CPG: I know, since '92…
AW: Oh, have we met before?

CPG: Maybe, I'm not sure.
AW: So what have you been doing here since then?

CPG: Painting.
AW: Oh amazing, so you've been an artist here. That's very surprising.

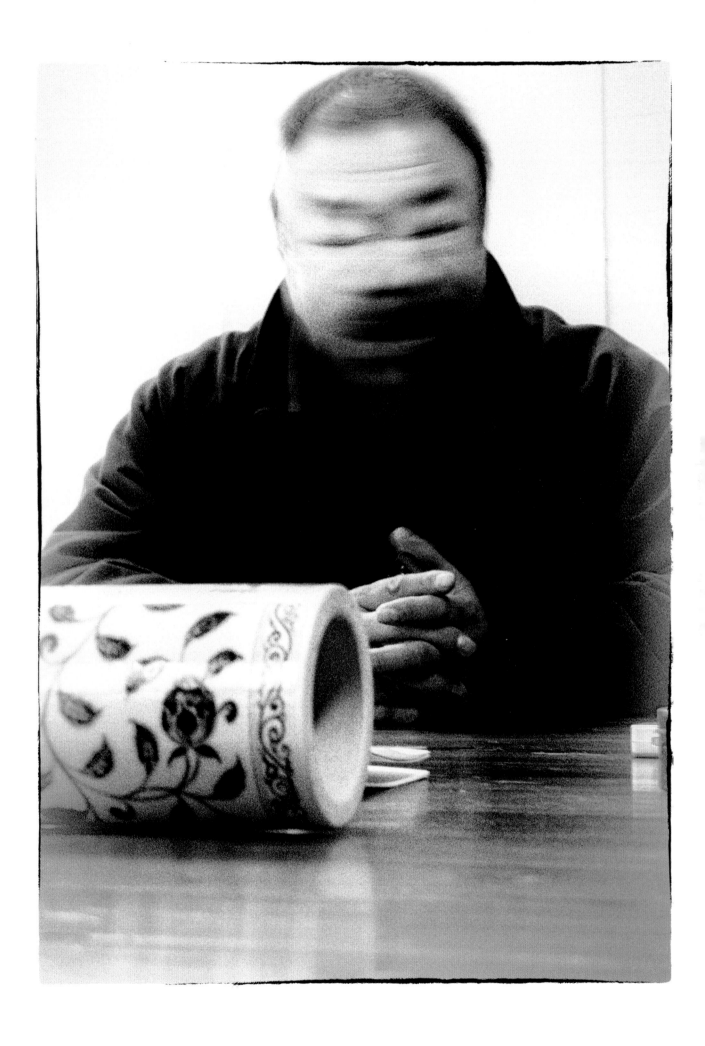

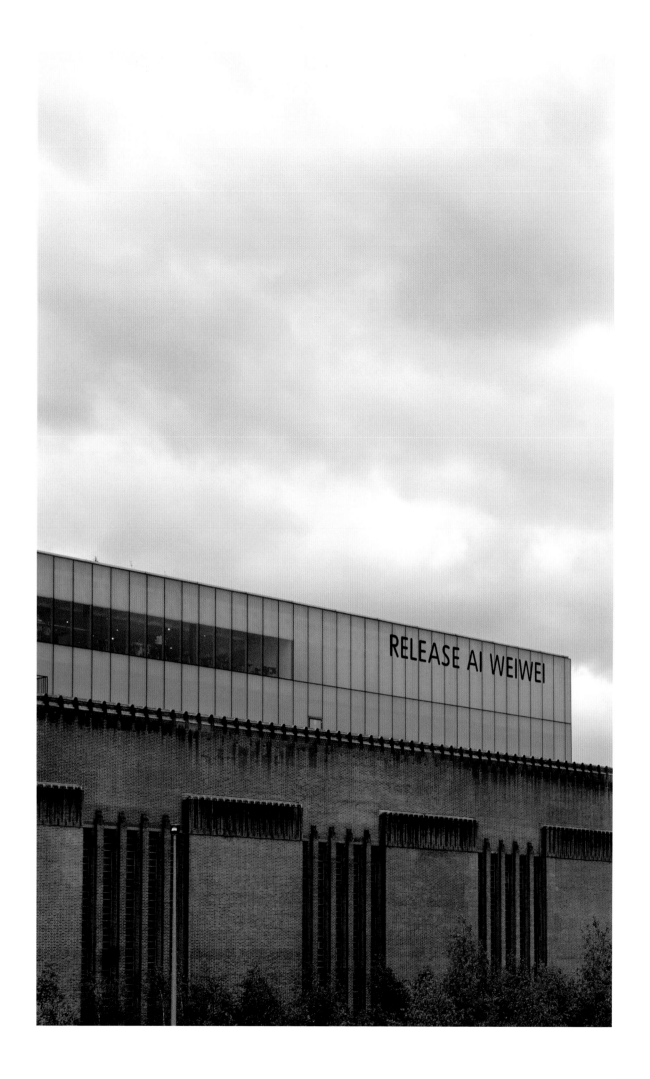

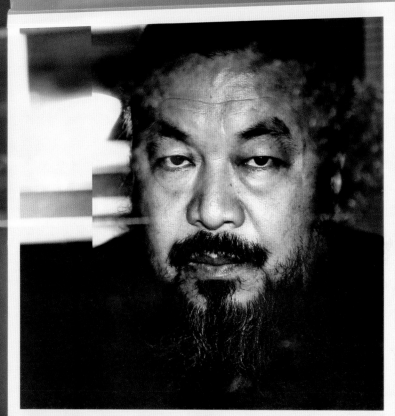

2000 years ago,
dynasty of 2000

That's it ?

ough?

Photo-Collage inspired by a documentary of Film-Director Jorien van Nes

When I broke the Han dynasty jar fro[m]
the meaning was that this jar from Ha[n]
years ago has been broken.

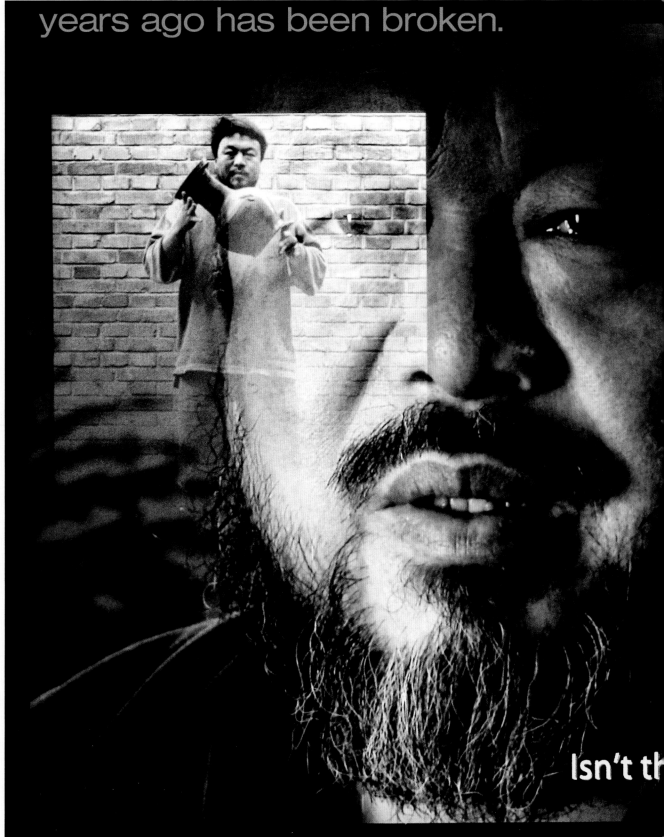

Isn't th[is]

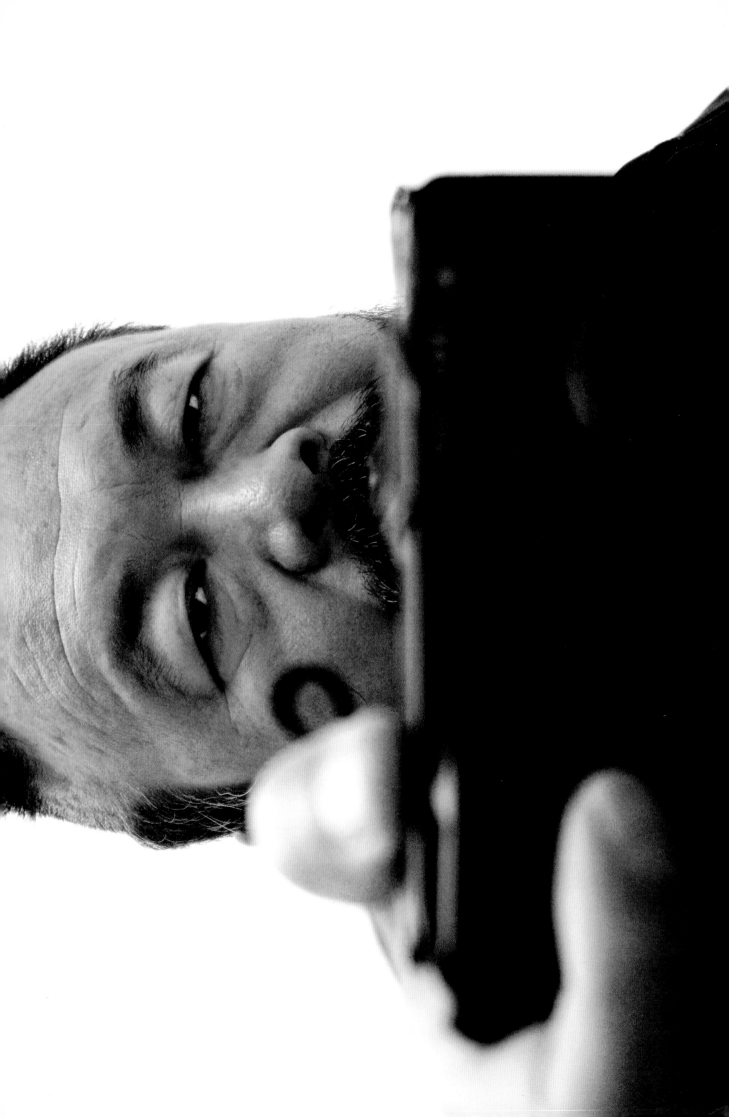

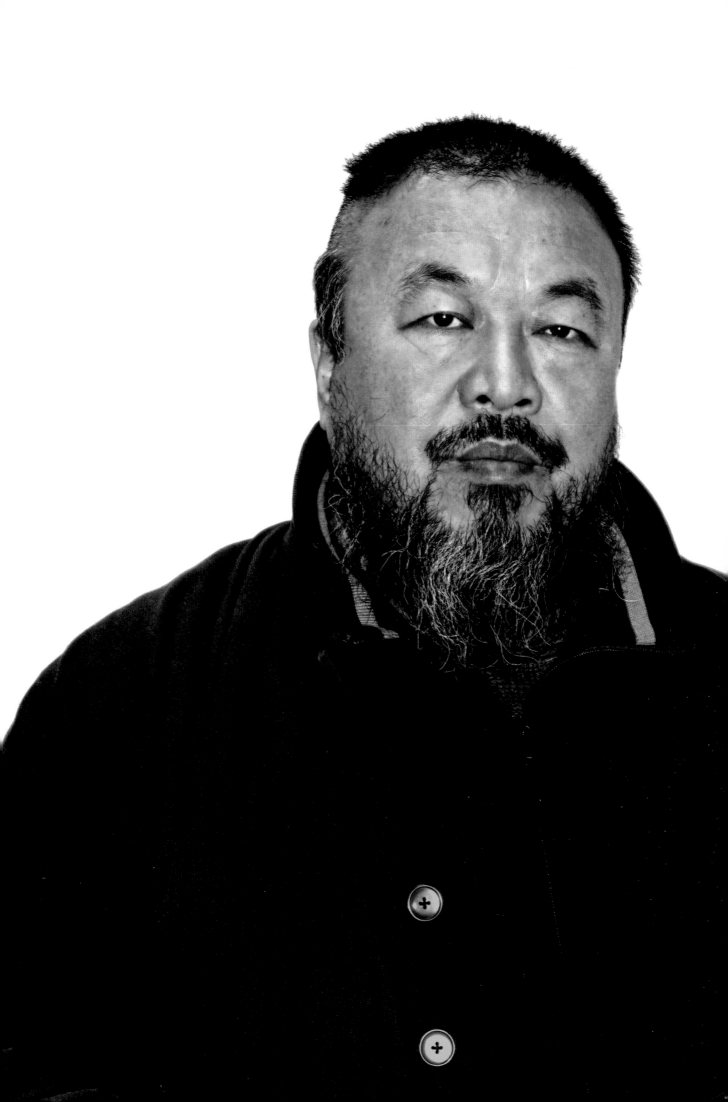

艸艸艸

Ai Weiwei

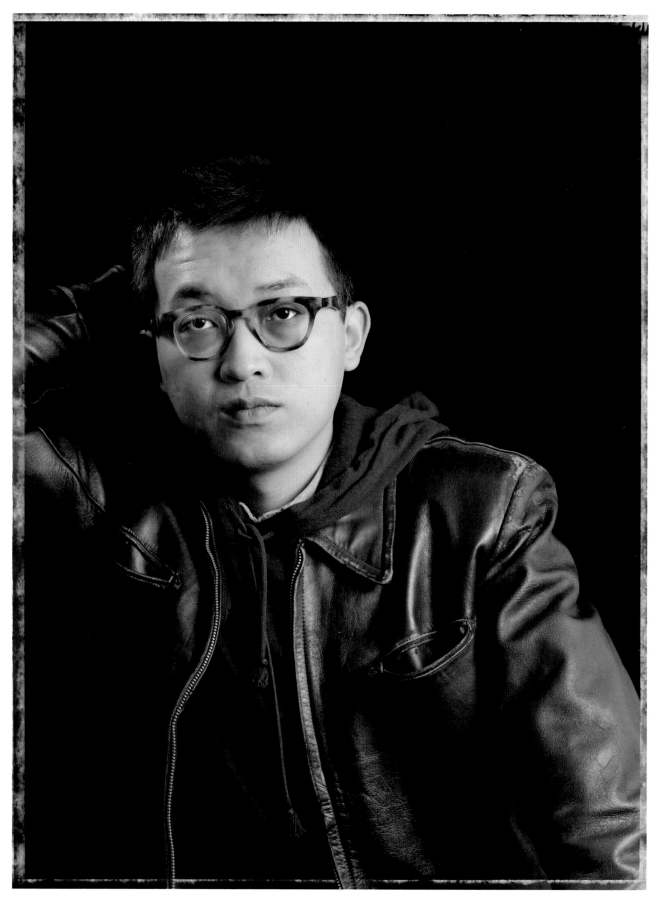

Feng Mengbo. Beijing, China, 1993

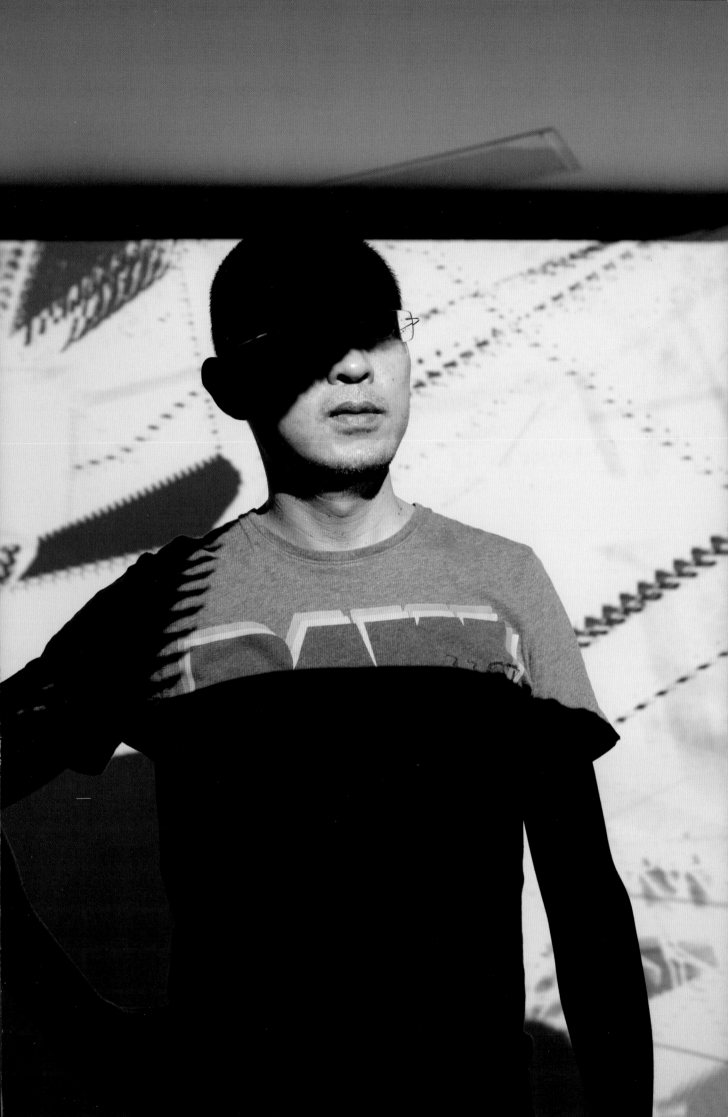

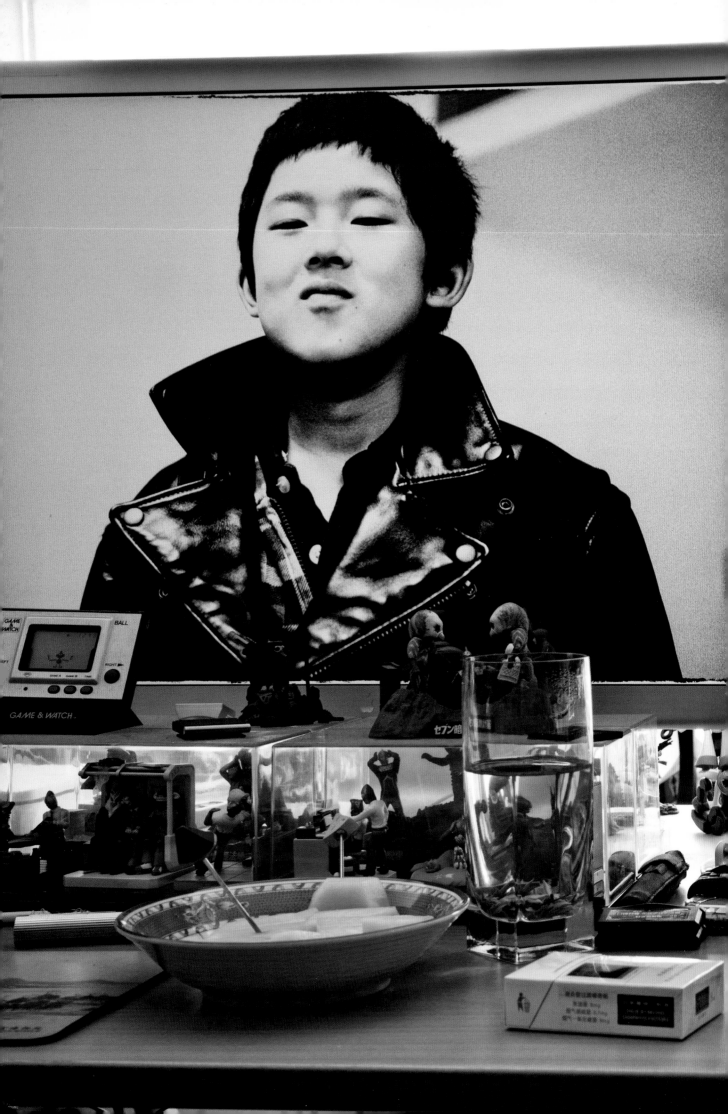

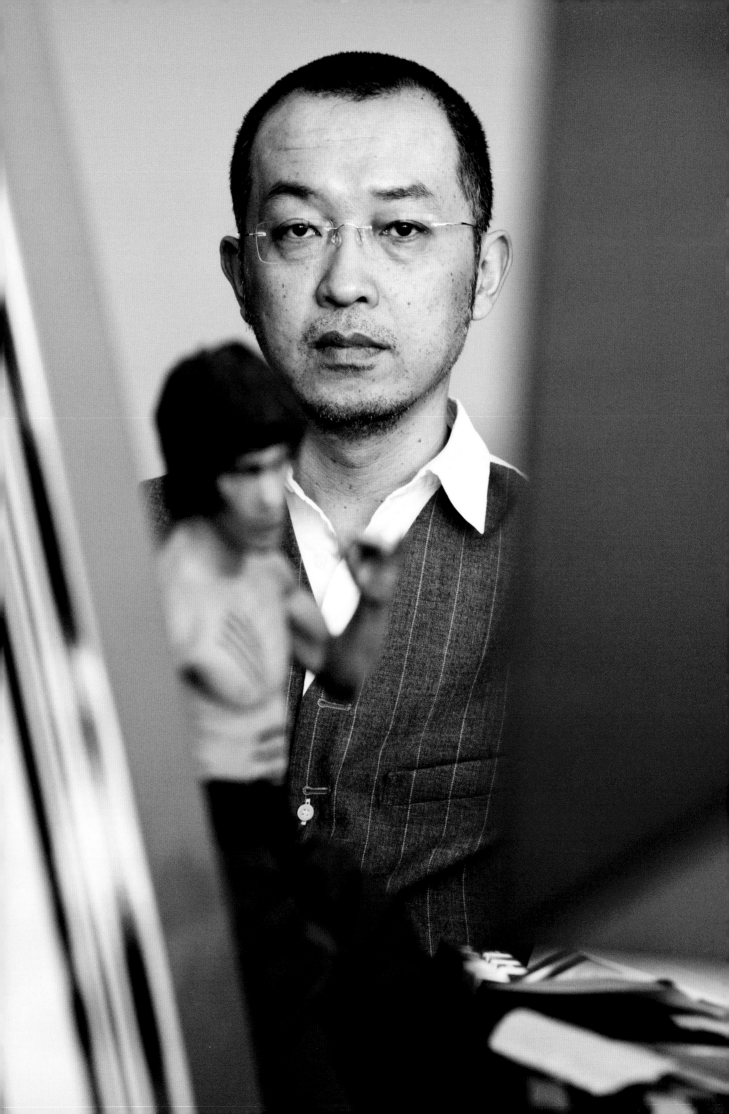

```
  **** COMMODORE 64 BASIC V2 ****
64K RAM SYSTEM   38911 BASIC BYTES FR
EADY.
```

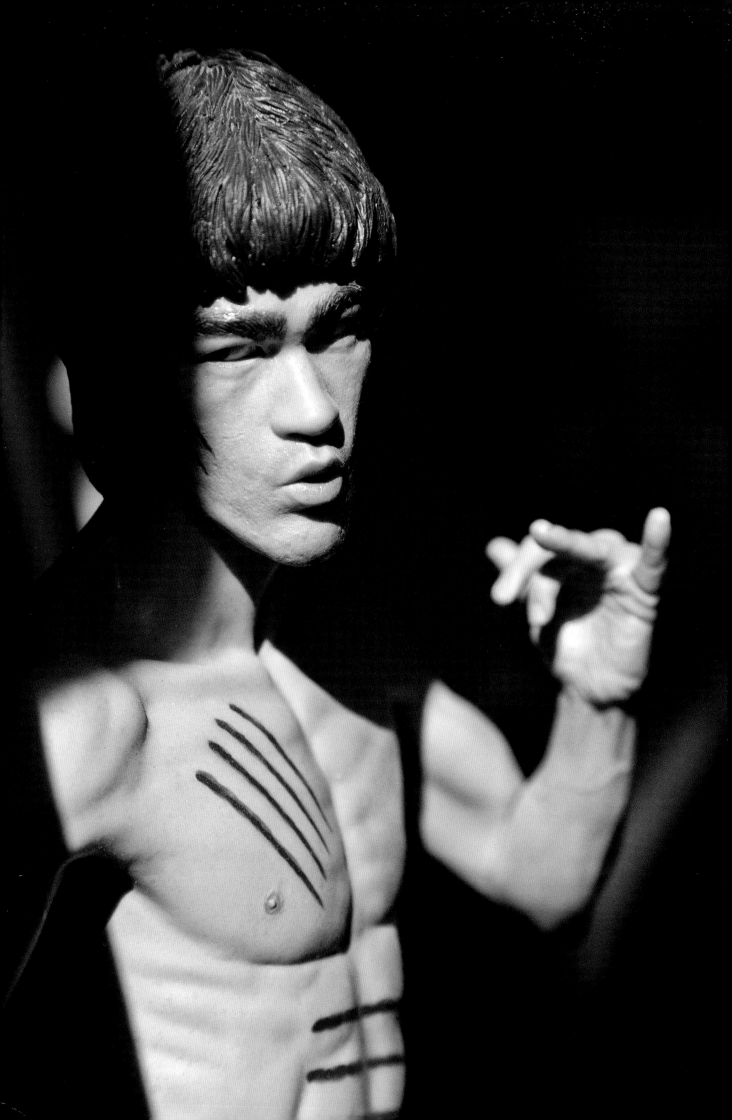

FENG MENGBO

1966 Born in Beijing, China
1988 Golden Prize of the Year, Central Academy of Fine Arts, Beijing, China
1991 Graduated in print-making from the Central Academy of Fine Arts, Beijing, China
2004 Award of Distinction: Feng Mengbo: "Ah_Q", Prix Ars Electronica-International Competition for CyberArts, Linz, Austria

Lives and works in Beijing, China

Selected Solo Exhibitions

2010 "Journey to the West", Shanghai Gallery of Art, Shanghai, China

"1 BiTe", Chambers Fine Art Gallery, New York, USA

2009 "Restart", Ullens Center for Contemporary Art, Beijing, China

2007 "Wrong Code: Shanshui", Hanart TZ Gallery, Hong Kong, SAR China

2006 "Bytes and Pieces", UNT Visual Art Gallery, Texas, USA

2005 "Q4U", The New England Institute of Art, Boston, USA

2002 "Q4U", The Renaissance Society, Chicago, USA

2001 "Phantom Tales", Dia Center for the Arts, New York, USA

"Paintings by Feng Mengbo", Hanart TZ Gallery, Hong Kong, SAR China

1998 "Feng Mengbo: Video Games", Haggerty Museum, Milwaukee, USA

"Feng Mengbo", Holly Solomon Gallery, New York, USA

Selected Group Exhibitions

2000 "Zeitwenden", Kunstmuseum Bonn, Germany, and Museum Moderner Kunst Stiftung Ludwig Wien, Vienna, Austria

1997 Documenta X, Kassel, Germany

1995 1st Gwangju Biennial, Gwangju, South Korea

1993 45th Venice Biennale, Venice, Italy

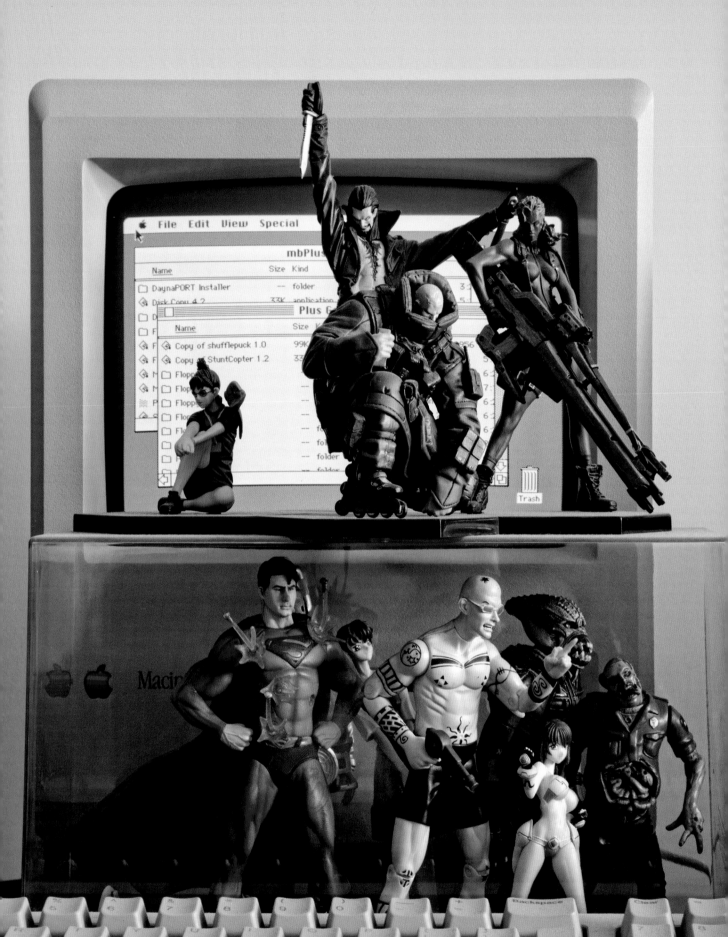

```
//generated by FENG  Mengbo, do not modify
unbindall
bind UPARROW "+forward"
bind DOWNARROW "+back"
bind LEFTARROW "+left"
bind RIGHTARROW "+right"
bind MOUSE1 "+attack"
bind MOUSE2 "+zoom"
bind WHEELDOWN "weapennext"
bind WHEELUP "weapenprev"
seta r drawworld "0"
seta timescale "0.01"
seta timlimit "0"
seta fraglimit "0"
exec FENG  Mengbo
```

//由冯梦波自动生成，不要改动
解除所有绑定
绑定 上键为"上"
绑定 下键为"下"
绑定 左键为"左"
绑定 右键为"右"
绑定 鼠标左键为"射击"
绑定 鼠标右键为"变焦"
绑定 鼠标转轮向下为"下一种武器"
绑定 鼠标转轮向上为"上一种武器"
设定 真实世界渲染为"零"
设定 时间拉伸为"百分之一"
设定 时间限制为"无限"
设定 伤害限制为"无限"
执行 冯梦波

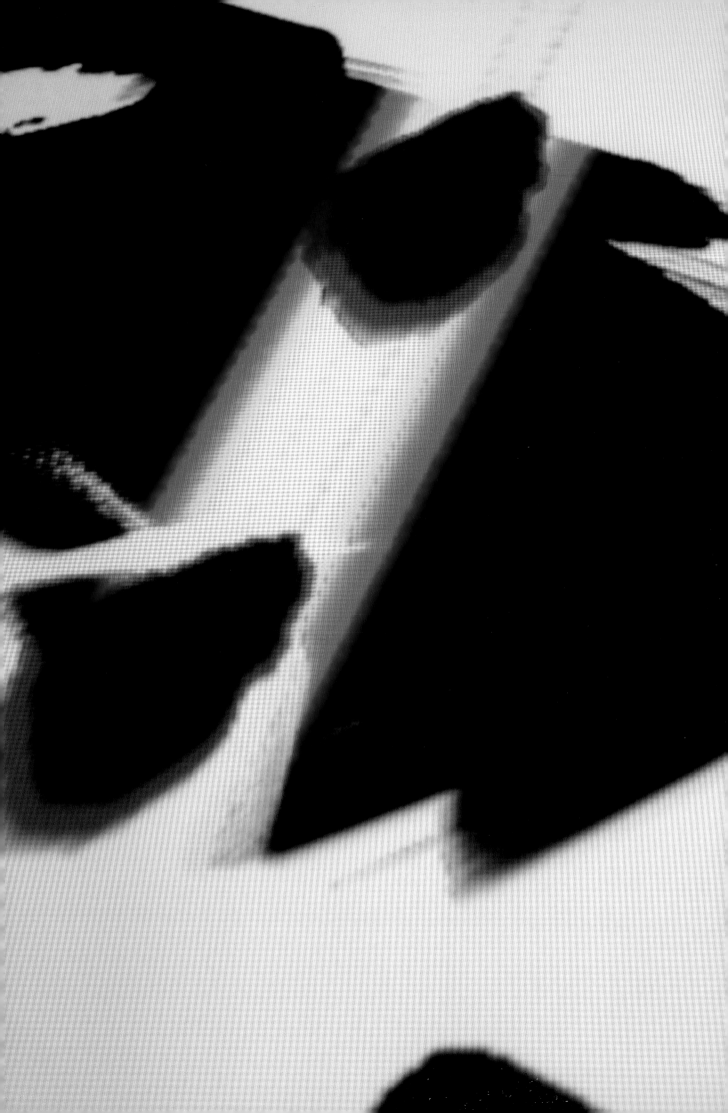

FENG MENGBO

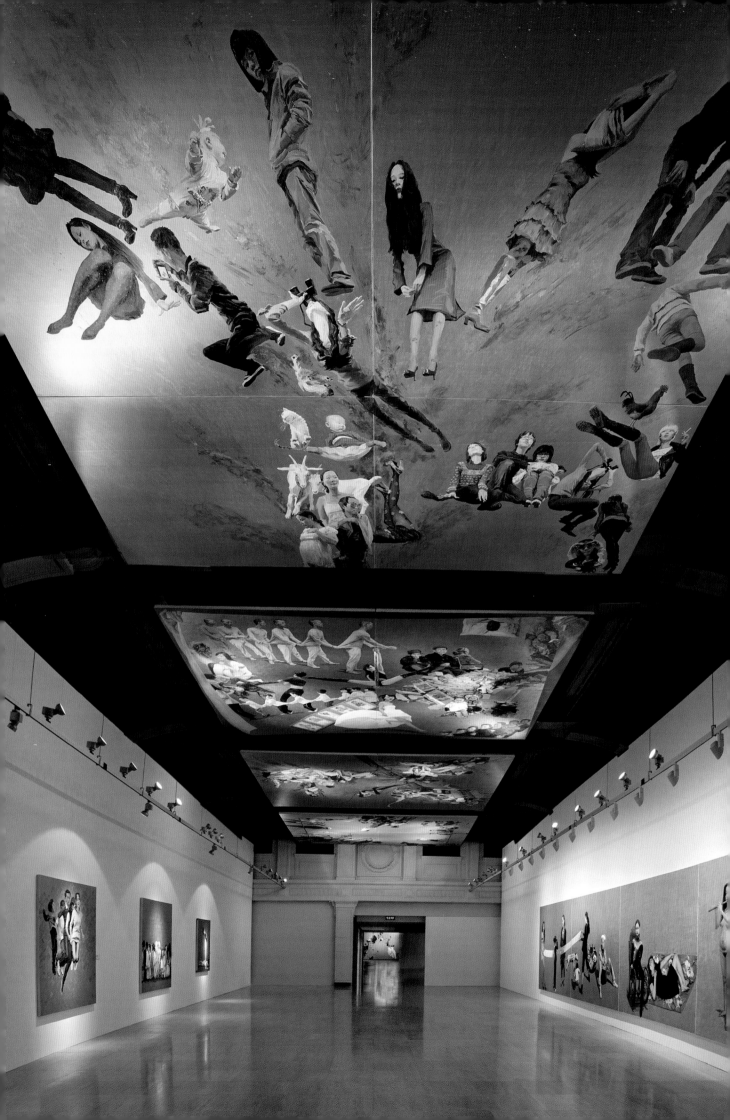

Selected Group Exhibitions

2010 "Reshaping History: China Art 2000–2009", National Convention Center, Beijing, China

2008 "Half Life of a Dream: Contemporary Chinese Art from the Logan Collection", SFMOMA, San Francisco, USA

"Face and Faces", Galeria Dolores de Sierra, Madrid, Spain

"Fresh Ink: Ten Takes on Tradition", Museum of Fine Arts, Boston, USA

2007 "Made in China", Louisiana Museum of Modern Art, Copenhagen, Denmark

"Jerusalem, Israel Energy and Character", China Art Museum, Beijing, China

2006 "Another Look", Long March Space, Beijing, China

"The Grand Promenade", National Museum of Contemporary Art, Athens, Greece

2005 "The Wall: Reshaping Contemporary Chinese Art", Millennium Art Museum, Beijing, China

"Contemporary Chinese Art", Tamayo Art Museum, Mexico City, Mexico

7th Sharjah Biennial, Sharjah, United Arab Emirates

2004 "Dreaming of the Dragon's Nation: Contemporary Art from China", Irish Museum of Modern Art, Dublin, Ireland

"Shanghai 5 Biennale: Techniques of the Visible", Shanghai, China

2003 1st Beijing Biennial Art Exhibition, National Art Museum of China, Beijing, China

YU HONG

1966 Born in Beijing, China
1996 Graduated with fine arts masters from the
Central Academy of Fine Arts, Beijing, China

Lives and works in Beijing, China

Selected Solo Exhibitions

2011 "Golden Horizon", Shanghai Art Museum,
Shanghai, China

2010 "Golden Sky", Ullens Center for
Contemporary Art, Beijing, China

2009 "In and Out of Time" Guangdong Museum
of Art, Guangzhou, China

2007 "Yu Hong: Witness to Growth", Eslite
Gallery, Taipei, Taiwan

2006 "Yu Hong" Loft Gallery, Paris, France

"Yu Hong: Figure and Ground", Loft Gallery, Paris,
France

2003 "A Woman's Life: The Art of Yu Hong",
Halsey Gallery, College of Charleston, Charleston,
USA

"Yu Hong: Witness to Growth", Museum of Hubei
Academy of Fine Art, Wuhan, China

2002 "Yu Hong: Witness to Growth", East Modern
Art Center, Beijing, China

"Yu Hong: Witness to Growth", He Xiangning Art
Museum, Shenzhen, China

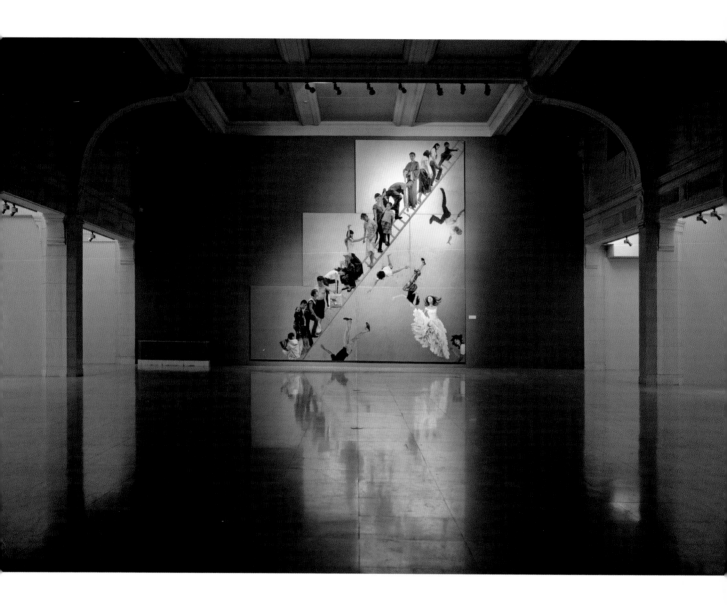

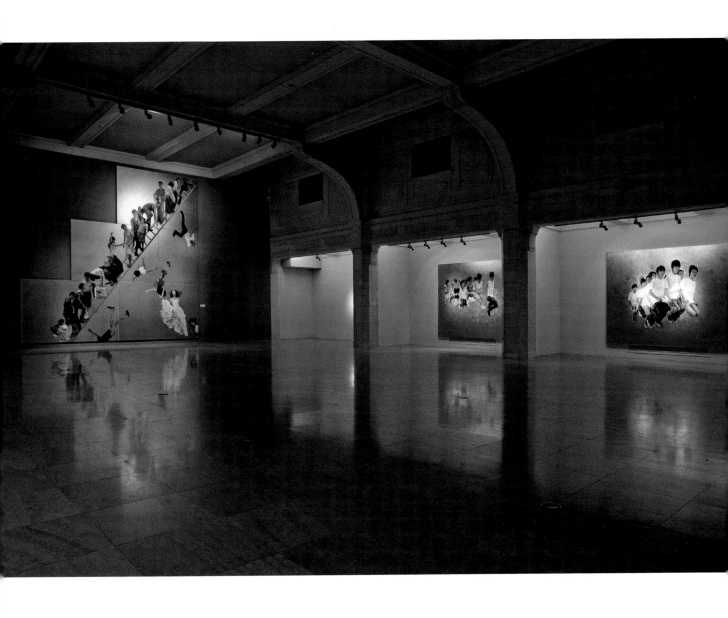

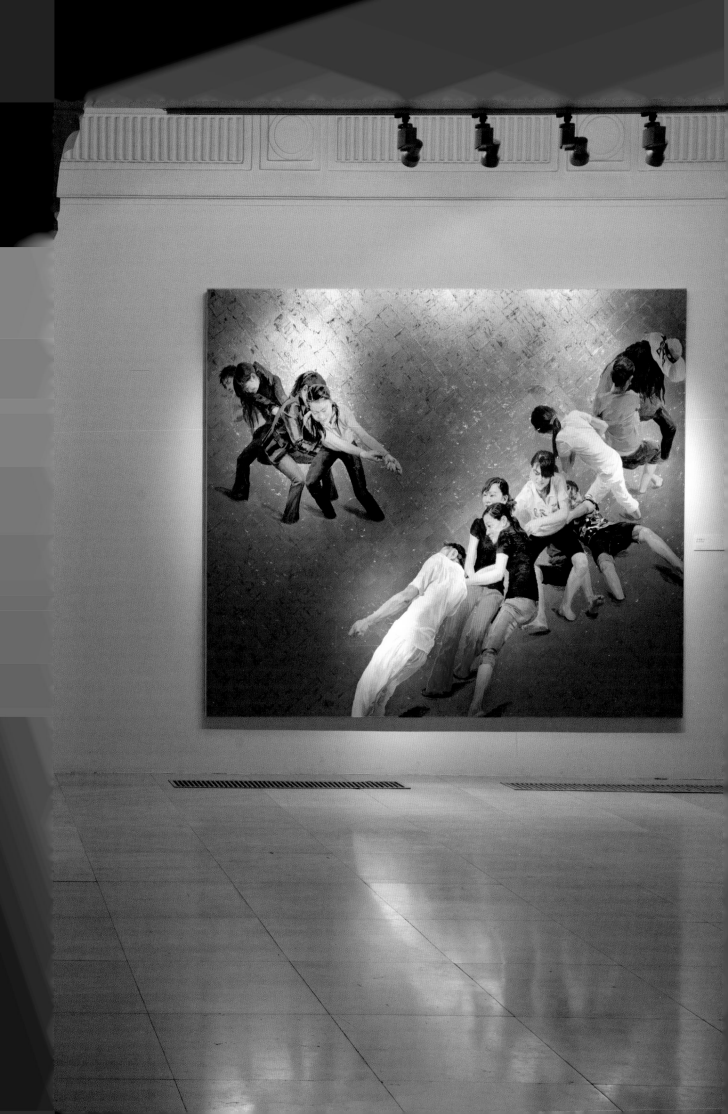

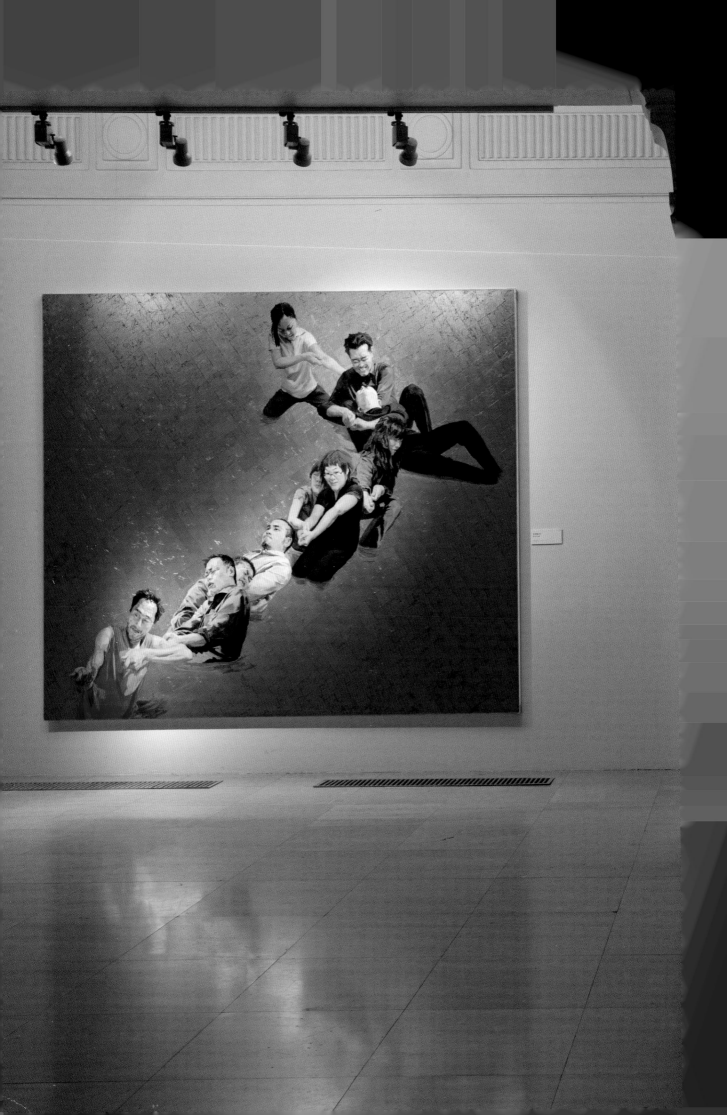

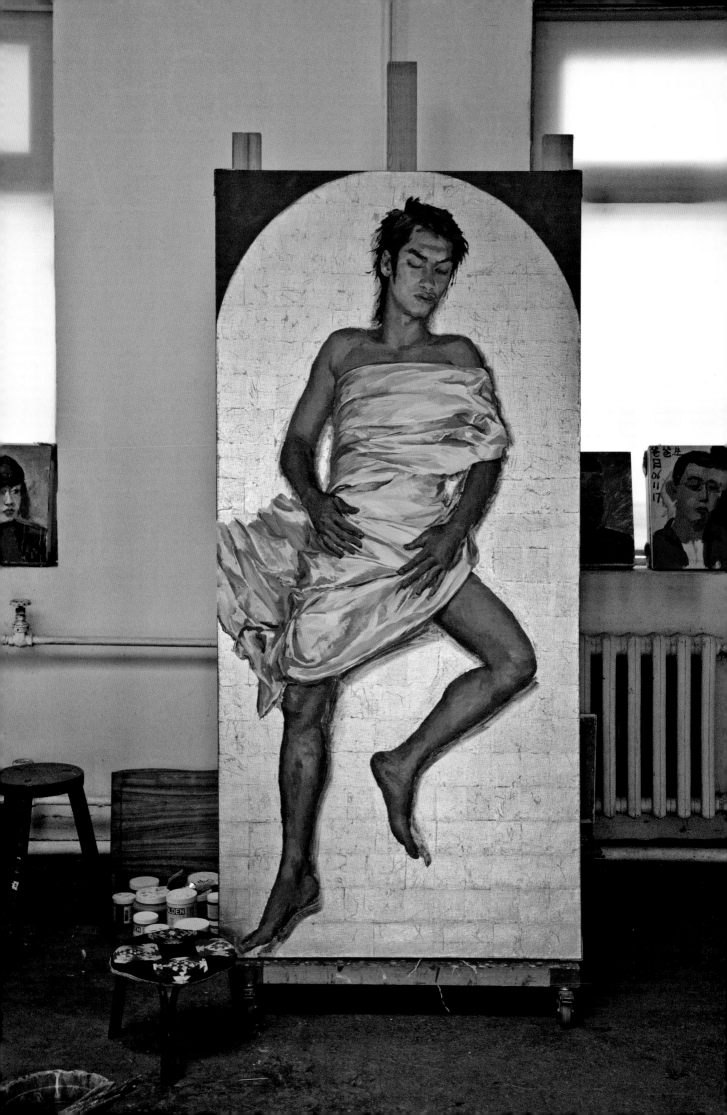

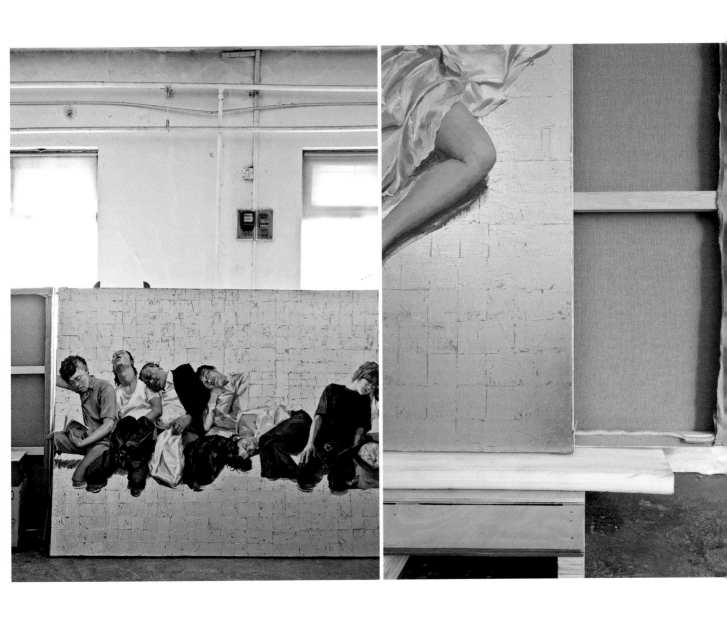

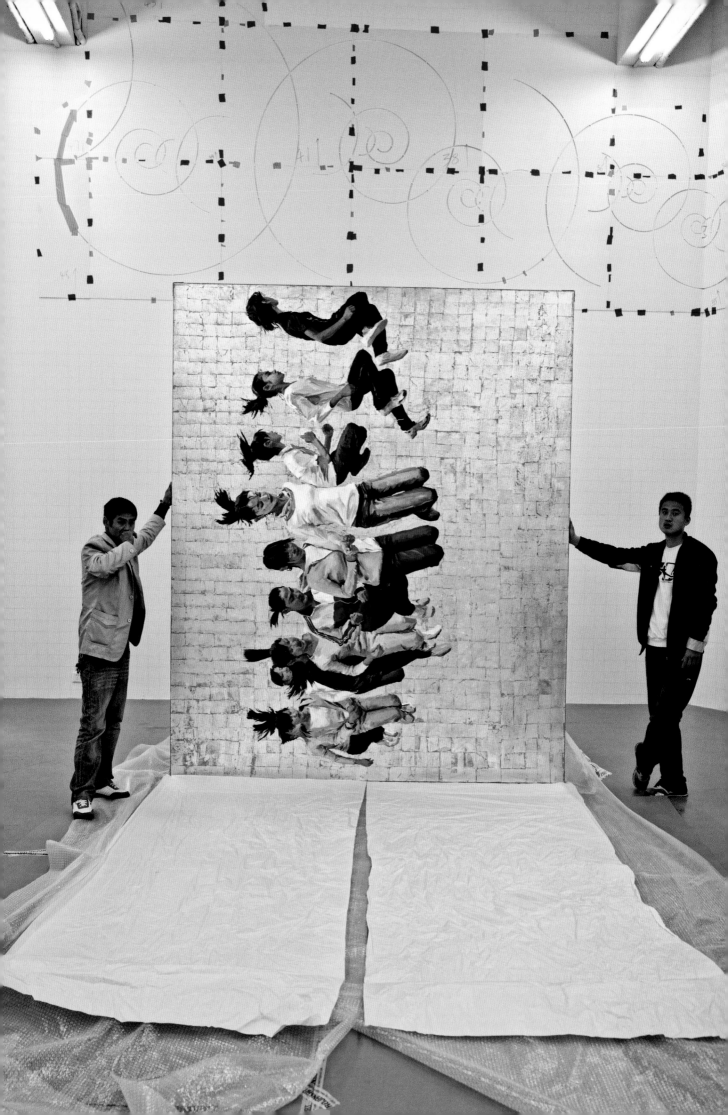

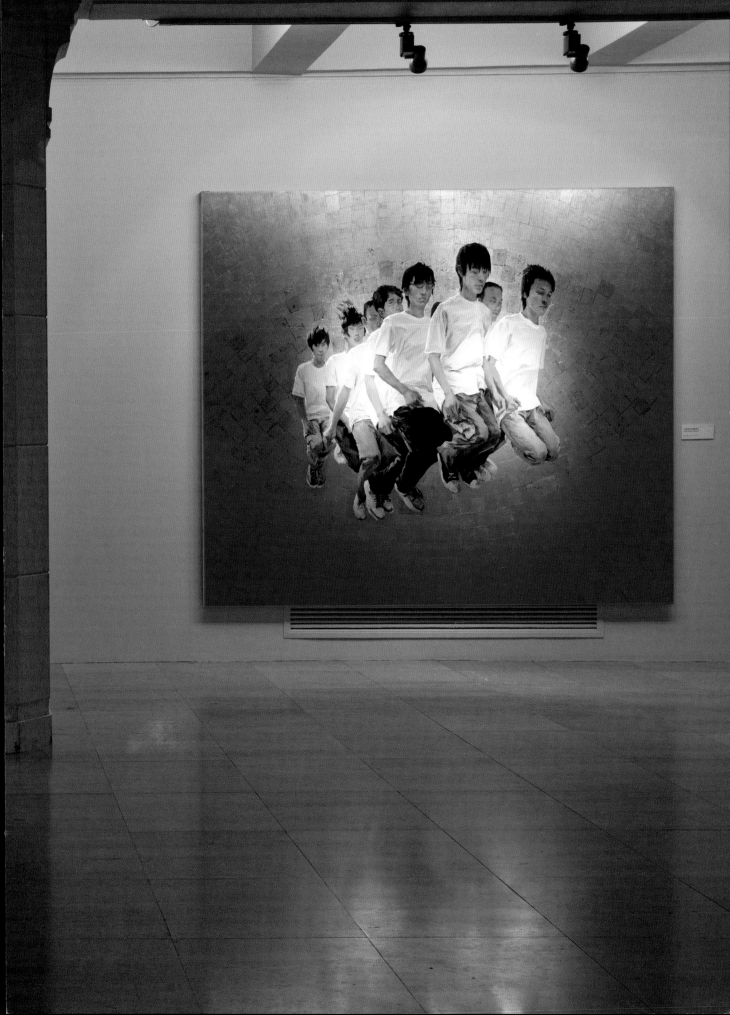

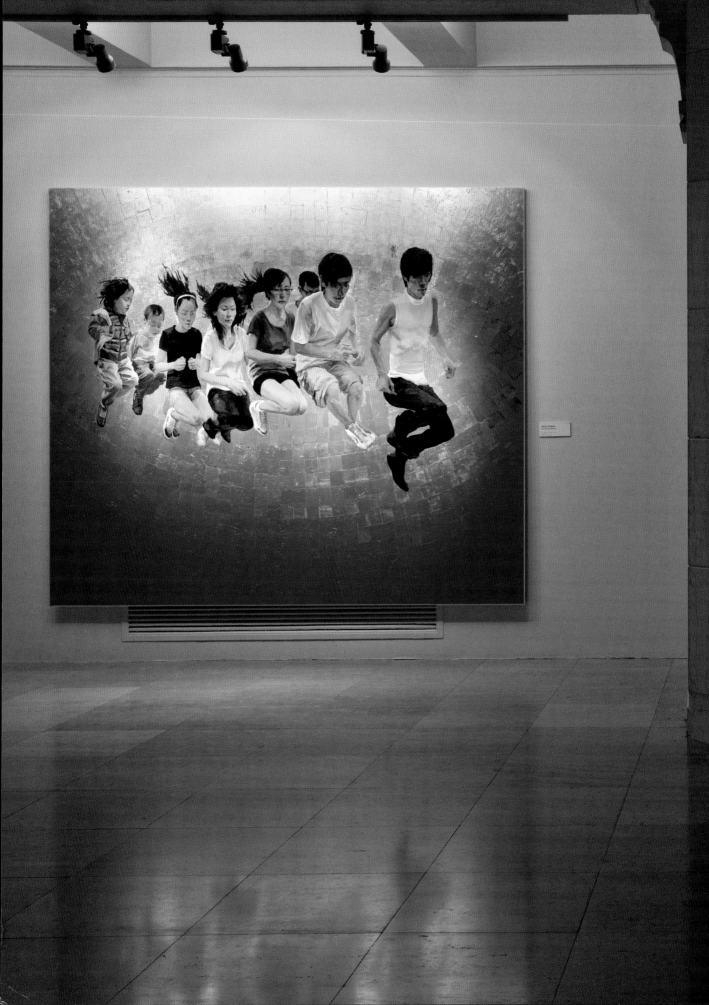

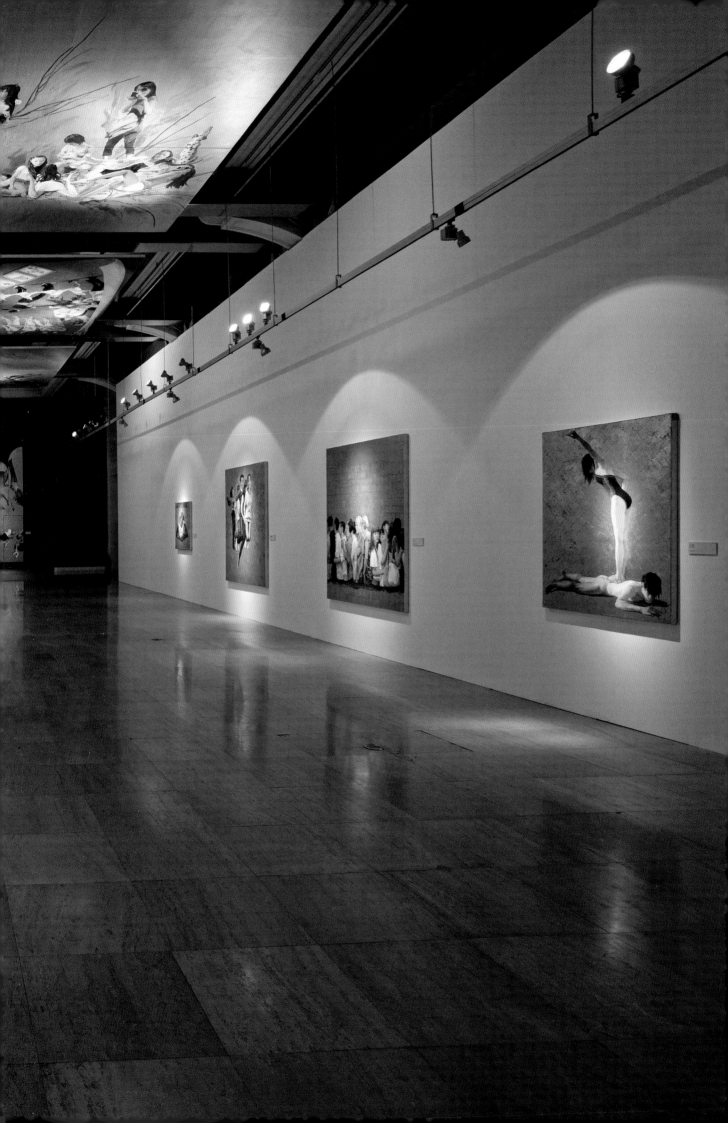

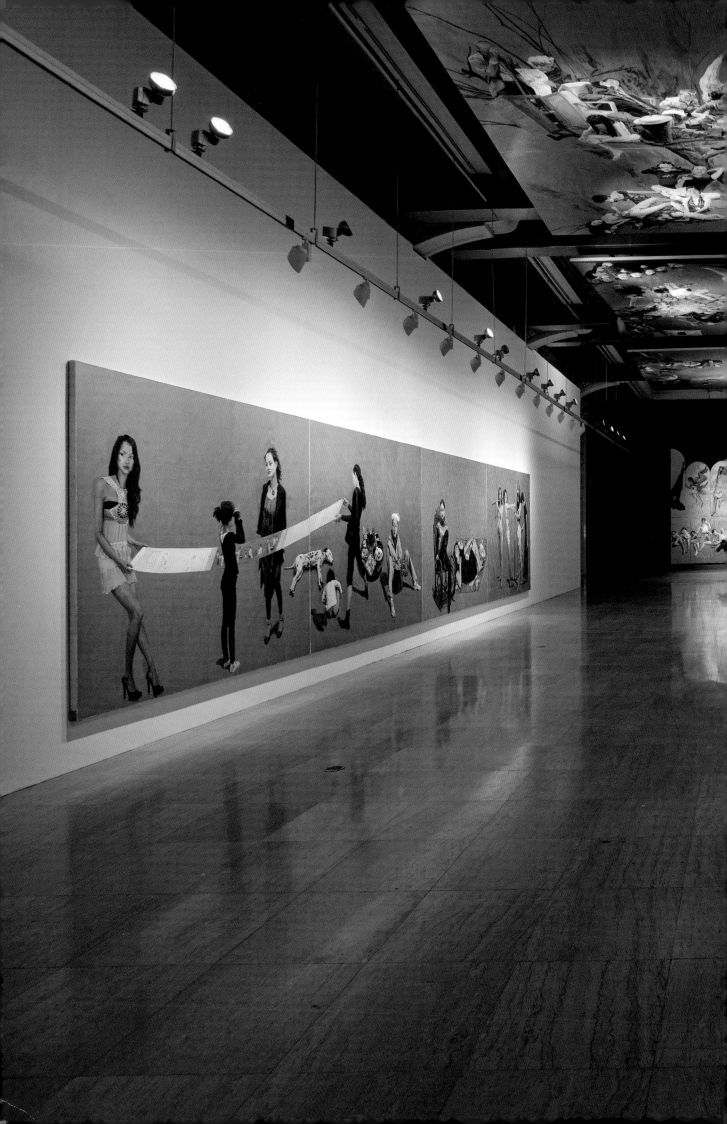

YU HONG

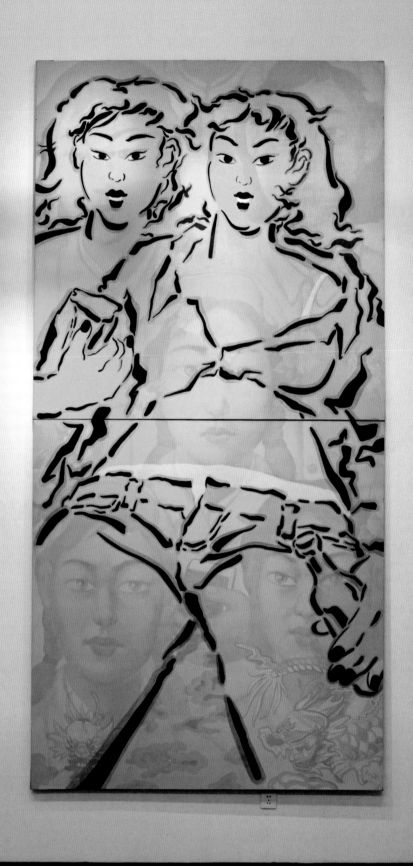

PU JIE

1959 Born in Shanghai, China
1986 Graduated in arts education from Shanghai Teachers University, Shanghai, China
2000 Graduated with fine arts masters from Shanghai University, Shanghai, China

Lives and works in Shanghai, China

Selected Group Exhibitions

2012 "Space-Time Reconstruction", Ausin Tung Gallery, Hong Kong, SAR China

2011 "Points of View: Contemporary Art in China", University of Colorado Art Museum, Boulder, USA

2009 ART Basel/Miami Beach Contemporary Art Fair, Miami, USA

"Look Ahead, Look Back", Today Art Museum, Beijing, China

"Memory and Witness", Museum at Tamada Projects, Tokyo, Japan

2008 "From Heaven to Earth: Chinese Contemporary Painting", Primo Marella Gallery, Milan, Italy

2008 "Art is not Something", Beijing Art Festival, 798 Art Centre, Beijing, China

2007 "Red Hot Asian Art Today from the Chaney Family Collection", Museum of Fine Arts, Houston, USA

2005 "Mahjong Contemporary Chinese Art from the Ulli Sigg Collection", Kunstmuseum Bern, Bern, Switzerland

2003 42nd England Contemporary Artist Invitational Exhibition, London Finance Building, London, UK

2002 Singapore International Exhibition of Contemporary Art, National Art Museum, Singapore

2001 ART Basel International Art Fair, Basel, Switzerland

1998 "Neo Lagoon: Contemporary Art of North East Asia", Niigata Prefecture Centre, Art Museum, Niigata, Japan

"BM99", Bienal da Maya, Maya Art Center, Lisbon, Portugal

1997 4ème Biennale d'Art Contemporain, Lyon, France

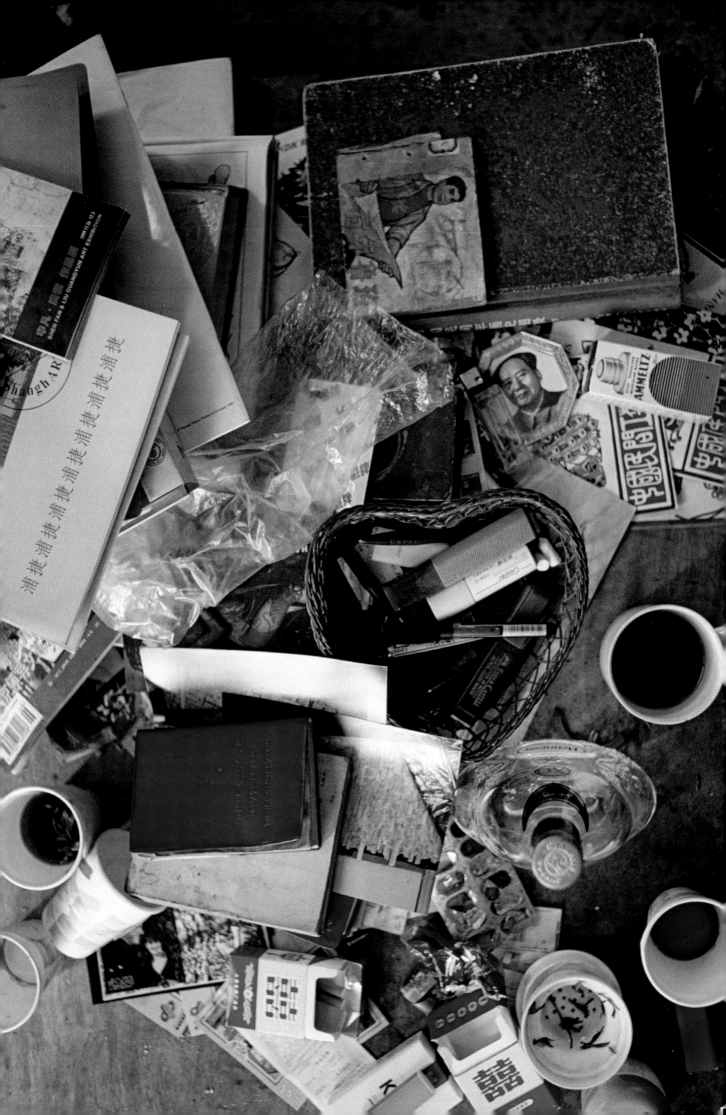

As a form of expression, the nail aimed to show up the construction and violence of Tiananmen and the Old Summer Palace by means of its functionality and accidentalness.

In that way, we can see the remarkable coincidence with those historical victories by the real cultural narrative with social sentiment, which also proved the ancient Chinese story that Shun was elected as the emperor in 23rd-22nd century BC.

'Double Vision', Pu Jie on Chinese contemporary art, history and society

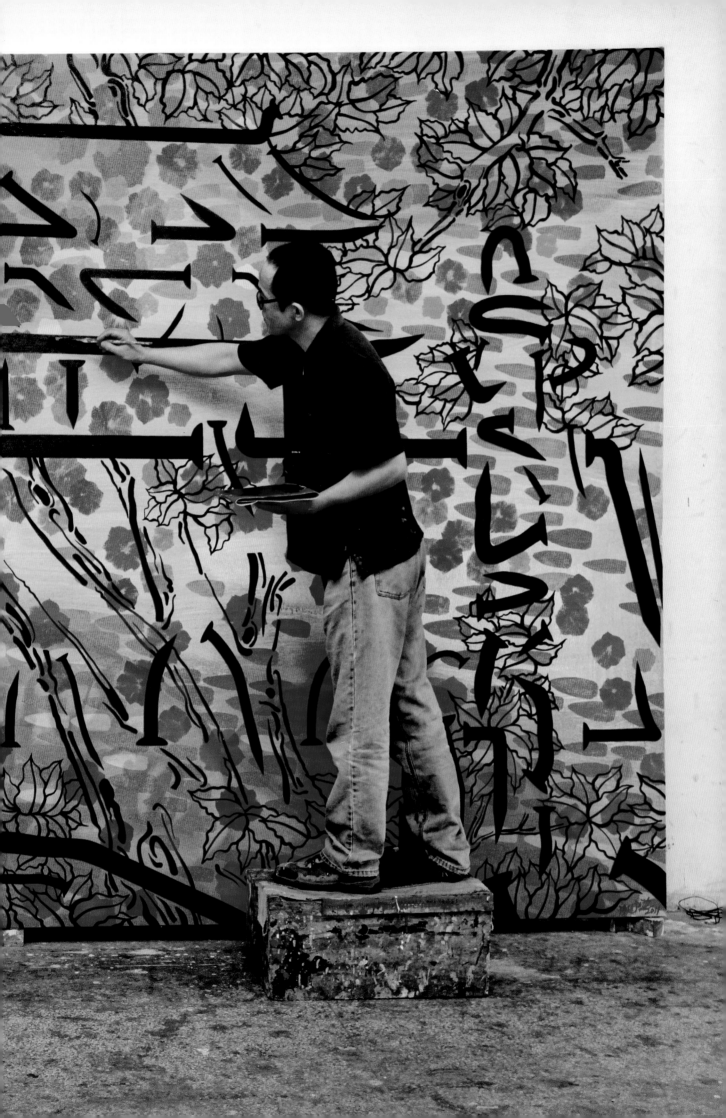

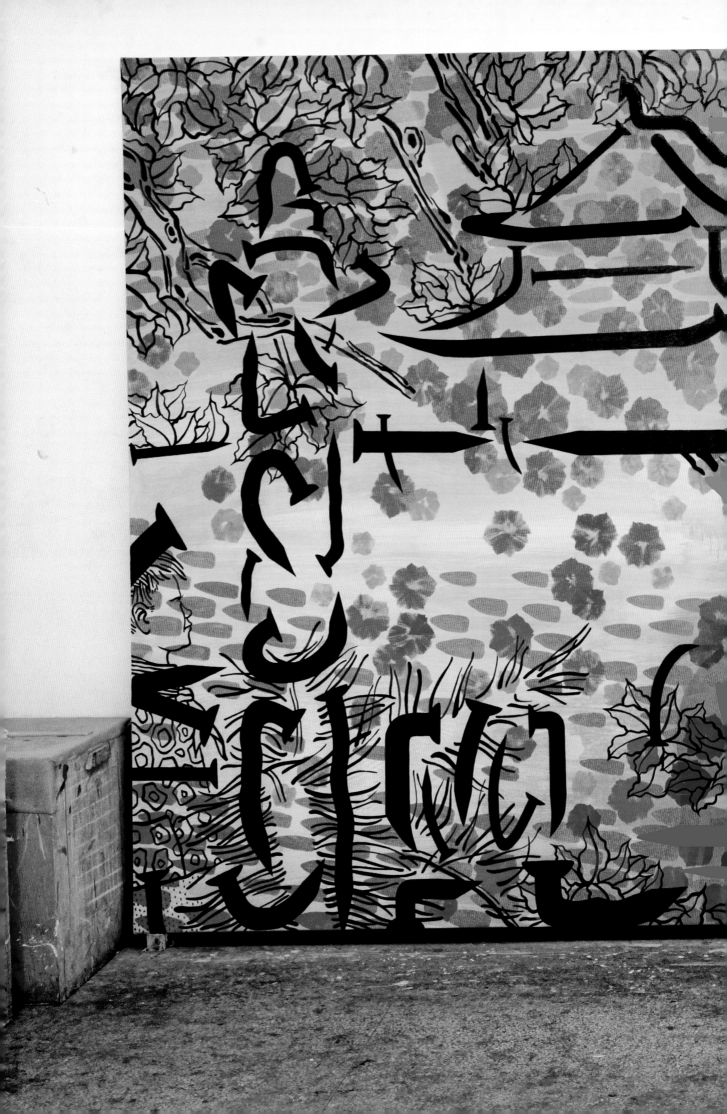

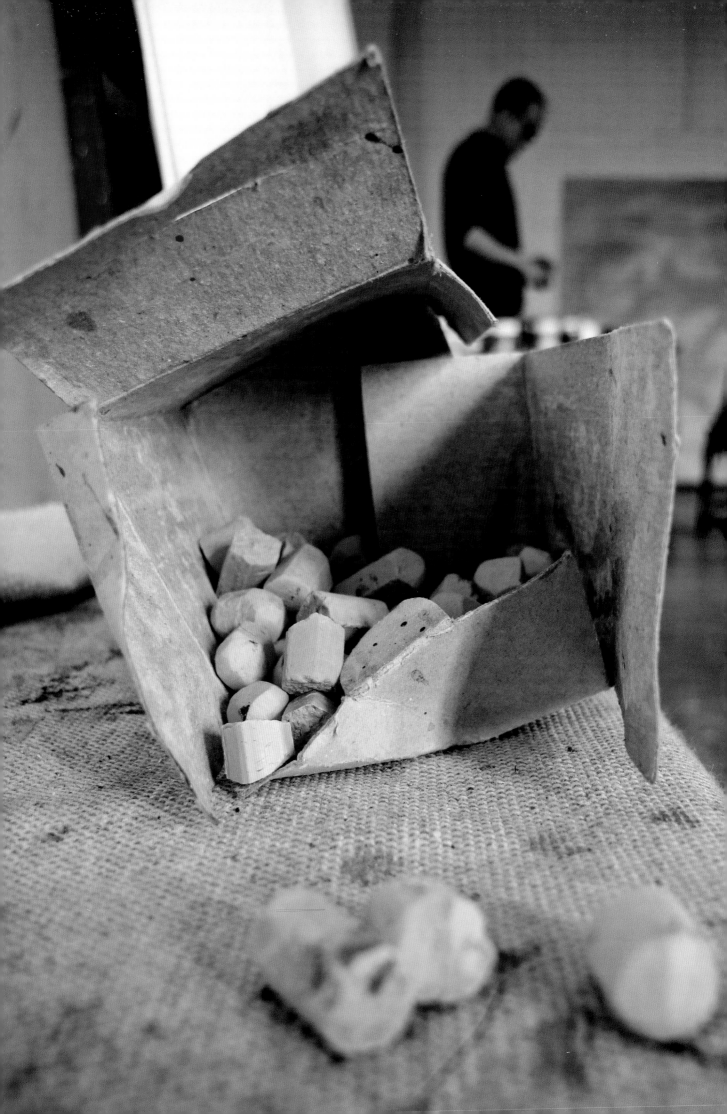

Installation by Elisabeth Gruebl / Shanghai 5.5.2010 / Studio # 14 Pu Jie / Sculpture

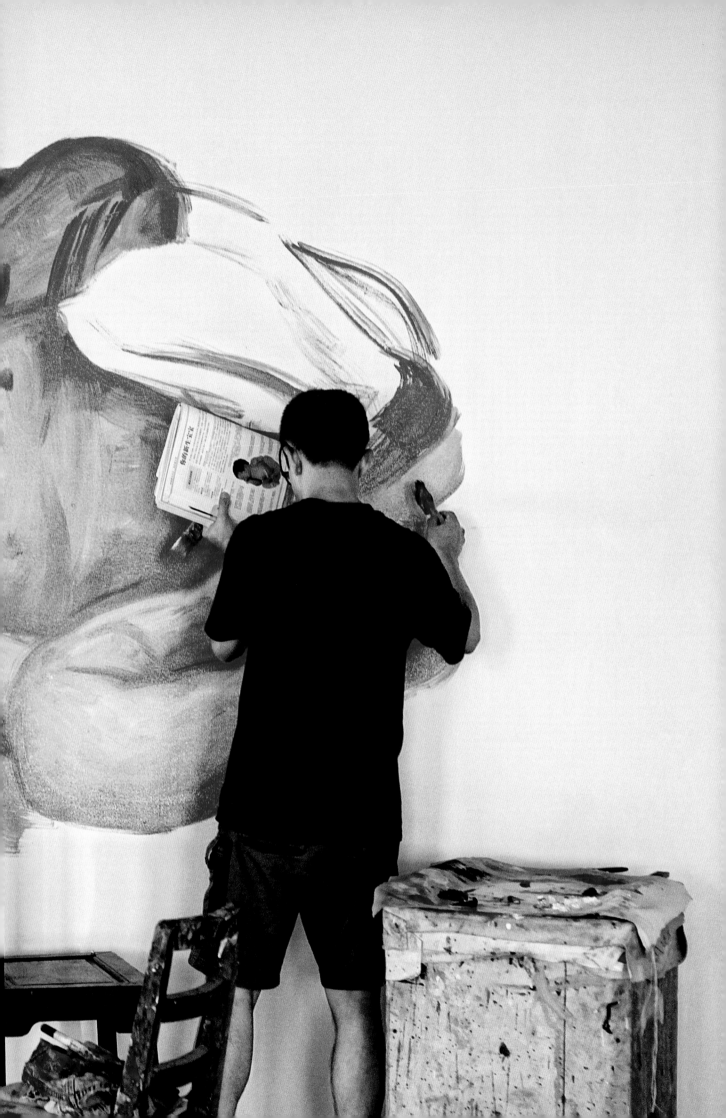

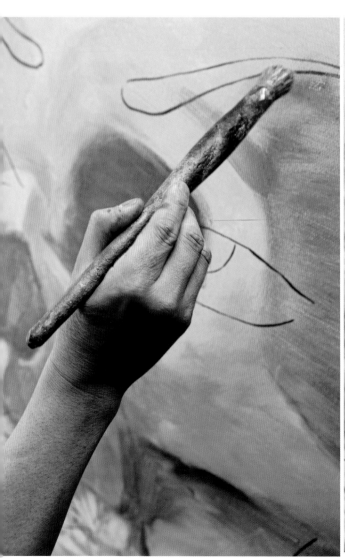

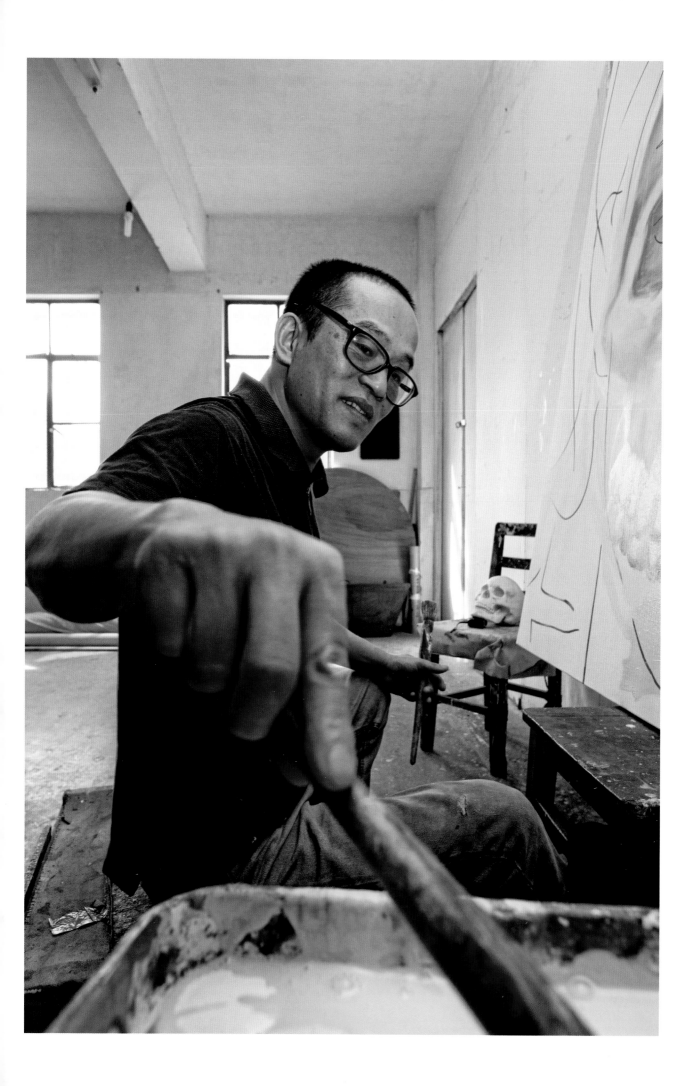

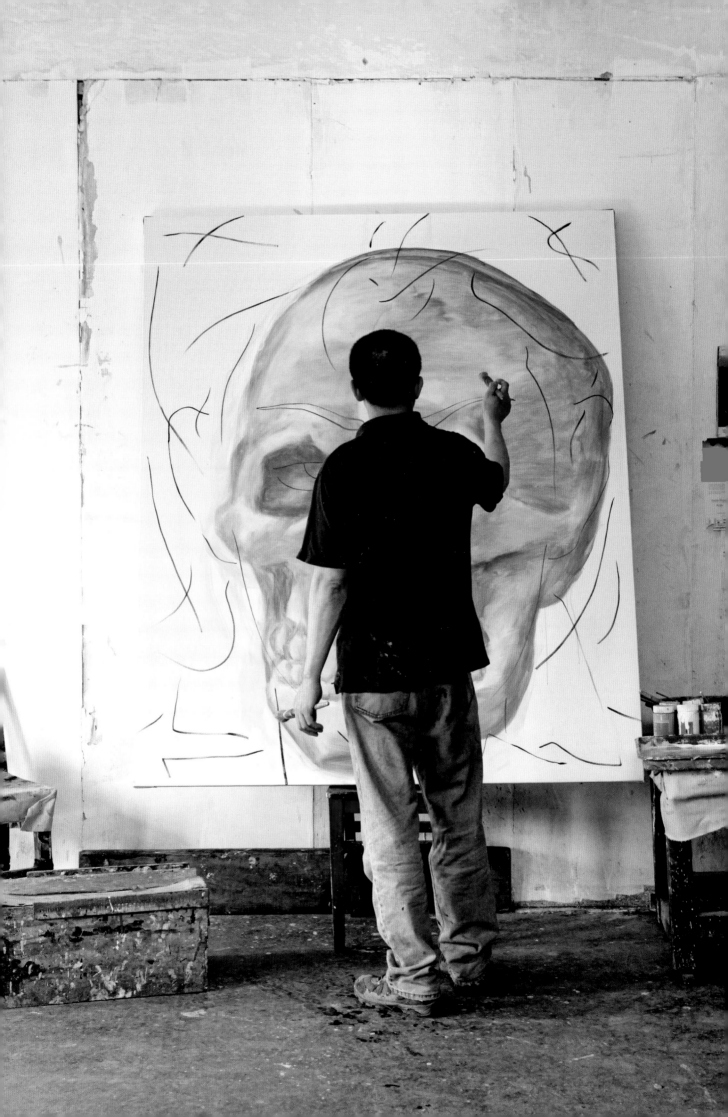

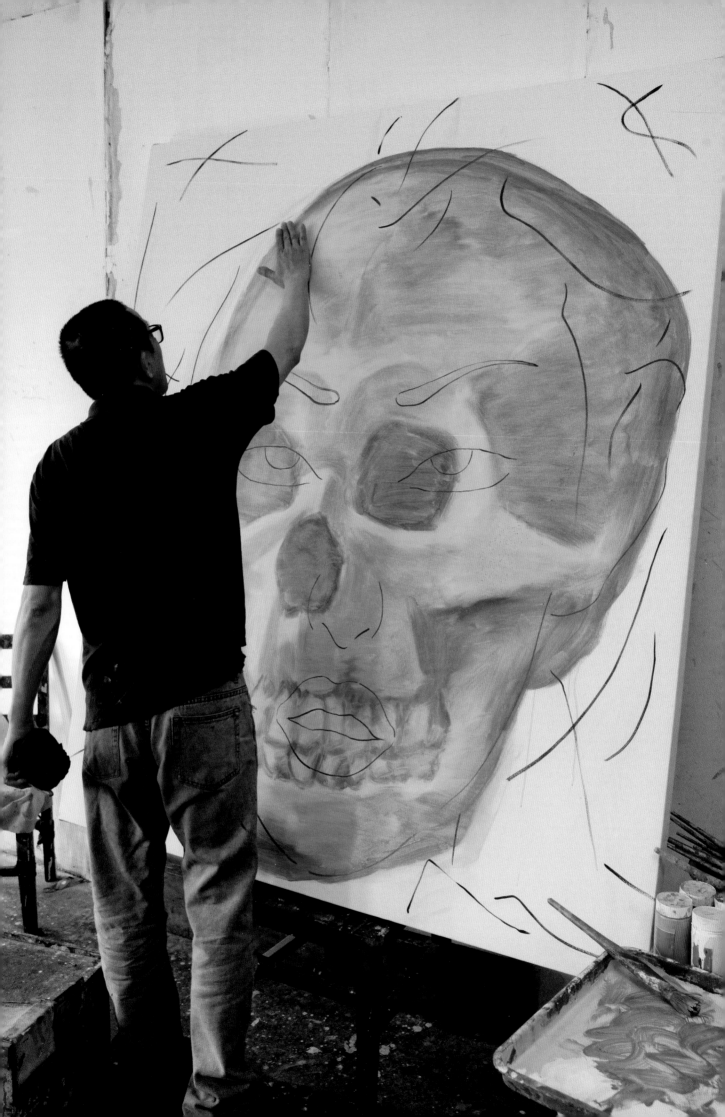

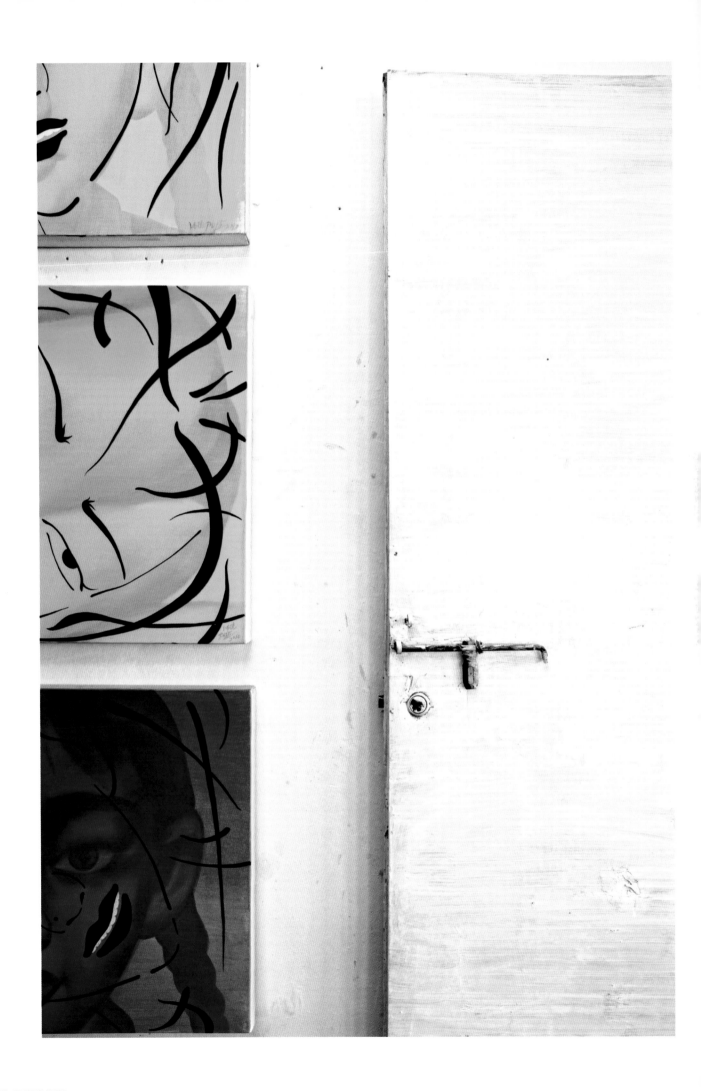

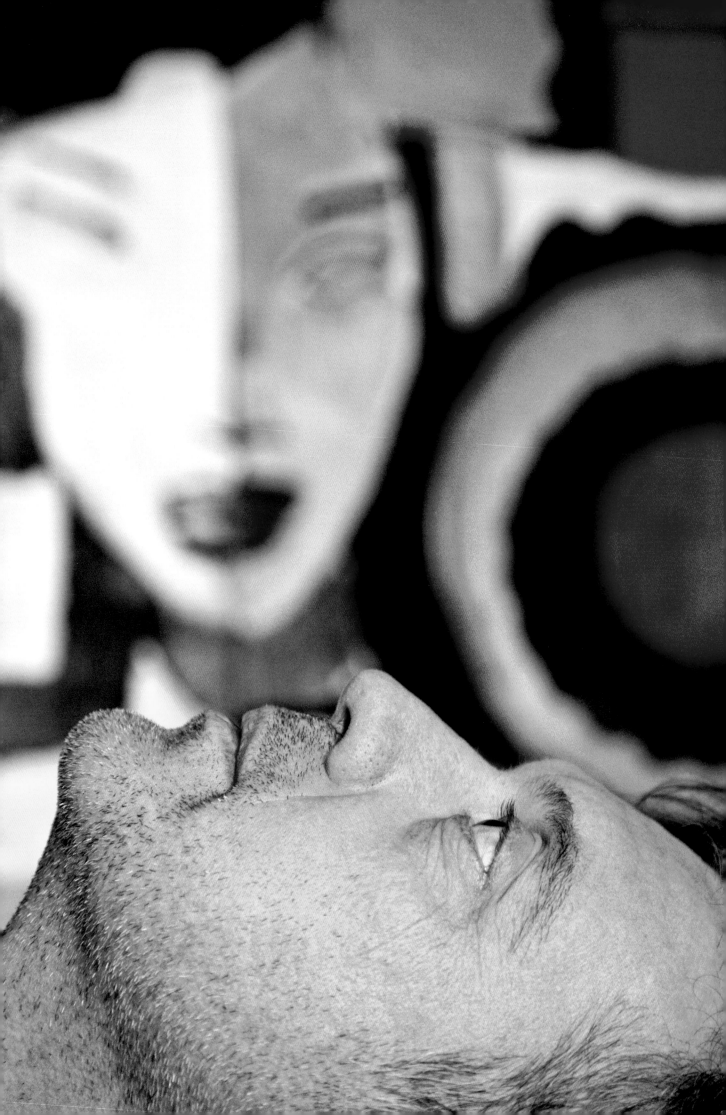

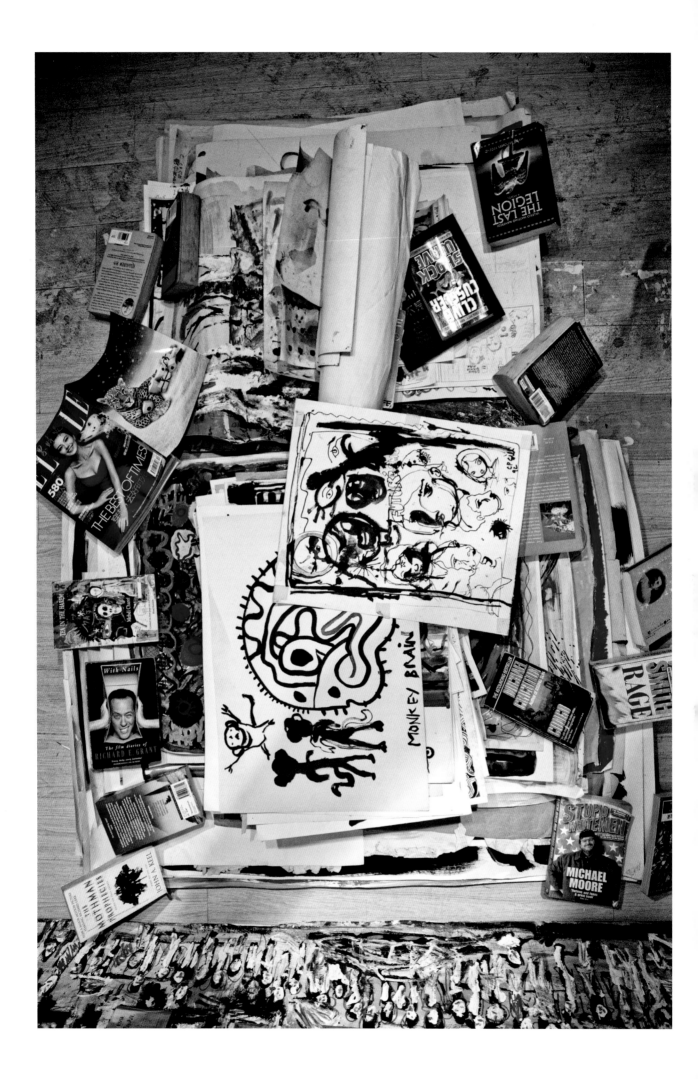

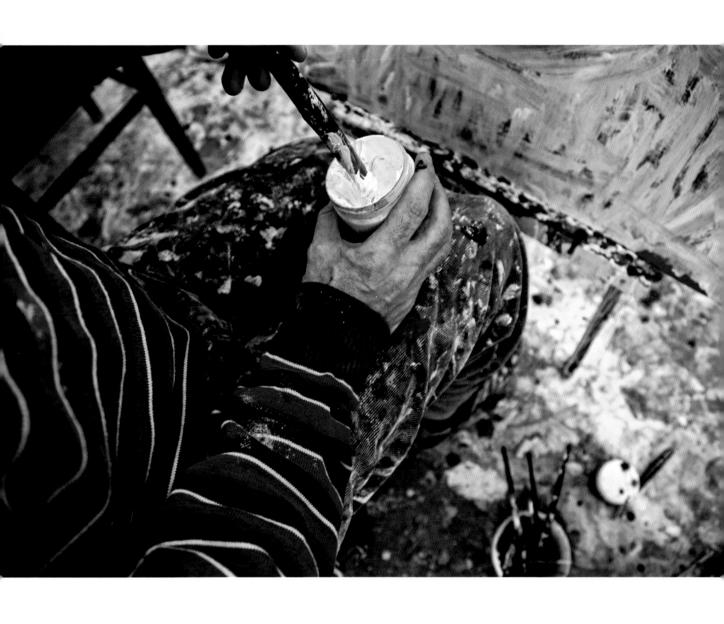

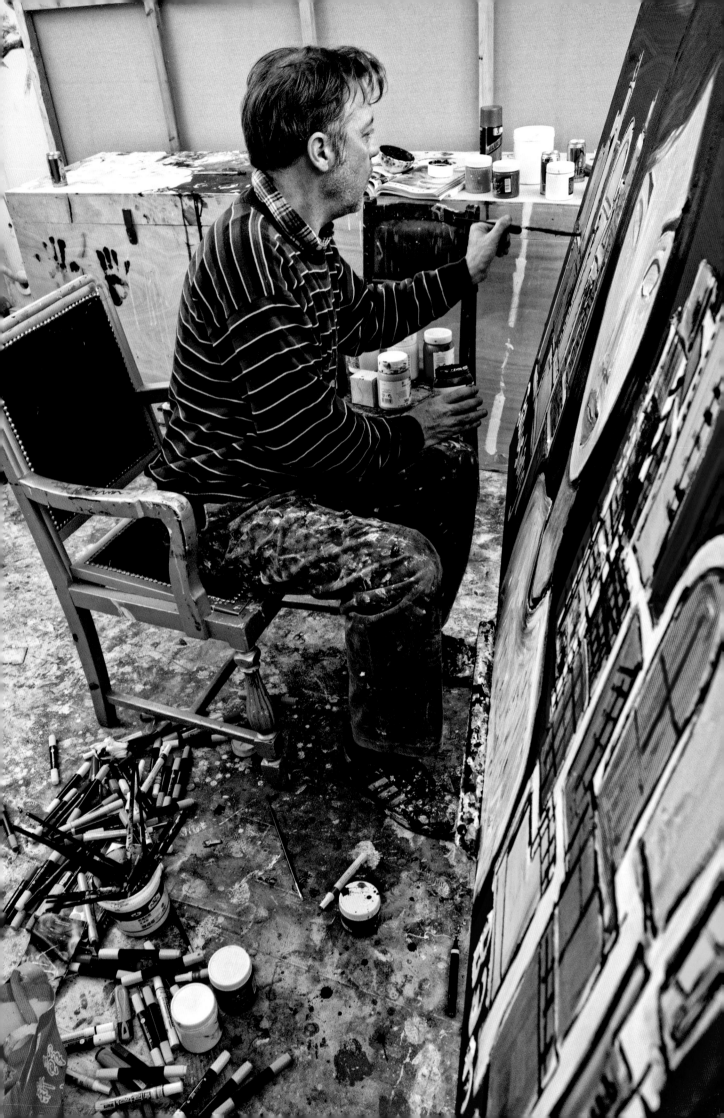

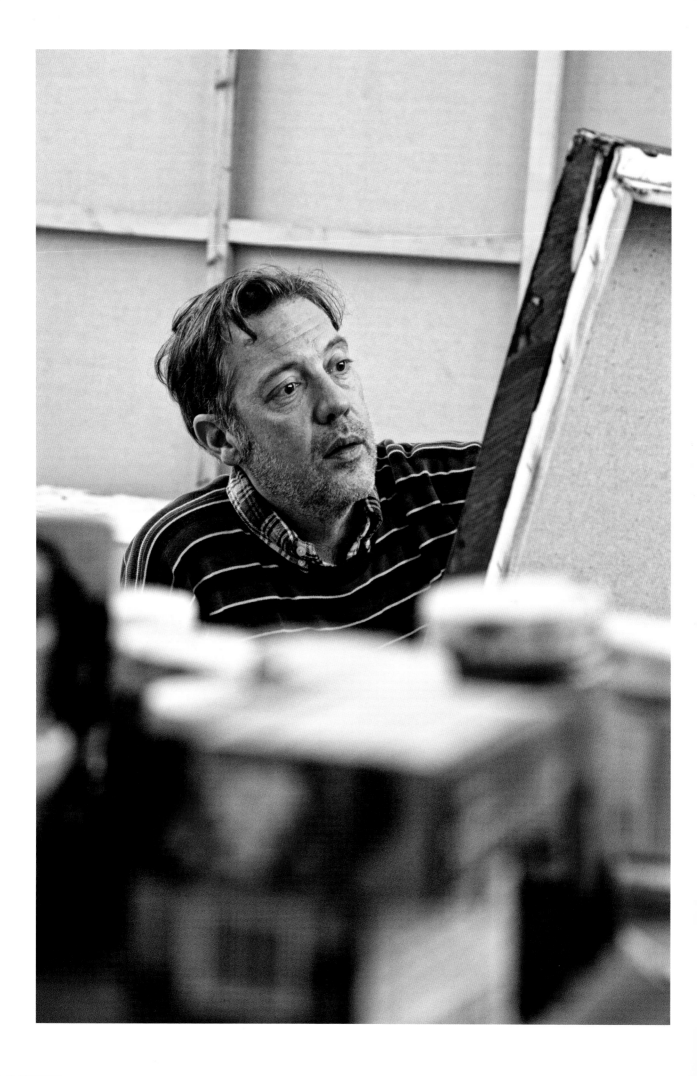

CHRIS P. GILL

1970 Born in Burnley, UK
1992 Studied Chinese language at the People's University of China, Beijing
1994 Graduated in politics and East Asian studies from the University of Newcastle, UK

Lives and works in Shanghai, China

Selected Solo Exhibitions

2012 "Chris Gill: Works on Paper", stageBACK Gallery, Shanghai, China

2011 "The World Mind", Yaochao Gallery, Shanghai, China

2010 "Multilocal", M50 Creative Space, Shanghai, China

2007 "City of Gold", Shanghai Art Museum, Shanghai, China

2006 "Be a better part of the collective consciousness", Yaochao Gallery, Shanghai, China

2002 "Works on Paper", Casj Gallery, Shanghai, China

1997 "China Work", Zhuqizhan Art Museum, Shanghai, China

1995 "Beijing Sanlitun", Red Gate Gallery, Beijing, China

Selected Group Exhibitions

2011 "China Dream", Red Gate Gallery, Beijing, China

"Lost & Found" stageBACK Gallery, Shanghai, China

2010 "point 21", Duolun Museum of Modern Art, Shanghai, China

"Weltschmerz", stageBACK Gallery, Shanghai, China

2009 "Intervention 3", Weihai Road Studios, Shanghai, China

"Stolen Treasures from Modern China", ShanghART Gallery, Beijing and Shanghai, China

1999 "Foreign Artists in Shanghai", ShanghART Gallery, Shanghai, China

"Dragon 2000", French Club of Shanghai and ShanghART Gallery, Shanghai, China

"Just 5 minutes", Eastlink Gallery, Shanghai, China

1992-1993 "Various Activities", Yuanmingyuan Summer Palace, Beijing, China

In any case, Gill is an Englishman and his perspective is necessarily affected by Western culture and the legacy of its modern and contemporary art movements. Even after twenty years of living in China this simple fact has not changed. Nonetheless, his Chinese life and its invisible and inevitable consequences must be taken into account.

At the start of the 21st century contemporary Chinese art began capturing the world's attention. Just as some Chinese artists reside and develop their work in the West, many Western artists are encouraged to practice in China. Produced in China, Gill's art is itself a manifestation of this country's continuous internationalization. Indeed, Chinese contemporary art is embracing the world and Western artists are growing in China. With the advancement of Chinese modernity and the globalization of its art scene, such wealth of interaction is boundless. In this sense, Chris Gill is a pioneer. His creativity took shape in Beijing's Yuanmingyuan and developed in Shanghai; he was born in England and has South African memories; and his work is a true fusion of both Western and Chinese characteristics.

Western-Style Contemporary Chinese Art or Chinese-Style Contemporary Western Art?

Pu Jie

The early 1990s were important in the development of contemporary China. They also heralded the beginnings of its contemporary art, and works from that period are typically referred to as 'modern' within Chinese art circles. At the time, a group of avant-garde artists began living near Yuanmingyuan ('Garden of Perfect Splendor') in Beijing. They rented simple abodes from local farmers as their studios. Strictly speaking, we can say that private studios in China gradually began to appear during that decade, as opposed to the facilities provided by the government to artists on the state payroll. It was a moment of profound historical significance in the evolution of Chinese art, initiating the spontaneous emergence of an artistic collective as most artists were focused on exploring modernist styles. So for Chinese contemporary art this period holds special meaning. Almost every artist who worked in Yuanmingyuan became an important practitioner on the Chinese scene.

However, what is not so well known is that during that same period Chris Gill [Chinese name Li Yunfei 李云飞], originally from England, also lived near Yuanmingyuan. This was quite unique at the time. It should be noted that throughout that decade most Chinese artists aspired to pursue their careers in Western countries and therefore paid particular attention to Western art. In terms of the concept of contemporary art and its various concerns, there was still much that was unknown in China and the majority of its artists had no clue then about what it actually was. As a Westerner, Gill chose to live and work in China on a long-term basis. Moreover, he lived with Chinese artists and together they explored the world of art. Perhaps something should be said for his special status as both an art journalist and an artist. This dual identity has endowed him with insights into the local scene from the very moment of its inception. I have often appreciated his distinctive understanding while talking to him.

This year marks the thirtieth year of contemporary Chinese art. Overall, it is still an experience of Western art that provides the point of departure in most examples of a 'Chinese-style'. Chris Gill naturally has quite different reactions to this process. It is fair to say that he is both a witness to the last three decades and an active participant in its results. What distinguishes his work from his Chinese peers is that it never strictly follows either Chinese or Western models. In fact, his creative efforts originate from his experiences growing up in South Africa and his English heritage. These two influences form the foundations of his personal expression. His South African childhood constitutes the DNA of his art, which undoubtedly demonstrates some clear cultural references. Perhaps indigenous African culture in general provides the actual 'roots' of his art.

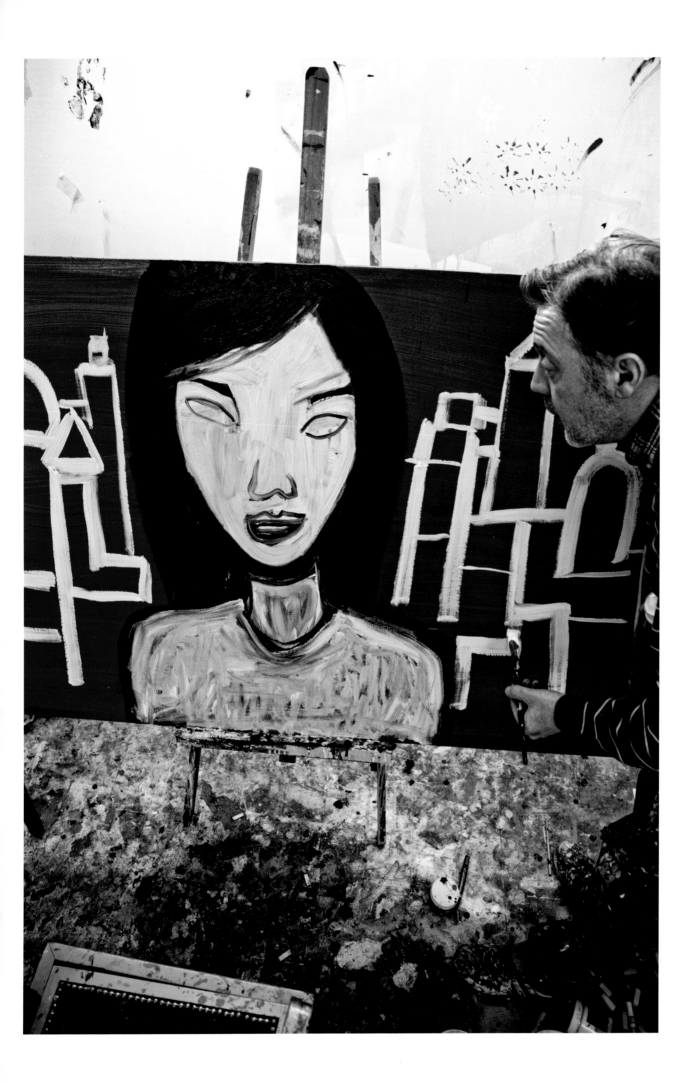

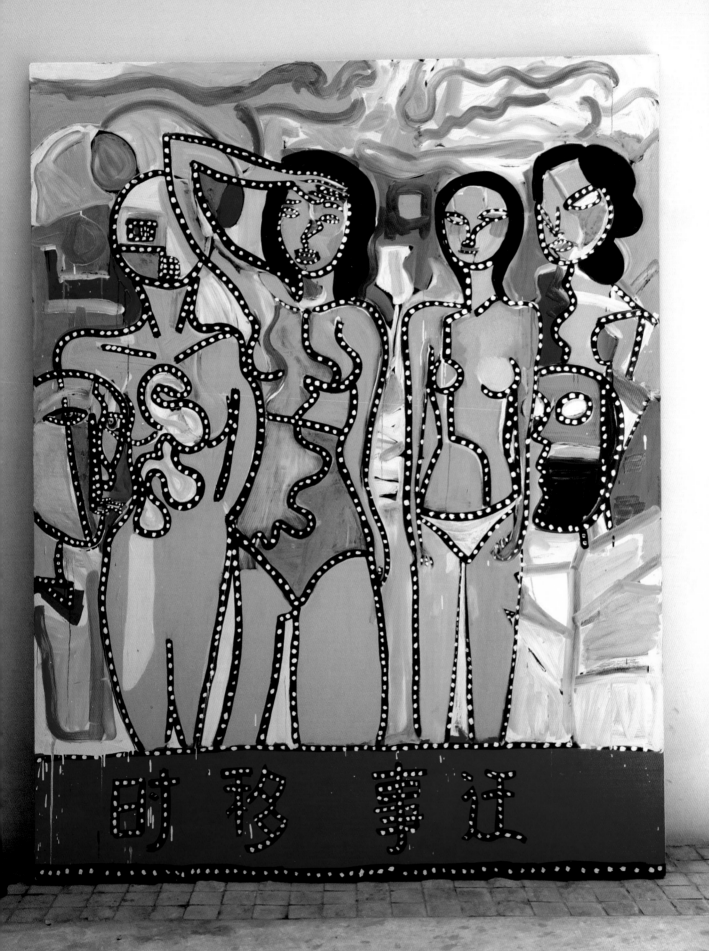

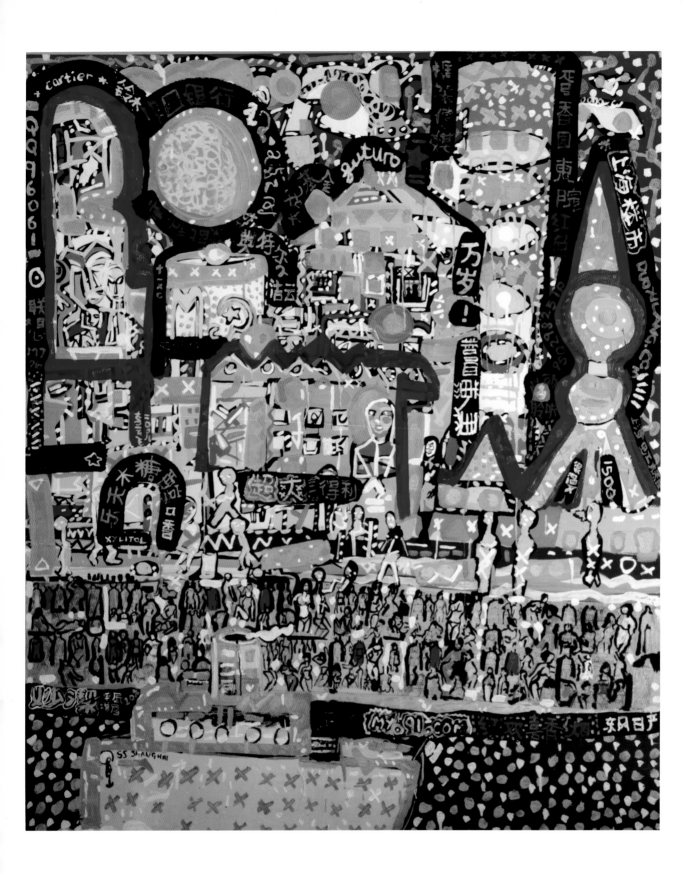

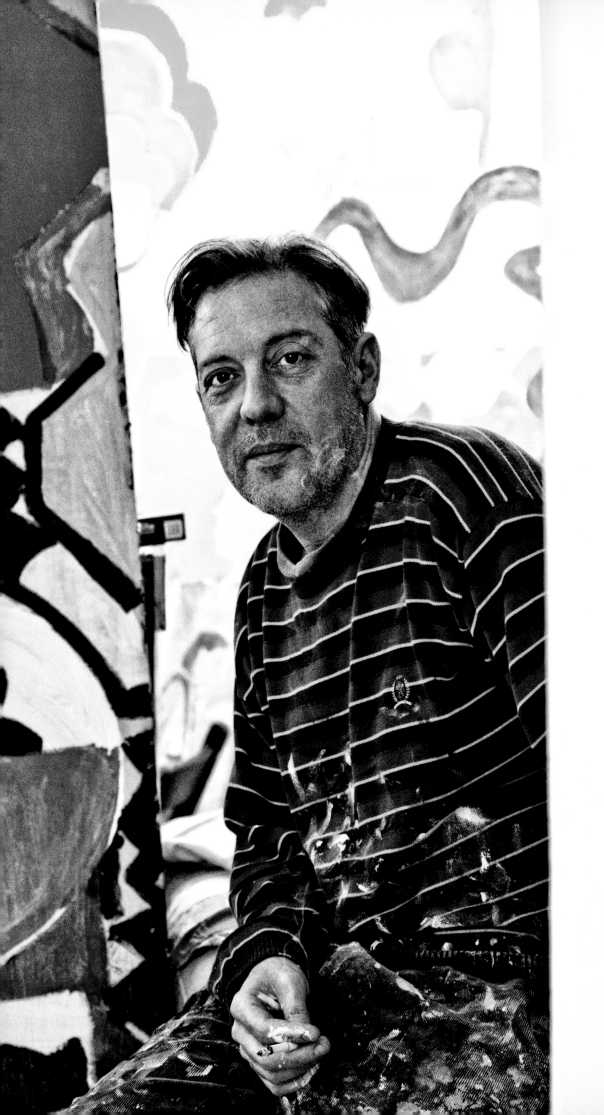

CHRIS P. GILL

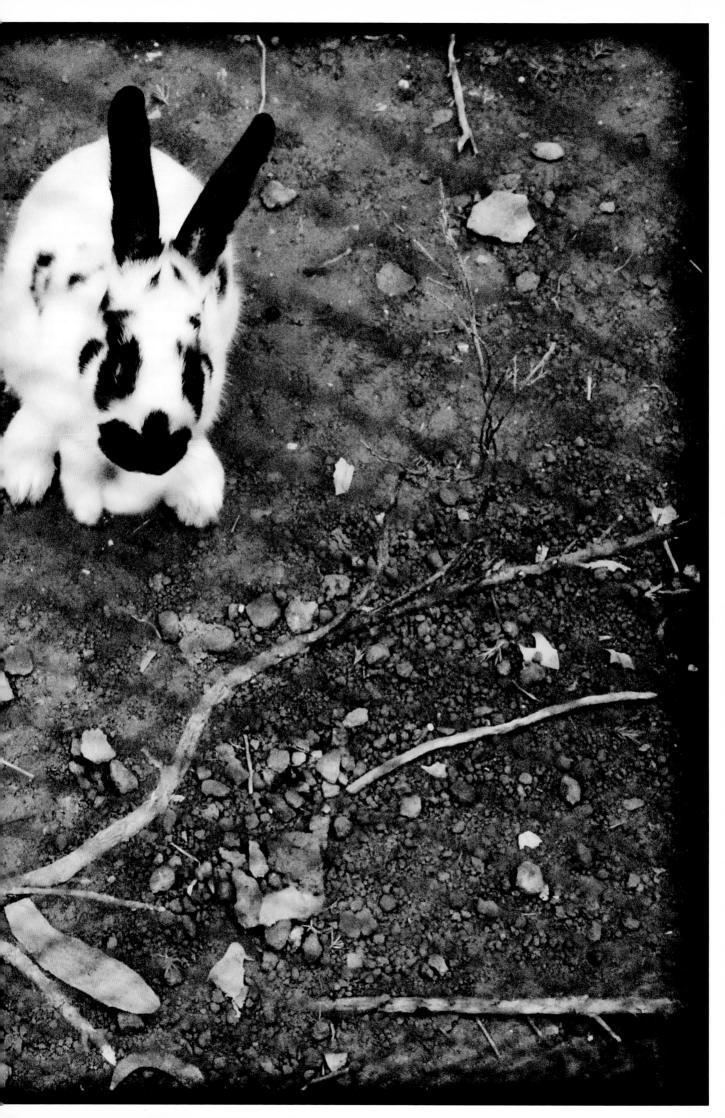

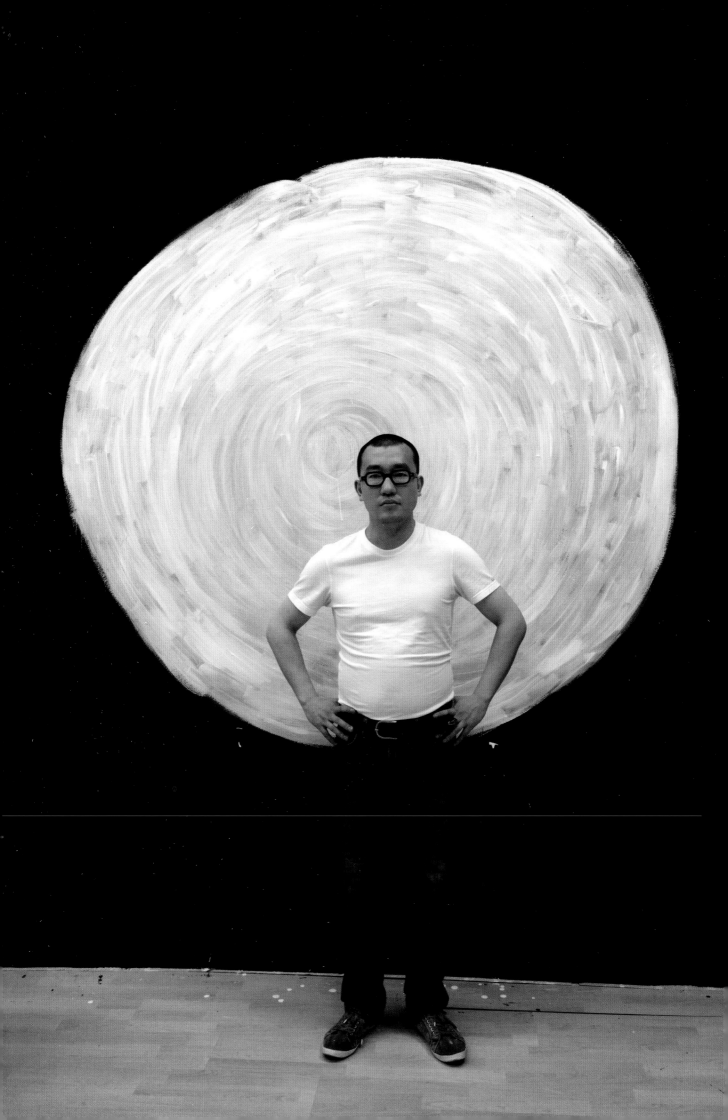

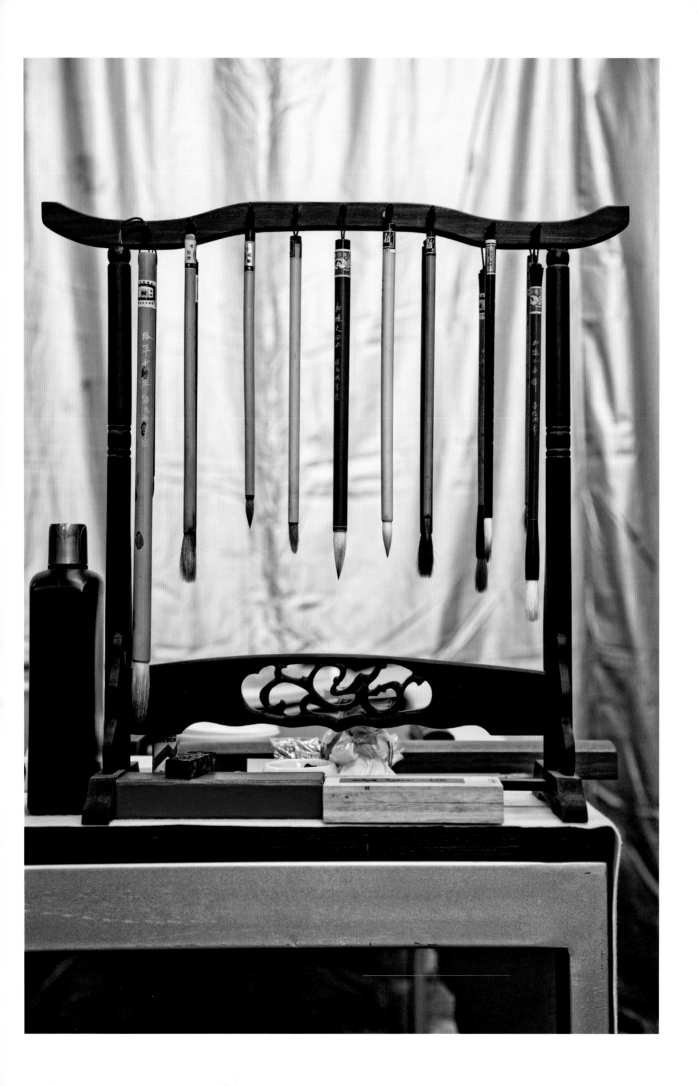

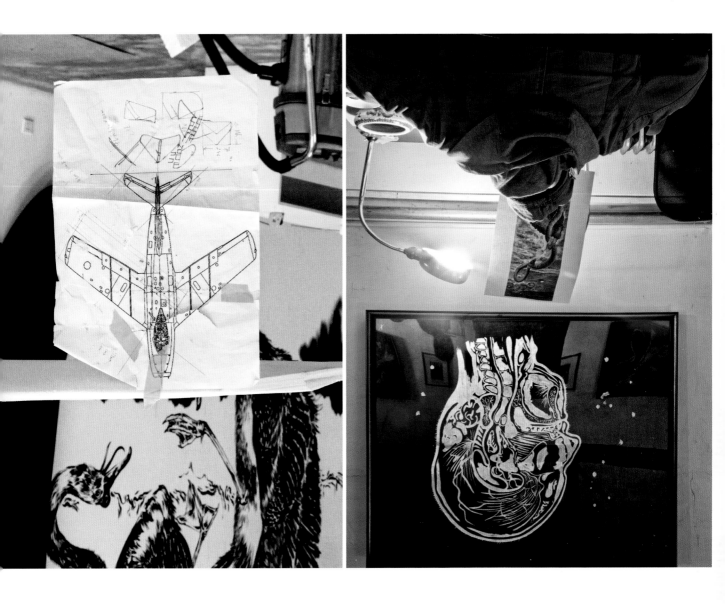

Chris P. Gill in conversation with Zhang Peili

Zhang Peili is one of China's leading artists, specialising in new media installation. He was also head of New Media at the China Art Academy in Hangzhou for nine years, until his department was suddenly merged with another. "Now I'm just an ordinary professor", he told *The Art Newspaper* (28 February 2012).

Since the early 1990s, his art has been intrinsically political, with sharp social commentary on China. He has long been considered an extremely important artist within many Chinese art circles, although he often refuses to talk about his work, his family background, or other personal issues. His early work entitled 'Standard Pronunciation', a video of a Chinese TV newsreader presenting a weather report (the same woman who read the news during the Tiananmen Square massacre, describing everything as "normal" in Beijing on 4 June 1989), is thought to be a key political piece. The newsreader here reiterates the normality in Beijing. The artist has never revealed why he made this work, perhaps for obvious reasons.

Zhang Peili is still based in Hangzhou, where he has a studio and has lived for most of his life.

CPG: So you used to paint gloves?
ZP: I started painting gloves in 1986 and kept it up for about a year.

CPG: What is the significance of these glove paintings?
ZP: What do the gloves mean? They have no meaning. I don't think painting needs to have a meaning. Our conditioning, then and now, is that painting should have a meaning. But in my view, painting doesn't need to have a specific meaning. To have no meaning is another kind of meaning.

CPG: The Western phrase "take off your gloves" means to really start working. Were the gloves your last attempt at painting and then you began your new media work?
ZP: No. I painted for a period after that, until 1994. I didn't think of that connotation, about taking off my gloves to start working. I never thought of it in such a complicated way.

CPG: I'd just like to ask you a bit about your family background. As I understand, your two grandfathers were landlords in two small towns...
ZP: Yes, in Zhejiang Province. The towns are close to each other, one is called Wenling and the other Huangyan.

CPG: Were they doing business there?

ZP: They had some business interests, that's right, but they were mostly important landlords. I'm not sure why you want to know about my family background or how it relates to my work. I never met my two grandfathers. They died before I was born. Afterwards I heard many stories about them, but anyway, it doesn't really matter... Everyone's situation has its own characteristics, everyone has their own background. Every family, every person, has their own special story. It's nothing, it's been difficult, and this kind of thing happened in China, I'm not the only one.

CPG: I know, but you happen to be an important representative of Chinese contemporary art...

ZP: I don't want to represent anything.

CPG: I heard there was an interesting story related to a boat disaster?

ZP: My grandfather had a cargo ship for transporting goods from a larger city that used to be called Haimen, now it's known as Zhaogiang. He ferried goods from Zhaogiang to Shanghai.

CPG: I heard there was trouble with that ship?

ZP: Oh yes, if I remember correctly it was in 1947. Near Shanghai, in a place called Songkou, there was a ferry travelling from Shanghai to Ningbo. The ship's official capacity was 3000 passengers. At the time it was very messy, so on that day the ship had somewhere between 4000 and 5000 people onboard. Many of them jumped on without tickets. When they reached the open sea, the ship hit something and exploded. Exactly how it sank isn't very clear, but the number of people who died is more than the British Titanic. About 4000 died. It could be the world's greatest maritime disaster, based on the death toll. My grandfather's ship just happened to be passing by, so he saved many people, four or five hundred, I'm not very sure. His boat wasn't very big. During the rescue operation it also began sinking, so he threw his cargo into the sea. At the time it was a huge issue, but now very few people know about it. It was after the Japanese war and during the civil war. Nationalists and Communists were fighting in the north, but they hadn't yet arrived in Shanghai. It was very messy, and Shanghai's economy was in bad shape. There was high inflation, money wasn't money anymore.

CPG: Why don't they talk about this now?

ZP: Who doesn't talk about it?

CPG: Why do people nowadays not know about it?

ZP: Because very few people survived. And this was also something that happened during the Nationalist period. It had nothing to do with the Communist party. After 1949 and the Communist victory my grandfather was executed, in 1951. So they really didn't talk about it. Others, including people they rescued, wouldn't talk about it either. He was executed, so nobody felt they could talk about this.

Just recently, people have begun to mention it. Some of those he rescued are still alive. Some TV stations and writers have produced documentaries and books about this issue, but they don't mention my grandfather, they just talk about the incident. The ship that sank was called Jiangyalun. My grandfather's boat was called Jingliyantao. A lot of information about the Jiangyalun is coming out now.

CPG: What was your grandfather's name?
ZP: Jiang Hanting.

CPG: When did you find out about this?
ZP: I was in high school. My father told me secretly. After the Culture Revolution we were able to talk about this kind of thing openly in the family. They didn't think this was a bad thing.

CPG: During the Culture Revolution did families with a landlord class background have many problems?
ZP: Certainly. Families with a certain socio-economic status had to pay a lot of attention to what they said. You had to be very careful about doing anything, even talking.

CPG: During this time at school, how did you start painting?
ZP: It's hard to be specific about that. Some people are just like that when they're born. Some like to sing, some like to do woodwork, some like to write. You can't clearly pinpoint why. At that time, they had art class. Everyone attended the same class. Some people liked it, some didn't. I liked it, and they said I painted very well, so I was very happy. I was better than the other students. That was in primary school, it doesn't exist now. Did you know that China had a famous figure called Yue Fei? He lived during the Song Dynasty, when they were fighting with the Mongols. He was a great general, attacked by many and finally killed. My school was formerly Yue Fei's stables and armoury. It was called Bingmazhong. It was knocked down during the Culture Revolution. It was in Hangzhou, it's very sad, I remember that building was exquisite. The woodwork inside the stables was very beautiful. We used to play in there.

CPG: Why did they knock it down?
ZP: You know, during the Culture Revolution they attacked anything historical. For instance, many temples were destroyed. They thought Yue Fei had no importance. The school was in the centre of Hangzhou city, in an area called Zhonganqiao. The building next door was also knocked down.

CPG: They knocked down a lot.
ZP: Everything, even the older buildings are fake. There are very, very few old ones left.

CPG: Hangzhou is one of the most beautiful cities in China.
ZP: Among Chinese cities, Hangzhou is one of the better ones, because it has a natural environment. They can't knock that down. Without it, Hangzhou would be ugly.

ZHANG PEILI

1957 Born in Hangzhou, China
1984 Graduated in painting from the Zhejiang Academy of Fine Arts, Hangzhou, China

Lives and works in Hangzhou, China

Selected Solo Exhibitions

2011 "Certain Pleasures, Zhang Peili Retrospective", Minsheng Art Museum, Shanghai, China

2008 "Mute: Zhang Peili", OCT Contemporary Art Terminal, Shenzhen, China

2008 "A Gust of Wind: Zhang Peili", Boers-Li Gallery, Beijing, China

2006 "Video Art by Zhang Peili", Currents - Art and Music, Beijing, China

2000 "Artist Project Rooms", Arco2000 Madrid, Spain, and MOMA, New York, USA

1999 "Zhang Peili", Jack Tilton Gallery, New York, USA

1996 Basel International Contemporary Art Fair, Basel, Switzerland

1993 "Maison des Cultures du Monde", Galerie du Rond Point, and Galerie Crousel-Robelin, Paris, France

Selected Group Exhibitions

2010 "Moving Image in China: 1988–2011", Minsheng Art Museum, Shanghai, China

"First Round Exhibition of '60 to'90", 9 Gallery, Beijing, China

"Reshaping History: Chinart 2000 to 2009", China National Convention Center, Beijing, China

2009 "A Gift to Marco Polo", 53rd Venice Biennale, San Servolo, Venice, Italy

2008 "Four Seasons", 3rd China Media Art Festival, China Academy of Art, Hangzhou, China

2007 "We Are Your Future", 2nd Moscow Biennial of Contemporary Art, Winzavod Center of Contemporary Art, Moscow, Russia

"Zhang Peili, Ai Weiwei, Tang Song", KOGO Art Space, Hangzhou, China

"'85 New Wave: The Birth of Chinese Contemporary Art", Ullens Center for Contemporary Art, Beijing, China

2006 "China Power Station Part 1", Serpentine Gallery, London, UK

SUN XUN

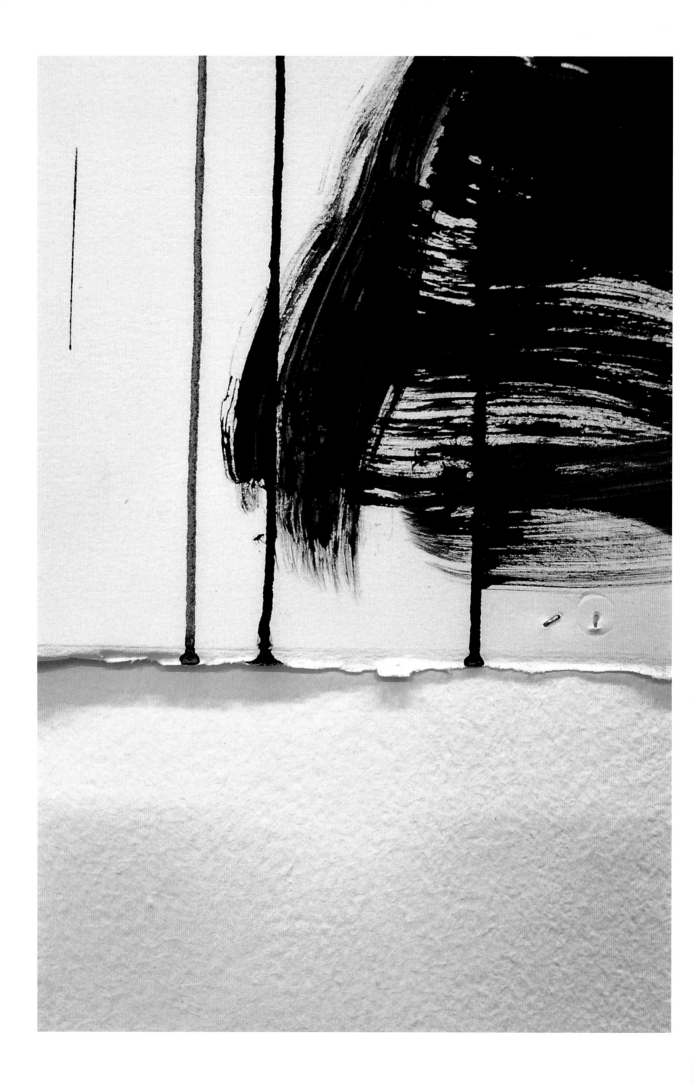

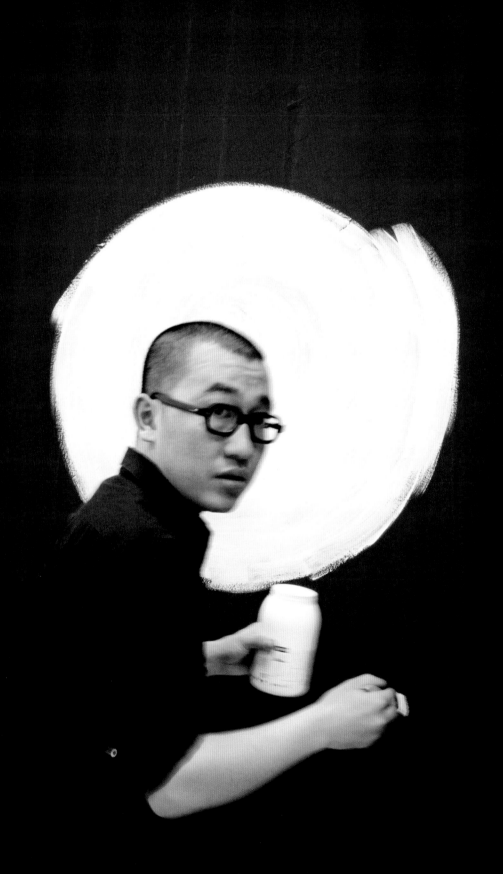

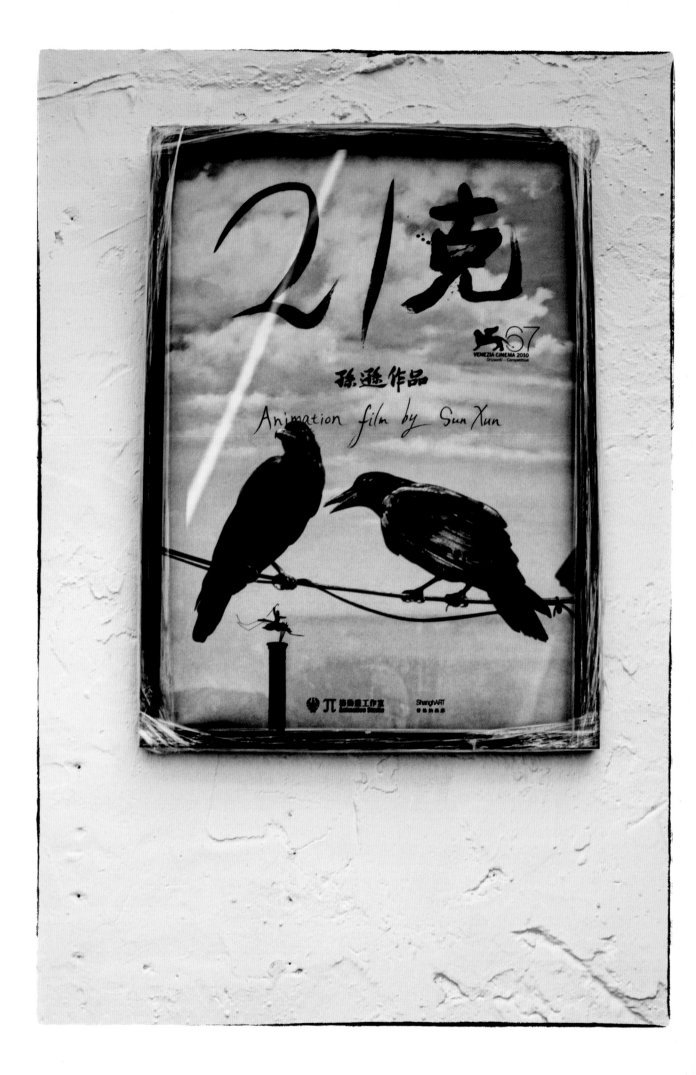

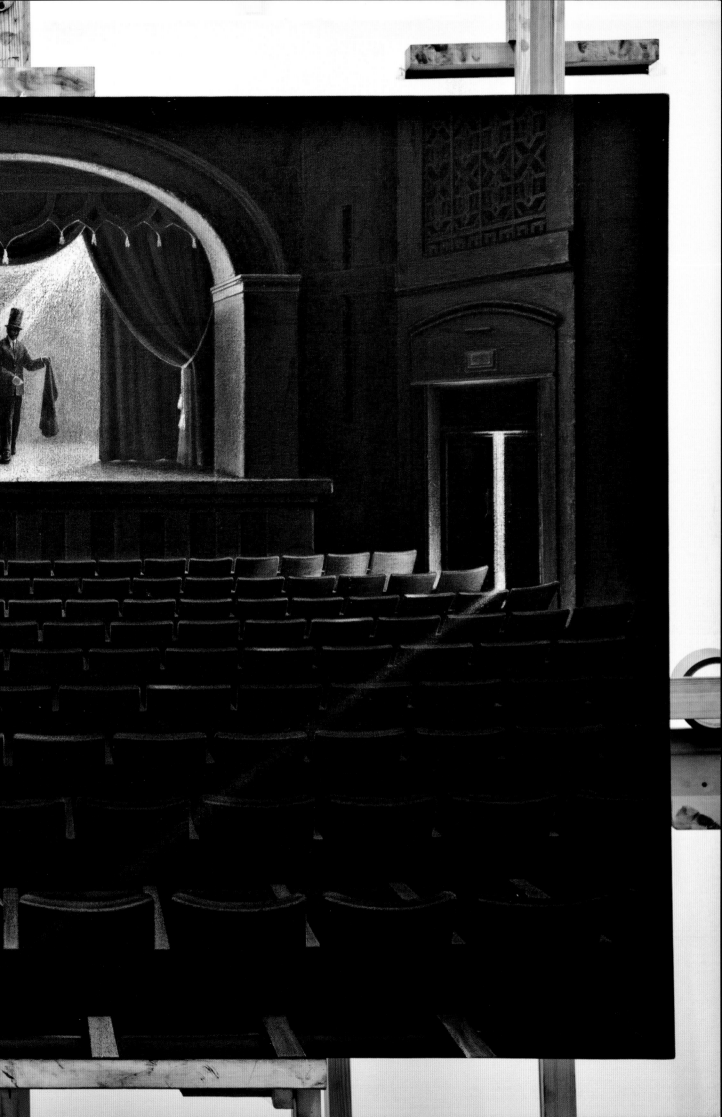

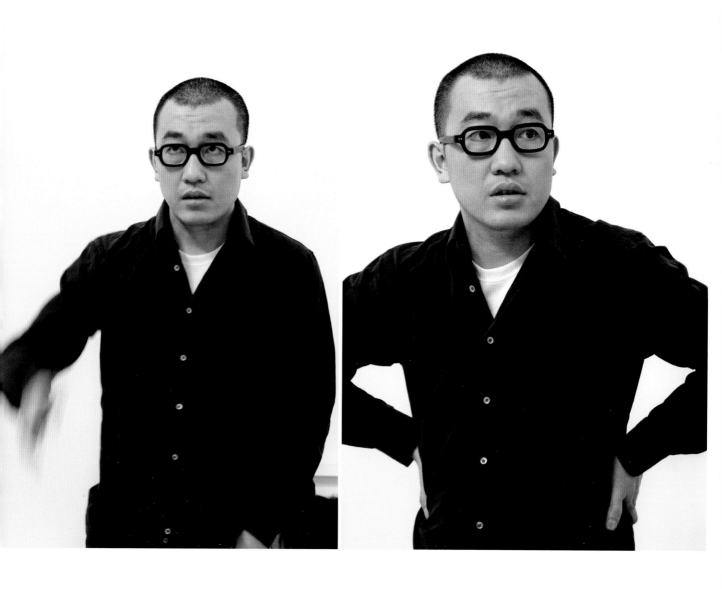

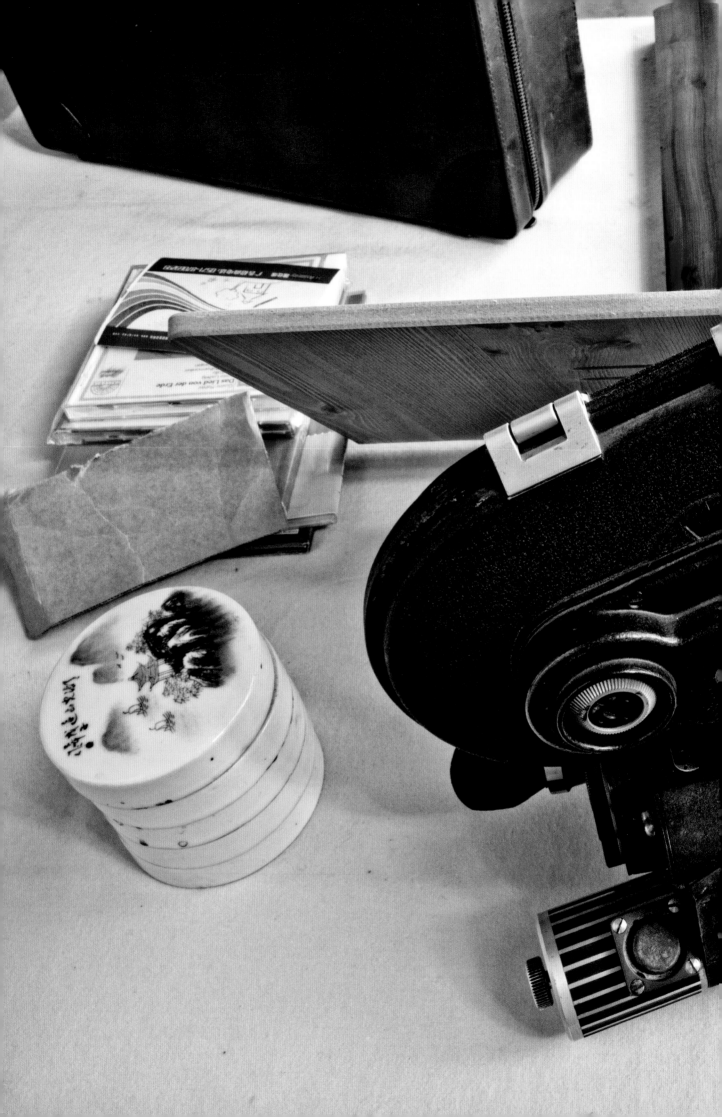

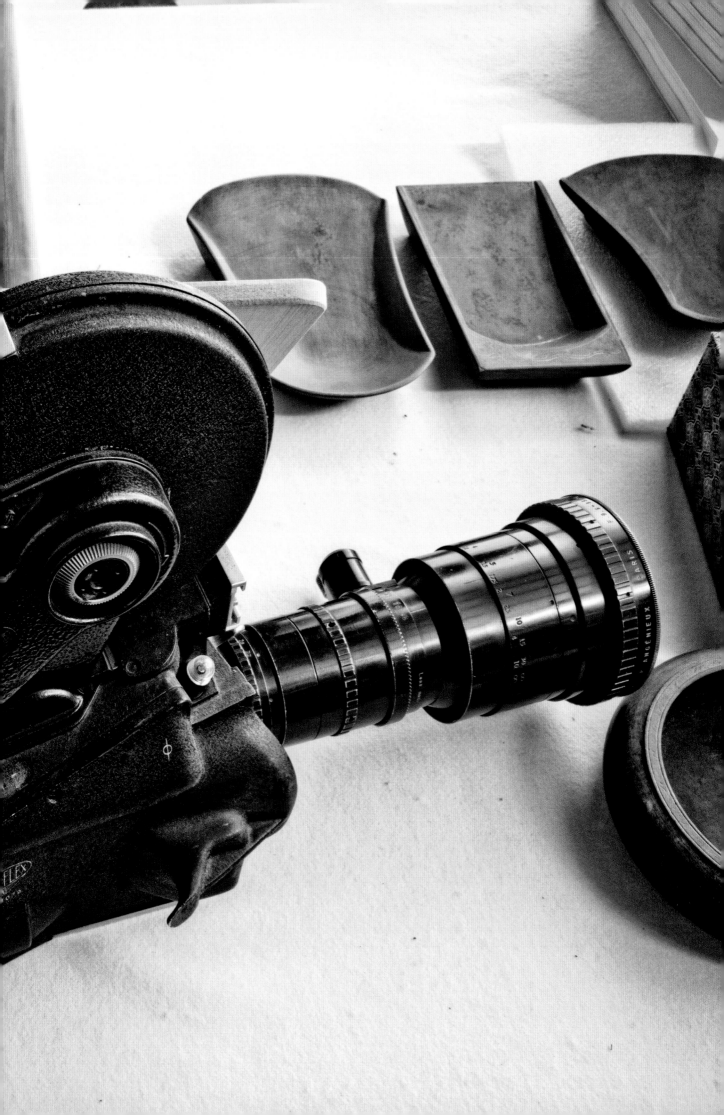

SUN XUN

1980 Born in Fuxin, Liaoning Province, China
2005 Graduated in print-making from the China Academy of Fine Arts, Hangzhou, China
2006 Established "Pi" Animation Studio in Hangzhou, Zhejiang Province, China
2009 Transferred "Pi" Animation Studio to Beijing, China

Lives and works in Beijing, China

Film Festivals

2012 62nd Berlin International Film Festival, Berlin, Germany

15th Holland Animation Film Festival, Utrecht, Netherlands

2011 30th Vancouver International Film Festival, Vancouver, Canada

2010 67th Venice International Film Festival, Venice, Italy

56th International Short Film Festival, Oberhausen, Germany

2008 "Festival of Shadows: Chinese Independent Cinema", Centre Pompidou, Paris, France

Selected Solo Exhibitions

2012 "Undefined Revolution", Collective Gallery, Edinburgh, Scotland

"Sun Xun, A Footnote to Time", Wall/Ladder/Machine Hub, New York, USA

2011 "Sun Xun: A Candid Dialogue", LV Taipei Maison, Taipei, Taiwan

"Clown's Revolution", Vanguard Gallery, Shanghai, China

"LAND-TA-MORPHOSIS: Last of the Trilogy-Beyond-ism", I/O Gallery, Hong Kong, SAR China

2010 "Clown's Revolution", Holland Animation Festival Center Museum, Utrecht, Netherlands

"21KE", Minsheng Art Museum, Shanghai, China

"The Soul of Time", Kunsthaus Baselland, Basel, Switzerland

"After Doctrine", Yokohama Creative City Center, Yokohama, Japan

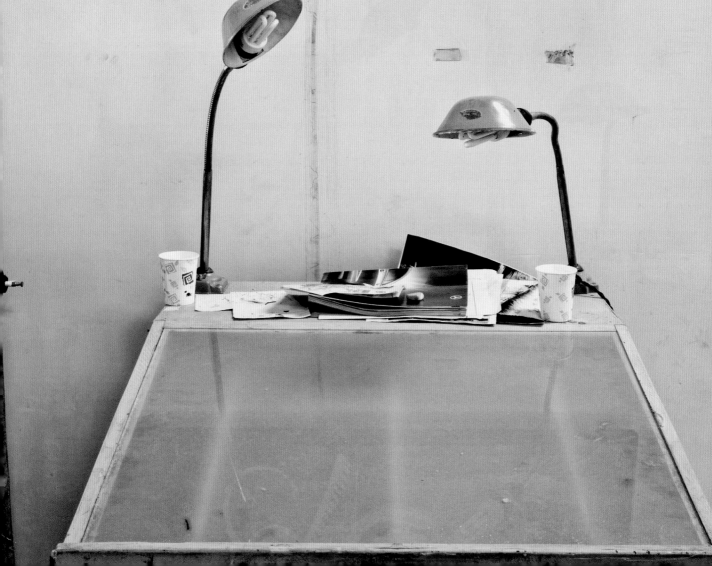

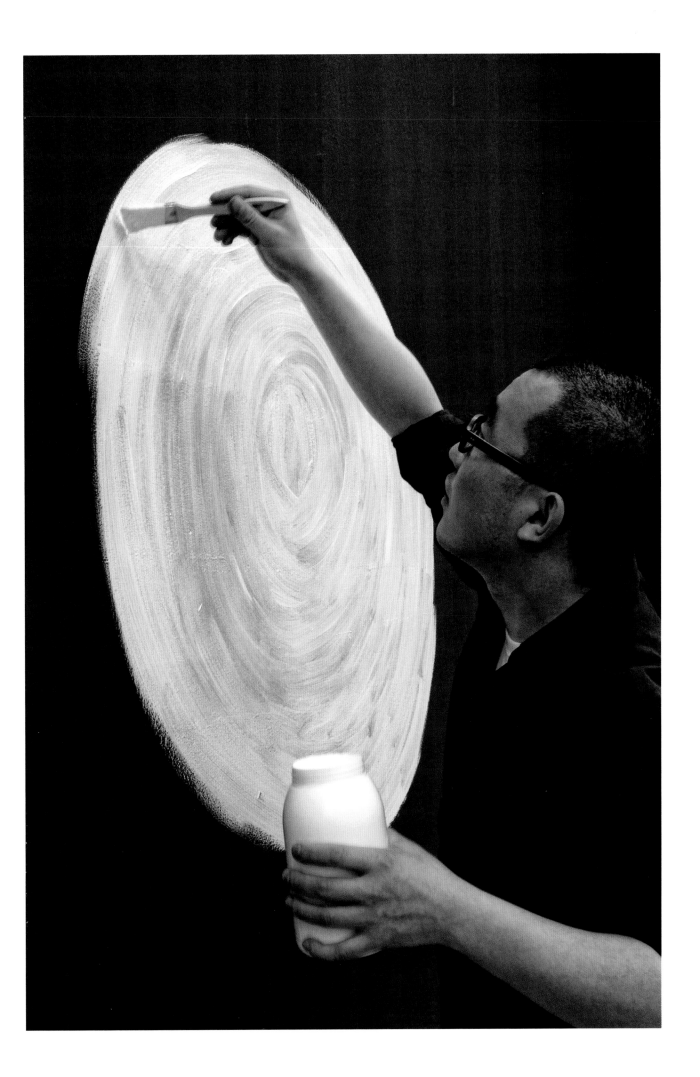

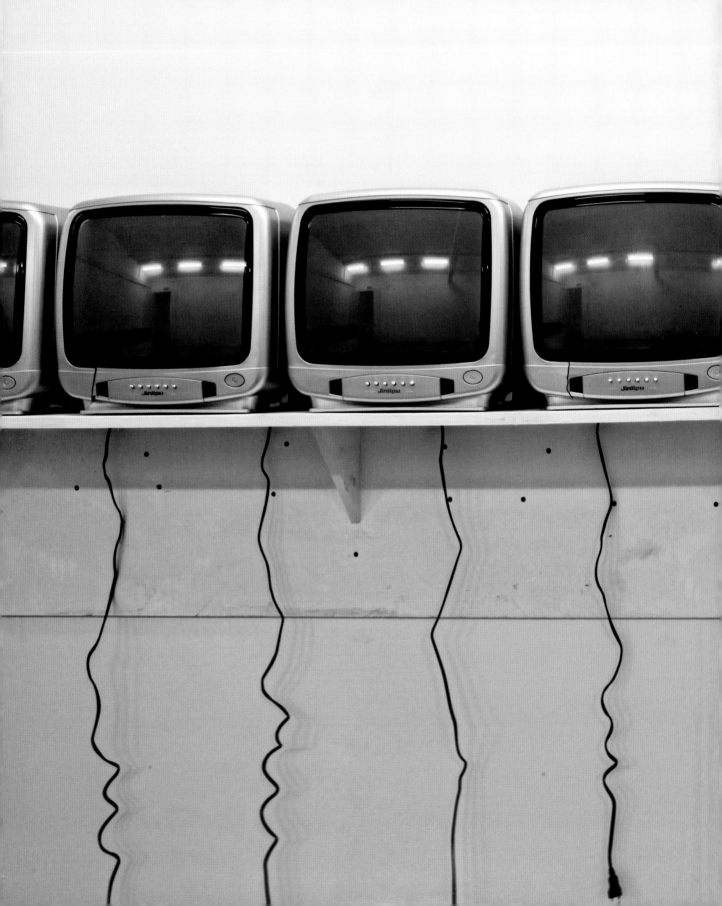

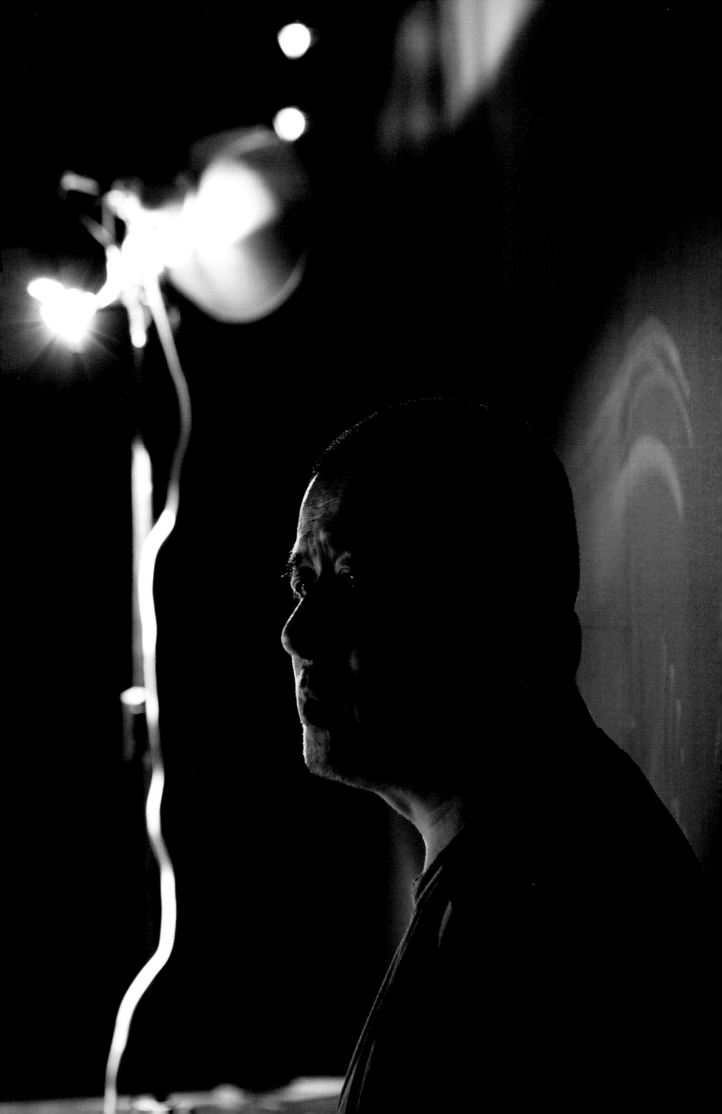

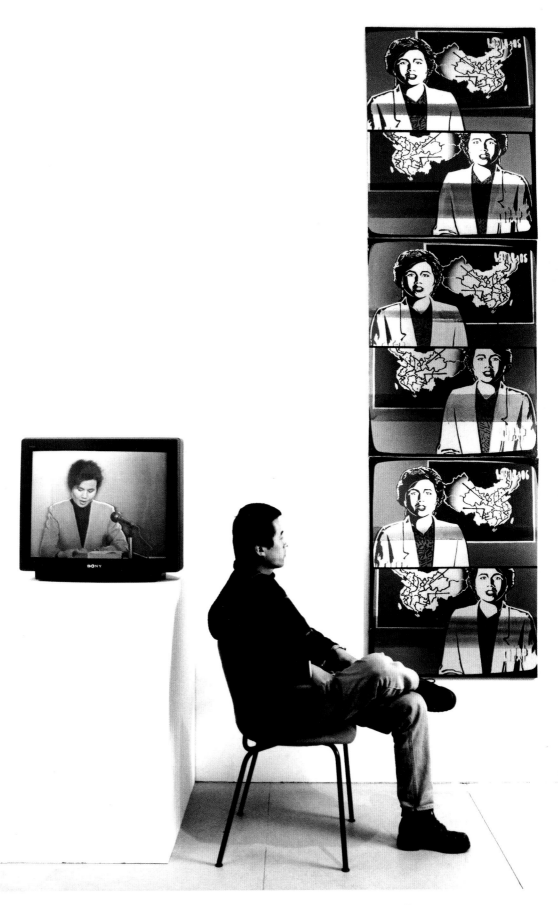

After world news on television there is the ocean weather forecast. In the morning it is cloudy, in the afternoon it will change to bright and sunny periods, in the evening there will be possible showers. I asked the newsreader to read the explanatory additions of the word water from a Chinese dictionary. She did that with very professional pronounciation.

Zhang Peili. Berlin, Germany, 1993

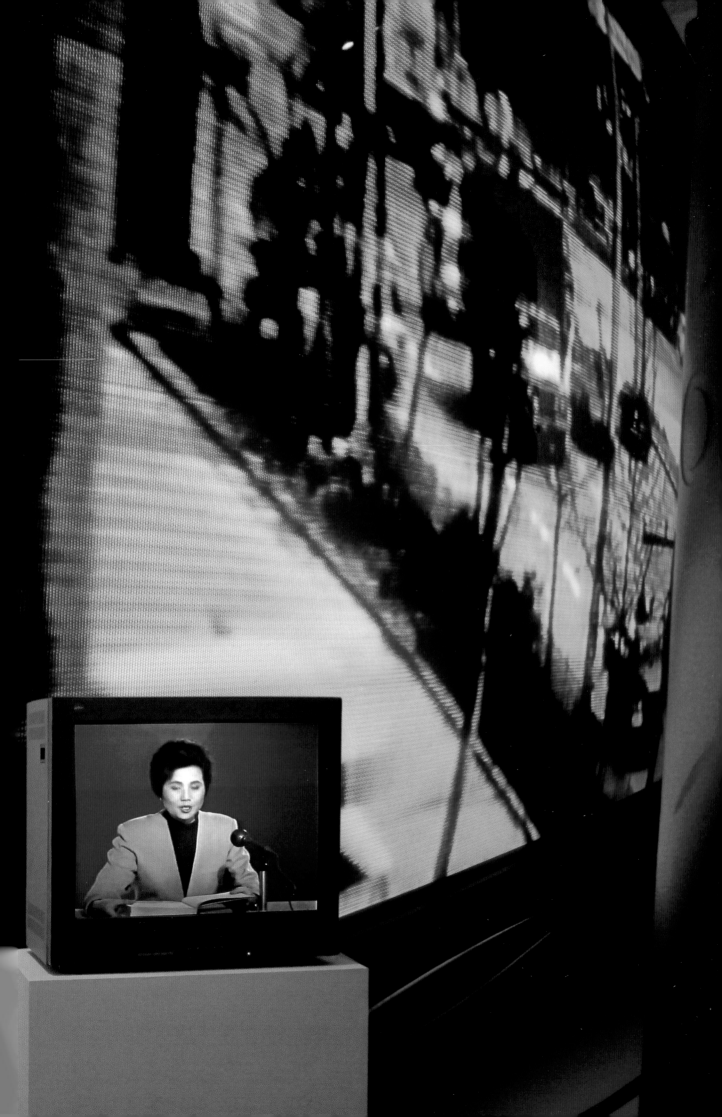

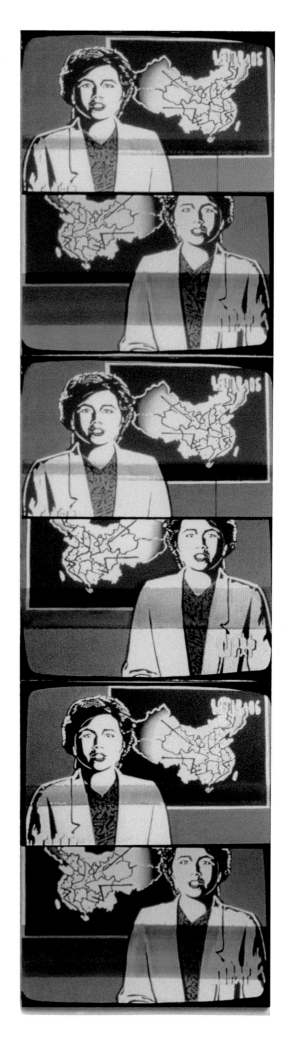

水—1989 的标准发音

1990

按原作图片处理后打印
原作为油画，尺寸：80 cm×100cm，3 件

WATER-Standard Pronunciation of 1989

1990

Edited prints of the original oil paintings
Original oil on canvas: 80cm x 100cm, three pieces

作为 1989 年至 1993 年完成的以健美、播音员为题材的系列绘画之一，这个作品通过大量标准的美学形式反映了标准化的美学。布面油画变得跟电视屏幕一样灵活和重复，而某个活动的形象在某个时刻变成了标准。

One component of a series of paintings completed between 1989 and 1993 depicting athletes and broadcasters, this piece reflects on the aesthetics of standardization through profusion of standard aesthetic forms. The canvas becomes as flexible and as repetitive as the television screen, a moving image made standard at least for a single moment in time.

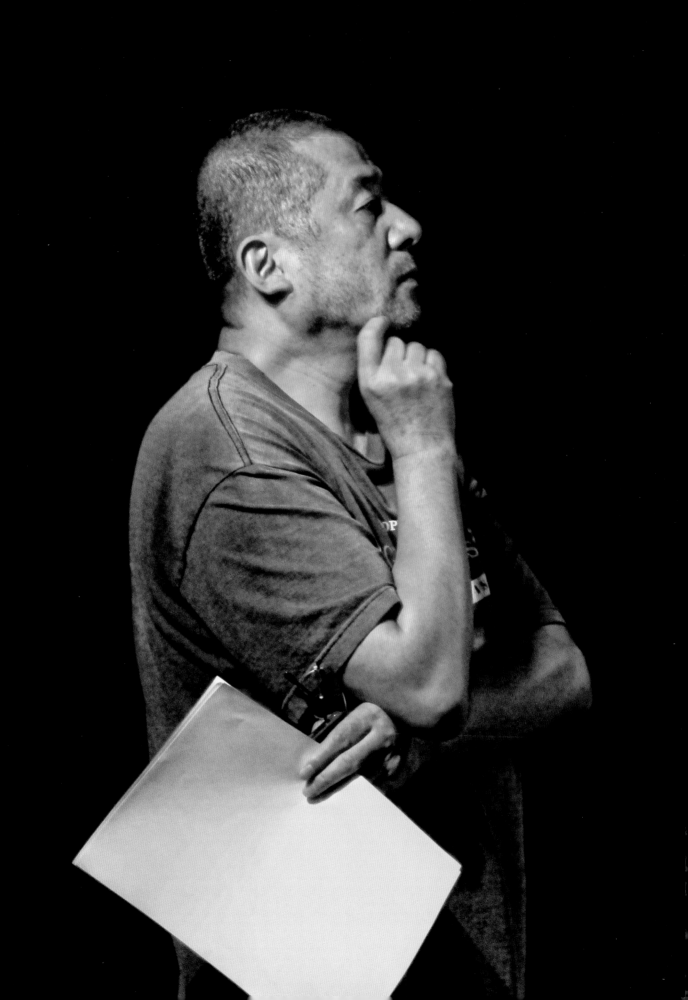

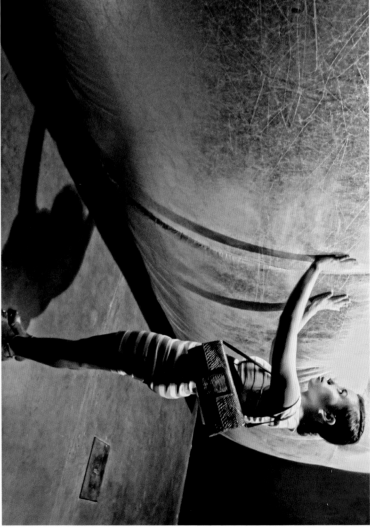

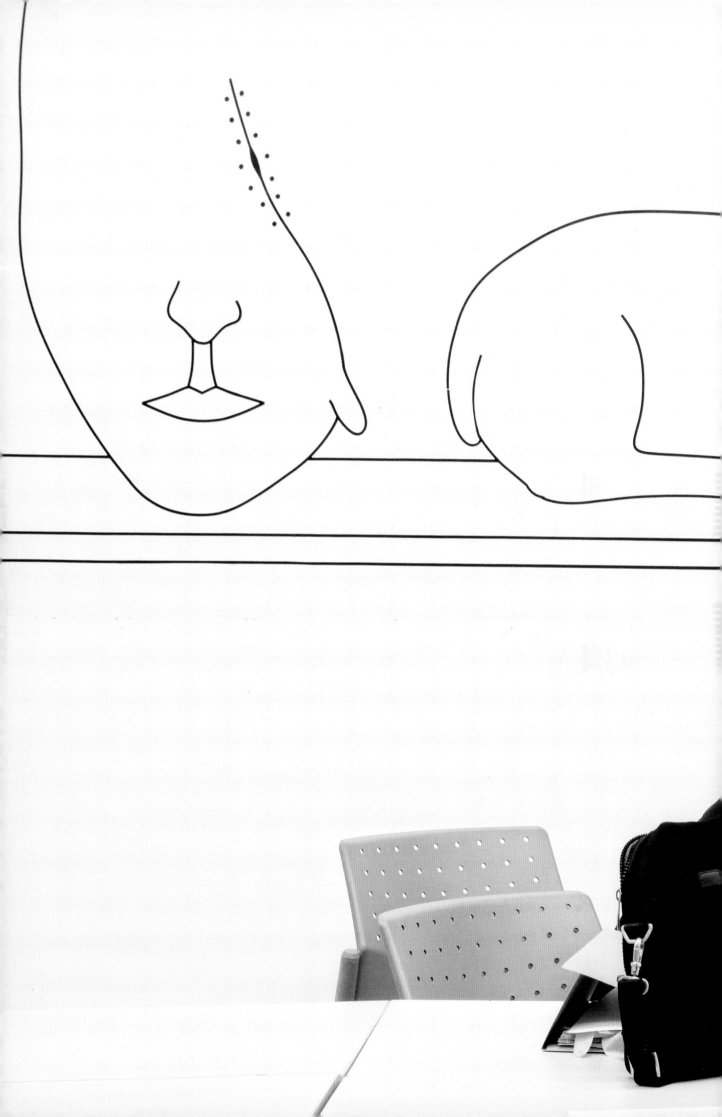

展品		
1	必要的立方体 A Necessary Cube	2011年 充气气囊、电路、白色布制系统 Inflatable sac, electric, computer
2	有球形建筑的风景 Landscape with Round Building	2008年 感应摄影装置 Inductive Photography Installation
3	焦距 Focal Distance	1996年 8视频8画面录像装置 8 channel video installation with 8 images
4	现场报道-物证一号 Live Report—Evidence No. 1	2009年 影像装置 Burned Car Wrecks, Pinhole Cameras, Live Show Projection
5	阵风 A Gust of Wind	2008年 5视频5画面录像投影装置 5 channel video installation with 5 images
6	7月16日-8月14日 16 July – 14 August	2011年 实时影像与影像静帧 Realtime video and still frames
7	圆圈中的魔术 The Conjuring in the Circle	2002年 8视频8画面录像投影 8 channel video installation with 8 images
8	不确切的快感II Uncertain Pleasure II	1996年 10视频10画面录像装置 10 channel video installation with 10 images
9	屏风I Screen I	1997年 3视频3画面录像装置 Single channel video installation with two-
10	水迹 Watermark	2005年 影像与影像静帧 Video and still frames
11	台词 Actor's lines	2002年 单视频录像 Single channel video
12	遗言 Last Words	2003年 单视频录像 Single channel video
13	喜悦 Happiness	2006年 双视频录像投影 2 channel video projection
14	规范动作 Standard Routine	2007年 双视频双画面录像与机械装置 2 channel video installation with 2 images
15	水——辞海标准版 WATER-Standard Version from the Dictionary Ci Hai	1991年 单视频录像 Single channel video
16	水——1989的标准发音 WATER-Standard Pronunciation of 1989	1990年 布面油画 Oil on Canvas
17	作业一号 Assignment No. 1	1992年 6视频12画面录像装置 6 channel video installation with 12 images
18	1千分之1秒至1秒 1 / 1000—1"	1995年 黑白照片（彩色扩印）22张一套 Black & White Photos with Electric Fan
19	X?	1986年 布面油画 Oil on Canvas
20	艺术计划二号 Art Project no. 2	1987年 文字 Chinese & English text
21	连续翻拍25次 Photocopying Continuously twenty five times	1993年 黑白照片（翻拍画报）25张一套 A set of 25 B&W Photos (photocopies)
22	（卫）字3号 Document on "Hygiene" No. 3	1991年 单视频录像 Single channel video
23	30×30	1988年 单视频录像 Single channel video
24	褐皮书1号 Brown Cover Ducument No. 1	1988年 医用乳胶手套、信件 Rubber Surgical Glove, letters

Yu Xiaoqin
Lee Vernassa
李嘉风

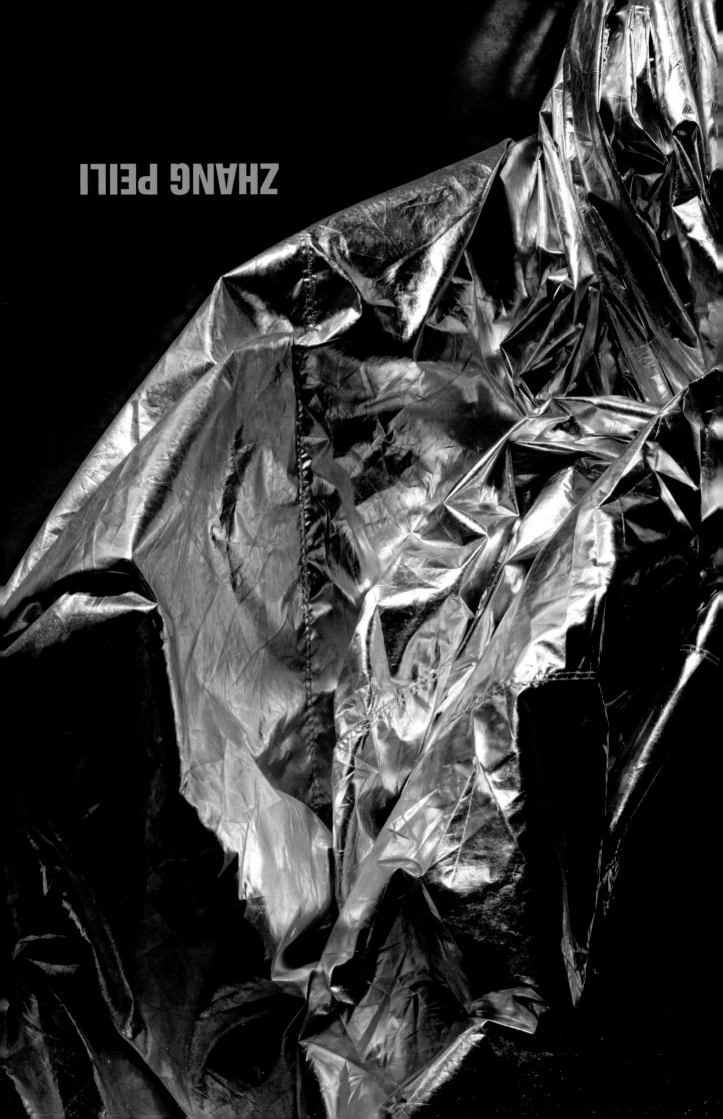

ZHANG PEILI

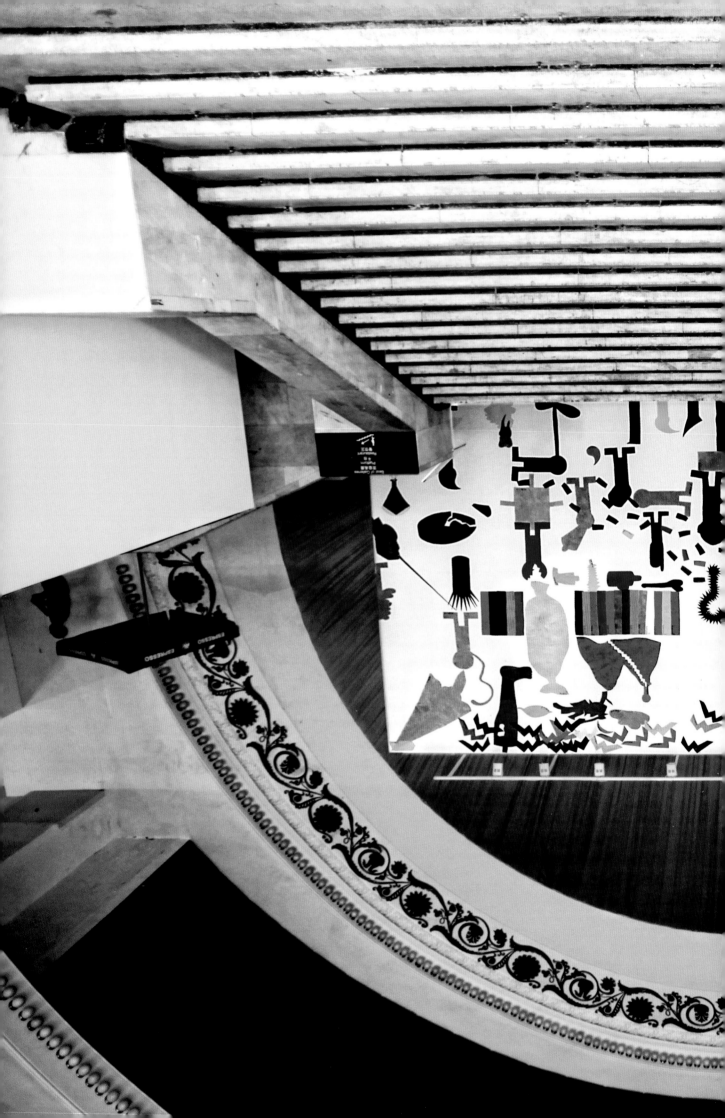

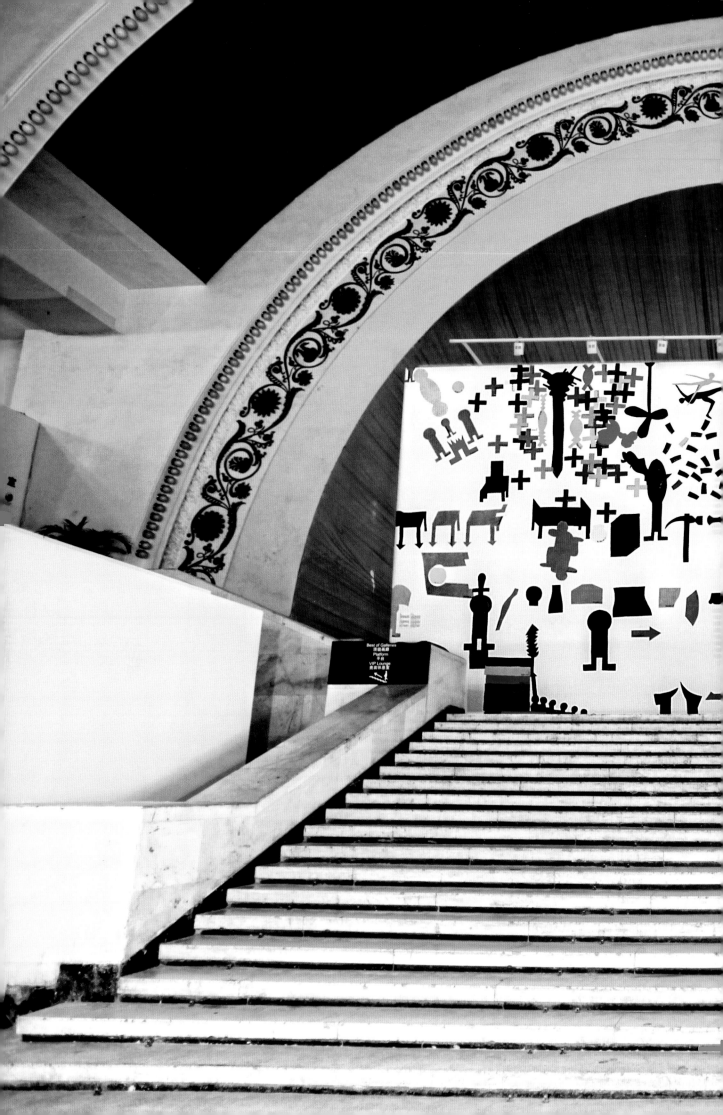

Selected Solo Exhibitions

2011 "Kuo Xuan, Wu Shanzhuan & Inga Svala Thorsdottir", Long March Space, Beijing, China
,
2009 "Thing's Right(s) 09, The More", Wu Shanzhuan, "Red Humour International & Inga Svala Thorsdottir", Thor's Daughter's Pulverization Service, Shanghai Gallery of Art, Three on the Bund, Shanghai, China

2008 "Wu Shanzhuan BUT STILL RED", Red Humour International & Inga Svala Thorsdottir, Thor's Daughter's Pulverization Service, Guangdong Museum of Art, Guangzhou, China

2001 "Thing's Right(s) New York 2001, Making Your Own Nationality", Ethan Cohen Fine Arts, New York, USA

1999 "Thing's Right(s) Cuxhaven", Cuxhavener Kunstverein, Cuxhaven, Germany

"Thing's Right(s) Hong Kong", Hanart TZ Gallery, Hong Kong, SAR China

1998 "Vege-Pleasure", Ingólfsstræti 8 Galleri, Reykjavík Arts Festival, Reykjavík, Iceland

1996 "Please Don't Move", Bahnwarterhaus, Galerien der Stadt, Esslingen, Germany

Selected Group Exhibitions

2011 "THE COUPLE SHOW!", Shanghai Gallery of Art, Shanghai, China

2010 "West Heavens, Place-Time-Play: India-China Contemporary Art", Shanghai, China

2009 "A Gift to Marco Polo", Venice Biennale, Venice, Italy

2008 "Bae Bae Iceland", Listasafn Akureyrar, Akureyri Art Museum, Akureyri, Iceland

2007 "Metamorphosis: The Generation of Transformation in Chinese Contemporary Art", Tampere Art Museum, Tampere, Finland

2006 "Yellow Box Projects in Qingpu", Visual Culture Research Centre of the China Academy of Art, Shanghai, China

2004 "On the Edge: Contemporary Chinese Photography & Video", Ethan Cohen Fine Arts, New York, USA

2003 "A Strange Heaven: Contemporary Chinese Photography", Galerie Rudolfinum, Prague, Czech Republic, and Art Museum Tennis Palace, Helsinki, Finland

2002 "Paris-Peking", Espace Cardin, Paris, France

INGA SVALA THORSDOTTIR & WU SHANZHUAN

Inga Svala Thorsdottir

1966 Born in Selfoss, Iceland
1991 Graduated in painting from the Icelandic School of Arts and Crafts, Reykjavík, Iceland
1995 Graduated from the Hochschule für bildende Künste, Hamburg, Germany
1993 Founded "Thor's Daughter's Pulverization Service", Hamburg, Germany
1999 Founded BORG in Hamburg, Germany

Wu Shanzhuan

1960 Born in Zhoushan, China
1986 Graduated from the Zhejiang Academy of Fine Arts, Hangzhou, China
1995 Graduated from the Hochschule für bildende Künste, Hamburg, Germany
1985 Founded "Red Humour", Zhoushan, China
1990 Founded "Red Humour International", Reykjavik, Iceland

Since 1991 Inga Svala Thorsdottir and Wu Shanzhuan have been exhibiting collaboratively.

They live and work together in Hamburg, Germany, and Shanghai, China.

an International Soup 93—09

ingredients :

MSG (USA)

Beef (Brazil)

Potato (Germany)

Tomato (Italy)

Bean (Kenya)

Chilli (Indonesia)

Curry (India)

Sesame Oil (China)

Onion (Japan)

Salt (Australia)

USA

BRA

TOBUY IS TOCREATE

0 14398 0055

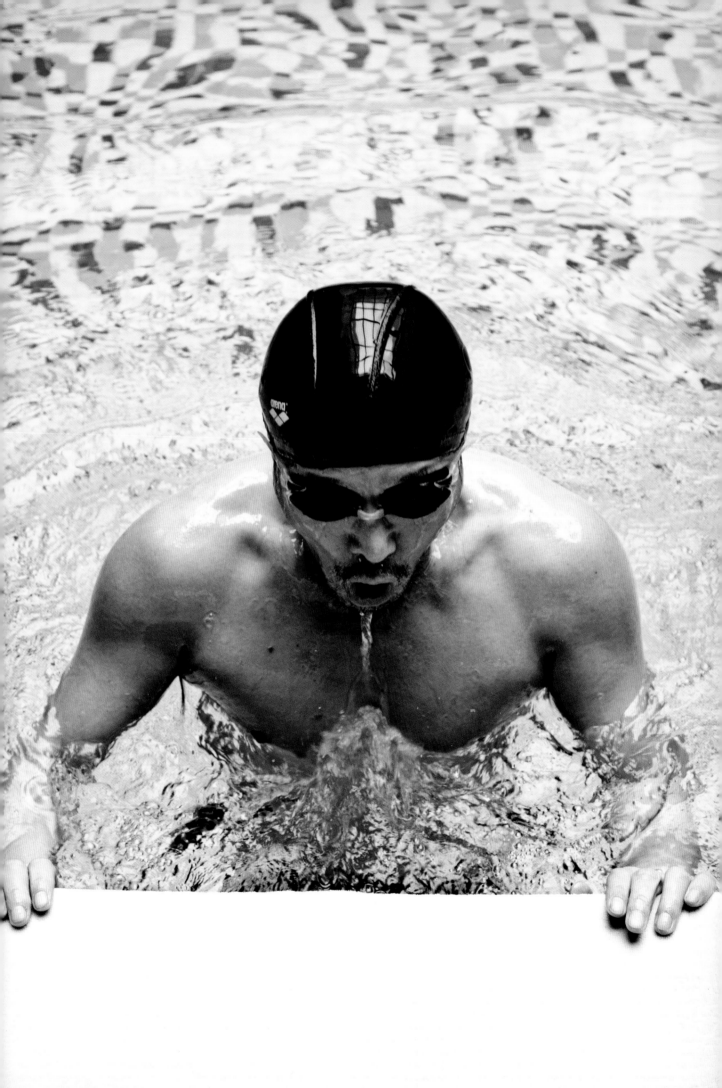

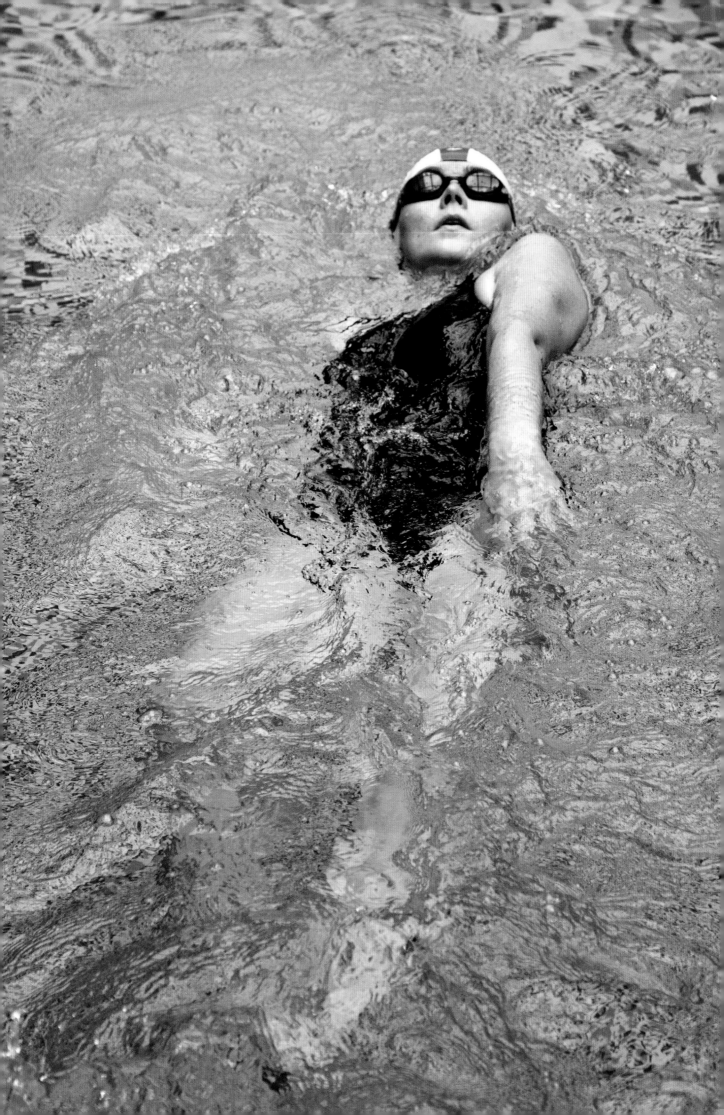

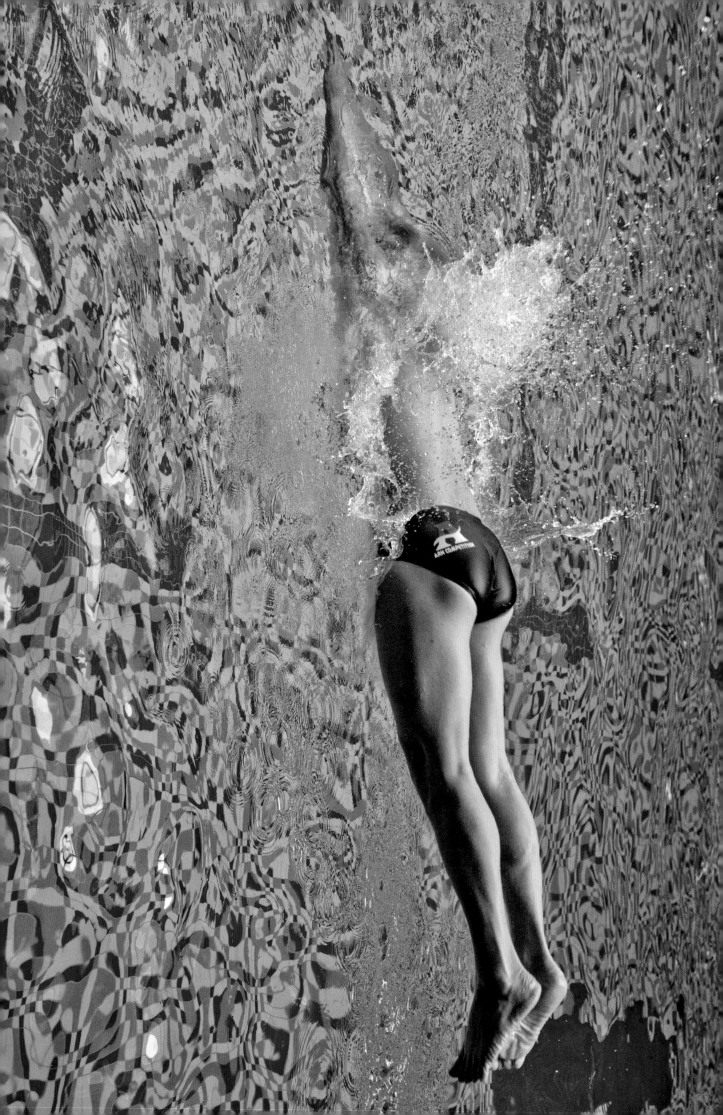

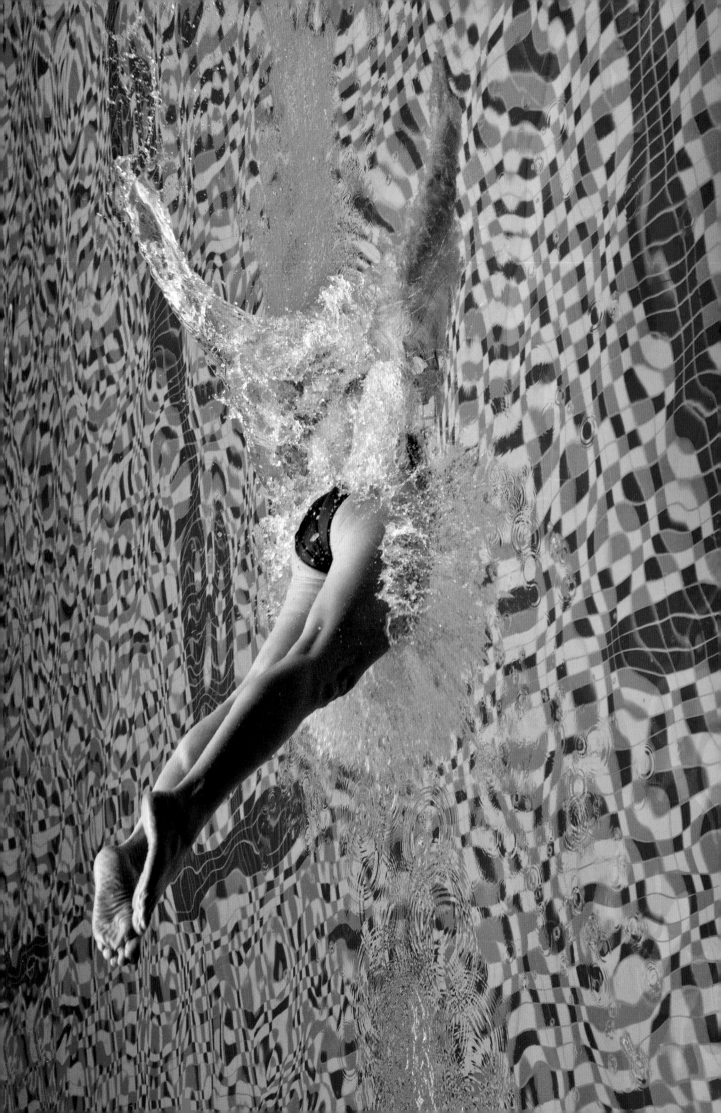

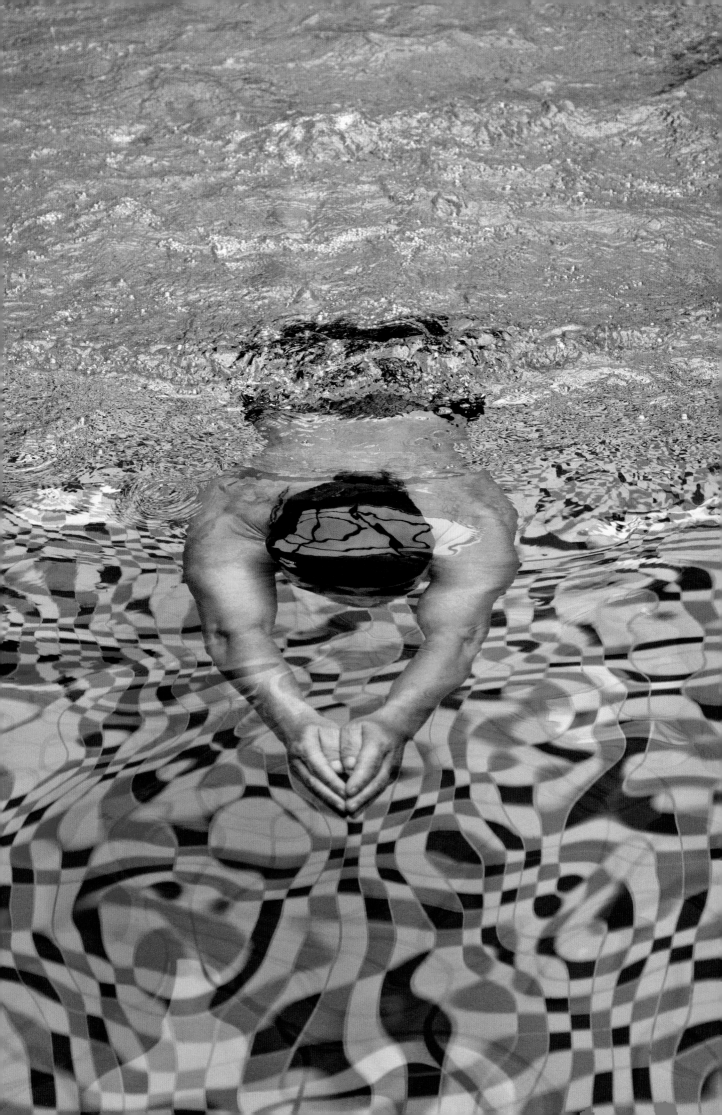

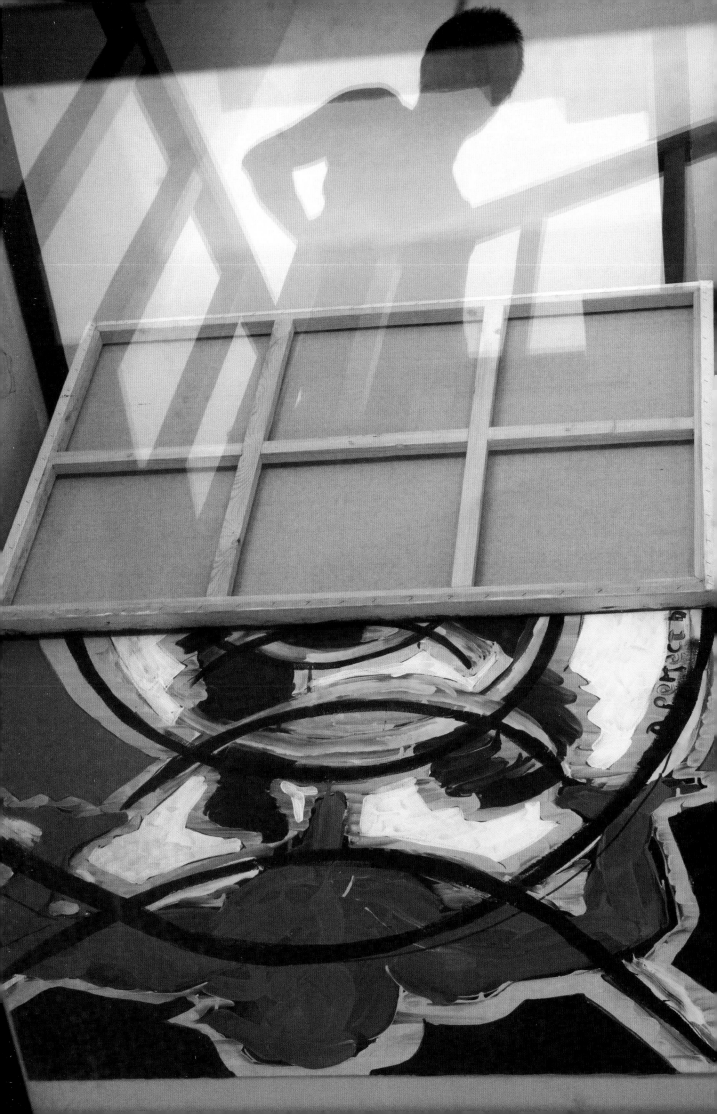

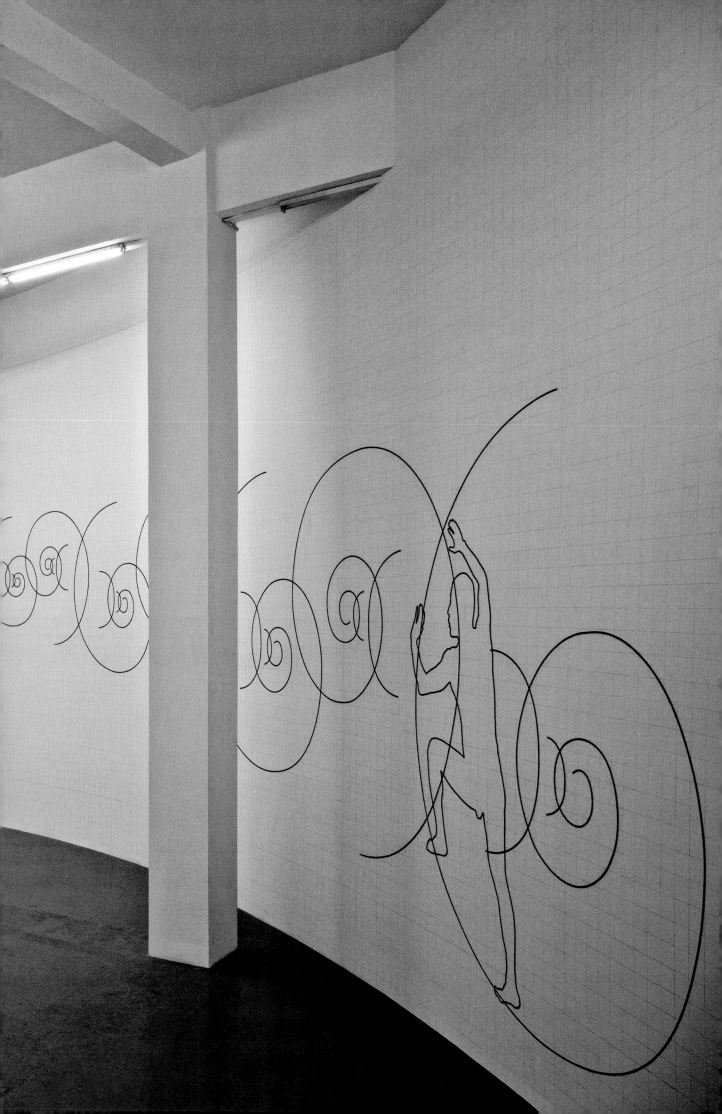

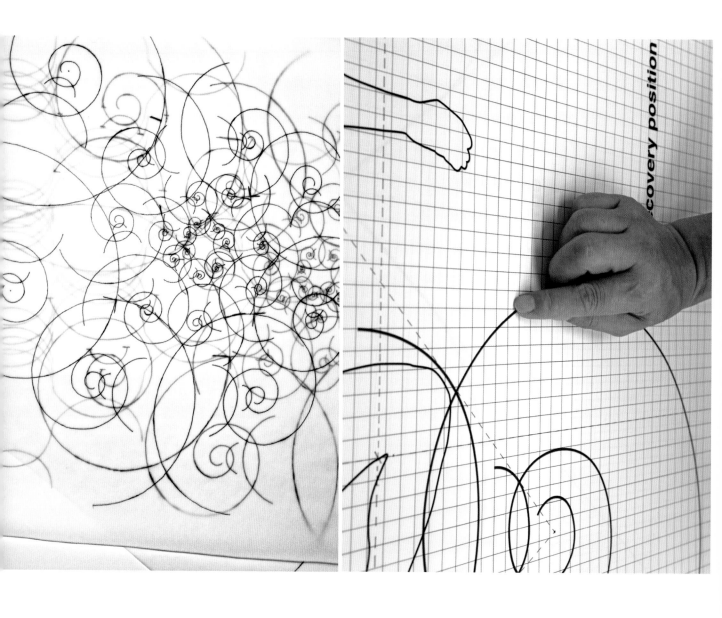

recovery position

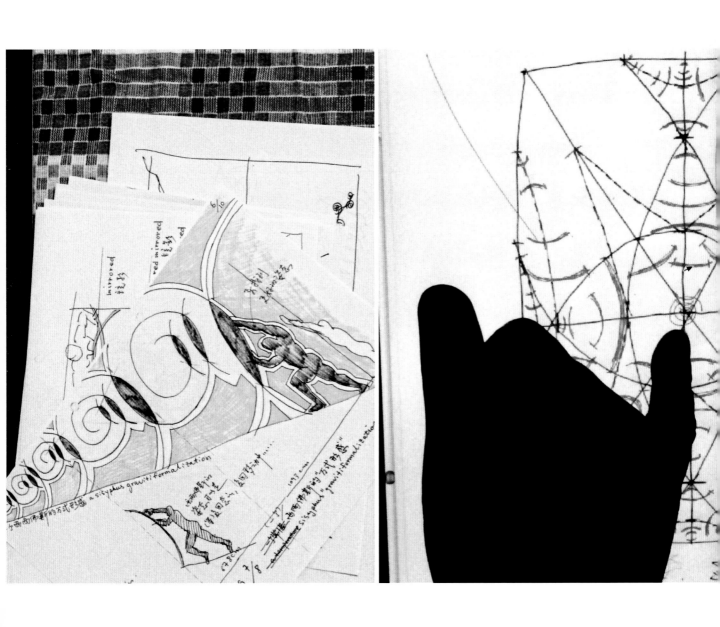

它死在刚开始的前面，活在刚结束的后面。

It dies just before it begins, and lives just after it ends.

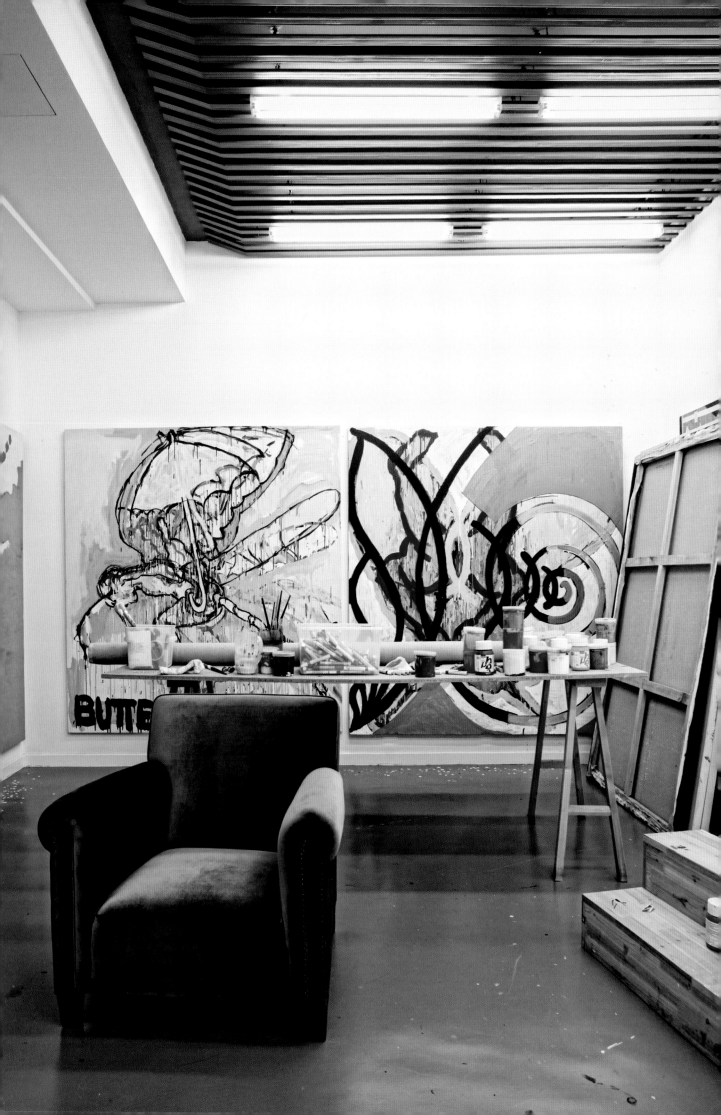

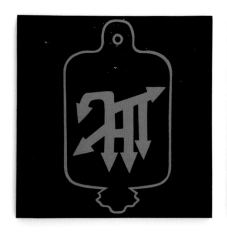

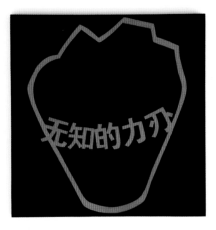

UNIDENTIFIED OBJECT
NO.OF:_____
WEIGH:_____
MATERIAL:_____
PLACE OF FOUND:_____
DATE OF FOUND:_____

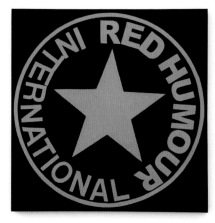

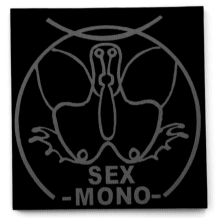

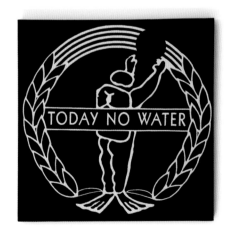

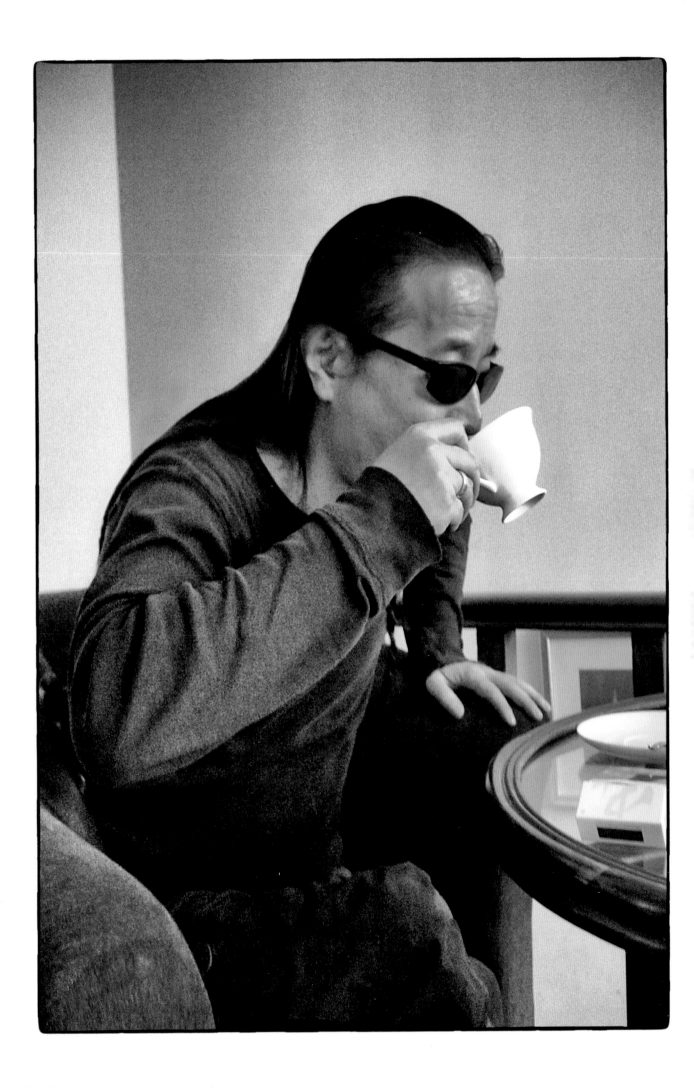

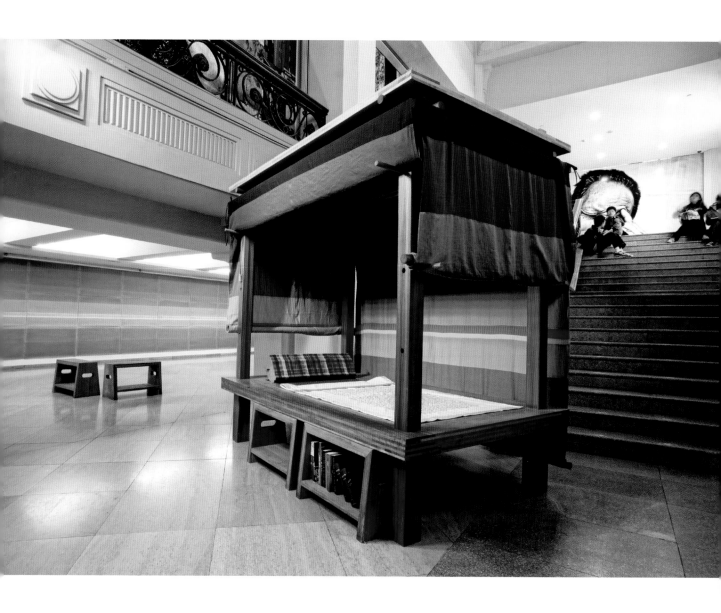

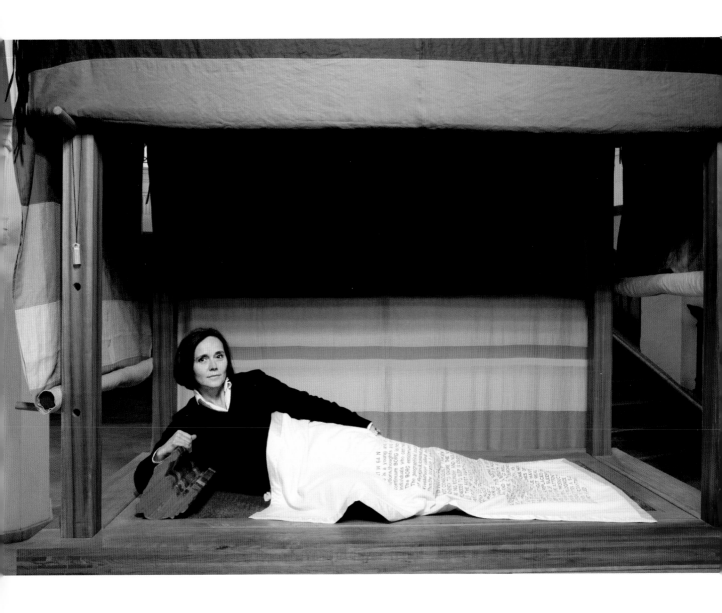

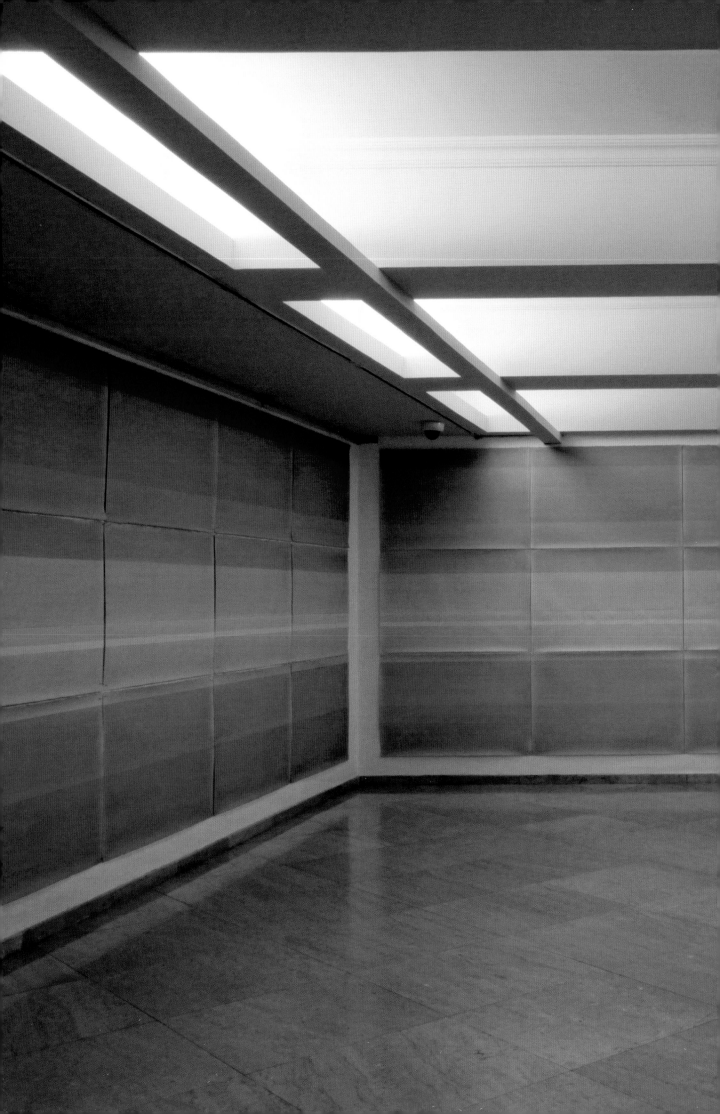

WU SHANZHUAN
INGA SVALA THORSDOTTIR

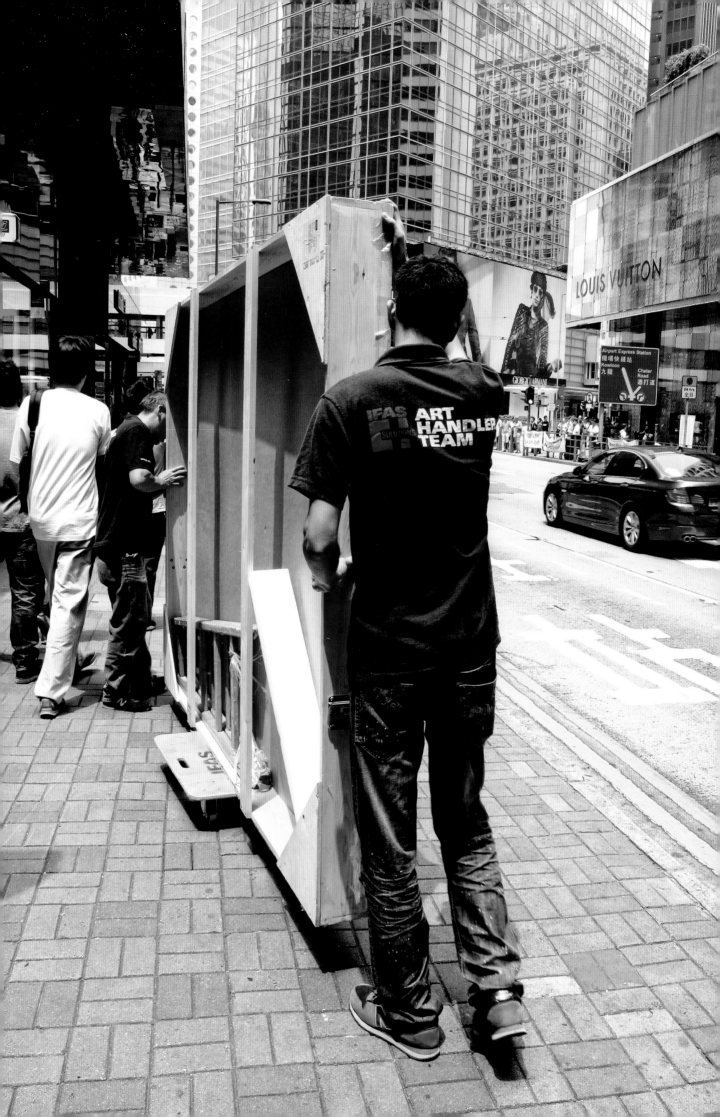

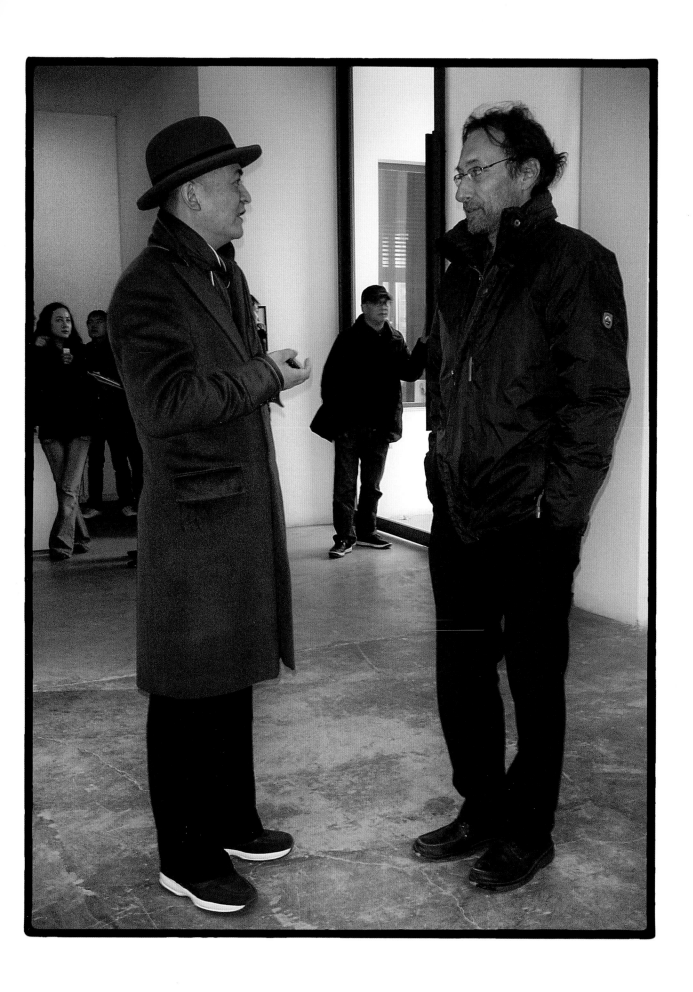

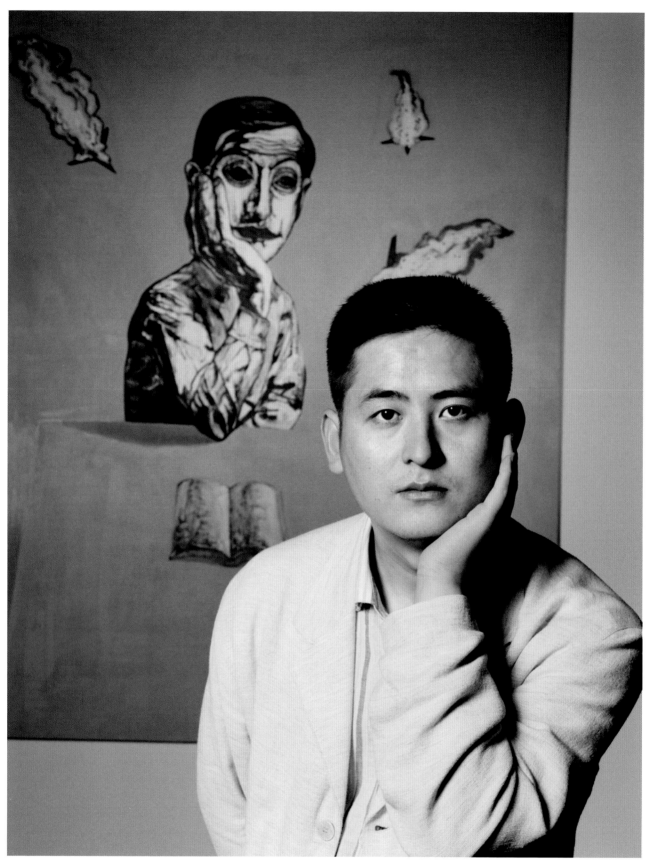

Zeng Fanzhi. Hamburg, Germany, 1995

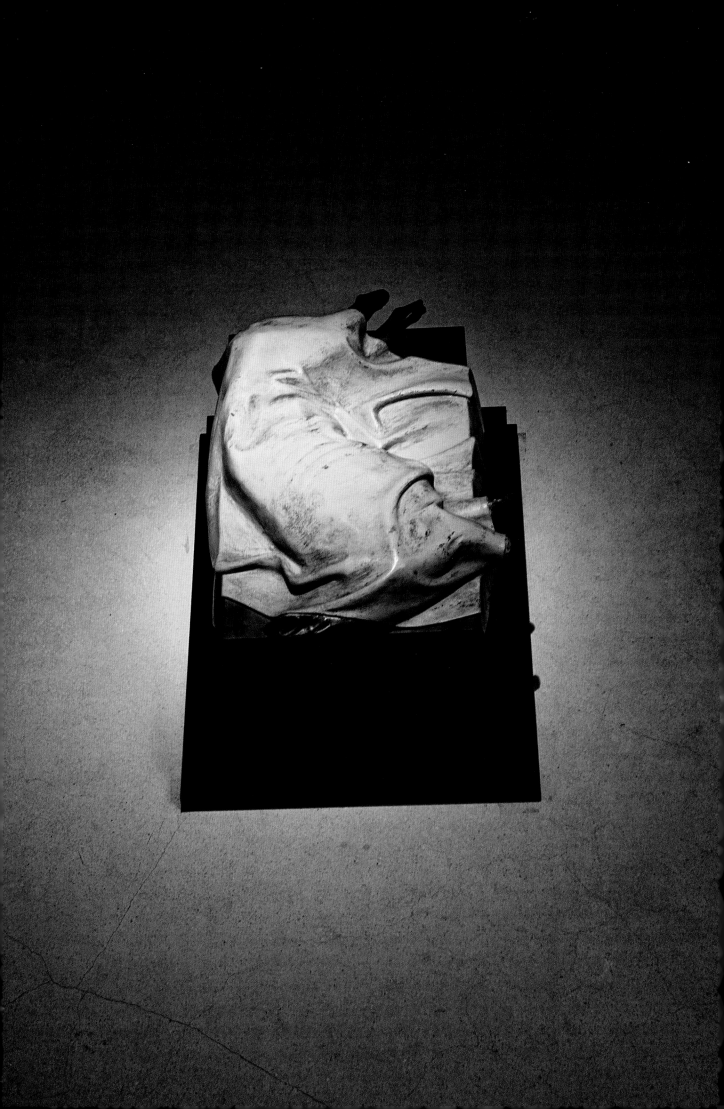

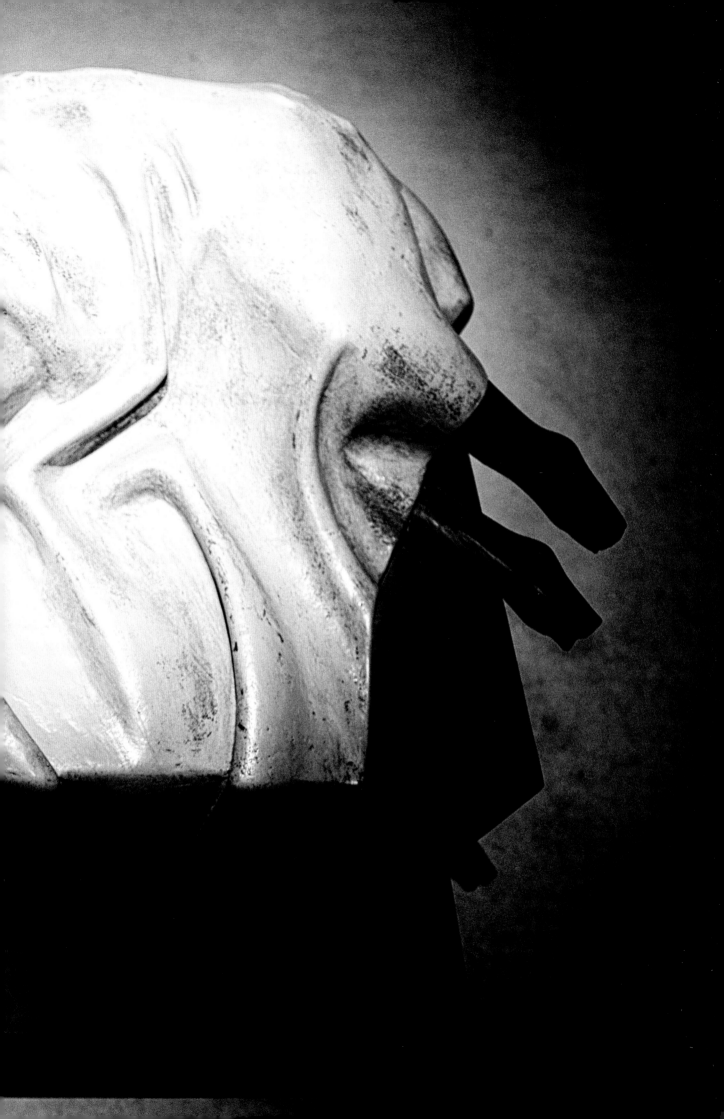

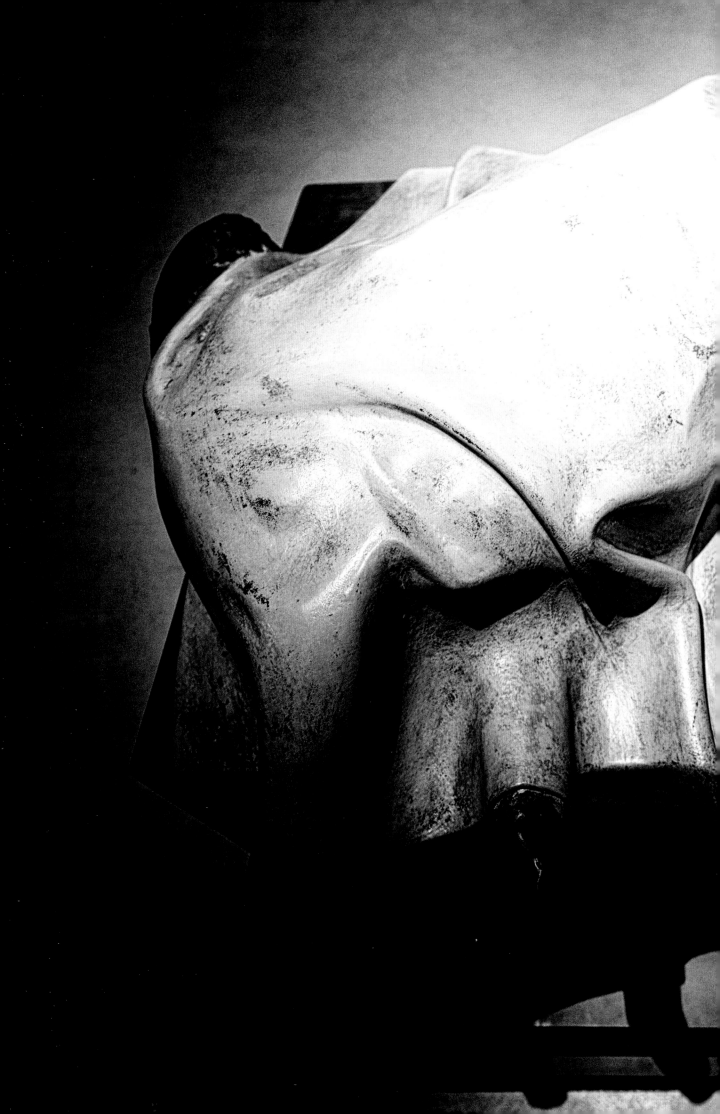

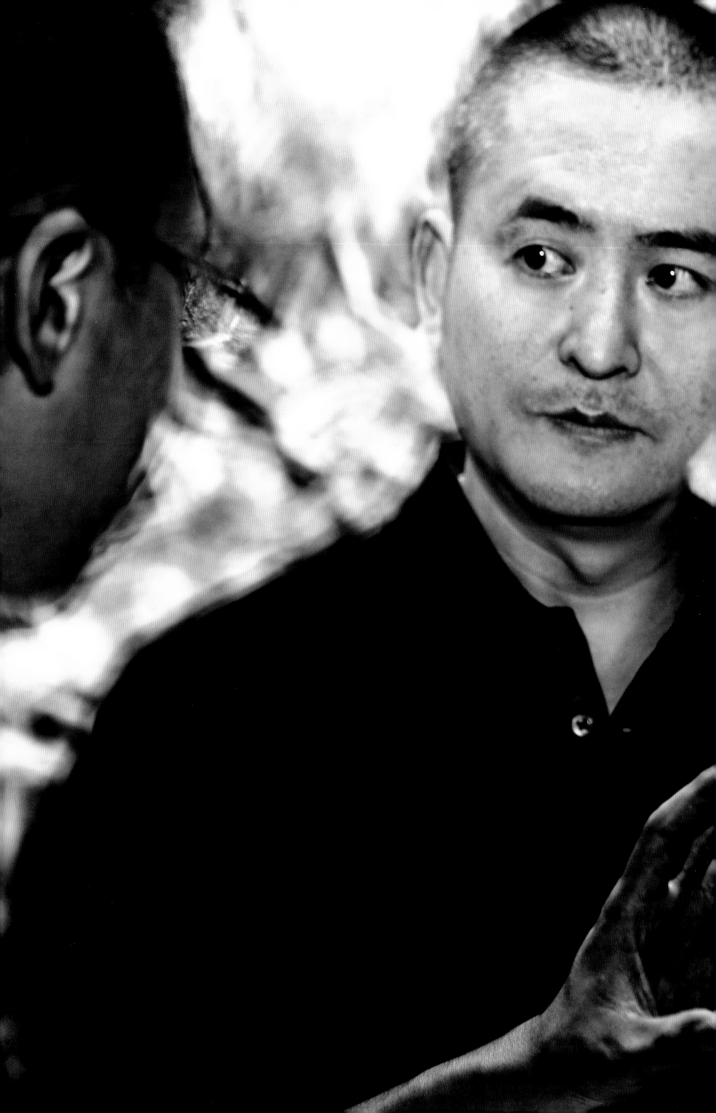

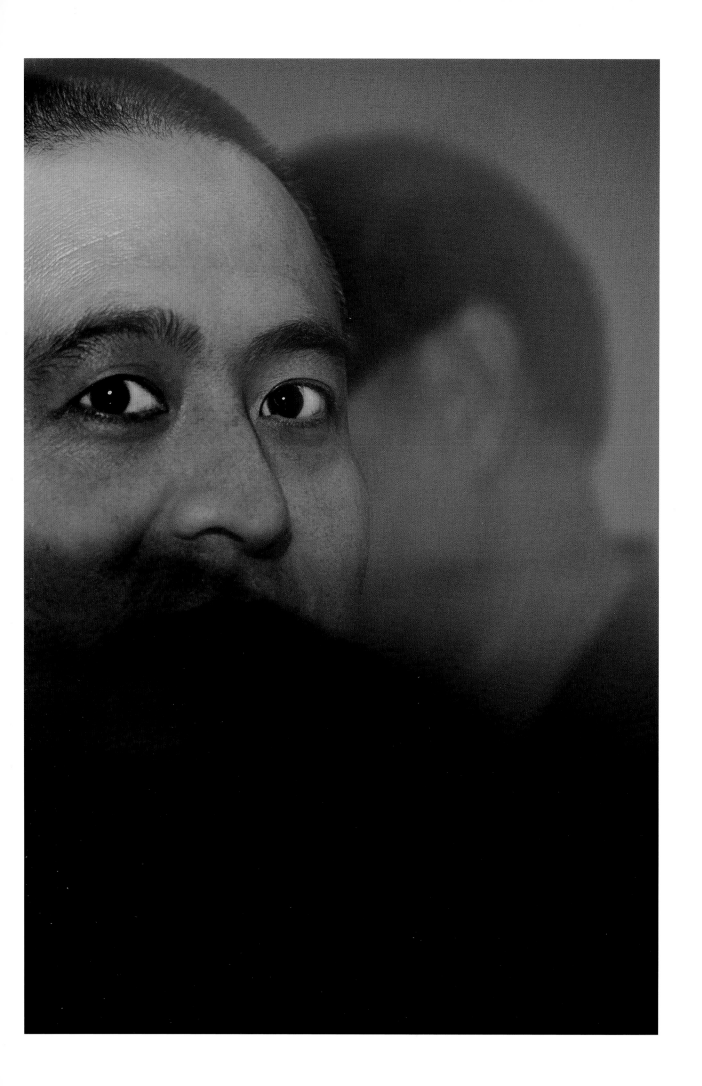

ZENG FANZHI

1964 Born in Wuhan, China
1991 Graduated from the Hubei Academy
of Fine Arts, Wuhan, China

Lives and works in Beijing, China

Selected Solo Exhibitions

2011 "Zeng Fanzhi", Gagosian Gallery, Hong
Kong, SAR China

2010 "Zeng Fanzhi", Rockbund Art Museum,
Shanghai, China

2009 "Who to Sit With", Suzhou Museum,
Jiangsu, China

2008 "Selected", ShanghART Gallery, Shanghai,
China

2007 "China Now", Cobra Museum, Amstelveen,
Netherlands

"Floating - New Generation of Art in China",
National Museum of Contemporary Art Korea,
Seoul, South Korea

"Zeng Fanzhi Idealism", Singapore Art Museum,
Singapore

"Zeng Fanzhi 1989–2007", Gallery Hyundai,
Seoul, South Korea

"Thermocline of Art - New Asian Waves", ZKM
Center for Art and Media, Karlsruhe, Germany

2006 "Zeng Fanzhi - Paintings", Wedel, London, UK

2004 "Scapes 1989–2004: The Paintings of Zeng
Fanzhi", He Xiangning Art Museum, Shenzhen, China

"Unmask the Mask - Zeng Fanzhi", Gallery Artside,
Seoul, South Korea

2003 "I/We, 1991–2003, Paintings of Zeng
Fanzhi", Shanghai Art Museum, Shanghai, China

Selected Group Exhibitions

2011 "The World Belongs to You", Palazzo
Grassi, Venice, Italy

2010 "30 Years of Chinese Contemporary Art",
Minsheng Art Museum, Shanghai, China

2009 "53rd Venice Biennale, Making Worlds",
Venice, Italy

2008 "The Revolution Continues, New Art From
China", Saatchi Gallery, London, UK

2007 "Time Difference, Initial Access",
Wolverhampton, UK

2005 "Mahjong: Sigg Collection of Modern
Chinese Art", Museum of Fine Arts, Bern, Switzerland

"China, Contemporary Painting", Fondazione
Cassa di Risparmio, Bologna, Italy

2002 Beijing China Space, Culture & Arts Event,
Paris-Beijing Cardin Art Center, Paris, France

2001 "Images of Contemporary Painting",
Shanghai Art Museum, Sichuan Art Museum, and
Guangdong Art Museum, China

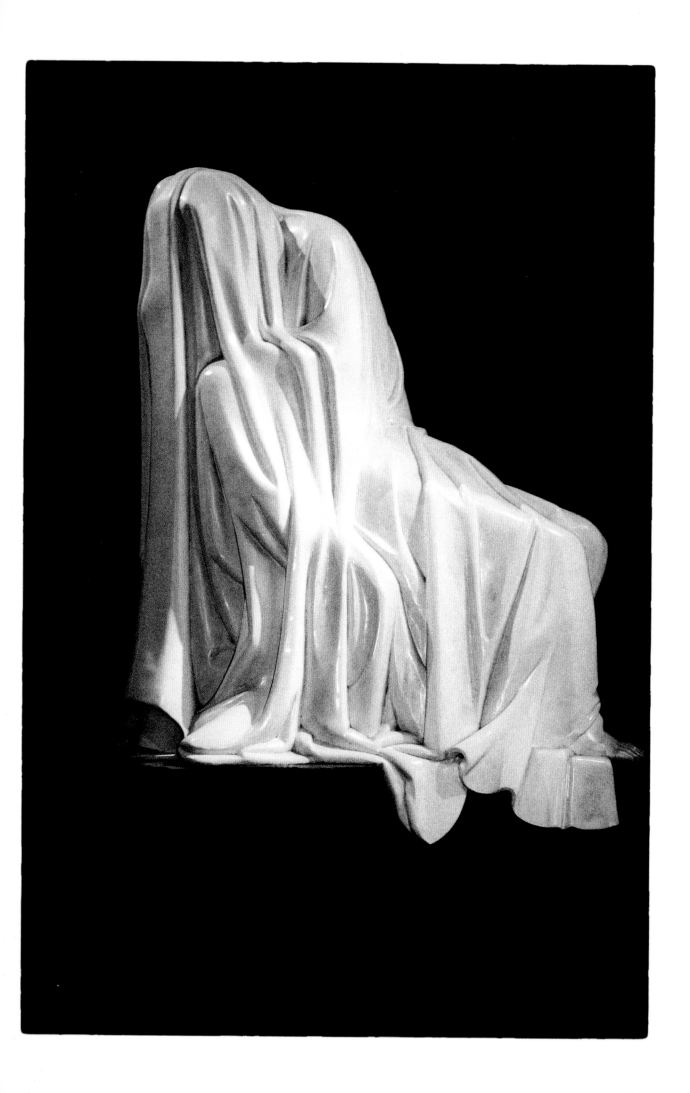

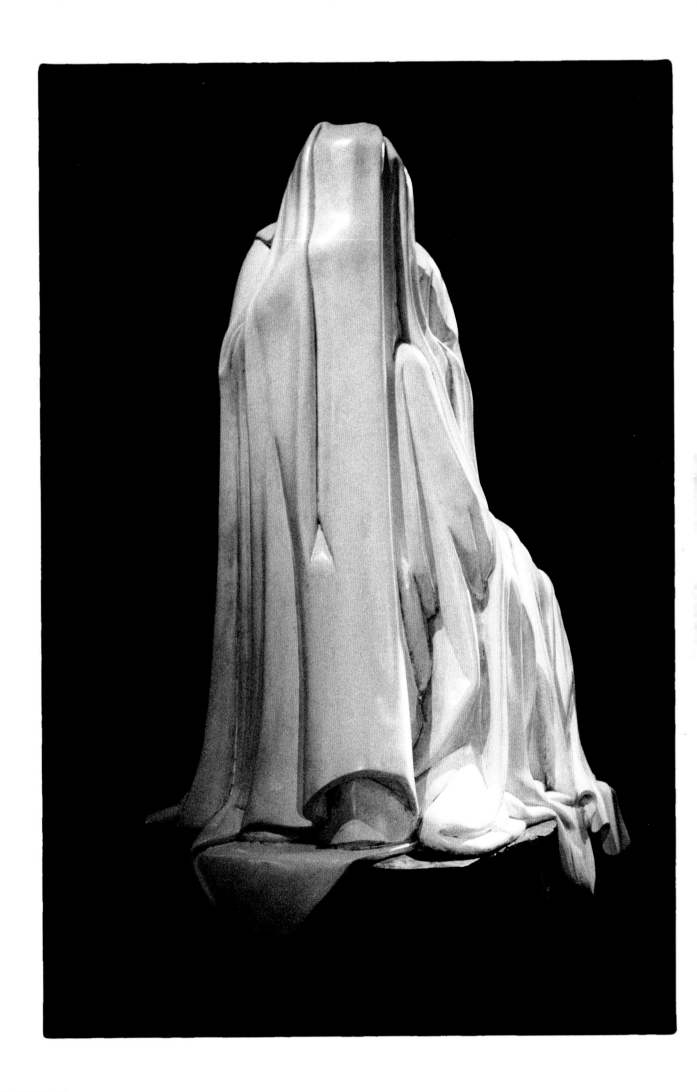

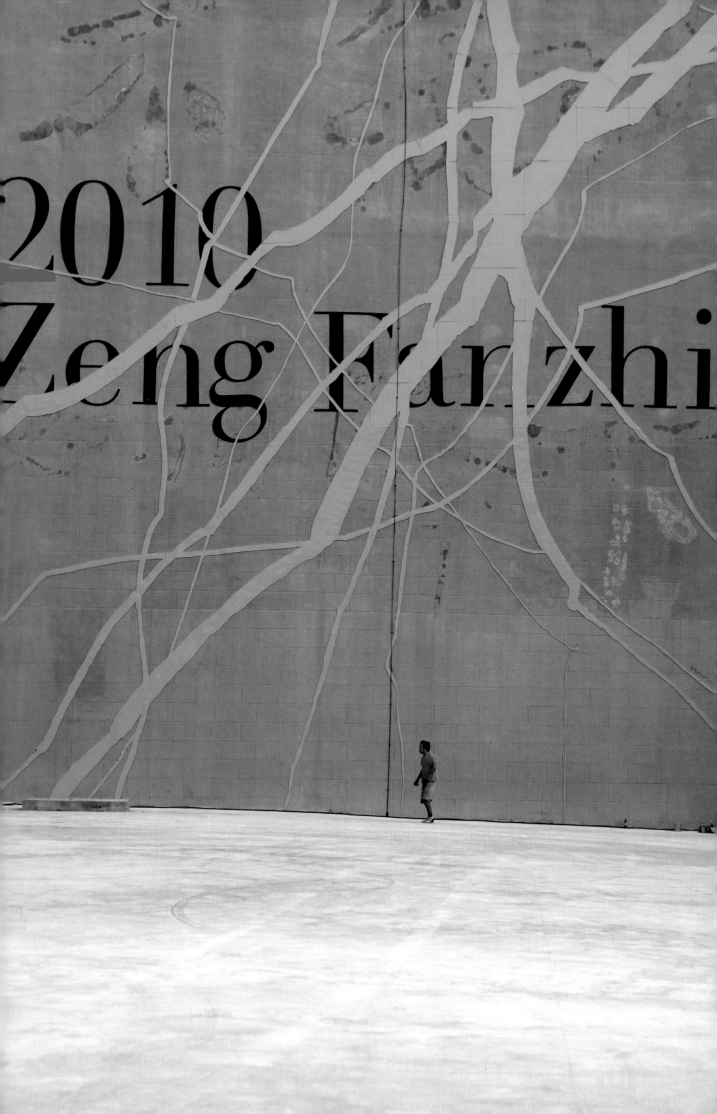

2010
Zeng Fanzhi

ZHANG DING

1980 Born in Gansu, China
2003 Graduated in oil painting from Northwest University for Nationalities, Lanzhou, Gansu Province, China

Lives and works in Shanghai, China

Selected Solo Exhibitions

2011 "Opening", ShanghART H-Space, Shanghai, China

2009 "Law", ShanghART Gallery, Beijing, China

2008 "Wind", Krinzinger Projekte, Vienna, Austria

Selected Group Exhibitions

2010 "China Power Station: Part 4", Pinacoteca Agnelli, Turin, Italy

"The Tell-Tale Heart", James Cohan Gallery, Shanghai, China

2009 "Bourgeoisified Proletariat: Contemporary Art in Songjiang", Songjiang Creative Studio, Shanghai, China

"Warm Up", Minsheng Museum, Shanghai, China

"Shanghai Kino, Shanghai Kino", Kunsthalle Bern, Bern, Switzerland

2008 "SHContemporary 08-Outdoor Projects", Shanghai Exhibition Center, Shanghai, China

2007 "China Power Station: Part 3", National Art Museum, Luxembourg, and "China Power Station: Part 2", Astrup Fearnley Museum of Modern Art, Oslo, Norway

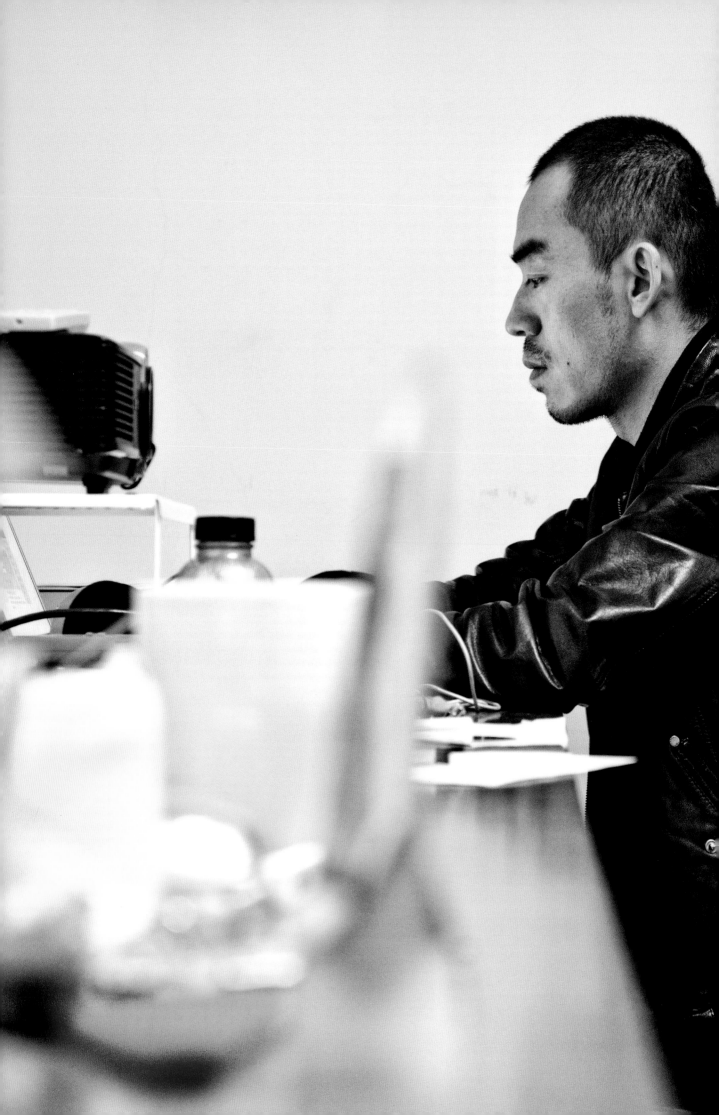

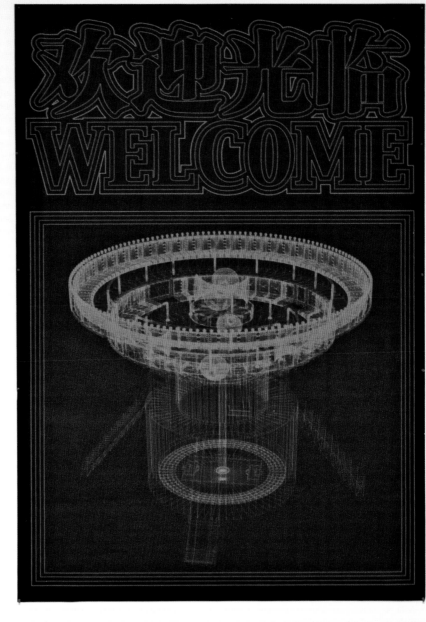

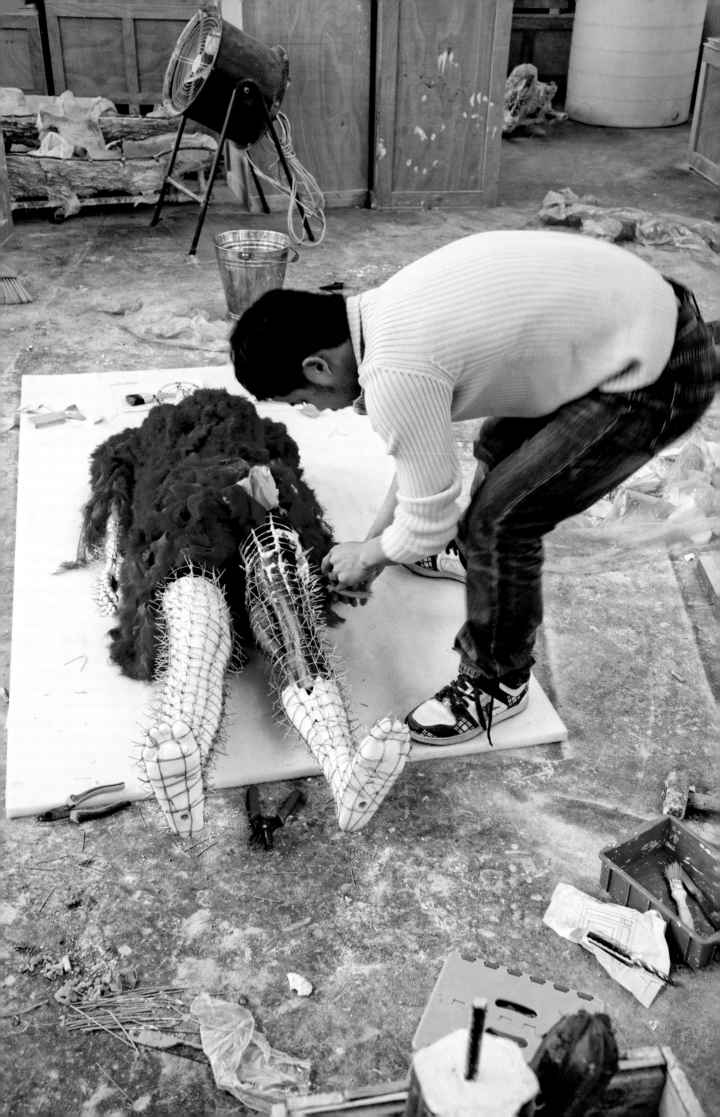

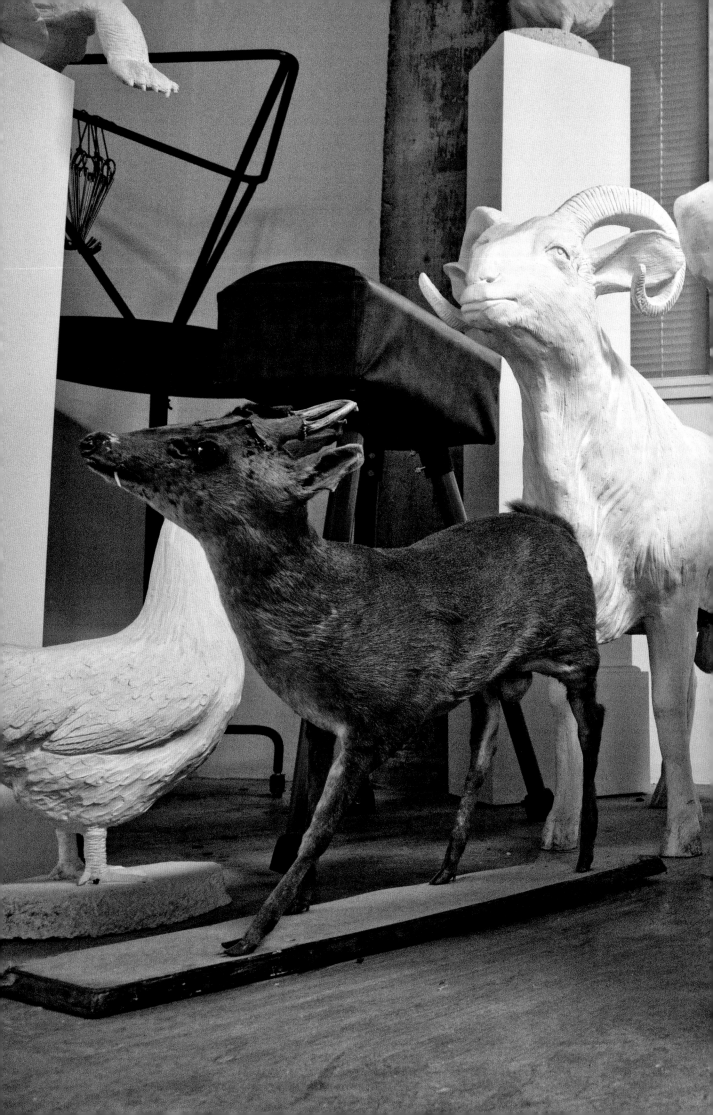

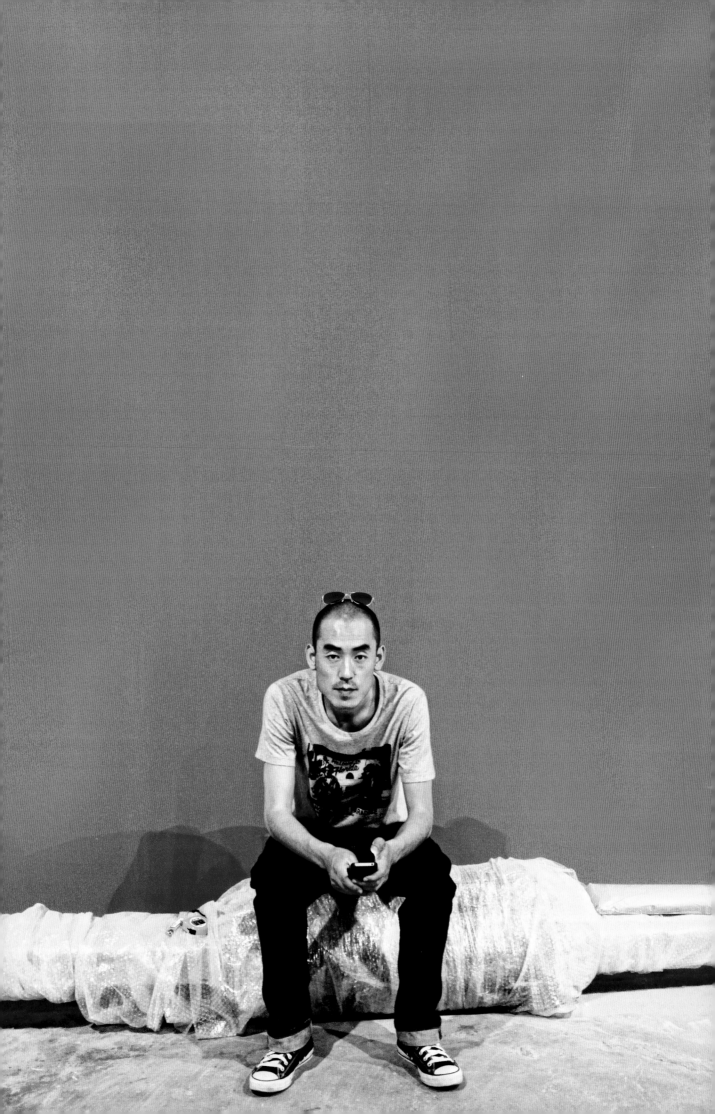

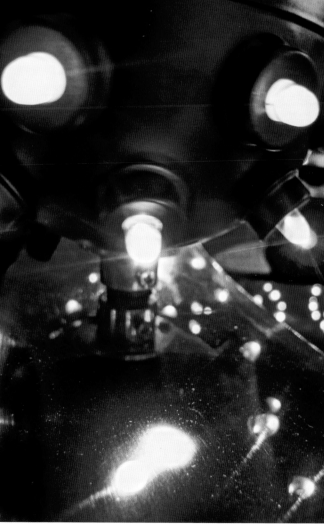

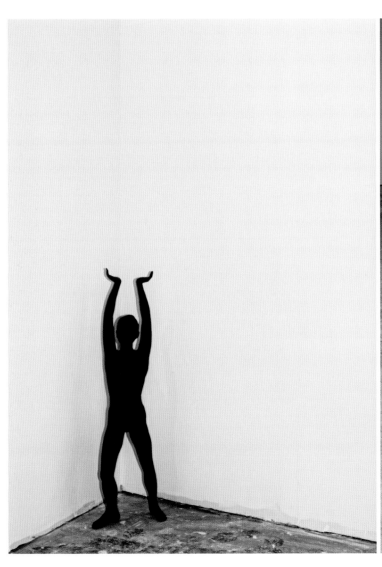
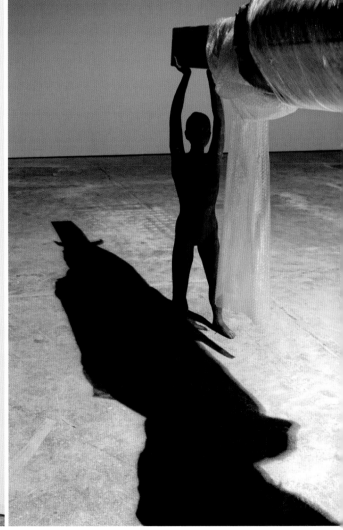

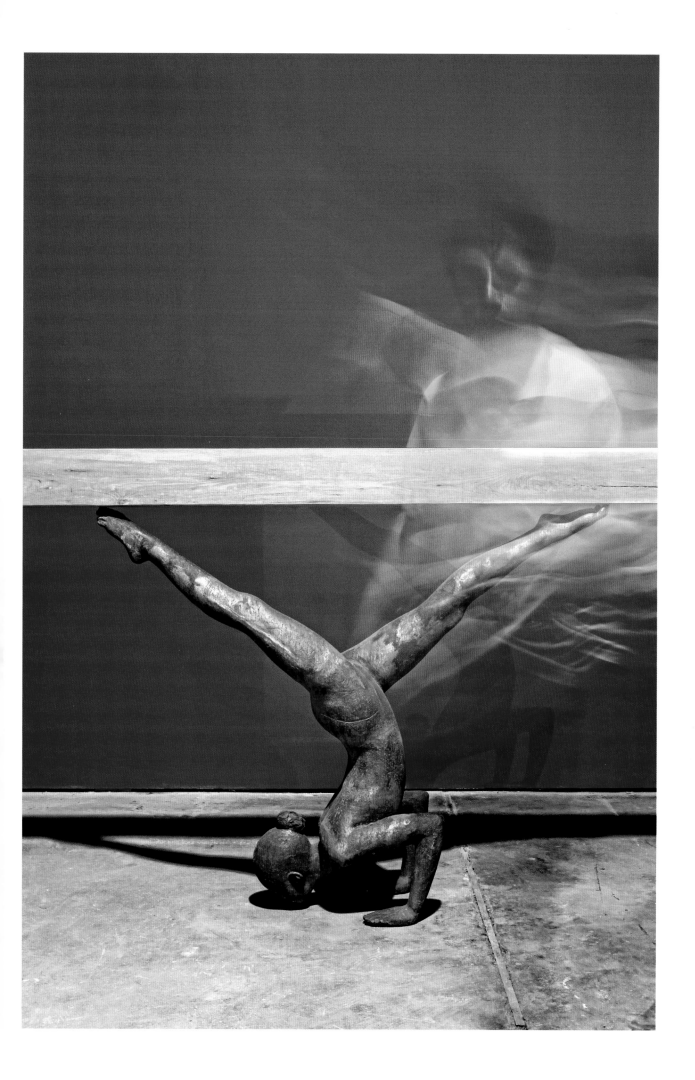

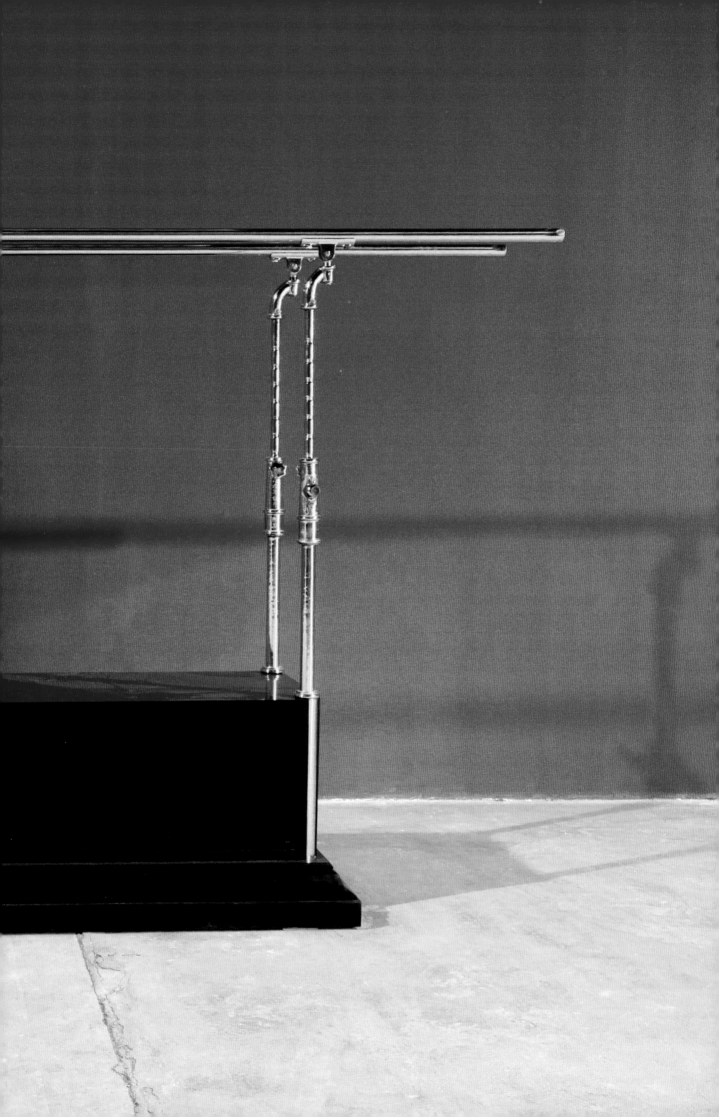

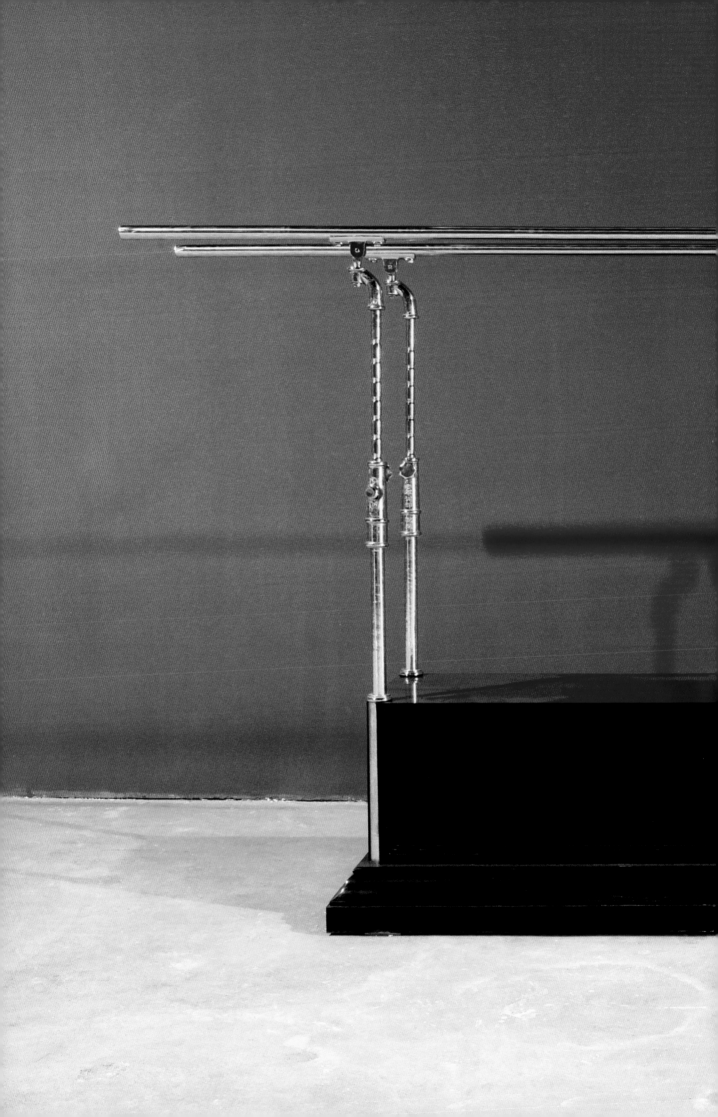

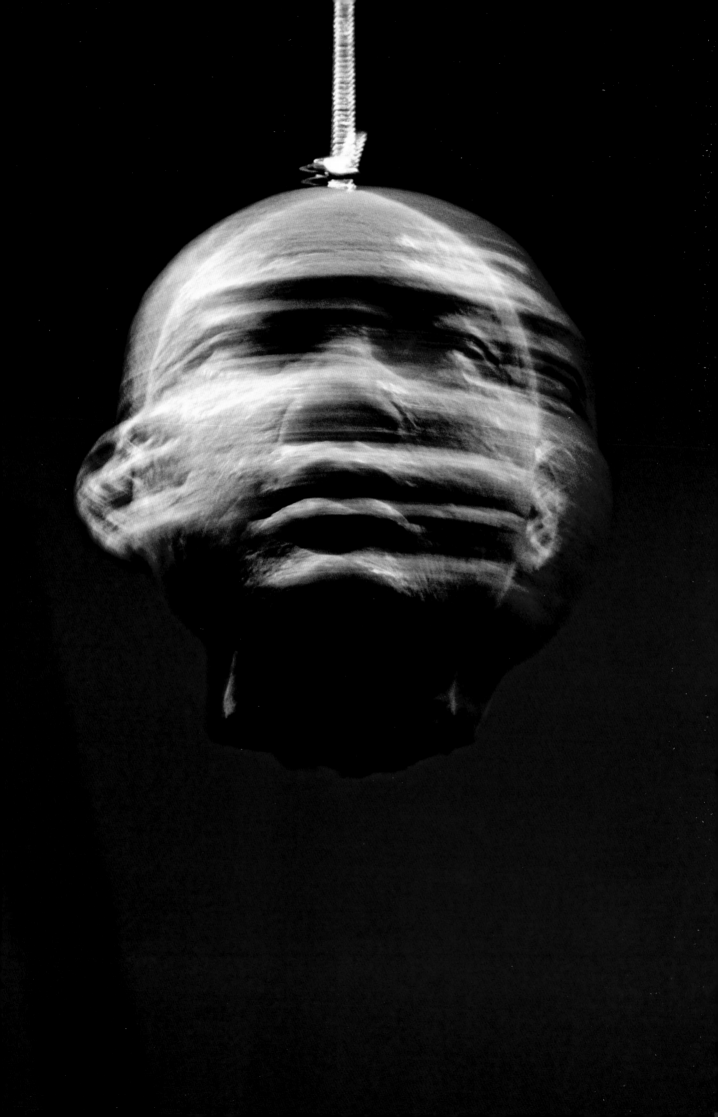

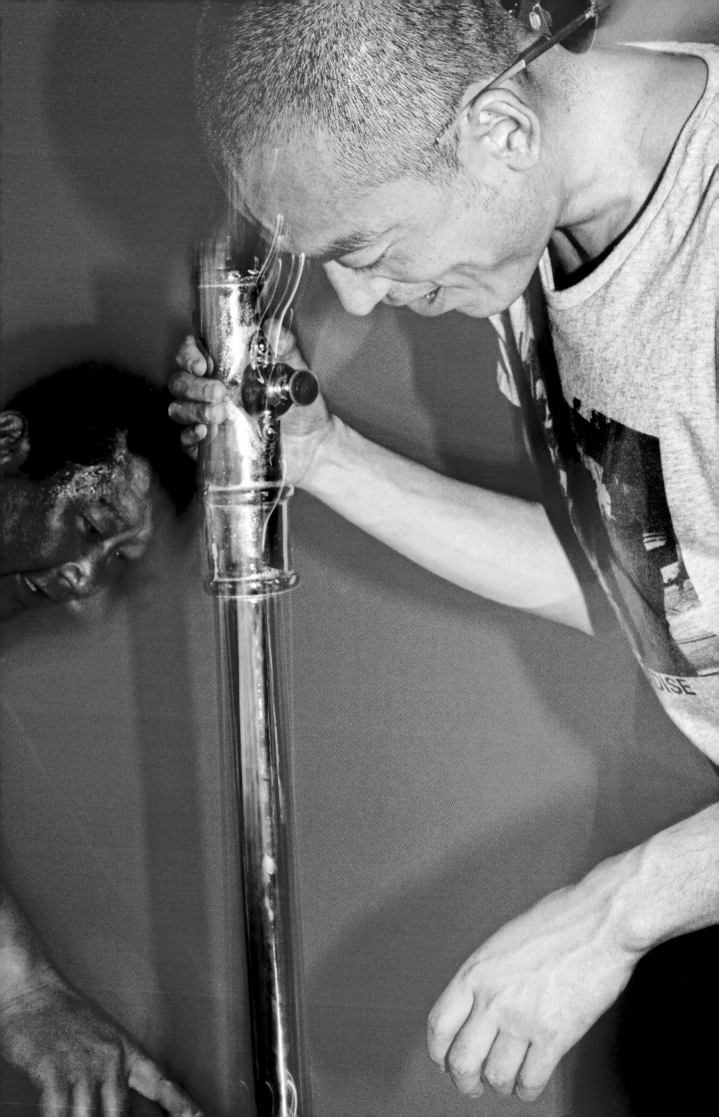

ZHANG DING

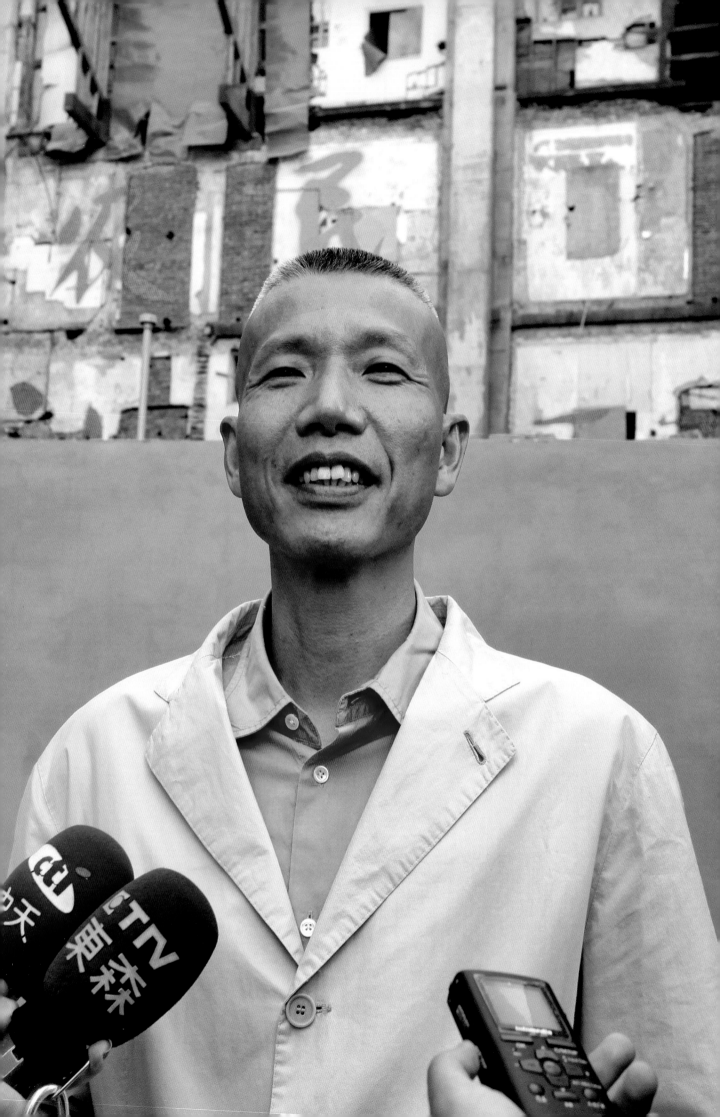

Selected Group Exhibitions

2011 "RegressProgress", Centre for Contemporary Art Ujazdowski Castle, Warsaw, Poland

2010 "The Beauty of Distance: Songs of Survival in a Precarious Age", 17th Biennale of Sydney, Sydney, Australia

2008 "God & Goods: Spirituality and Mass Confusion", Villa Manin Centro per l'Arte Contemporanea, Codroipo, Italy

2007 "Journeys: Mapping the Earth and Mind in Chinese Art", Metropolitan Museum of Art, New York, USA

2005 "The Wall: Reshaping Contemporary Chinese Art", Millennium Monument Art Museum, Beijing, China

CAI GUO-QIANG

1957 Born in Quanzhou, Fujian Province, China
1985 Graduated in stage design from the Shanghai Theater Academy, Shanghai, China

Lives and works in New York City, USA

Awards and Nominations

1996 Finalist Hugo Boss Prize

2001 Winner 48th Venice Biennale International Golden Lion Prize

2001 CalArts/Alpert Award in the Arts

2008 Director Visual and Special Effects for opening and closing ceremonies of the Summer Olympics in Beijing, China

Selected Solo Exhibitions

2011 "Cai Guo-Qiang: Saraab", Mathaf Arab Museum of Modern Art, Doha, Qatar

2010–2011 "Cai Guo-Qiang: Sunshine and Solitude", Museo Universitario Arte Contemporáneo, Mexico City, Mexico

2009 "Cai Guo-Qiang: Hanging Out in the Museum", Taipei Fine Arts Museum, Taipei, Taiwan

2008–2009 "I Want to Believe", Solomon R. Guggenheim Museum, New York, USA and Guggenheim Museum, Bilbao, Spain

2007 "Inopportune: Stage One and Illusion", Seattle Art Museum, Seattle, USA

2006 "Cai Guo-Qiang on the Roof-Transparent Monument ", Metropolitan Museum of Art, New York, USA

2005 "Cai Guo-Qiang", Associazione Arte Continua, Colle di Val d'Elsa, Tuscany, Italy

2004 "Traveler", Arthur M. Sackler Gallery and Hirshhorn Museum and Sculpture Garden, Smithsonian Institution, Washington DC, USA

2003 "An Explosion Event: Light Cycle Over Central Park", Asia Society Museum, New York, USA

"Ye Gong Hao Long: Explosion Project for Tate Modern", Tate Modern, London, UK

2002 "Cai Guo-Qiang", Shanghai Art Museum, Shanghai, China

2001 "Cai Guo-Qiang: An Arbitrary History", Musee d'art Contemporain, Lyon, France and Stedelijk Museum voor Actuele Kunst (SMAK), Ghent, Belgium

2000 "Cai Guo-Qiang", Fondation Cartier pour l'art contemporain, Paris, France

遊走太魯閣一石頭
Taroko Gorge: Stone
蔡國強 Cai Guoqiang
2009

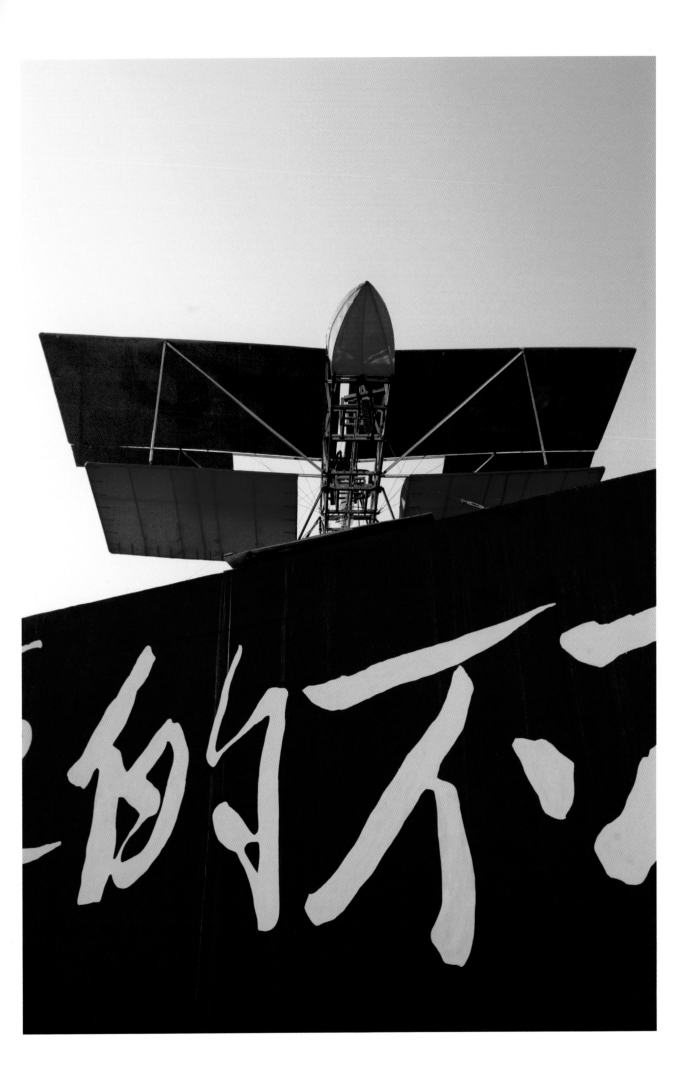

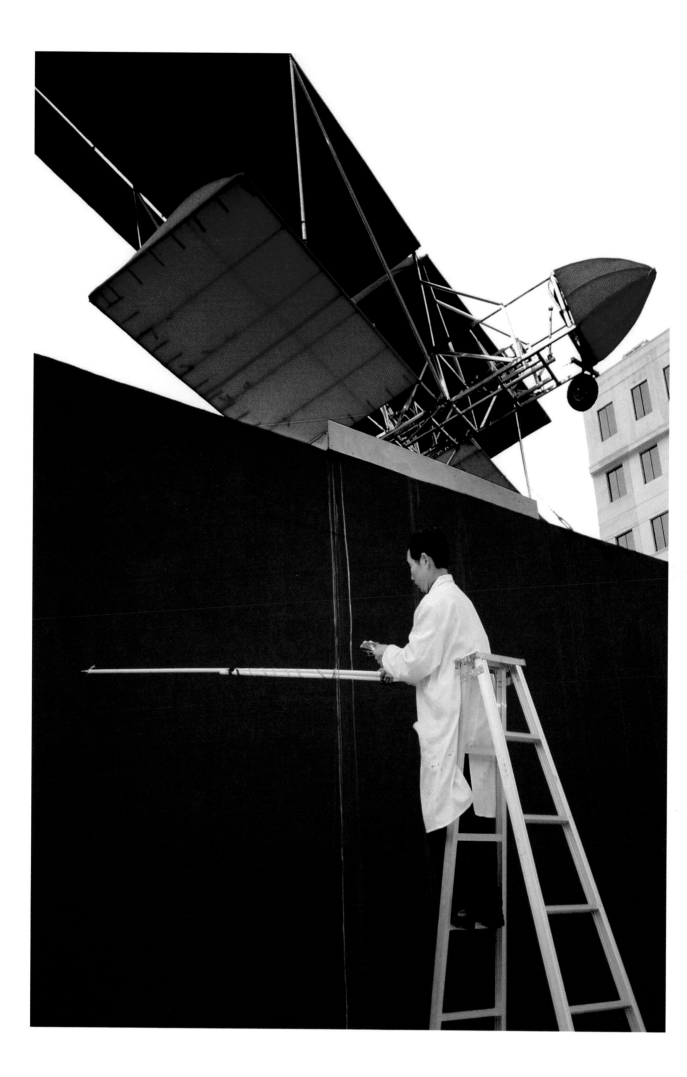

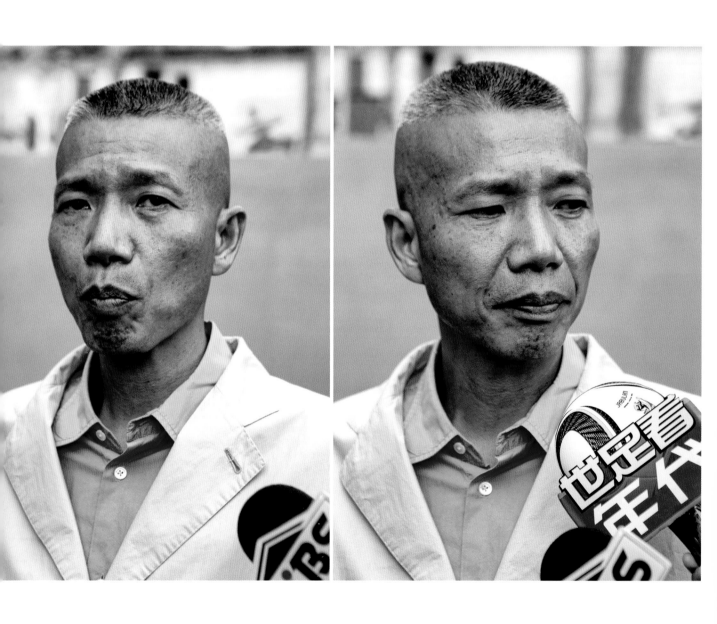

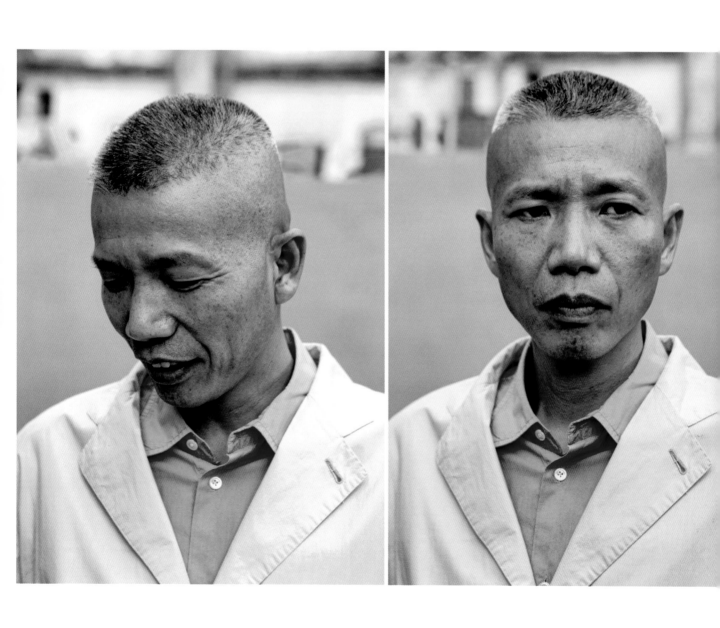

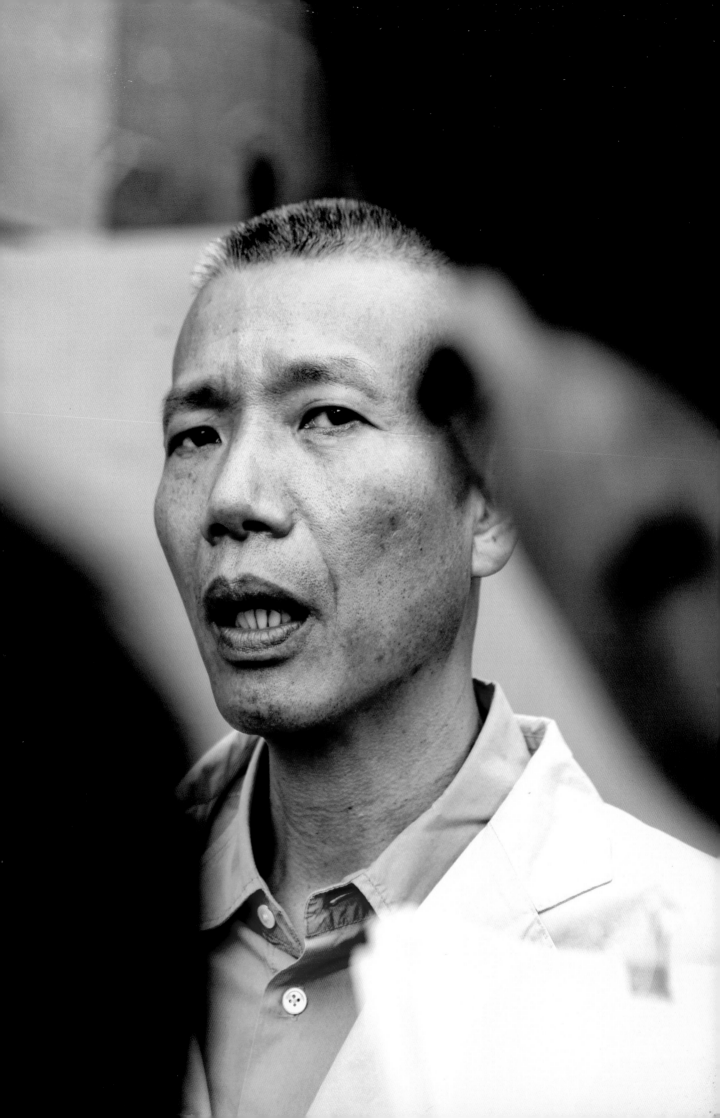

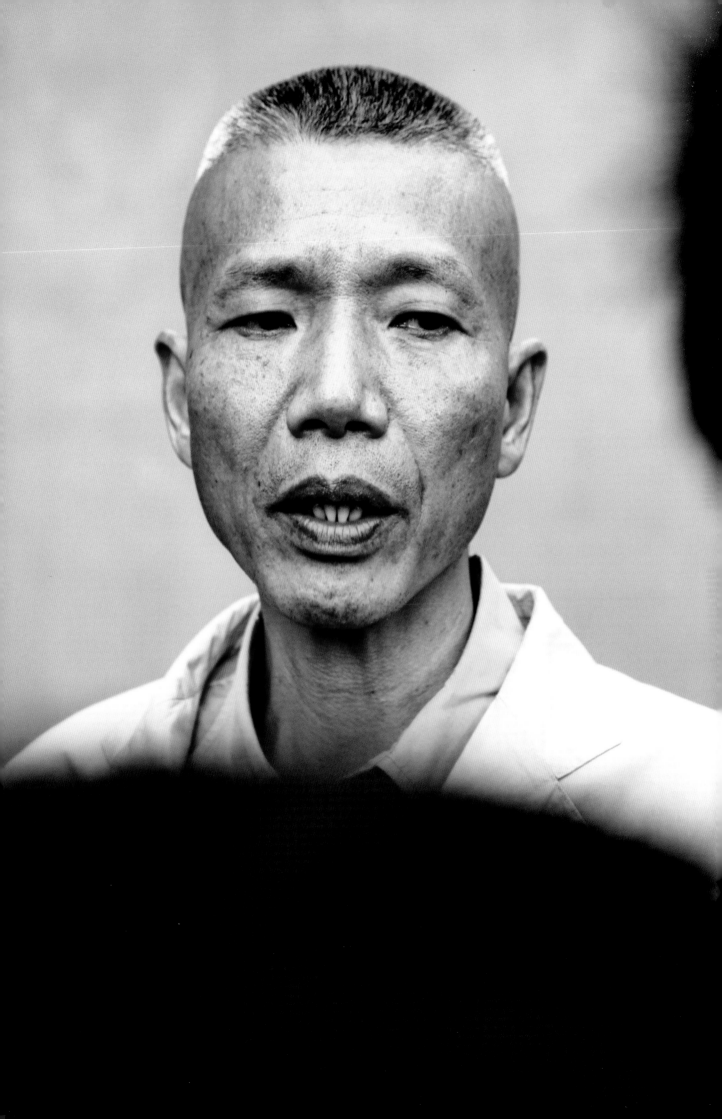

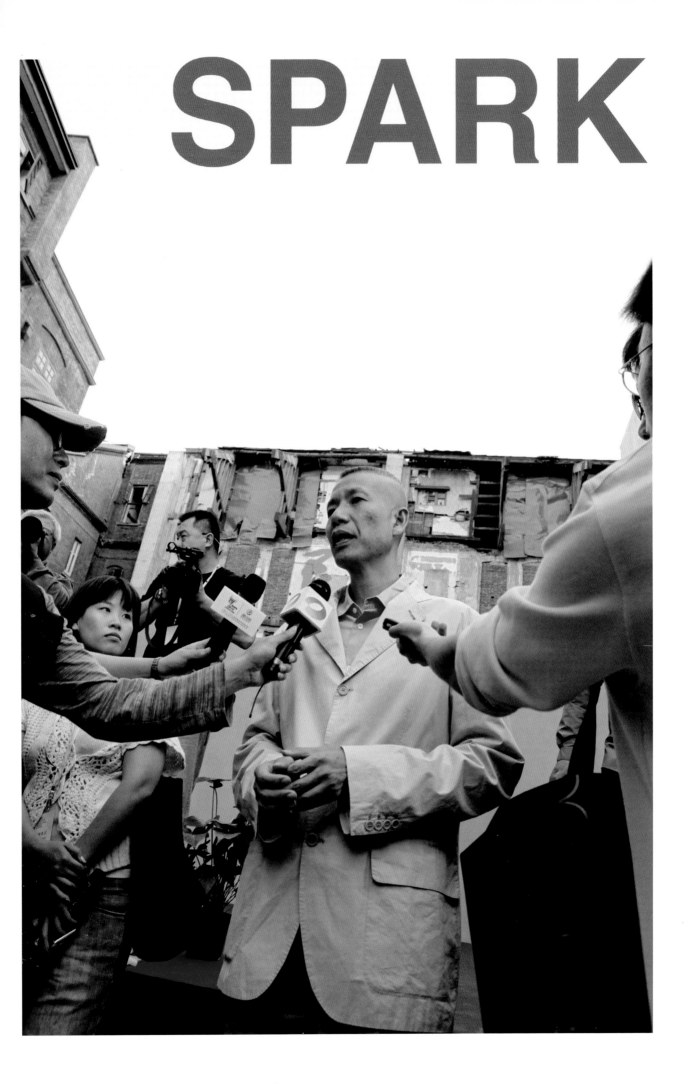

SPARK

白银
芙和乡
村
机
木

赛车

寸

行
十六人座

北京平谷区 明店 新型...
新型燃柴炉 直升飞机 直升飞机 彭耶
周广志 陈种植 童麻记
耳大黄 大梁山庄
太阳能灶 福建漳浦 海上飞机
武隆县和顺镇高寒 木飞机 李园
起飞
温宝客厅 无名氏 辽宁东港
高永行 直升飞机 电动小汽
王金瑞 赵秀顺 赵秀国 王宏
山东滕州 广东潮阳
飞机 飞机 F1赛车 河北
无名民 张斗三 无名氏 水陆两
飞机 福建泉州 四轮

车

舒城县晓天镇　　峡东郯城县

马头镇

飞碟直升器　　柳顺村

刘斌　　　　　　直升飞机

陈 烟台牟平区大窑镇　　张

小汽车　　　　张金铎

周治威元　　　F1赛车　　郑

四川温江县　　　　　凤

万春镇红罐村　　郭师傅

九江市星子县

飞机　无名氏　　飞机

艇　　双人直升机　　阮

张羽　　无名氏　　蒸汽

机器人

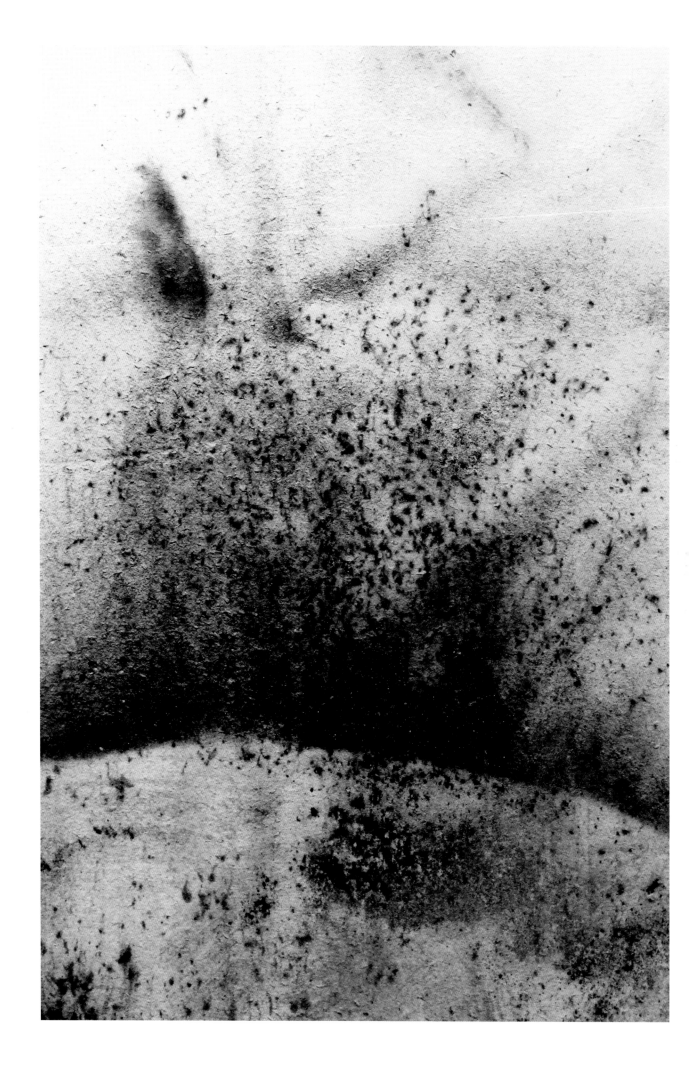

CAI GUO-QIANG
PEASANT
DA VINCIS

MAY 4–JULY 25, 2010
INAUGURAL EXHIBITIO
ROCKBUND ART MUS
SHANGHAI

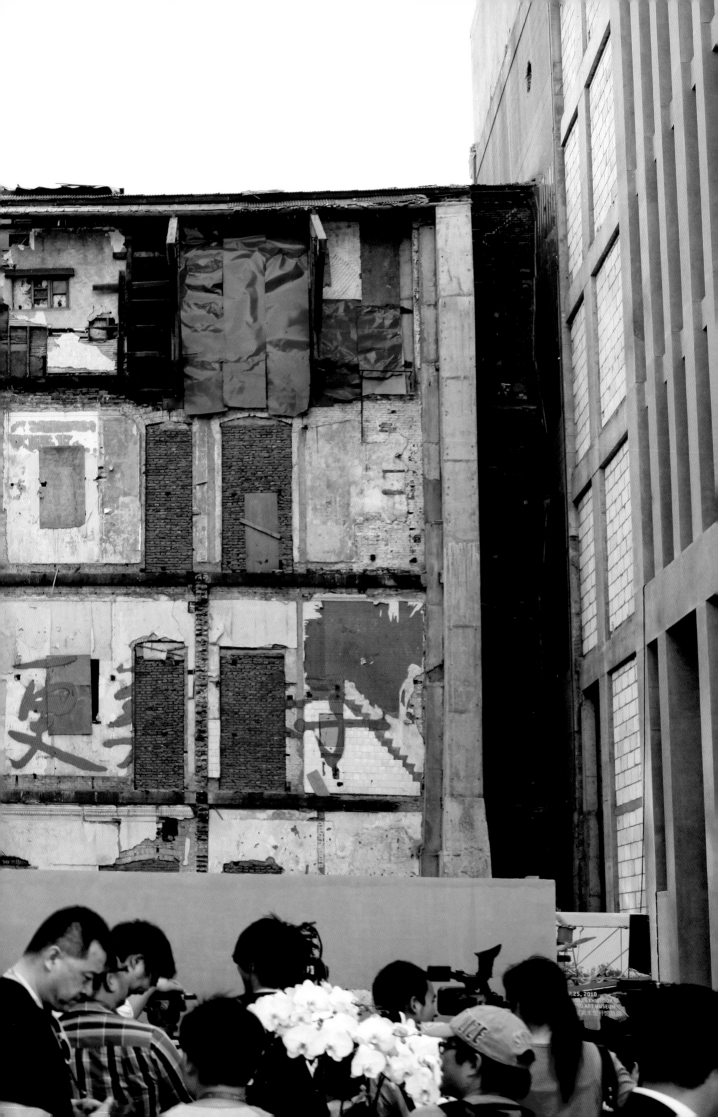

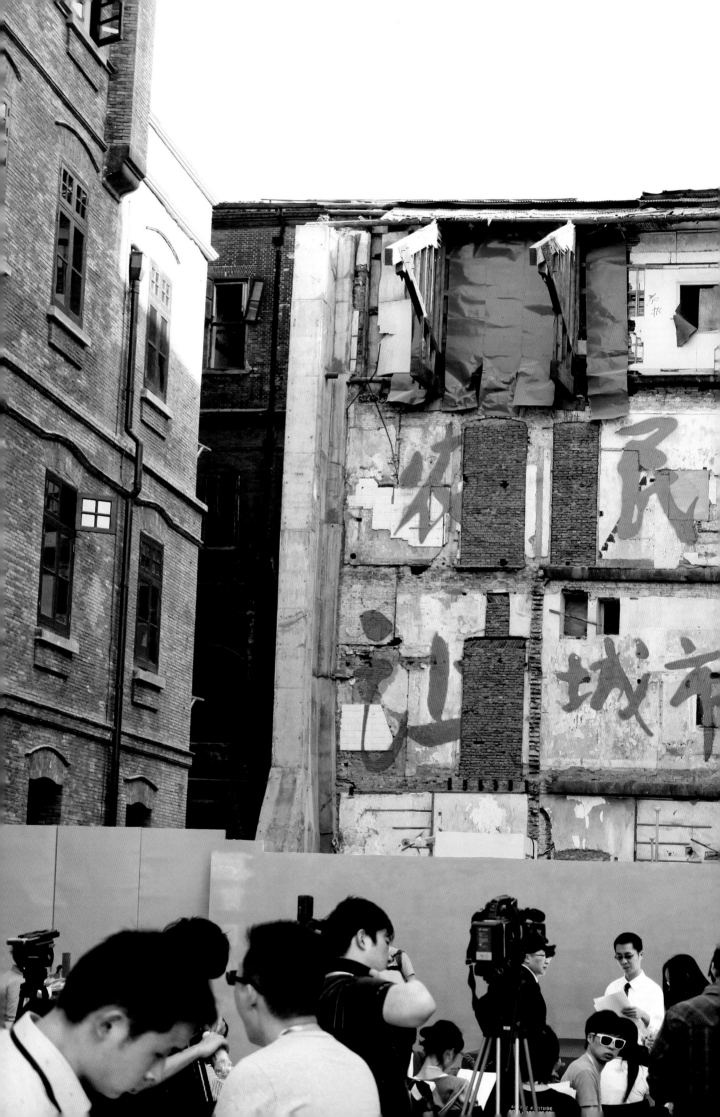

CAI GUO-QIANG

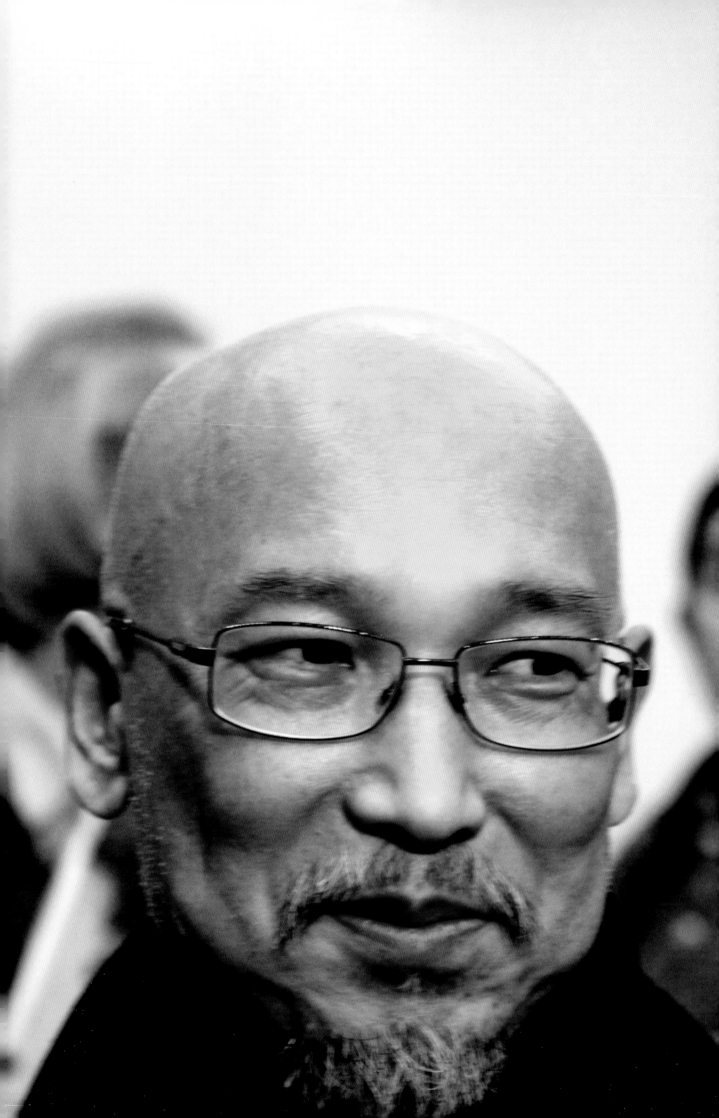

Selected Group Exhibitions

2011 "GUANXI: Chinese Contemporary Art",
Today Art Museum, Beijing, China

"Beyond the Crisis", 6th Curitiba Biennial, Museu
Alfredo Andersen, Curitiba, Brazil

"Guanxi", Guangdong Museum of Art,
Guangzhou, China

2010 "Negotiation: The Second Today's
Documents", Today Art Museum, Beijing, China

"10,000 Lives", Gwangju Biennale 2010, Gwangju
Museum of Art, Gwangju, South Korea

"Thirty Years of Chinese Contemporary Art",
Minsheng Art Museum, Shanghai, China

2009 First Annual Conference Collectors of
Chinese Contemporary Art, Hejingyuan Art
Museum, Beijing, China

"Warm Up", Minsheng Art Museum, Shanghai,
and 5x5 Castelló 09, International Contemporary
Art Prize, Espai d'art contemporani de Castelló,
Castellon de la Plana, Spain

2008 "Five Years of Duolun: Chinese
Contemporary Art Retrospective", Shanghai
Duolun Museum of Modern Art, Shanghai, China

"Trans Local Motion", 7th Shanghai Biennale,
Shanghai Art Museum, Shanghai, China

"The World of Others: Contemporary Art", Museum
of Contemporary Art, Shanghai, China

"China New Vision: Contemporary Collection
Shanghai Art Museum", Centro d'Arte Moderna
e Contemporanea, La Spezia, Italy

2007 "China's Neo Painting: A Triumph over
Images", Shanghai Art Museum, Shanghai, China

"Size Matters- XXL - Recent Large-Scale Paintings",
Hudson Valley Center for Contemporary Art, New
York, USA

Royal Academy Summer Exhibition 2007, Royal
Academy of Arts, London, UK

"Circulate, there is nothing to see", Objectif
Exhibitions, Antwerp, Belgium

"Individual Positions 1", ShanghART Gallery,
Shanghai, China

2006 "Z-art Center Opening Exhibition", Z-art
Center, Shanghai, China

"Infinite Painting, Contemporary Painting, and
Global Realism", Villa Manin Centro per l'Arte
Contemporanea, Codroipo, Italy

"PRE-EMPTIVE", Kunsthalle Bern,
Bern, Switzerland

ZHANG ENLI

1965 Born in Jilin, China
1989 Graduated from the Arts & Design Institute
of Wuxi Technical University, Wuxi, China

Lives and works in Shanghai, China

Selected Solo Exhibitions

2011 "Zhang Enli", Shanghai Art Museum,
Shanghai, China

"Zhang Enli", Hauser & Wirth Gallery, New York,
USA

2010 "Zhang Enli", Minsheng Art Museum,
Shanghai, China
"Zhang Enli", Hauser & Wirth Gallery, London, UK

2009 "Zhang Enli", Kunsthalle Bern, Switzerland
"Zhang Enli", Ikon Gallery, Birmingham, UK

2008 Zhang Enli, ShanghART H-Space,
Shanghai, China

2007 "Zhang Enli", Hauser & Wirth Gallery,
Zürich, Switzerland

2006 "Zhang Enli", Armory Show, Hauser & Wirth
Gallery, New York, USA

2005 "Zhang Enli", W&B House and Buero
Friedrich, Berlin, Germany

2004 "Human to Human", BizArt,
Shanghai, China

2000 "Dancing", ShanghART Gallery,
Shanghai, China

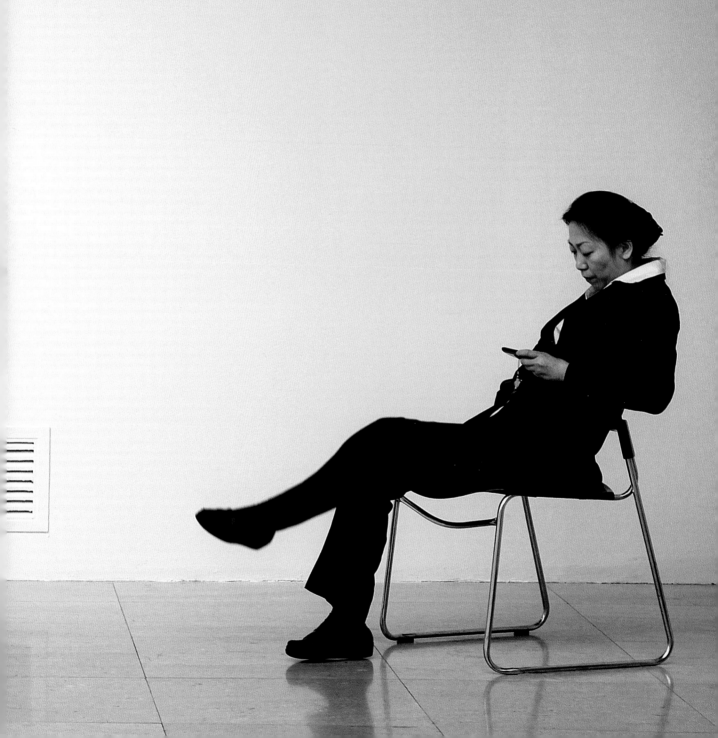

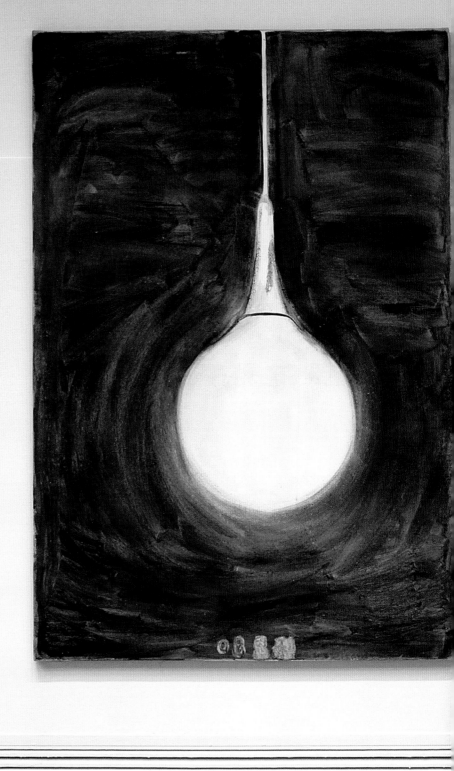

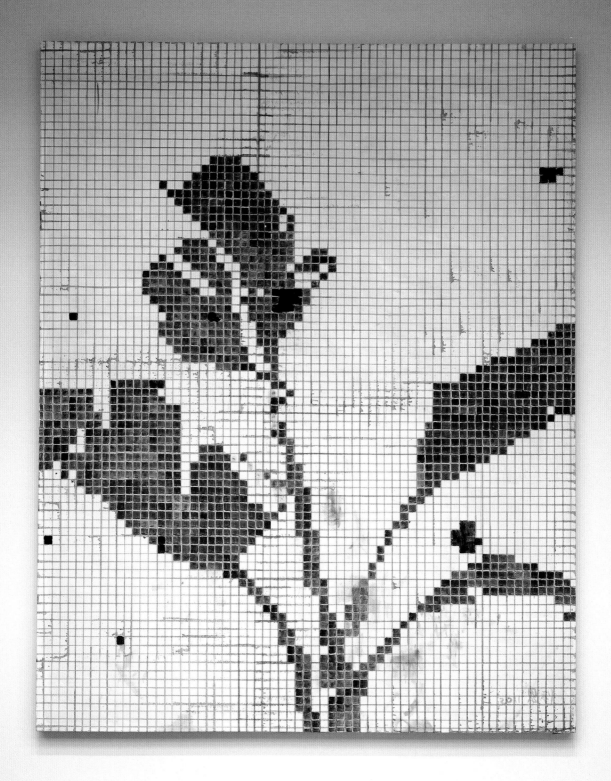

Wang Jun on Zhang Enli

Zhang Enli once told me: "I revise my paintings as little as possible. I keep the mistakes and regard them as providing a kind of depth." I again approached his almost bare painting, looking for this 'depth' on a canvas that was covered with a thin layer of colour. What I saw was a relatively striking grid compared to the painting itself. Slowly, I noticed the traces of sketching and swelling paint, both prominent and yet not so obvious at first. For instance, when we appreciate tablet inscriptions, we don't consider the grid on the tablet as an error. And this is precisely why the swelling and traces here are not mistakes in my eyes, and actually enliven these works. So what is vitality? And what is a memorable life? How can we understand our mistakes? Are they intrinsic to perfection? Throughout his artistic career Zhang Enli has progressed from people to objects, from thick paints to thin colours, and even from being considered a 'nobody' to becoming an established 'somebody'. When I read his publications or see exhibitions of his paintings from various periods, I feel a strong sense of his painstaking journey of exploration, which over time has gradually defined a complete artistic system of his own. Perhaps there's still room for improvement, but that's life. I would not say his earlier paintings are any lesser or that his recent ones are the best. Analogically speaking, I cannot regard his so-called mistakes as imperfections.

Wang Jun is an artist and a curator who lives and works in Shanghai, China

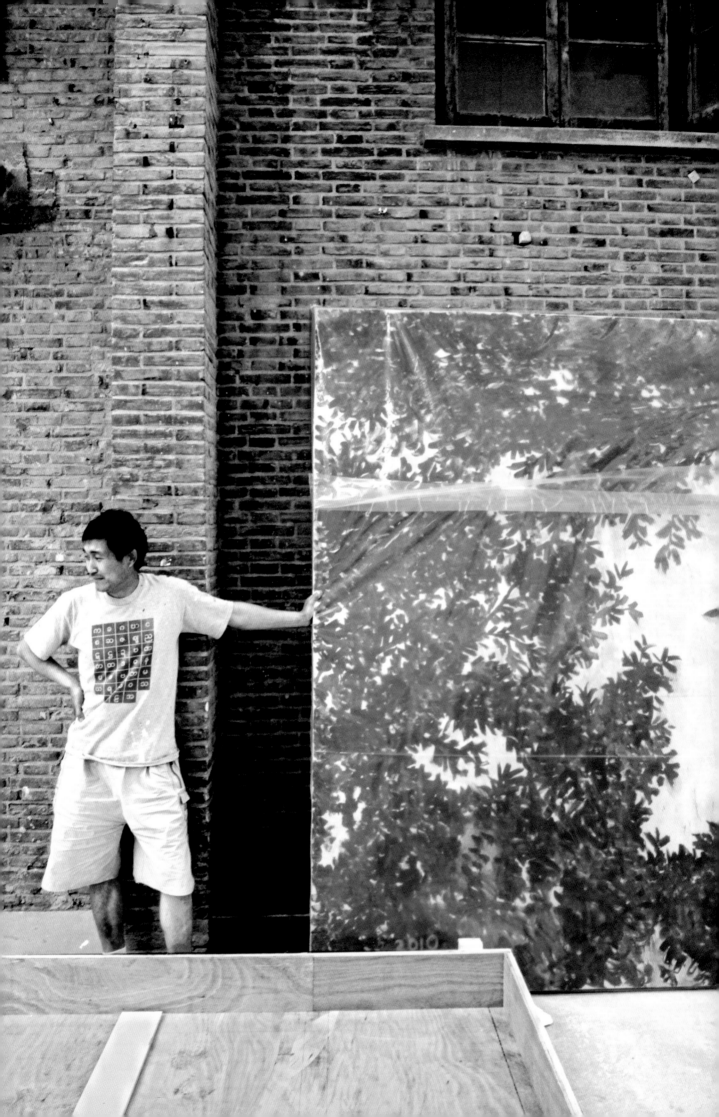

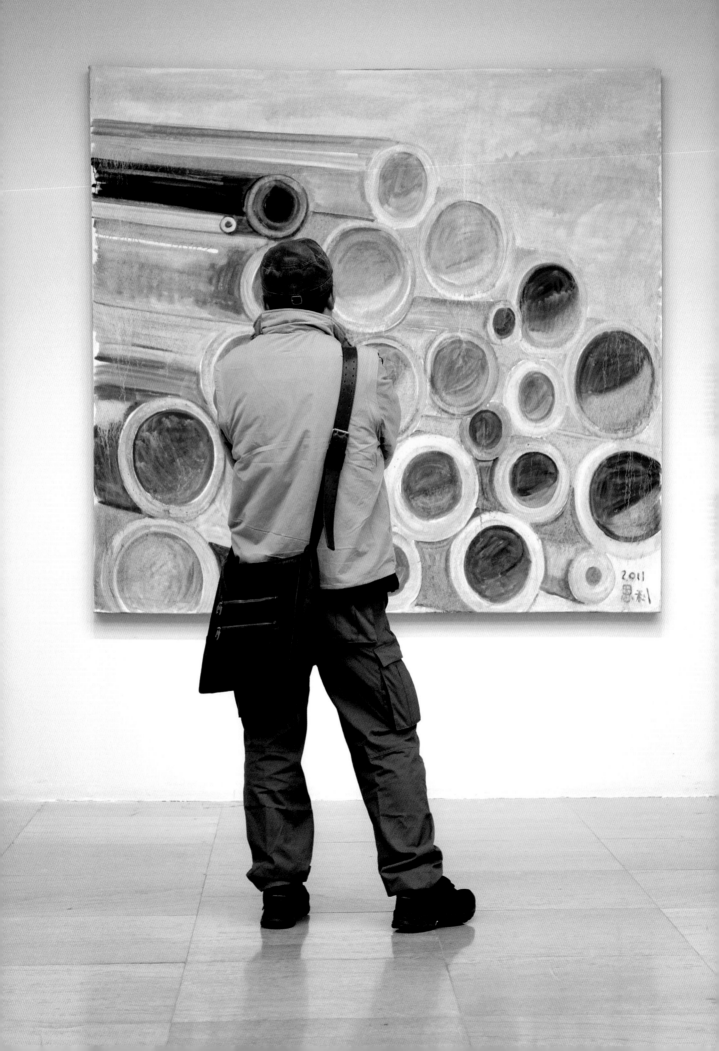

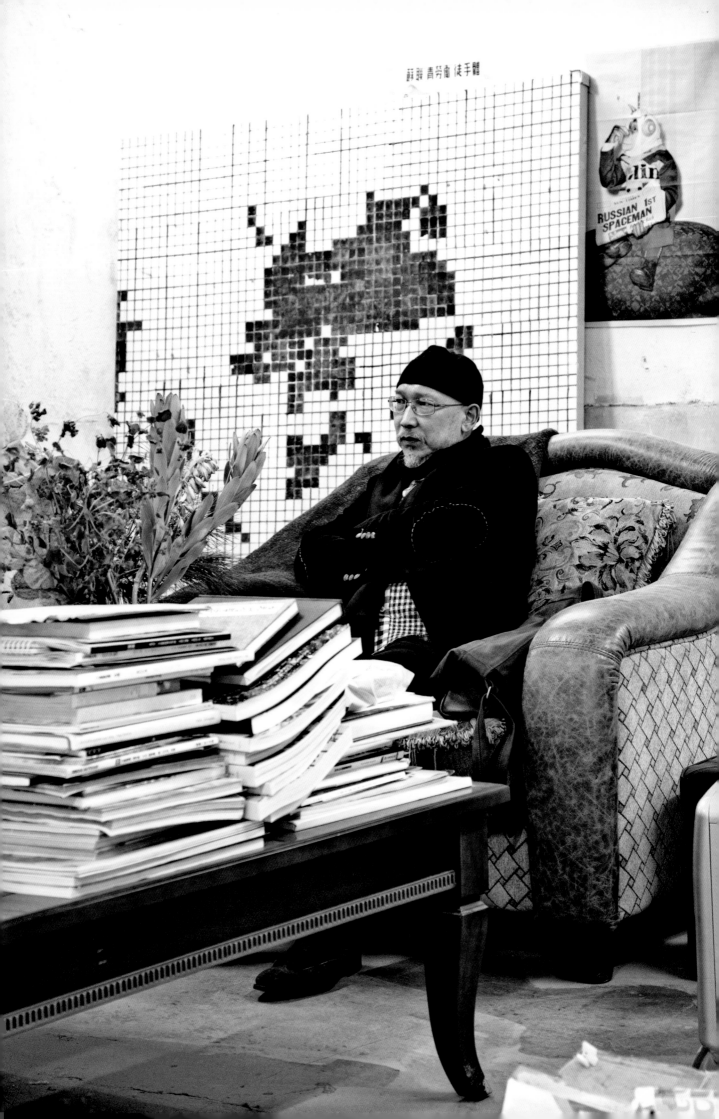

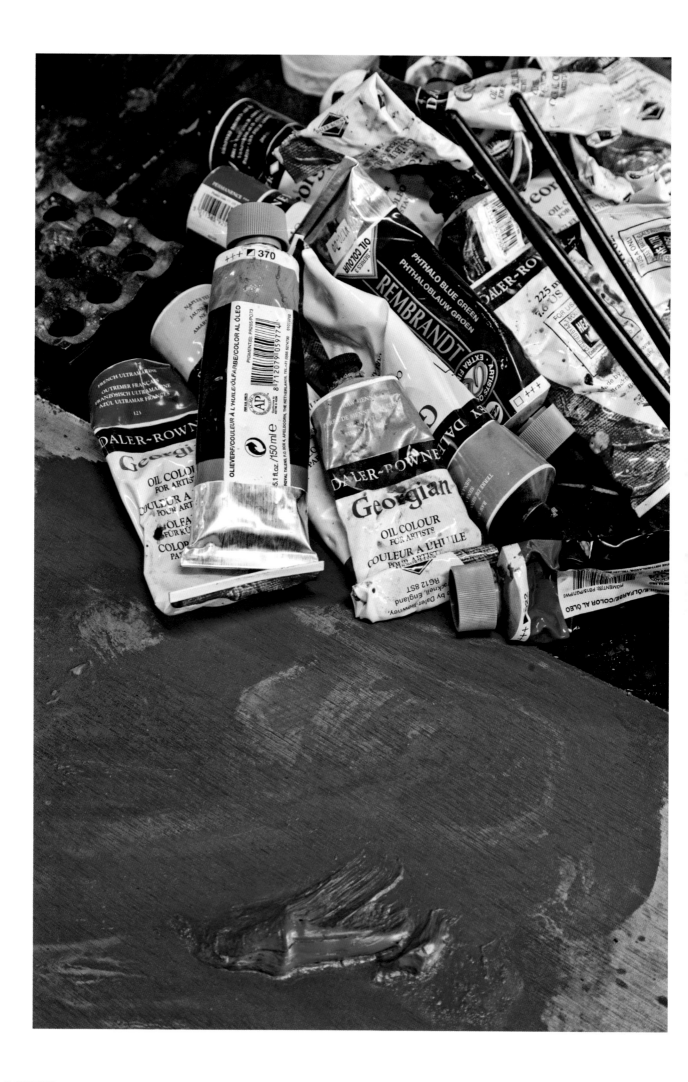

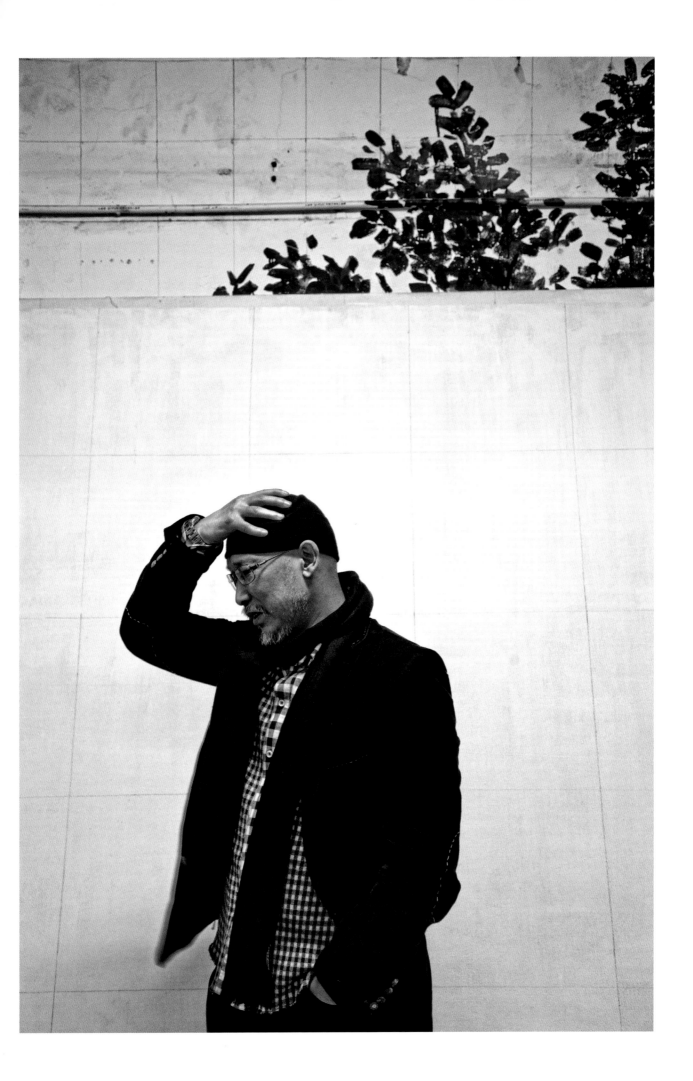

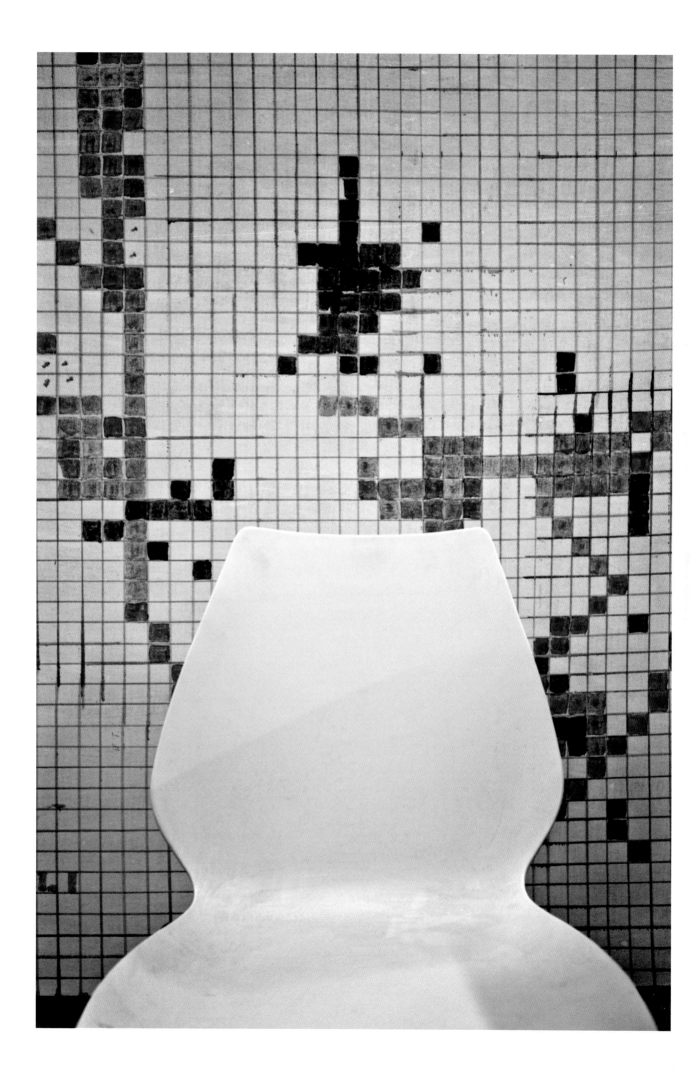

ZHANG ENLI

LIU WEI

1972 Born in Beijing, China
1996 Graduated from the National Academy of Fine Arts, Beijing, China
2006 Chinese Contemporary Art Awards - Honourable Mention
2008 Chinese Contemporary Art Awards - Best Artist

Lives and works in Beijing, China

Selected Solo Exhibitions

2011 "Myriad Beings", Today Art Museum, Beijing, China

"Trilogy", Minsheng Art Museum, Shanghai, China

2009 "The Forgotten Experience", Galerie Hussenot, Paris, France

2007 "The Outcast", Boers-Li Gallery, Beijing, China

"Love it, Bite it", China Art Archives & Warehouse and Boers-Li Gallery, Beijing, China

2006 "Property of Liu Wei", Beijing Commune, Beijing, China

Selected Group Exhibitions

2010 "DREAMLANDS", Centre Pompidou, Paris, France

"State of Things: Contemporary Art Exchange between China and Belgium", National Art Museum of China, Beijing, China

Shanghai Biennale - Rehearsal, Shanghai Art Museum, Shanghai, China

2009 "Breaking Forecast: 8 Key Figures of China's New Generation Artists", Ullens Center for Contemporary Art, Beijing, China

2008 "Expenditure", Busan Biennale, Busan, South Korea

"Farewell to Post Colonialism", Third Guangzhou Triennial, Guangzhou, China

"The Revolution Continues: New Art from China", Saatchi Gallery, London, UK

2007 "History of a Decade that Has Not Yet Been Named", 9th Lyon Biennale, Lyon, France

2005 51st Venice Biennale, Venice, Italy

"Mahjong", Kunstmuseum Bern, Bern, Switzerland

Second Guangzhou Triennial, Guangzhou, China

2004 "Techniques of the Visible", Shanghai Biennale, Shanghai, China

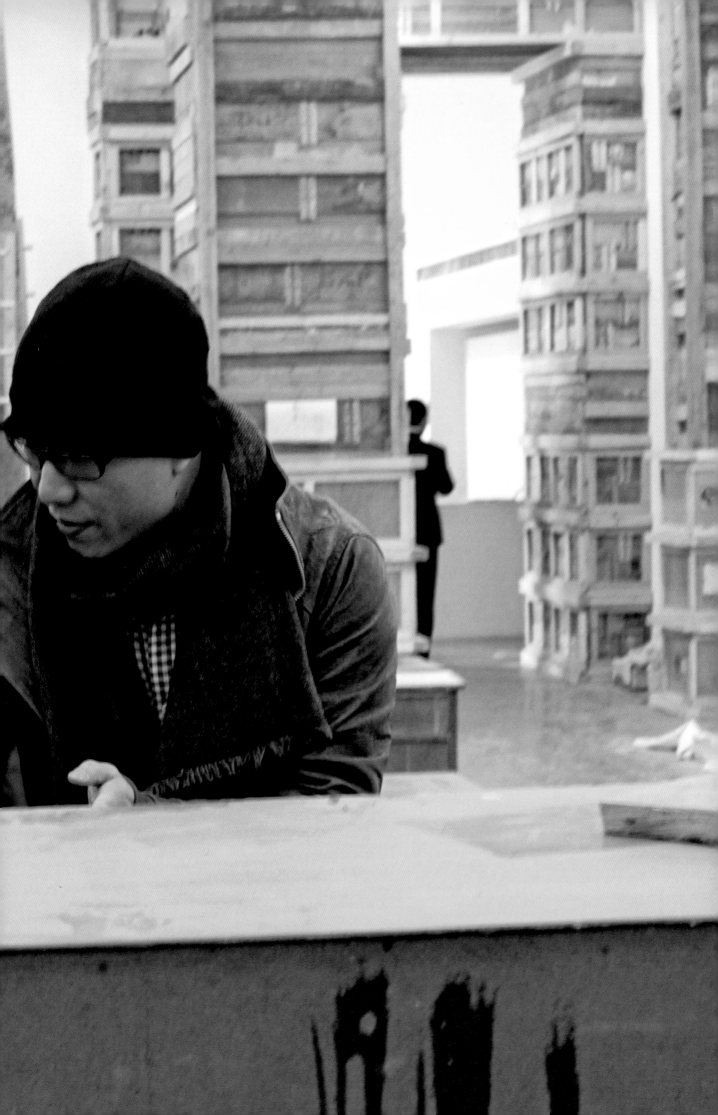

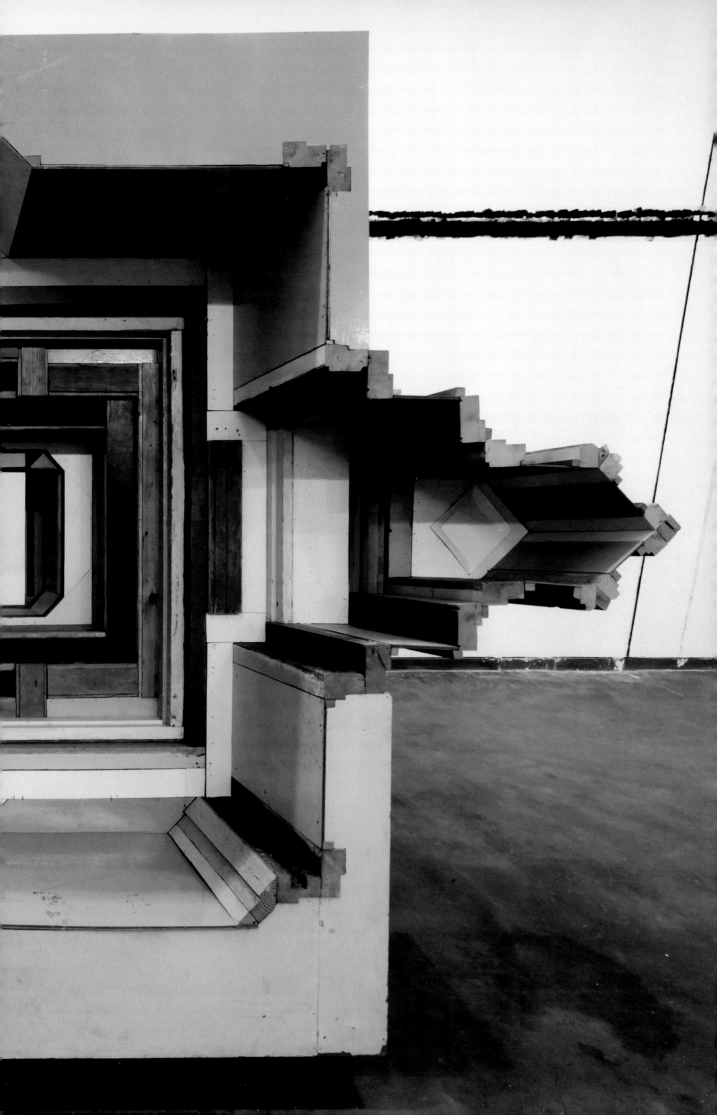

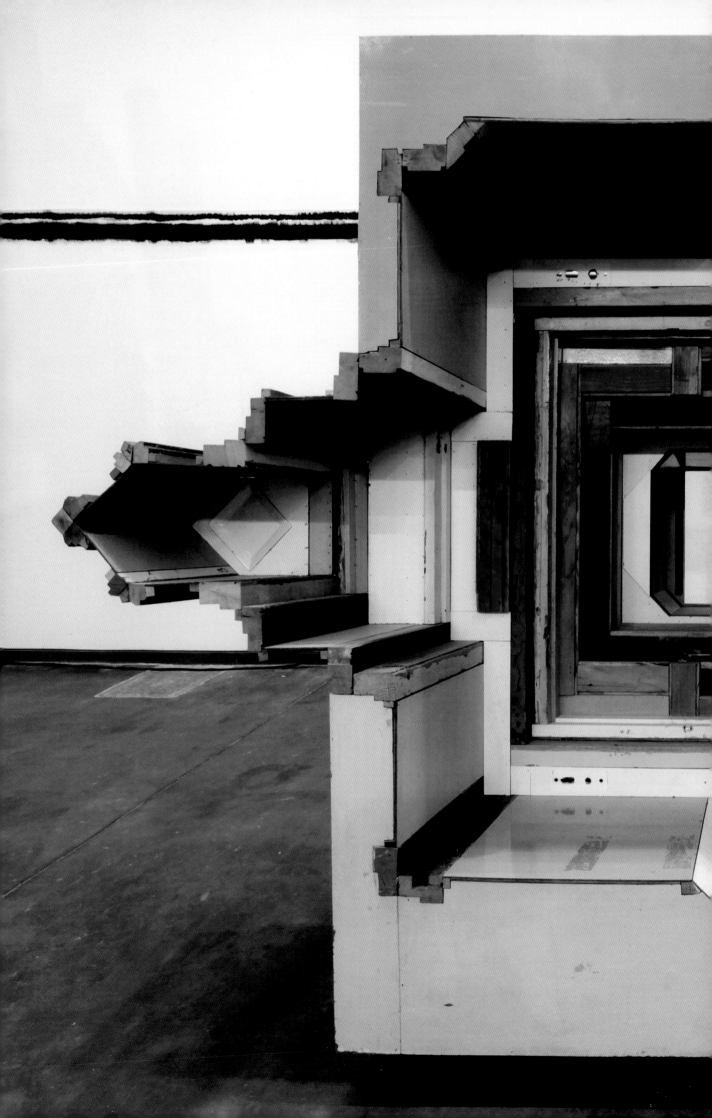

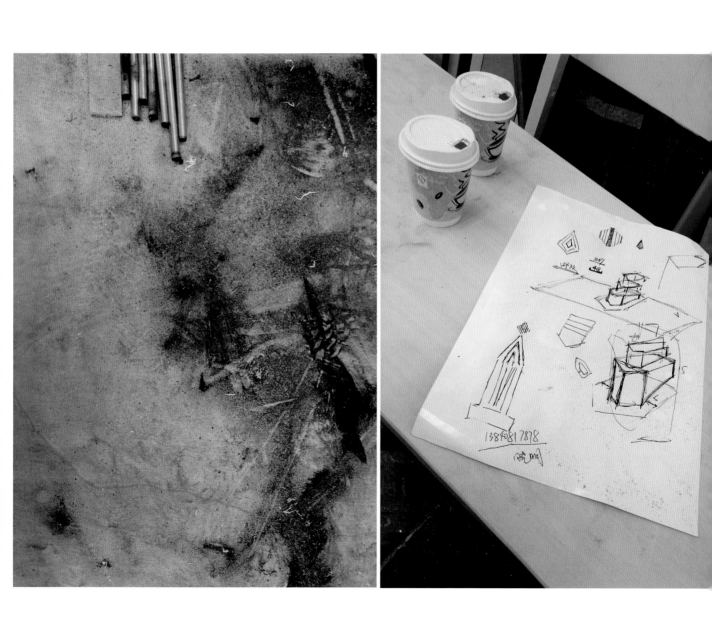

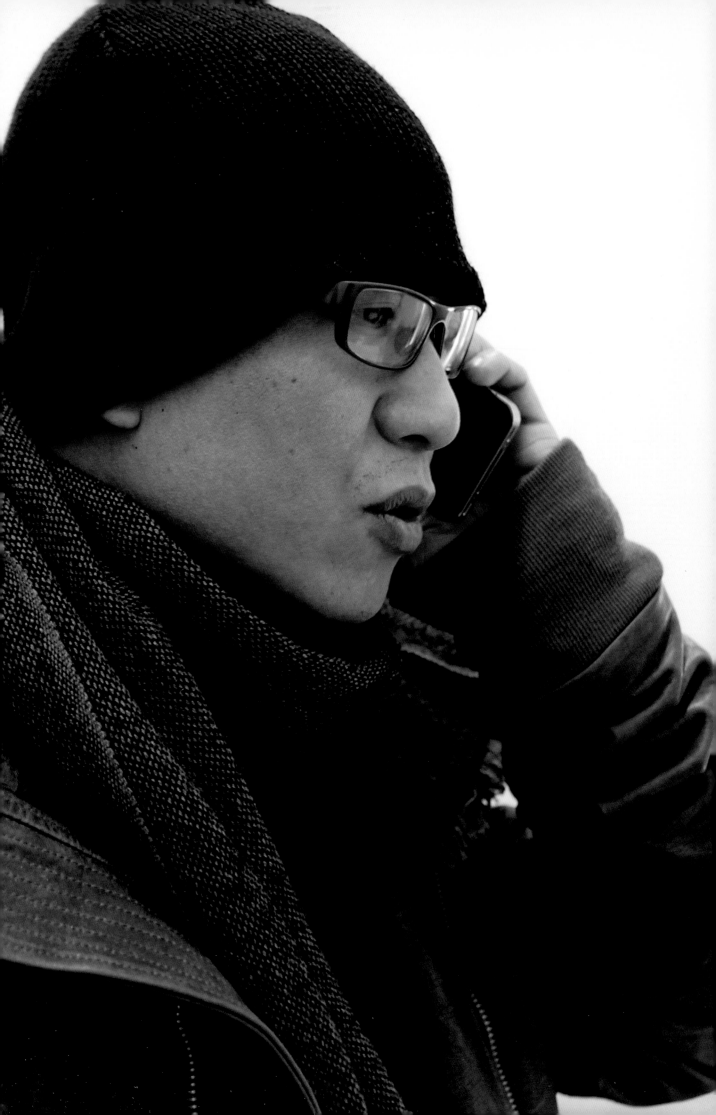

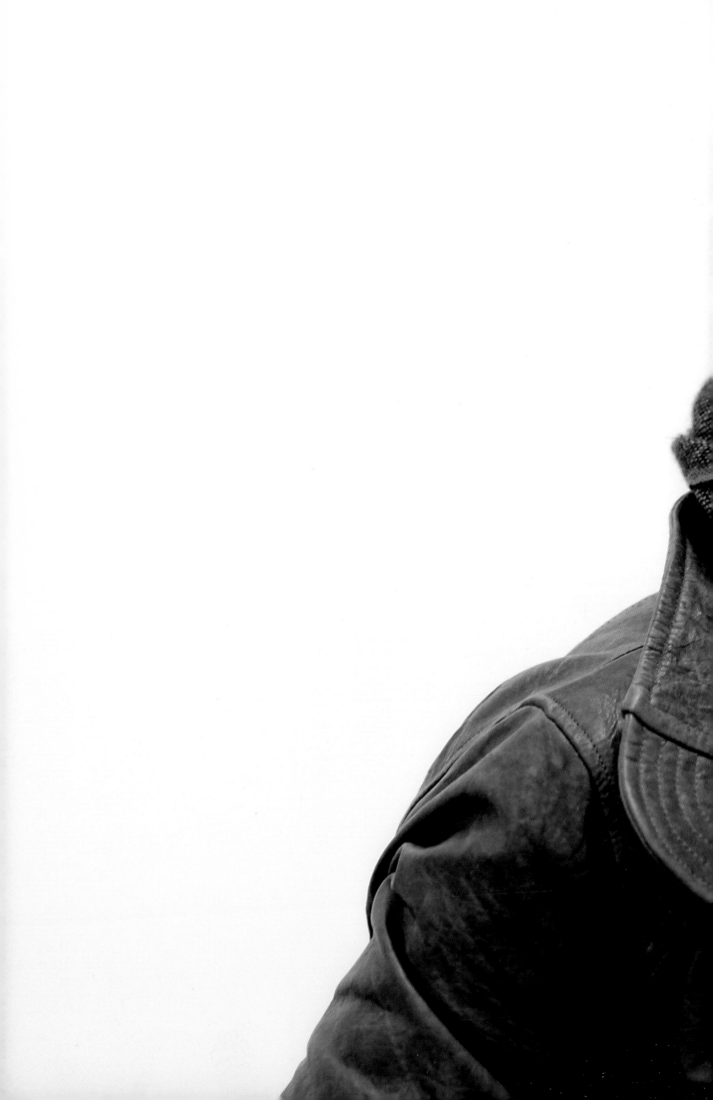

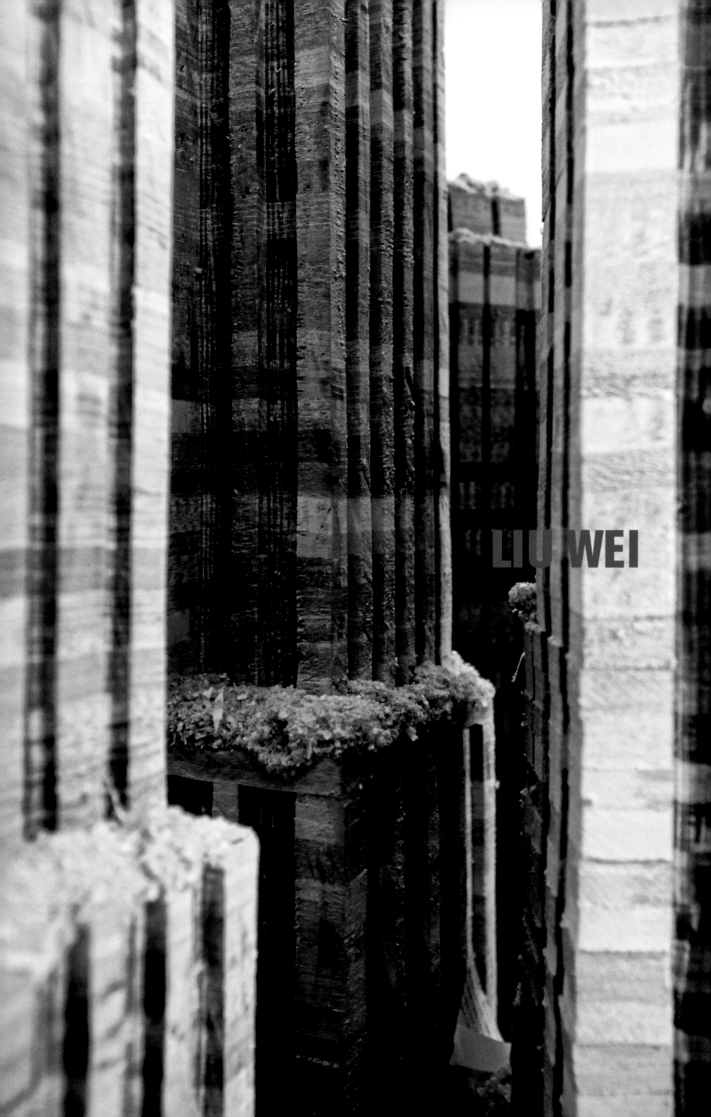

LIU WEI

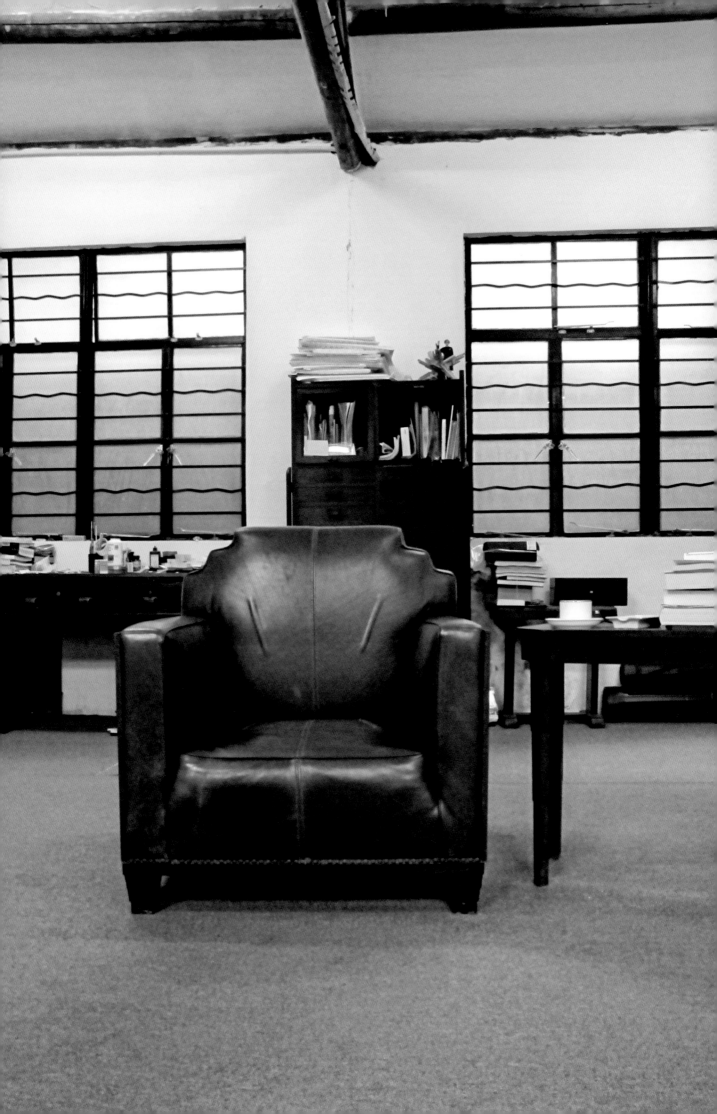

DING YI

1962 Born in Shanghai, China
1990 Graduated in fine arts from Shanghai University, Shanghai, China

Lives and works in Shanghai, China

Selected Solo Exhibitions

2011 "Specific Abstracted: Ding Yi Exhibition", Minsheng Art Museum, Shanghai, China

2008 "Appearance of Crosses from 1989–2007", Museo d'Arte Moderna, Bologna, Italy

2005 "Appearance of Crosses", Ikon Gallery, Birmingham, UK

2004 "Crossed Vision: Works by Ding Yi", CAAW China Art Archive & Warehouse, Beijing, China

2003 "Appearance of Crosses", Galerie Urs Meile, Lucerne, Switzerland

Selected Group Exhibitions

2012 ART HK 12 International Art Fair, Hong Kong Convention Center, Hong Kong, SAR China

2011 "Verso Est: Chinese Architectural Landscape", MAXXI Museo Nazionale, Rome, Italy

2010 "One by One", ShanghART Group Show, ShanghART Gallery, Shanghai, China

"Thirty Years of Chinese Contemporary Art", Minsheng Art Museum, Shanghai, China

2008 "Avant-Garde China: Twenty Years of Chinese Contemporary Art", National Art Center, Tokyo, Japan

2005 "Mahjong: Contemporary Chinese Art from the Sigg Collection", Kunstmuseum Bern, Bern, Switzerland

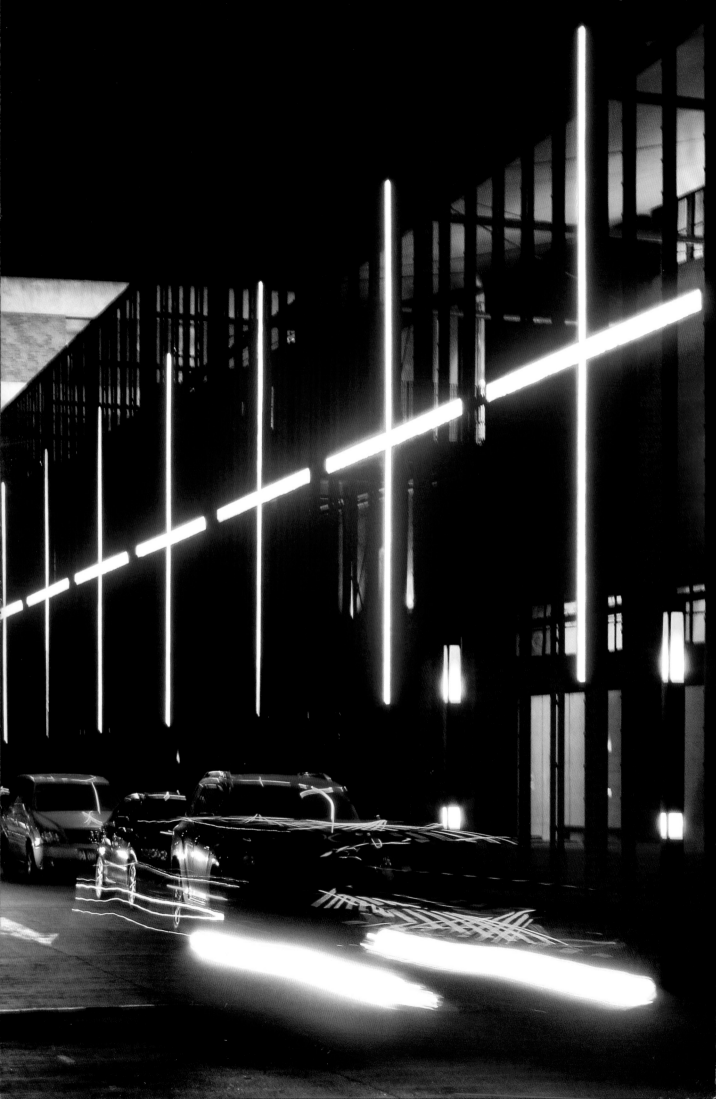

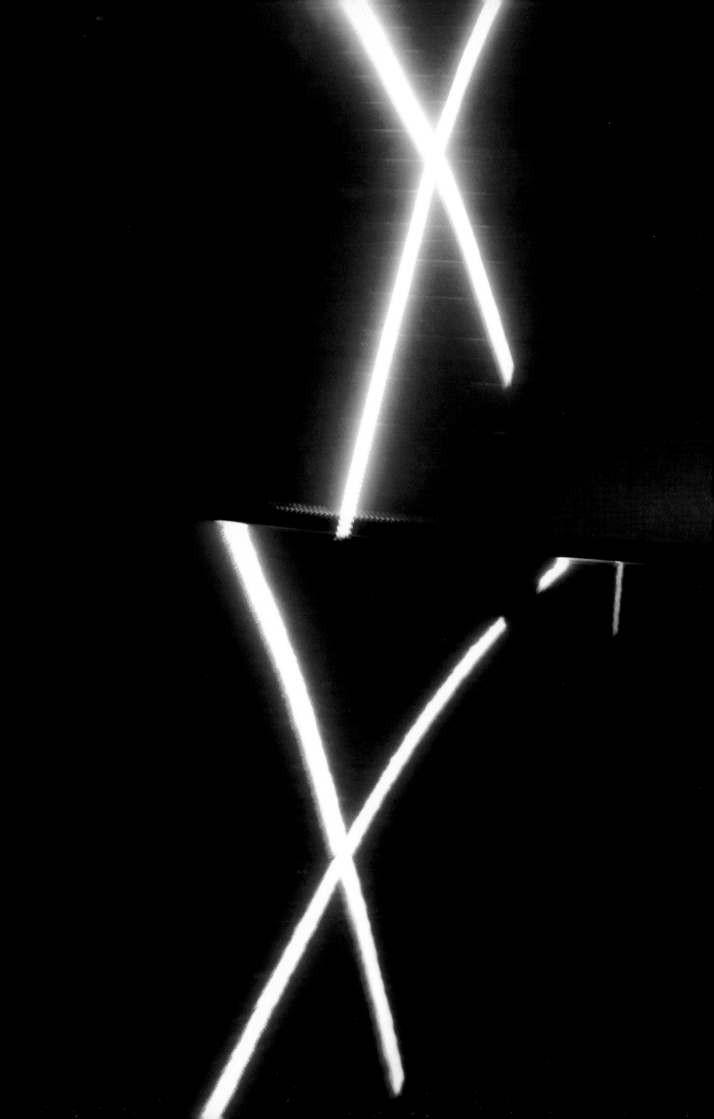

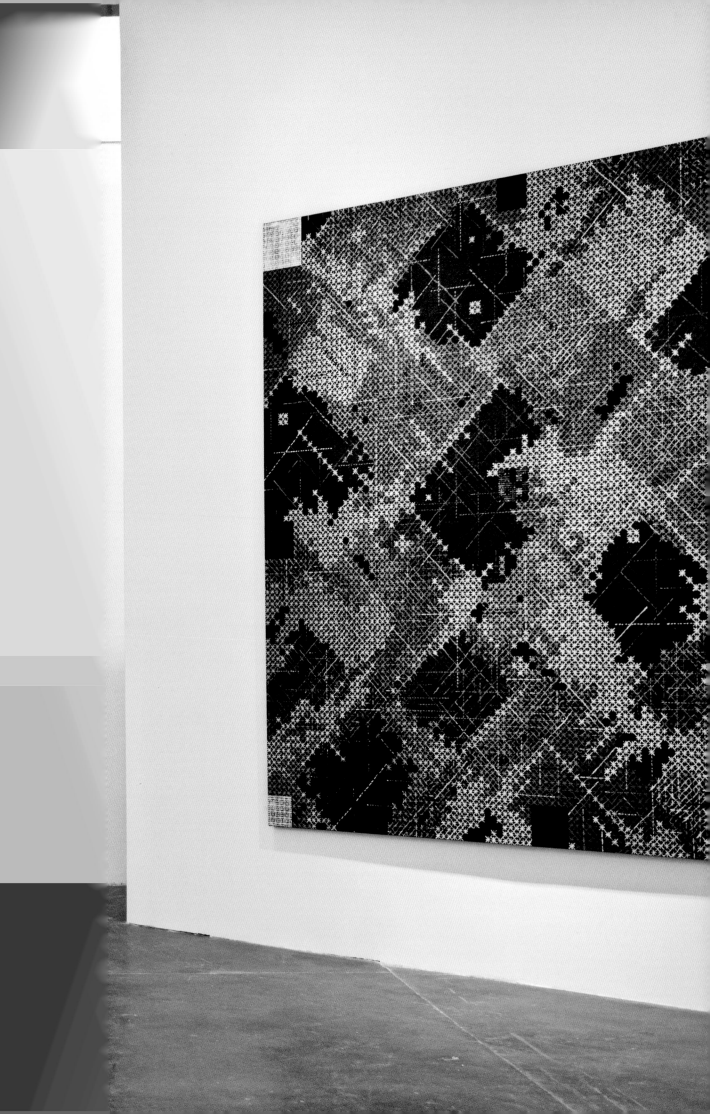

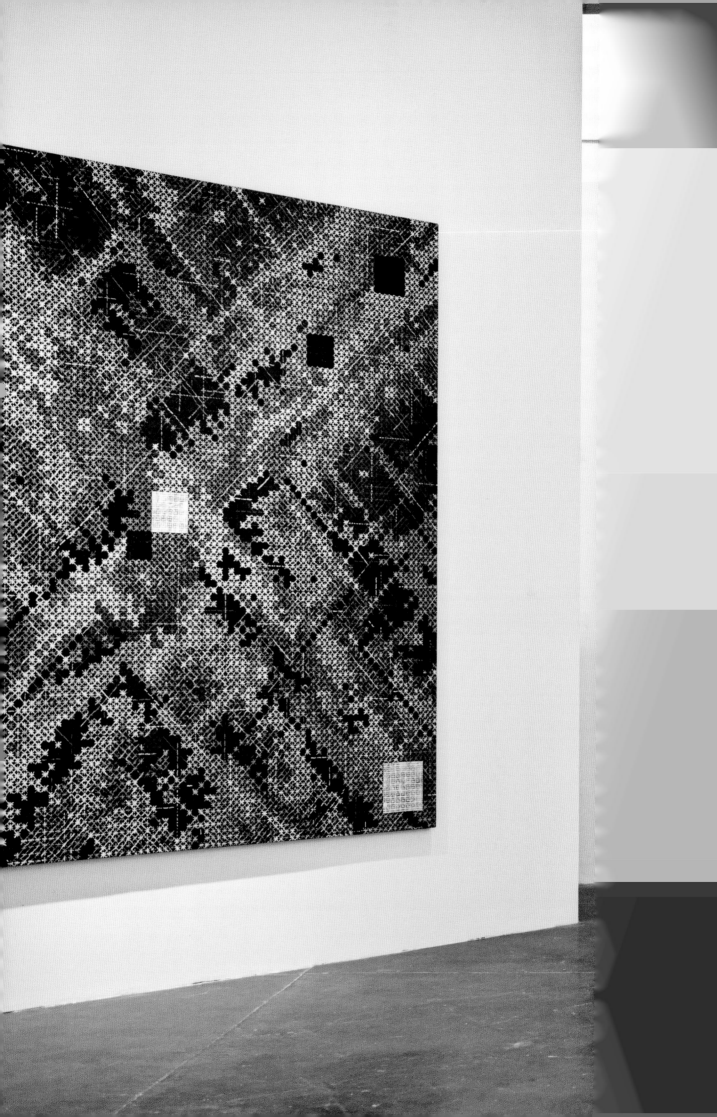

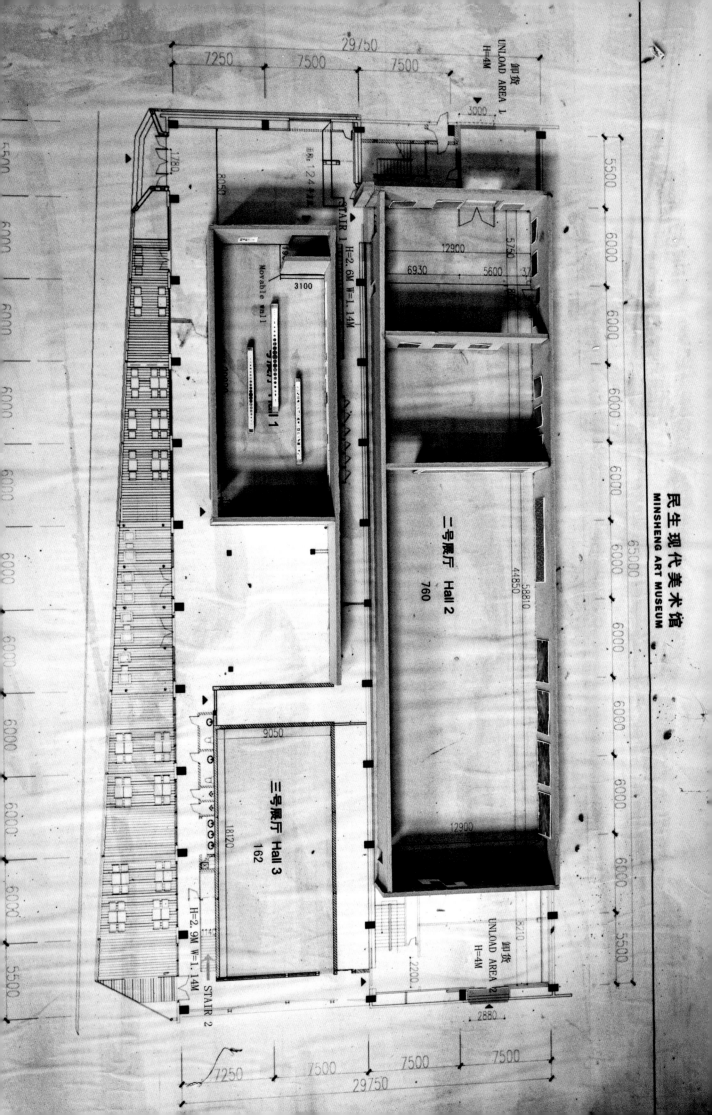

民生现代美术馆
MINSHENG ART MUSEUM

UNLOAD AREA 1
卸货
H=4M

STAIR 1 H=2.6M W=1.14M

Movable wall

Hall 1

一号展厅

二号展厅 Hall 2
760

三号展厅 Hall 3
162

UNLOAD AREA 2
卸货
H=4M

STAIR 2 H=2.9M W=1.14M

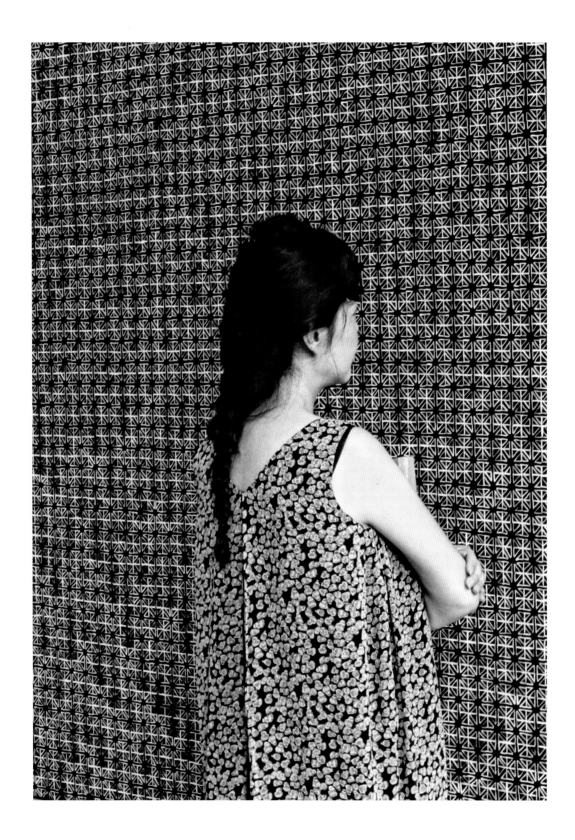

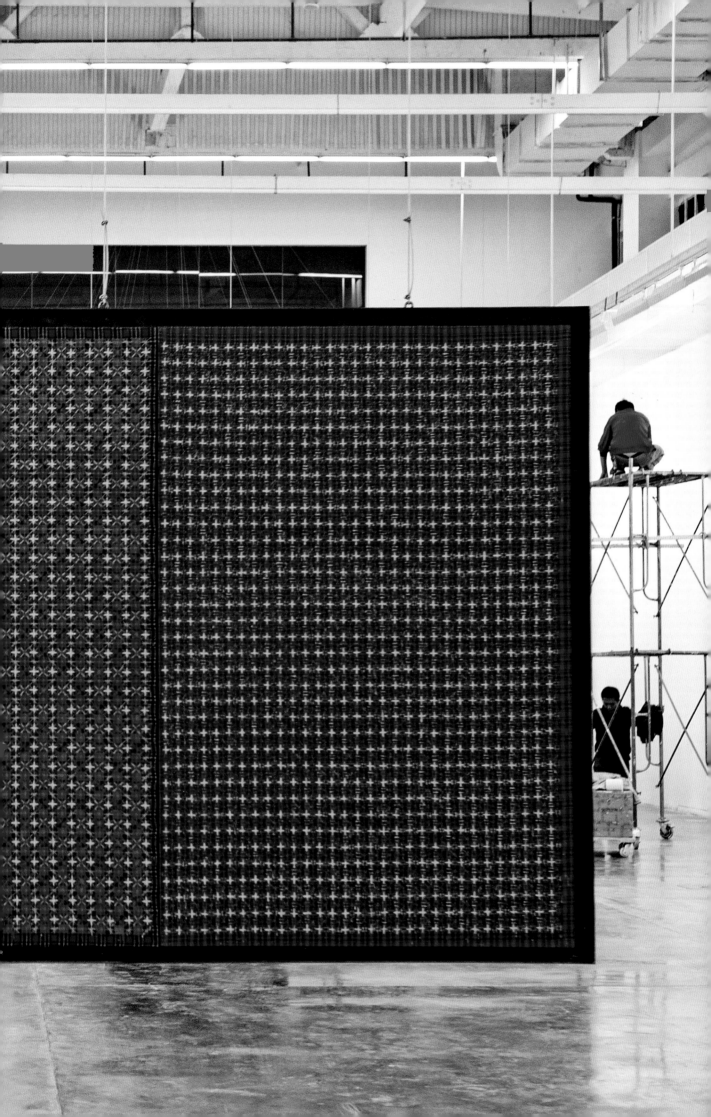

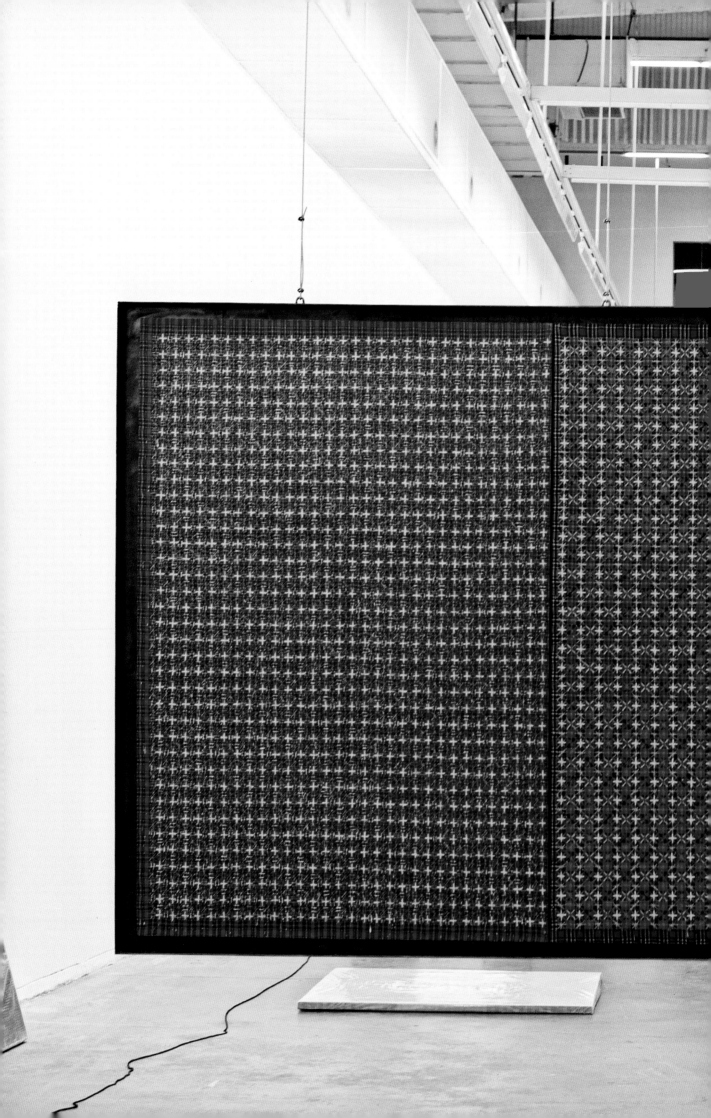

Cross Coordinates:
The Limits and Breakthroughs of Two Decades

Interview with Ding Yi by Linghu Lei and Hu Qihong from CHINA LIFE MAGAZINE

CLM: I am curious as to how you start to work when faced with a blank canvas.

DY: Actually, it is a little like playing Chinese chess. There is an overall arrangement. I do not paint from start to finish. I hit the high spots, and add some rational elements at the same time.

CLM: There is a change from tools like the ruler to hand painting in your work, and you once described it as "a change from absolute accuracy to verbal style".

DY: Every change has its moment. I used to paint using a ruler. I had to use two chairs to hold the ruler in front of the canvas and then bend down to paint. When I am painting, I rarely stop during the process. I will even paint with a cigarette in my hand. From 1988 to 1992 I continued to paint like this and I strained my back. The pain made me change. I was thinking of how to solve the problem and discovered the so-called 'verbal style' (hand painting). I was no longer pursuing absolute accuracy.

CLM: It seems that whether you are narrating with 'absolute accuracy' or 'verbal style' the content is about you, not the public.

DY: For the general public, it is just a painting. In fact, it is a connection between the artist and the canvas, but it is more than a dialogue. There is often a contradictive relationship between me and the canvas. You have to conquer something frequently; to try your best to overcome it. It is like fighting.

CLM: You said you were most afraid of familiarity. When you repaint a cross, is it a repetition or a new idea?

DY: Over the last two decades I have often looked for a new start. When I paint a cross it is a start, but when an artist constantly creates and recreates, there is a dilemma. How do you get past this problem? For me, there are many enemies, and familiarity is one of them. When you begin to know a method well, you paint very easily. For me, beauty is frivolous, like weeds. I hope there is something more profound in my work, even serious.

CLM: You have continued to paint 'Cross Coordinates' for more than twenty years. Do you have any particular reflection on this?

DY: Not really. The reviews from several critics made me feel ashamed. There are basically two views about my painting. Some think there has been no change in two decades and others say I am changing all the time. It is quite embarrassing, as if I am so clumsy that I cannot forget this kind of symbolism. Actually, I really don't want to let it go so readily. I still feel excited when I start a new painting. I am not feeling numb to it. When I say "I cannot stop", it is an added stimulus. I want to hurry and finish the work, to see the final effect. In the process, you are adding fragmentary thoughts and you still have no idea about the final outcome. The result can only be seen once the work is finished.

China Life Magazine, 42nd issue, Zen, May 2009

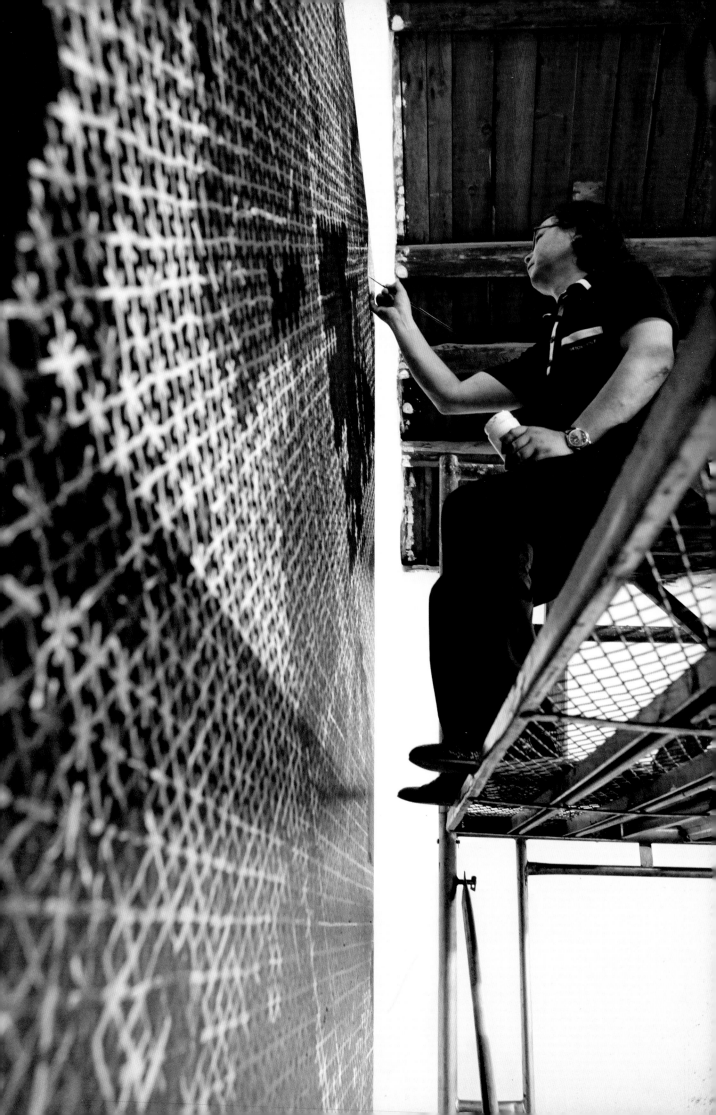

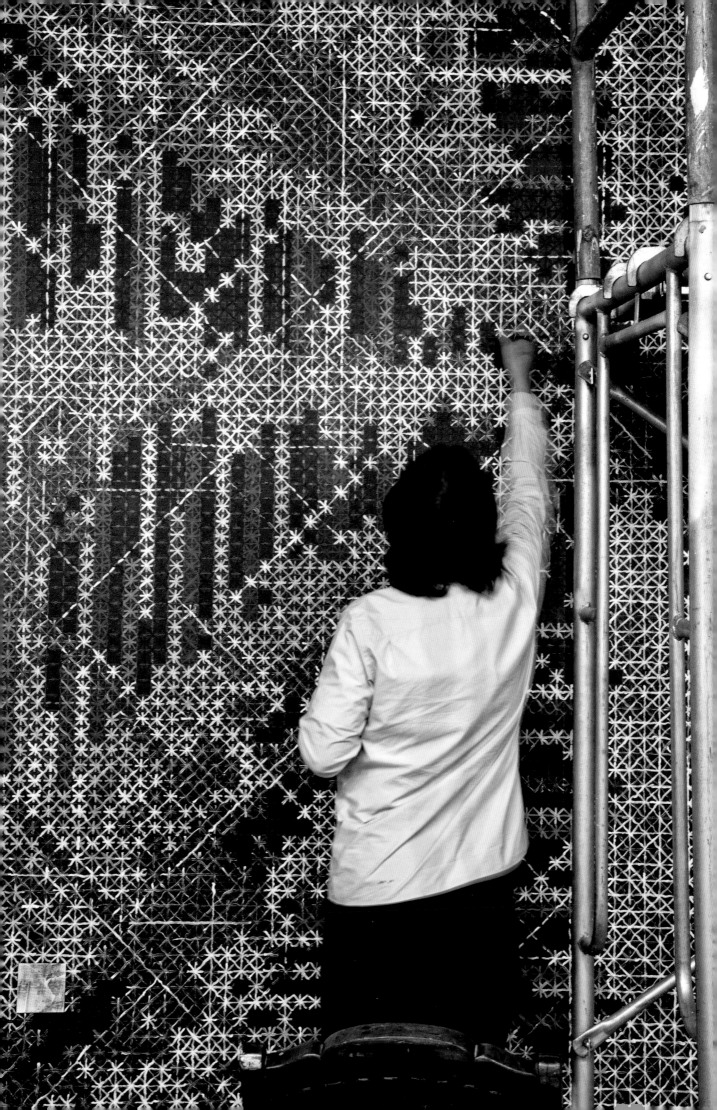

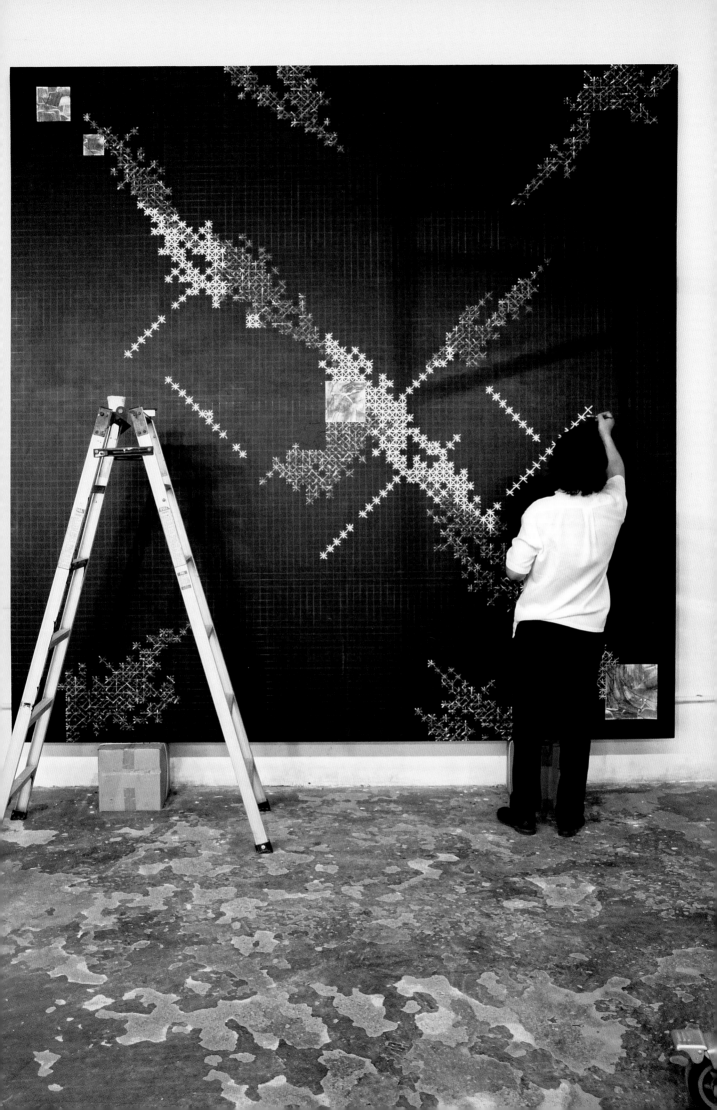

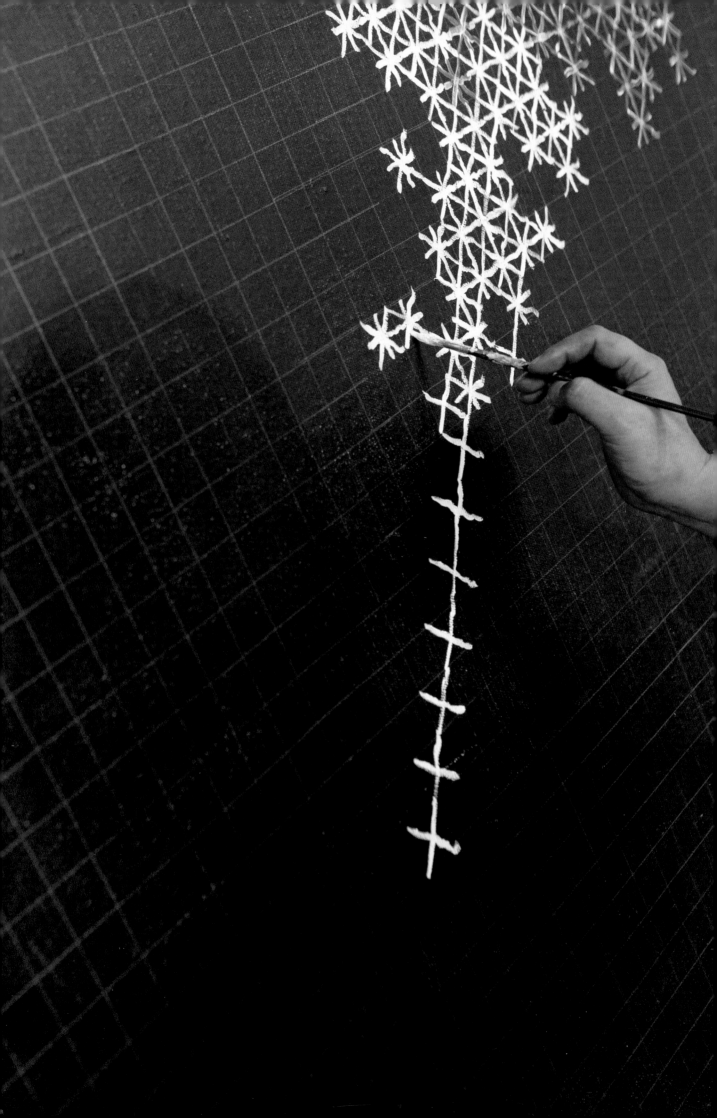

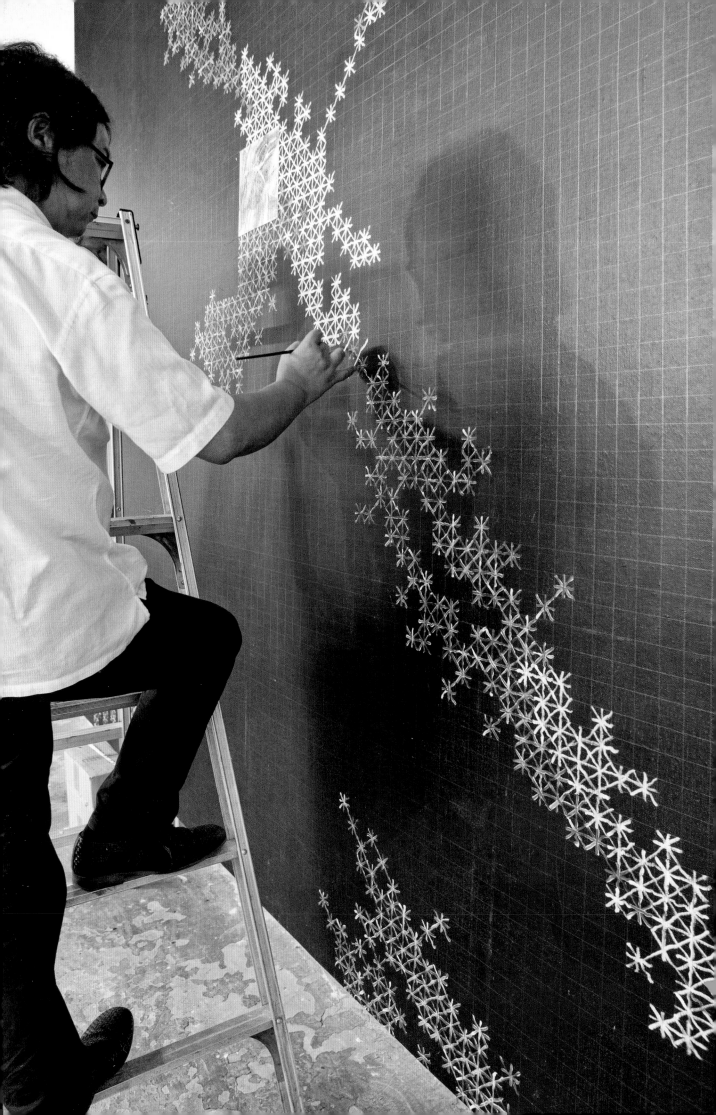

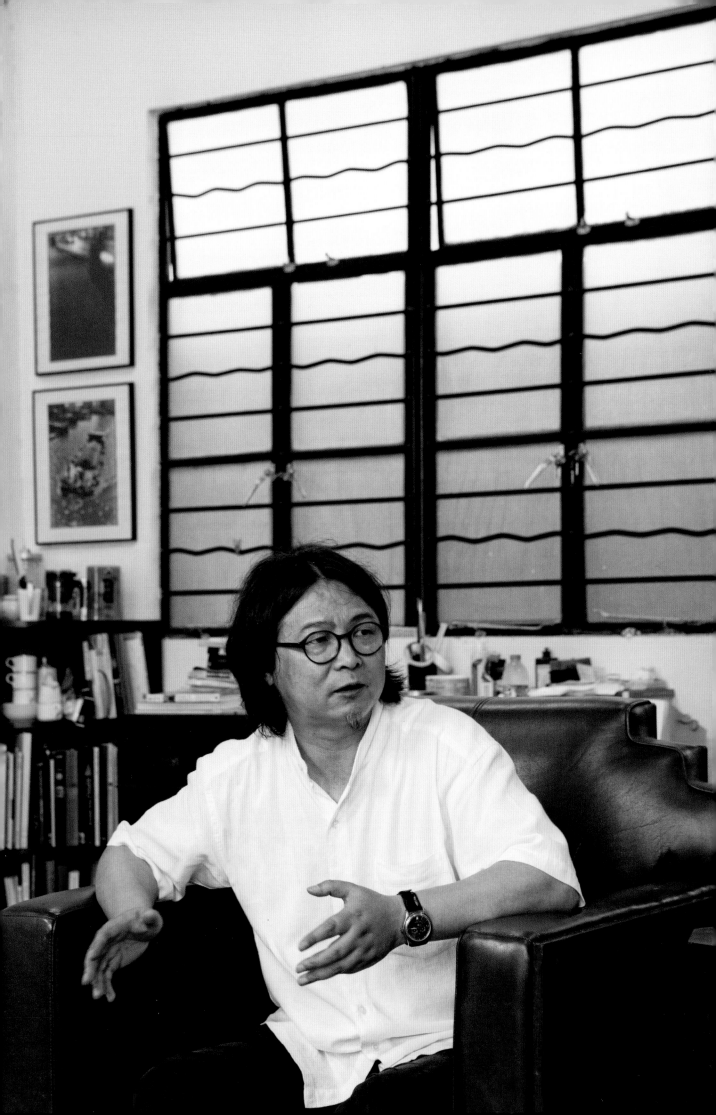

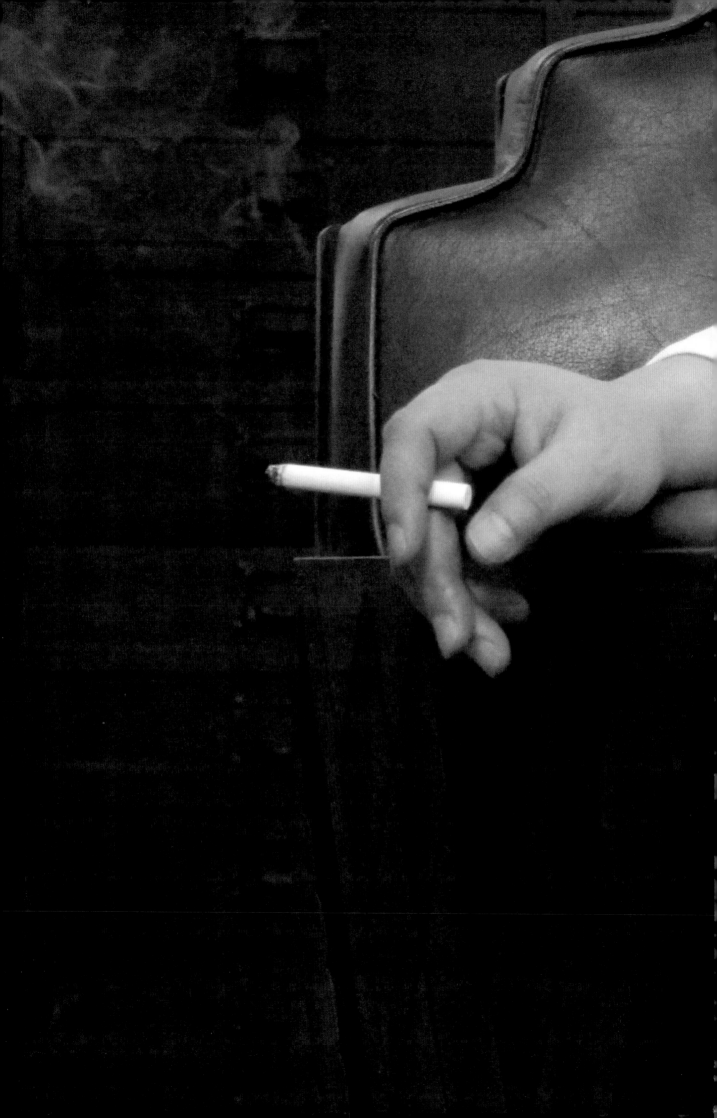

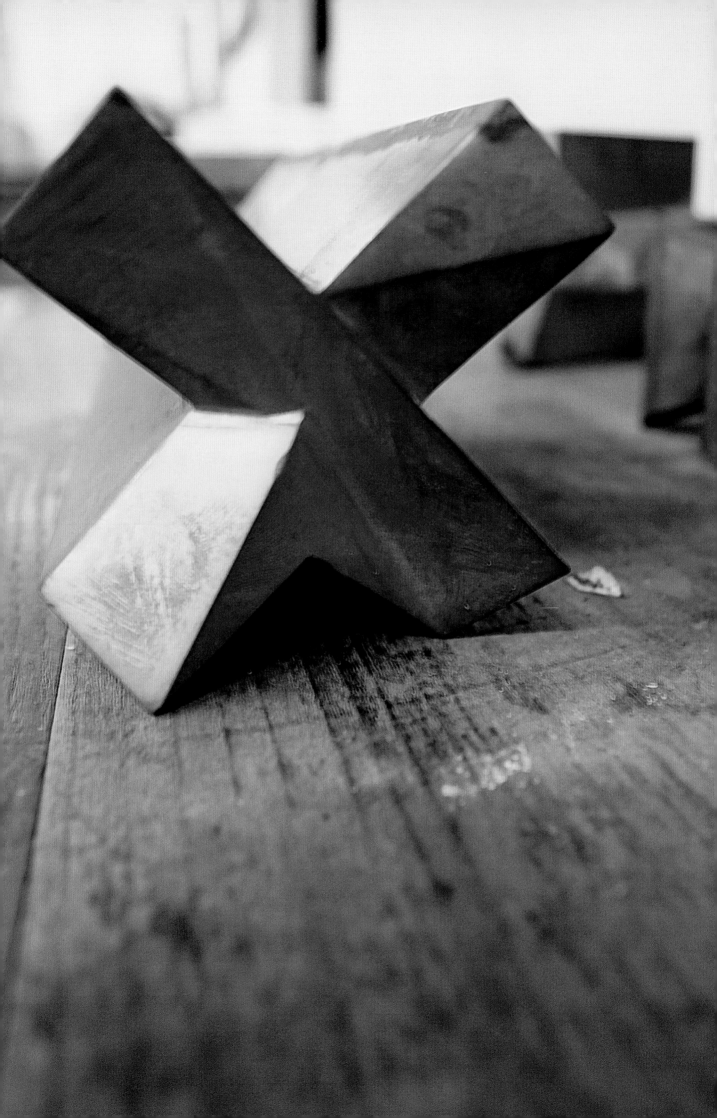

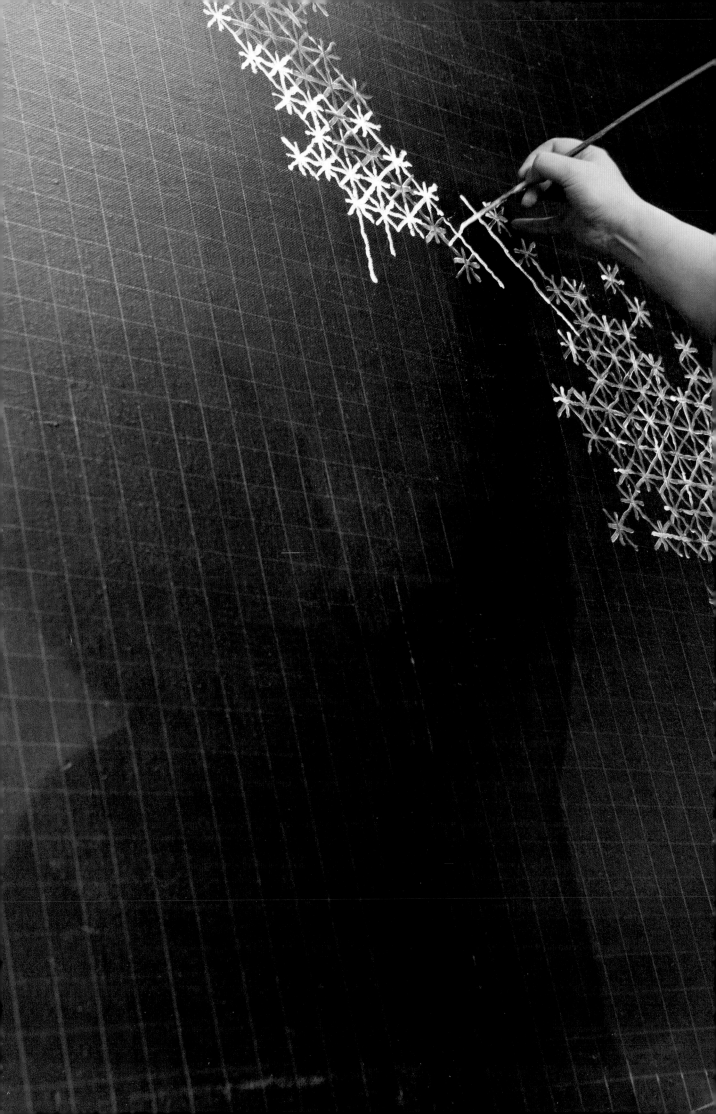

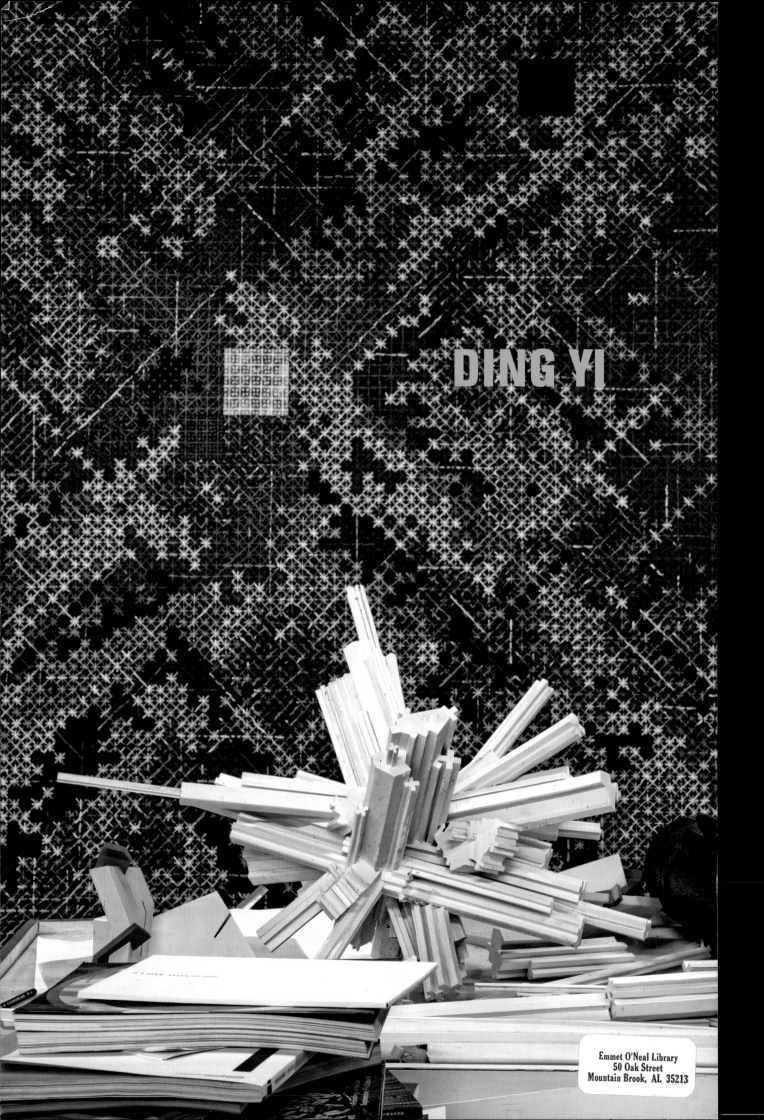

DING YI